MUSEUM SKEPTICISM

DAVID CARRIER

MUSEUM SKEPTICISM

A History
of the
Display of Art in
Public Galleries

DUKE UNIVERSITY PRESS Durham and London 2006

© 2006 Duke University Press

All rights reserved

Printed in the United States of America

on acid-free paper ∞

Designed by C. H. Westmoreland

Typeset in Adobe Garamond

by Tseng Information Systems, Inc.

Library of Congress Cataloging-in-

Publication Data appear on the

last printed page of this book.

for BILL BERKSON,

CATHLEEN CHAFFEE,

LYDIA GOEHR,

and DING NING

and for

MARIANNE NOVY,

without whom

not

MY PURPOSE is to tell of bodies
which have been transformed into shapes
of a different kind. You heavenly powers,
since you were responsible for those changes,
as for all else, look favourably on my attempts,
and spin an unbroken thread of verse, from
the earliest beginnings of the world,
down to my own times.

—OVID,
Metamorphoses

THE LIFE Achilles chooses is an image
of all life as Homer understood it. . . . It is only
because life is irretrievable and irrepeatable
that the glory of appearance can reach such
intensity. Here there is no hidden meaning, no
reference to, nor hint of, anything else. . . .
Here appearance is everything.

—ROBERTO COLASSO,
*The Marriage of Cadmus
and Harmony*

Contents

Acknowledgments

Art, *ars*, means "deception," and . . . the artist (suspending disbelief)

must participate in his own illusion, if it is to be convincing. He must

fool himself. —PAUL BAROLSKY

Guided by a Hegelian philosophical framework presented in the over-
ture, this book employs case studies to explain the origin of the modern
public art museum, describe how it developed, and indicate why now
it is undergoing a radical transformation. Research began on March 29,
1986, when I started reading Thomas Crow's *Painters and Public Life in
Eighteenth-Century Paris*. His analysis of art in the public sphere provided
one central idea, but I didn't know that until I began writing in 1998.
It took me two years to understand the central importance of museum
skepticism and three more years to comprehend fully how to use that
concept in my historical discussion. The final argument was worked out
in April 2003, thanks to Eleanor Munro's *Memoir of a Modernist's Daugh-
ter*, which showed how to link Crow's discussion to discussion of the
present fate of the museum. My use of Ovid's conception of metamor-
phosis builds self-consciously upon Paul Barolsky's claims. In writing art
history, he argues, we need to acknowledge that "our understanding of
art, far richer than the sum of the documented facts, is itself fictive, given
form by a web of poetic influences that escape detection in conventional
exegesis."[1] Within such narratives a firm dividing line between strict his-
torical truth and creative fiction may be impossible to establish. I play the
philosopher's inevitable concern with truth against the creative writer's
natural fascination with metamorphosis, with resolution coming only in
the conclusion, where the distinction between what is and what might
be is deconstructed.

Like successful visual artists, art writers have a personal style. Once
you have done a number of books, then (so I have found) the basic ma-

terials needed for your next one are already available in your prior work, if only you know where to look. In 1991 I published *Principles of Art History Writing*, a study of the rise of academic art history. Then by the late 1990s I realized that in order to justify this analysis I needed to describe the institutional foundations of art history. That extension of that earlier account built upon a pregnant observation in the book collecting my art criticism: "Like an inept narrative, a poorly organized museum tells a story that is hard to follow. By contrast, a carefully hung museum like a lucid essay, makes its transitions seem effortless."[2] *High Art* (1996), my study of Charles Baudelaire's criticism, showed how to explain the role of contemporary art in the J. Paul Getty Museum. *The Aesthetics of Comics* (2000) indicated how to understand the relationship between high art and mass art, a theme further developed in *Sean Scully* (2004). And, finally, *Writing about Visual Art* (2003) compared art history narratives and historical museum hangings in an analysis that I now extend and modify. A close reader of my oeuvre will see that this present book, which is entirely self-sufficient, fits into a larger plan.

Unlike faculty, museum employees are not at liberty to discuss their institutions with outsiders. And so, as Sherman Lee notes, "critical (in the best sense of the word) studies and attitudes are uncommon in this area. . . . The intellectual stimuli symbolized by the healthy give-and-take of responsible criticism are largely absent from the 'universe' of the art museum."[3] I thank the curators and administrators who talked to me: Richard Armstrong, John Caldwell, Mark Francis, Madeleine Grynsztejn, and Thomas Sokolowski at the Carnegie Museum of Art, Pittsburgh; DeCourcy D. McIntosh of the Frick Art and Historical Center; John Elderfield of the Museum of Modern Art, New York; Daniel Seidel of the Shelden Museum, Omaha, Nebraska; Constance Lewallen, the Berkeley Art Museum; Jeffrey Grove, Constantine Petridis, and Charlotte Vignon of the Cleveland Museum of Art; Timothy J. Standring at the Denver Museum of Art; Marcia Reed, Michael Roth, and Steve Rountree (in one generously full e-mail) at the J. Paul Getty Museum and the Getty Research Institute; Michael Conforti of the Clark Art Institute, who read a portion of the manuscript; Michael Clarke of the National Gallery, Scotland; and Gloria Williams of the Norton Simon Museum.

Seidel arranged for me to present my ideas to his colleagues, and Jeffrey Weiss of the National Gallery, Washington, D.C., invited me to his Col-

lege Art Association panel in 2002. Thanks to Cordula Grewe, I attended "Exhibiting the Other: Museums of Mankind and the Politics of Cultural Representation," Centre Allemand d'Histoire de L'art, Paris, November 2000, which allowed me to learn about natural history museums. Richard Hertz arranged for me to talk about the Getty Museum at the Art Center College of Design, Pasadena. Dorothy Johnson invited a lecture at the University of Iowa, as did Carl Goldstein and his colleagues at the University of North Carolina, Greensboro. Mark Cheetham and his colleagues at the University of Toronto responded to two presentations. That material, a version of chapter 7, will be published in *Editing the Image: Strategies in the Production and Reception of the Visual*, ed. Mark A. Cheetham, Elizabeth M. Legge, and Catherine Soussloff (Toronto: University of Toronto Press, forthcoming 2007). In 2004 portions of this material were given at a conference on popular culture at the University of Buffalo; the High Lane Gallery, Dublin; Mount Holyoke College; and the Clark Art Institute. A symposium held at the Clark in October 2004 provided a most valuable exchange of ideas.

Paul Benacerraf and Alexander Nehamas supported my position as Lecturer in the Council of the Humanities and Class of 1932 Fellow in Philosophy, Princeton University, for the spring semester of 1998, making it possible for me to test my claims. As a Getty Scholar in 1999–2000 I had the leisure to read widely. And then my high-spirited students at Case Western Reserve University and the Cleveland Institute of Art helped me to refine the argument. Deborah Cherry, editor of *Art History*; Brian Fay at *History and Theory*; Pradeep Dhillon, editor of the *Journal of Aesthetic Education*; Philip Alperson and Tiffany Sutton from the *Journal of Aesthetics and Art Criticism*; John Dixon Hunt, editor of *Word and Image*; Roger Malina, *Leonardo*; Simona Vendrame at *Tema Celeste*; and Laurie Schneider at *Source* published materials that here are drastically reworked. Robert Mangold and Garner Tullis provided memories of the Cleveland Museum of Art under Sherman Lee. Christa Clarke shared her research on Albert Barnes, and Henry Adams showed me his unpublished lectures on Ernest Fenollosa. Sean Scully has said how much he depends on his friends:[4] "I want emotional and contextual information to enter the work all the time, this is the pasture on which it grows. The people who are friends are affecting my work, it's made through the vitality of these relations." The same is true for me. I thank Paul and Ruth

Barolsky, Mark Cheetham, Arthur Danto, Bianca Finzi-Contini Calabresi, Jonathan Gilmore, Richard Kuhns, George Leonard, and Gary and Loethke Schwartz for sustaining discussions. Scully's view of modernism was a decisive influence. Malcolm Bull, Terry Smith, and Charles Salas made comments on my discussion of the Getty. John O'Brian commented on chapter 8. In Cleveland's museum Barolsky, Danto, and Richard Wollheim listened to halting presentations of chapter 10.

Some topics are best presented in a self-sufficient analysis. But in order to understand art museums, it is necessary to respond to the vast literature. My analysis develops dialectically, in opposition to the claims of the most influential recent commentators. Once you have identified the fundamental philosophical questions, Danto has said, then all the details of your narrative fall into place. My analytical framework comes from his trilogy *Analytic Philosophy of History* (1965), *Analytic Philosophy of Knowledge* (1968), and *Analytic Philosophy of Action* (1973); his treatise on aesthetics *Transfiguration of the Commonplace* (1981); and the summary of his system *Connections to the World* (1997). "To be human is to belong to a stage of history and to be defined in terms of the prevailing representations of that period," Danto has written. But philosophers "have not pondered the complex interrelations between individual representational systems and the cultural or historical representational systems that define the circumstances in which we live."[5] Following this model, I analyze the relationship between works of art and the museums in which they are displayed. My style has been most influenced by Barolsky's and Nehamas's. I thank Barolsky, Danto, and Kuhns—great patient friends!—for reading drafts; my daughter Liz Carrier for many discussions of pop culture; and Brigston, our golden retriever, for accompanying me on walks in Pittsburgh's parks and Williamstown, good occasions for reflection. When the book was almost finished, a heart attack gave personal urgency to my interest in preserving the past. James Slater, MD, saved my life. I am indebted, also, to two readers for Duke University Press, and to Sage Rountree, the copy editor. The final draft was edited when I was a Clark Fellow. My research assistant Kerin Sulock read the entire manuscript and made many valuable suggestions. Michael Ann Holly, Mark Ledbury, Gail Parker, and the staff members made my visit enjoyable and productive.

The dedication expresses debts to five essential friends. In July 1998, I

taught at the National Academy, Hangzhou where Ding Ning made it possible for me to learn about Chinese art and culture. In 1999 a miraculously suggestive conversation at the California Palace of the Legion of Honor, San Francisco with Bill Berkson provided one necessary conception. At the Getty I enjoyed happily ferocious debate with Lydia Goehr. In Cleveland Cathleen Chaffee criticized my claims and cocurated an exhibition with me.[6] Last and *not* least, my wife, Marianne Novy, who has enthusiastically supported and frequently participated in my adventures while writing her own books, worked hard to help me refine these arguments. Without such loving support, what reason would I have to write?

Williamstown, December 12, 2004

Overture

Forms would become manifest insofar as they underwent metamorphosis. Each form had its own perfect sharpness, so long as it retained that form, but everybody knows that a moment later it might become something else. —ROBERTO CALASSO

Ovid's stories about personal identity are very suggestive for the philosopher of art. Arachne, an arrogant weaver who challenges a rival to a weaving contest, learns too late that this old woman is the goddess Pallas in disguise. Defeated Arachne attempts to hang herself but survives, metamorphosized into a spider: "She yet spins her thread, and as a spider is busy with her web as of old."[1] Philosophical theories of personal identity explain how a child becomes an adult and, finally, an old man, remaining the same person as his body ages. Ovid's *Metamorphoses* discusses more extreme physical transformations. Philosophers are concerned with the identities of actual persons, things, and institutions. Creative writers have broader concerns. Presenting magical radical alterations of persons or things, Ovid shows what is fictionally plausible.[2] All figurative visual art involves metamorphosis because an image transforms physical materials into a representation. As Leonard Barkin puts it, "The art of metamorphosis is the art of the image."[3] Then the materials of art illusionistically become what they depict. "If metamorphosis produces an apprehensible trace of distant or incredible events in the real world of the readers, so too does a statue, a painting," writes Andrew Feldherr. "Thus metamorphosis becomes a way of dramatizing the act of representation itself."[4]

Representing metamorphosis is a special challenge for the visual artist —rival of the poet—who must show change, presenting past and future in one image. The poet can describe the entire process, but the visual artist is only able to show the transition in progress. Consider, for example, the story of Apollo and Daphne: "A deep languor took hold on her limbs,

her soft breast was enclosed in thick bark, her hair grew into leaves, her arms into branches, and her feet that were lately so swift were held fast by sluggish roots, while her face became the treetop. Nothing of her was left, except her shining loveliness."[5] Bernini's *Apollo and Daphne* depicts Apollo grasping the fleeing Daphne *as* she is becoming a tree (fig. 1). But Ovid tells that story. In his striking account of this theme, J. G. Ballard describes a world in which objects, animals, and people turn to crystal: "A huge four-legged creature . . . lurched forward through the crust. . . . Invested by the glittering light that poured from its body, the crocodile resembled a fabulous armorial beast. Its blind eyes had been transformed into immense crystalline rubies."[6] Like the scene of Apollo and Daphne, this metamorphosis could inspire a visual artist.

Museums are centrally concerned with metamorphoses, both because they contain so much figurative art and because often their contents have survived dramatic change. An adequate account of these institutions thus needs to be as imaginative as *Metamorphoses*, whose "picture of natural generation, assuming a universe that's unceasingly progenitive, multiple, and fluid, organizes the relationships between creatures according to axioms of metaphorical affinity, poetic resonance, and even a variety of dream punning," as Marina Warner describes it.[7] Christopher Allen writes that as a pre-Cartesian way of thinking, "metamorphosis implies that nature is animate, that bodies can change their forms, and that spirit and matter can still act on each other."[8] Retelling Ovid's stories, a modern novelist argues that "in the capital city of Emperor Augustus, the very title of the book had been presumptuous, a provocation to Rome, where every edifice was a monument to authority, invoking the stability, the permanence, and the immutability of power."[9] But the political implications of *Metamorphoses* are complex, for while conservatives often fear change, leftists do not necessarily welcome it.

Caroline Walker Bynum describes metamorphosis as "about process, *mutatio*, story — a constant series of replacement changes."[10] To say that a person can become a spider only because *Metamorphoses* tells us that happens is surely unsatisfactory. We want to understand *how* Arachne's metamorphosis is possible. People and spiders are very different, so Ovid's claim that a woman can become a spider is puzzling. Arachne survives her transformation, Ovid implies, because her essential quality, being a skilled weaver, is preserved. According to Stephen Wheeler, "The iden-

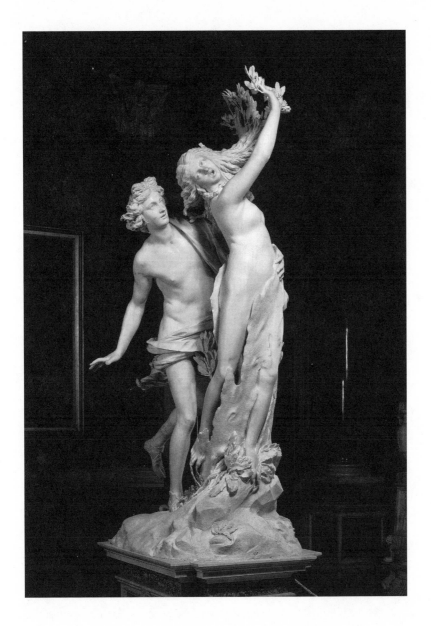

1. Gian Lorenzo Bernini (1598–1680). *Apollo and Daphne.*
Marble, 1622–25. Front view, post-restoration. Galleria Borghese, Rome.
Photo: Scala / Art Resource, N.Y.

tity of a changed form persists in its new body."[11] When, to cite another Ovidian example, Narcissus is transformed into "a flower with a circle of white petals round a yellow center," there is a natural connection between the physical qualities of this beautiful youth and that plant.[12]

The complex changes Ovid describes always are logical. When Tiresias, who had "experienced love both as a man and as a woman," is asked whether women or men got more pleasure from sex, he annoys Juno by giving the nod to women. She blinds him, but Jupiter, in response, "granted Tiresias the power to know the future and softened his punishment by conferring this honour on him."[13] Are there some limits on what transformations are conceivable? Perhaps! Could we imagine that a person first become a rock, then a plant, and, finally, a person again? Maybe not, at least not until some creative writer shows what principle of continuity is invoked. According to Virginia Woolf, Orlando "had become a woman. . . . But in every other respect, Orlando remained precisely as he had been. . . . His memory . . . went back through all of the events of her past life without encountering any obstacle. . . . Orlando was a man till the age of thirty; when he became a woman and has remained so ever since."[14] Through the dramatic physical change Orlando retains his memories and essential personality.

"The central moral to be drawn from Ovid's *Metamorphoses*," Richard Wollheim writes, "is that, if it is imaginable that there are animals, non-human animals, that are persons, then they have to be—that is, they have to be imagined to be—persons through, or in virtue of being, animals."[15] His suggestive remark, which is more than a little enigmatic, leads to a very interesting question: "What is it to lead the life of a person?" Like persons, works of art may be said to have lives. What is it to lead the life of a work of art? This book will answer that question. Like Ovid's characters, works of art pose philosophical dilemmas about identity through time when they undergo metamorphoses. In an Indian temple a sculpture is worshipped. Transported to an American museum, that artifact becomes art. And so a theory is required to explain how an object can survive such dramatic changes. To learn what it is to lead the life of a work of art, we need to understand museums.

The philosophical literature on personal identity discusses memory, the possibility of changing bodies, and the uses of psychological and psychoanalytic evidence.[16] Some writers hold that identity is tied to the

body; others say that it is essentially linked to mental qualities. Identity of persons (or animals or things) over time requires some such form of continuity. Metamorphosis suggests that more radical changes of identity are possible by offering a convincing narrative linking earlier and later times. The wolf attacking Peleus's flocks is changed to marble: "The body preserved its original appearance in every respect, except as regards colour; the whiteness of the stone showed that it was no longer a wolf, and need not be feared any more."[17] Without Ovid's narrative, we could not understand how the wolf and stone are the same thing.

An adequate theory of personal identity must take account of this double identity of persons. Works of art also have a dual nature. Wollheim and Arthur Danto, philosophers with very different aesthetics, agree that the visual work of art cannot simply be identical with a physical object that is moved into a museum. Wollheim writes: "Art, and its objects, come indissolubly linked. . . . Aesthetics then may be thought of as the attempt to understand this envelope in which works of art invariably arrive."[18] Danto agrees: "An artwork cannot be flattened onto its base and identified just with it, for then it would be what the mere thing itself is—a square of red canvas, a dirty set of rice paper sheets, or whatever. . . . without the artworld there is no art. . . . Art is the kind of thing that depends for its existence upon theories."[19] Wollheim and Danto are influenced by much recent art, which exists as art only in relation to theorizing, but their claims have more general validity. Baroque Italian painting is not fully comprehensible unless you understand Counter-Reformation Catholicism, seicento theories of emotion, and Ovid's *Metamorphoses*. Chinese and Japanese art can be properly seen only if you know how Asians comprehend landscape painting, calligraphy, and artistic originality. No form of art wears its meaning entirely on its face.

All visual art thus is inextricably linked with what Wollheim calls its envelope and what Danto identifies as a theory of art. In this way works of art are like people, a unification of body and something else—call it mind, soul, or a system of mental states. Wollheim says: "Living is an embodied mental process."[20] And Danto writes: "The mind-body problem, which is our heritage from the seventeenth century, is an artifact of the concept of substance."[21] Visual works of art, which are physical artifacts accompanied by theory, also have a double nature, as Wheeler explains: "Metamorphosis involves a continuation of the old identity in

the new. As a metaphor, metamorphosis gives coherence to change by revealing the mysterious interconnectedness and parity between things."[22] To understand what happens when art enters the museum, we need to identify what, following Wollheim, I will call its envelope.

Once we make this distinction between the work of visual art and a physical object in which it is embodied, then we need also to discuss interpretation. Metamorphosis, it has been suggested, "can be read as a metaphor for interpretation: moving from manifest to latent, from latent to manifest, reflecting the conscious and unconscious levels of representation . . . reflecting as well those stories in which a demand is made for penetrating into an inner meaning."[23] To interpret is to change and preserve. That an object is preserved does not show that the work of art survives. In their original settings, many older sculptures and altarpieces were employed in religious rituals. Interpretation, it might be said, marks out the distance between these communities and our museum culture. To properly see Poussin's *Landscape with Diana and Orion* (1658), you need to know that Orion has been temporarily blinded by the goddess.[24] To comprehend Sean Scully's *Walls of Light* you must recognize that these late 1990s paintings reject his earlier concern with abstract narratives.[25] Poussin is historically distant, and so considerable interpretative labor is needed to reconstruct the beliefs of his community. Scully is a contemporary master extending abstract expressionist tradition, and so less bookish learning is required to understand his paintings.

Plausible competing interpretations are often possible. Consider recent debates about whether Caravaggio's early genre pictures are homo-erotic; the claim that Jacques-Louis David was already a political artist in the 1780s; and the controversial interpretation of Jackson Pollock's late 1940s paintings as anticipating fashionable "adjection" art of the 1980s and 1990s.[26] Trained as a philosopher, I became fascinated with such conflicts once I entered art history. Why, I asked, do competing commentaries describe pictures so differently? We philosophers believe that rational debate is possible. My *Principles of Art History Writing* (1991) discussed this issue. This book extends these concerns to the art museum. Like paintings and sculptures, art museums too can be interpreted. And they should be, for to fully understand art we must analyze its setting. A container for individual works of art, the museum itself is a total work of art.

Museum displays project implicit interpretations. Like art writers, curators thus create the envelopes in which art arrives. And we can compare and contrast competing museum interpretations, testing them against the visual evidence. We see one display while recalling or imagining how that art could be installed differently. We view one painting in relation to others and recall what we have just seen or are about to view. We learn who owned art before it entered the museum and how it was displayed at earlier times. And we become aware of the history of a museum and its setting in ways that contribute to our experience of individual paintings. As if in compensation for their inability to present explicit written interpretations except in wall labels, museums suggest many ways of thinking about the artifacts that they collect. Art writing and art museums thus offer complimentary ways of theorizing visual art.

Two views of museums dominate the literature. According to the practice of historians and the memoirs of curators, when art enters the museum it retains its full prior identity. Looking at a painting, you need not examine the context, for all that matters for understanding its artistic qualities is what you see within the frame. Social historians of art extend but do not essentially transform this way of thinking when they argue that knowing the artist's culture may legitimately influence what we see inside that frame. By contrast, according to museum skepticism, the most influential theory, old art cannot survive the metamorphosis taking place when it enters the museum. I will argue that the truth lies between orthodox art history and museum skepticism. When the museum envelope changes, we view its contents differently. But because we can view or imagine viewing art in another context, we are able to subtract out, as it were, the interpretative setting.

Like Ovid's gods who become human or his humans who become animals or natural objects, works of art thus preserve their identity through changes. Since about 1750, the art museum has been one essential element of the envelope in which visual art typically arrives. To fully comprehend an individual work of art, we need to understand the history of the museums in which it has been exhibited. Stated baldly, the argument for that assertion is so simple as to be self-evident. When its context changes, visual art then is seen differently. Buddhist sculptures and Catholic altarpieces are in a new context when put in the museum. And when historians interpret that art, they are providing a permanent writ-

ten record of its contexts. But to be convincing, this argument cannot simply be stated baldly. Case studies are required to show how a work of art survives changes in its envelope.

"I have banished all care from my mind, I have secured myself peace":[27] In the opening paragraph of his "First Meditation," René Descartes prepares to consider "what can be called in question." In discussing museums, similarly, we need initially to set ourselves momentarily apart from the everyday practical concerns of curators. Descartes's proper philosophical analysis is abstract and austere. As his epistemology raises questions that seem distant from the practical concerns of the man on the street, so our philosophical account of museums deals in problems far from the concerns of the working curator. But when its implications are spelled out, then the links of our investigation with museum practice will become apparent. What makes my allusion to Descartes more than a vague analogy, so we will see, is the deep parallel between the double natures of persons, both body and soul; and works of art, artifacts linked to their envelopes.

After concluding his critical analysis, Descartes passes "from contemplation of the true God, 'in whom are hidden all the treasures of knowledge and wisdom,' to the knowledge of other things."[28] Our account, to extend this comparison, will move from a philosophical discussion of museums to a historical account of their practice.[29] Recent art historians devote considerable attention to the history of their discipline. The art writing of Vasari, Bellori, and Winckelmann prepared for the aesthetic theorizing of Kant and Hegel, which was an essential resource for the great original founding historians — Panofsky, Riegl, Warburg, Wolfflin, and some other writers of the late nineteenth and early twentieth centuries.[30] But once we recognize that the implicit interpretations projected by art museums complement the written interpretations of historians, then that history needs to be supplemented by an account of collectors, curators, and museum architects. My central figures are Baron Dominique Vivant Denon, first director of the Louvre; Bernard Berenson, whose connoisseurship helped Isabella Gardner found her museum; Ernest Fenellosa, who applied Hegelian aesthetic theory to Asian art and assembled a collection now in the Boston Museum of Fine Art; Albert Barnes, who wrote about and collected modernist painting; Richard Meier, architect for the J. Paul Getty museum; and Sherman Lee and

Thomas Munro, the Cleveland Museum director and his art educator. These are not necessarily the most important or even the most famous museum personalities. But they are the best figures for my narrative of the birth, expansion, and fall of the public art museum. In another book different men might be discussed. That mine is an all-male cast reflects the realities of museum life before the immediate present.

Jorge Luis Borges's short story "Averroes' Search" tells of an Islamic commentator on Aristotle who, never having seen a theater, is unable to understand that philosopher's distinction between comedy and tragedy. Arguing that one speaker may read any written words, Averroes is unable to imagine why different actors play the various parts. Borges's fine irony comes when he reveals that had Averroes only attended to the playacting of nearby children, he would have found the answer to his query. Without needing to read Aristotle, these kids spontaneously act a play with several actors. His story, Borges says, is concerned not just with failure but with "a more poetic case . . . a man who sets himself a goal that is not forbidden to men, but is forbidden to him."[31] Inspired by that story, let us look at the origin of museums.

There were no public art museums in Renaissance Europe, where, as Kenneth Clark describes it, "in the fifteenth century art aspired to be a branch of knowledge, in which a permanent record of natural appearances was valuable both for its own sake and because it could furnish men's imaginations with credible images of God, his Mother, and his Saints."[32] Because historians customarily explain what *did* happen, asking why there were *no* art museums in the Renaissance may seem strange.[33] But sometimes answering questions about what did *not* happen is enlightening. Why was there no large socialist party in nineteenth-century America? Engels thought this a good question, for answering it reveals much about class structure.[34] Around 1900 American museums collected plaster casts of European masterpieces. The Carnegie Museum in Pittsburgh still has a large room of such copies. And the nearby University of Pittsburgh art history department houses copies of Renaissance paintings. Much might be learned by explaining why most museums do not any longer exhibit such copies.

Housing of the treasures of the Greek gods in the temple, Julius von Schlosser argued, could mark the origin of the public museum.[35] Most recent historians think this claim misleading. Not until the eighteenth

century do we find institutions like our art museums. Renaissance Italy had a historical perspective on culture, a well-developed market in contemporary art, and a highly sophisticated tradition of art writing, but no public art museums. The Medici aimed "to acquire the finest ancient statues that came from the soil of Rome," Filippo Rossi writes. "Not only did they commission the best Florentine artists of the *quattrocento* for their own homes and villas . . . but with the comprehension and taste of true collectors, they also collected the works of foreign artists."[36] China too had sophisticated artistic traditions, connoisseurs and collectors, but no public art displays, as Joseph Alsop explains: "Art Museums are a strictly Western phenomenon. . . . In the other rare art traditions, splendid shows were for the masses, but the more refined pleasures to be got from studying individual works of art were for the classes."[37] Why did such non-European cultures not also have museums?

All of the machinery of the public art museum had been invented in the Renaissance. There were artists, collectors, and connoisseurs. And Vasari's *Lives* provided a historical way of organizing collections. Why then was the birth of this institution delayed until the late eighteenth century? Historians such as Susan Pierce explain the origin of the public art museum in sociological terms: "The new public art museums required a new philosophy and a new iconography which would draw upon the idea of classification inherited from the previous century and link this with the applied intellectual rationale characteristic of the developing European middle class, who wanted to see a clear increase in knowledge and understanding for their own efforts, and who preferred this knowledge to underpin their own position."[38] The first such museums were royal collections opened to the public.[39] Lacking our distinction between beautiful works of nature and works of human art, Renaissance *Kunstkammers* and *Wunderkammers* mixed together rare animals, plants and stones, and works of art.[40] But such collections did not survive the rise of modern science, which destroyed what Paula Findlen calls "the valiant attempts of Renaissance and Baroque naturalists to preserve their image of the world."[41]

German aestheticians discuss this history in more abstract terms. For Kant, art is both similar to and also essentially different from nature: "A product of fine art must be recognized to be art and not nature. Never-

theless the finality in its form must appear just as free from the constraint of arbitrary rules as if it were a product of mere nature. . . . fine art must be clothed with the aspect of nature, although we recognize it to be art."[42] As G. E. Moore puts it in his summary of this tradition: "It is not sufficient that a man should merely see the beautiful qualities in a picture and know that they are beautiful, in order that we may give his state of mind the highest praise. We require that he should also *appreciate* the beauty of that which he sees and which he knows to be beautiful—that he should feel and see *its beauty*."[43] Hegel, by contrast, makes a much more dramatic distinction between art and nature: "The beautiful objects of nature and art, the purposeful products of nature, through which Kant comes nearer to the concept of the organic and living, he treats only from the point of view of a reflection which judges them subjectively."[44] Hegel greatly admired Napoleon, whose policies could, he thought, instruct German rulers.[45] But he did not relate Napoleonic politics to the Louvre.

The birth of the public art museum was intimately bound up with the rise of academic art history, new aesthetic theories, and the development of democracy. Once high art moved from churches, temples, and princely collections into the public space of the museum, visitors needed to be educated. In the late eighteenth century, Johann Winckelmann wrote an elaborate history of Greek and Roman art. He was not much attracted by most postclassical painting, but his analysis, in which, Per Bjurström writes, "the development of art was equated with the natural life cycle of birth, growth, maturity and decline," was quickly applied within the new museums in Vienna and elsewhere.[46] In Düsseldorf in the 1770s, for example, Andrew McClellan explains, "an effort was made to define the Flemish and Italian schools by displaying them in separate galleries. At Vienna in the early 1780s Chrétien de Mechel transformed the ornate baroque gallery into what was arguably the first art historical survey museum."[47] "Until the turn of the nineteenth century access was governed by the rules of court protocol and aristocratic etiquette," Karsten Schubert writes.[48] This policy sometimes created awkward situations. In 1773, Schubert reports, an English nobleman "tired out with the insolence of the common people" refused admittance to his museum "to the lower class except they come provided with a ticket from some

Gentleman or Lady of my acquaintance."[49] As late as 1785, a German historian complained that in order to visit the British Museum it was necessary to present credentials and wait fourteen days for a ticket.

Public museums admitting every visitor appear near the end of the old regime, in Rome and in the German-speaking countries, but the great model is the Louvre, the former royal palace opened to the public on August 10, 1793.[50] McClellan explains, "It was in Paris in the later half of the eighteenth century that the central and abiding issues of museum practice . . . were first discussed and articulated."[51] This institution was a product of the revolution and Napoleon's looting, and so here the link between the public museum and modernist politics was made fully explicit. Findlen writes, "In the Rousseaian climate of revolutionary Europe, collections were no longer the property of a private individual, the church . . . or the personal possession of a monarch."[52] Once the king admitted any well-dressed gentleman to view his treasures, it was easy to think the royal collection belonged to the nation. In Germany "in the course of the eighteenth century, the circle of those who could gain admittance to the collection steadily widened as a number of princes came to believe that their art, like their gardens, libraries, and theatres, should be more available to their subjects."[53] Art in the nation's museums was really owned in common by all citizens.[54]

The public art museum thus is linked with the French Revolution and the novel aesthetic theories of German philosophers. "In distinguishing civil from political society, Hegel recognized the emergence of a new social configuration: a separate private social sphere, within which agents lived for themselves, without participating in political affairs. The heart of this new sphere was the modern market economy."[55] In a letter of September 9, 1827, he described the Grand Gallery in the Louvre, "a straight long hall, vaulted at the ceiling and with paintings hanging on both sides—an almost endless corridor a quarter-hour long."[56] Hegel said more about the museums in Dresden, Vienna, and Holland, but in no case does he respond to either the buildings or the collections in any interesting detail. He did, however, sketch a theory of the public art museum. "Unless we bring with us in the case of each picture a knowledge of the country, period, and school to which it belongs and of the master who painted it, most galleries seem to be a senseless confusion out of which we cannot find our way. Thus the greatest aid to study and intel-

ligent enjoyment is an *historical* arrangement."[57] Hegel's late-1820s lectures on aesthetics provided the intellectual framework for the historical hangings of the new public museums. And then in 1830 the Prussian king Friedrich Wilhelm III, an admirer of Denon, founded the Berlin gallery.

Hegel is the great theorist of the historical art museum because, as Beat Wyss writes, his "philosophy of history was reconstructed as an imaginary museum. His art history is museum-like, since the present is separated off from the past. Only what has the aura of the historical and has been passed by the social consensus is admitted to this museum."[58] A recent commentator writes: "Hegel insists that the expression of *Geist* must (metaphysically) have a physical seat (the activities of people—physical beings in a physical world—and their products). Geist is 'constituted' (in the sense of actualized) by human beings engaging in the social, political, and cultural practices of their community."[59] I certainly do not mean to suggest that the theorizing of Kant and Hegel guided museum directors. If anything, the process worked the other way around—the abstract arguments of philosophers, developed mostly without explicit reference to museums, reflected changes in the practice of collectors and historians. In many ways, indeed, Denon's Louvre employed a traditional organization. He told Napoleon that he aimed for "a history course in the art of painting," but in the Grand Gallery "commitment to art historical demonstration was outweighed by a desire to achieve a visually pleasing, symmetrical hang."[60] Nor did historical installation styles affect every museum immediately or take effect at once.[61] Here it is useful to draw an analogy with political institutions. "The chief permanent achievement of the French Revolution was the suppression of those political institutions, commonly described as feudal, which for many centuries had held unquestioned sway in most European countries."[62] It certainly did not finally destroy absolute monarchy, which in any event had been under serious attack before the last days of the old regime. But by 1793 it was clear that this political system was outdated.

When Baron Denon was young, he charmed Louis XV. After traveling extensively in Italy, writing accounts of his voyages and himself making pictures, some pornographic, he proved supple enough to survive the Revolutionary terror, Napoleon's expedition to Egypt, and the fall of that patron.[63] Denon purchased *Gilles* (fig. 2), Antoine Watteau's most famous painting, during the First Empire. At seventy-eight he went to

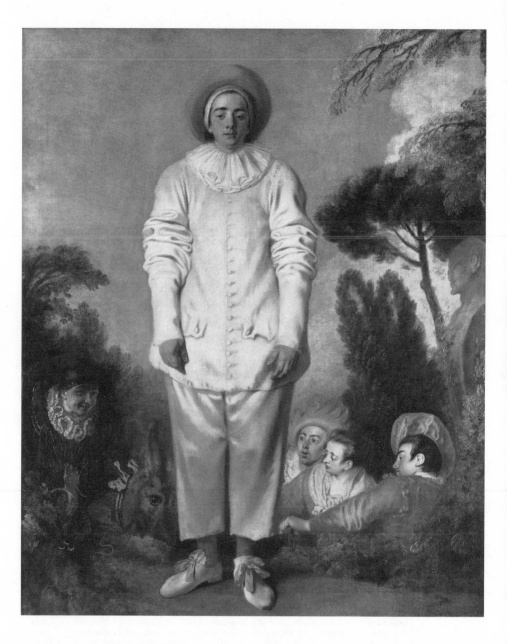

2. Jean Antoine Watteau (1684–1721). *Pierrot*, formerly called *Gilles*.
Oil on canvas, 184 × 149 cm. Musée du Louvre, Paris. Photo: J. G. Berizzi,
Réunion des Musées Nationaux / Art Resource, N.Y.

an art auction, came home with a chill, and died. In 1869, after passing through the hands of other collectors, *Gilles* entered the Louvre. Denon's successor at the Louvre, Pierre Rosenberg, has noted the difficulty of understanding this picture. "The expression on his face has caused considerable perplexity. People have read in it 'stupidity,' 'credulousness,' 'lethargy,' 'revery,' 'melancholy,' 'poignancy.' It is in fact indefinable, as in the emotion that the painting brings out. . . . Cut off from the world surrounding him, without movement, isolated and alone, Watteau's poignant and awkward image of *Pierrot* remains unique in the history of art."[64] *Pierrot* might stand for that museum, a perplexing institution hard to interpret, which also is set apart from the world of change.

This book describes the birth, development, and end of the history of the public art museum. There were institutions before 1793 that made art accessible to the public, but in linking the origin of the museum with the French Revolution we draw attention in a natural way to its relationship with modern democratic culture. In tracing the expansion of the museum to include art of non-European cultures and its elaboration in countries outside its original European home, we describe developments very closely related to the expansion of bourgeois democracy and imperialism. Socialism, so it has been said, links French revolutionary politics, English industrialization, and the German philosophy of Hegel and his most important heir, Marx.[65] For all of its obvious problems, that quick generalization suggests how to describe the historical relationship between the public art museum and its supporting culture. There are museums almost everywhere because European institutions have triumphed, admittedly at the price of being radically transformed, almost everywhere. The large new I. M. Pei museum in Shanghai, for example, demonstrates that this Western institution has taken root in an exotic culture. Art museums are found nearly everywhere now because almost no part of the world remains outside of capitalist culture.

Constant expansion has defined the history of the public art museum since 1973. Once art from all cultures and contemporary art was collected, then the development of this institution was closed. Just as the origin of our museums is linked to modernism, so the present radical transfiguration of this institution relates to recent changes in our larger culture. The public art museum is a fabulously successful institution. Every city has at least one, many are expanding, and most have an in-

satiable desire to create new exhibitions. It may seem strange to speak of the end of this institution when our prosperous museums, drawing larger, more diverse crowds than ever before, are the subject of so much popular and academic attention. Certainly the story of this institution will continue, but what has recently ended, so I will argue, is the development of the modernist museum, that institution whose development began on August 10, 1793.

Just as the modernist artistic tradition has ended, to be replaced by what Arthur Danto has identified as our posthistorical era, so the story of the modernist art museum has now concluded. Our present-day museums display art inherited from their modernist precursors, and they shared many goals. But this institution now is reinventing itself in dramatic ways. When Marxism became "the repository of ideals and values not attained in actuality, and perhaps not capable of attainment," then it disintegrated, for "its accomplishments are shown to be incompatible with its ultimate aims, which thus disclose their essentially metaphysical, i.e., transcendental and unrealisable, nature."[66] By showing how the modern public art museum disintegrated because its accomplishments were incompatible with its ultimate as yet unrealizable aims, we will be prepared to anticipate its next metamorphosis.

1

"Beauty and Art, History
and Fame and Power"

ON ENTERING THE LOUVRE

Representation in general has indeed a double power—that of ren-
dering anew and imaginarily present, not to say living, the absent
and the dead. . . . if representation reproduces not only de facto but
also de jure the conditions that make its reproduction possible, then
we understand that it is in the interests of power to appropriate it for
itself. Representation and power share the same nature.

—LOUIS MARIN

Just as works of art require interpretation, so too do the museums in
which they are displayed. But while everyone understands the need to
explain visual art by identifying its iconography and social significance,
and by placing individual paintings in historical narratives, the idea that
museums also require such analysis is less familiar.[1] That may seem sur-
prising, for we certainly interpret them informally. When approaching
we judge the architecture. Upon entering we sense if the ingress is inviting
and the floor plan easy to follow. Reading wall labels, we reflect upon the
provenance of objects in the collection and the roles played by curators in
organizing their display. We readily think about the visual relationships
of the works of art on display. And thanks to Nietzsche's genealogy of
Christian morality and Foucault's books about madness and the prison,
we are very aware that institutions can be interpreted. As Alexander Ne-
hamas writes, "Genealogy is interpretation in the sense that it treats our
moral practices not as given but as 'texts,' as signs with a meaning, as

manifestations of a will to power that this interpretation tries to reveal."[2] Because Nietzsche and Foucault are interested in political power, their ways of thinking are very suggestive for our present purposes.

The literature of art is devoted to individual paintings. And so the argument of my *Principles of Art History Writing* was relatively easy to work out, for identifying it merely required examining the practice of art historians. Locating my present analysis was more difficult, because although art museums have been much discussed recently, there is less articulated awareness that we interpret them as total works of art. When a painting or sculpture is given a suggestive analysis, what I call an interpretation by description, then its appearance changes before our eyes.[3] For example, Rudolf Wittkower says that in Bernini's *Ecstasy of St. Teresa*, Cornaro Chapel, S. Maria della Vittoria, "directed heavenly light . . . sanctifies the objects and persons struck by it and singles them out as recipients of divine Grace. . . . we realize that the moment of divine 'illumination' passes as it comes."[4] When he adds that "here in the ambient air of a chapel [Bernini] did what painters tried to do in their pictures," use real light, his account carries real art historical weight. When Adrian Stokes writes that the figures in Cézanne's *The Large Bathers* in the National Gallery, London, could "suggest a quorum of naked tramps camped on top of railway carriages as the landscape roars by from left to right," he changes how we see that picture.[5] And Arthur Danto's description of Cy Twombly's *Leda and the Swan* projects a strong interpretation of that abstract painting, calling it "the zero degree of writing, drawing, painting, composition, somehow achieving—at its greatest achieving— a certain stammering beauty, where the base elements are possibly even transformed into elegant whispers. There is an almost Taoist political metaphor here for those who seek such things."[6] Much art writing—by Vasari in the sixteenth century as well as by *Artforum* critics today—is interpretation by description.

A strong interpretation changes dramatically, perhaps permanently, how art is seen. The aim of successful interpretations, Leo Steinberg writes, is "that they be probable if not provable; that they make visible what had not previously been apparent; and that, once stated, they so penetrate the visual matter that the picture seems to confess itself and the interpreter disappears."[7] A Marxist commentator characterized this activity in political terms: "Interpretation is not an isolated act, but takes

place within a Homeric battlefield, on which a host of interpretative options are either openly or implicitly in conflict."[8] True enough, but in our bourgeois society, debate about conflicting interpretations, including Marxist accounts, is possible. T. J. Clark's justly famous discussion of Manet's *A Bar at the Folies-Bergère* says: "The girl in the mirror does seem to be part of some . . . facile narrative. . . . But that cannot be said of the 'real' barmaid, who stands at the centre, returning our gaze with such evenness, such seeming lack of emotion or even interest. There is a gentleman in the mirror. . . . Who is this unfortunate, precisely? Where is he? Where does he stand in relation to her, in relation to us?"[9] Once close concentration was focused on the relationship of the barmaid to the mirror, elaborate attention was soon devoted to Clark's questions. My *Poussin's Paintings* reinterprets *Apollo and Daphne*: "The two figures, one seeing and the other blind to his desire, face one another directly. Because our point of view is at right angles to them, we see both the desiring Apollo and the oblivious Daphne. . . . our presence is needed to link the figures, but their triangular arrangement exists independently from us."[10] Earlier commentators treat Poussin as an impersonal classicist, but perhaps my interpretation will cause reexamination of that cliché.[11]

Museum scholars, too, engage in interpretation by description, changing how the building and collection are seen. When, for example, you learn that the central domes of older museums allude to the temple of the muses or realize that walking up the entrance stairs elevates you out of ordinary reality into the art world, then you will see such domes and stairs differently. Mieke Bal analyzes the impressionist galleries in the Metropolitan Museum, noting that "part of the intended meaning of the space as it has been arranged is to be minimally visible, unintrusive; this is how the expository agent, including its authority, makes itself invisible."[12] Carol Duncan interprets the Morgan Library: "The room today preserves much of its original look, so much so, in fact, that visitors can barely examine its contents."[13] And Albert Levi describes the Frick as "a presentation of works of art in their naked individuality, a temple of pure aesthetic experience, a virtual embodiment of the idea of *the art museum as an exclusive assembly of nothing but masterpieces*."[14] Once you look, then you will find many such interpretations by description.

The styles of museum interpreters are as diverse as those of art historians. Goethe tells of his visit to the museum in Dresden, "in which splen-

dour and neatness reigned together the deepest stillness. . . . [it] imparted
a feeling of solemnity . . . which so much . . . resembled the sensation
with which one treads a church . . . the objects . . . seemed here . . . set
up only for the sacred purposes of art."[15] Stephen Greenblatt interprets
the Musée d'Orsay, noting that "by moving the Impressionist and Post-
Impressionist masterpieces into proximity with the work of far less well-
known painters. . . . what has been sacrificed . . . is visual wonder centered
on the aesthetic masterpiece."[16] Donald Preziosi offers a highly complex
analysis of Sir John Soane's Museum, London: "You have . . . a series of
progressions mapped out throughout the museum's spaces—from death
to life to enlightenment; from lower to higher; from dark to light; from
multiple colors to their resolution as brilliant white light. . . . Soane stands
at the pivotal point of all of this."[17] Elizabeth Gray Buck argues that Gus-
tave Moreau's museum in Paris "prevented the French government from
pressing his paintings into anonymous ideological service for the greater
glory of France and the *patrimoine*."[18] And Ivan Gaskill claims that in
the National Gallery, London, "by alternating the Vermeers with church
interiors" the curator "pointedly avoids a comparison between Vermeer's
domestic interiors and those of his contemporaries."[19]

Victoria Newhouse devotes a lively book to interpretation by descrip-
tion of the art museum. She criticizes the Metropolitan Museum for en-
larging the original front steps: "The new stairs made the façade appear
to be part of a large horizontal background." And she argues that in the
J. Paul Getty Museum "the excesses of the new . . . galleries underscore
the shortcomings of the collection."[20] Just as comparative studies are im-
portant to literary scholars, so what might be called museum intertex-
tuality, comparisons between institutions, provide essential perspectives.
Douglas Davis, for example, discusses how Arata Isozaki's Museum of
Contemporary Art, Los Angeles, "jousts with the meaning of his interior
and his factious client by covering his roof with pyramids that inevitably
recall Egypt and its stark, dry landscape," showing that the museum is
in a cultural desert.[21] He is more sympathetic to P.S. 1, in Long Island
City, praising the "rusticity" of the style which "springs almost entirely
from its vital 'found' container,'" the public school building restored by
the architect Shael Shapiro. Whether or not you agree, once attention is
called to such features, you will probably see these museums differently.
A full discussion of all the major art institutions is needed, for the two

older survey histories now are dated.[22] But much can be learned, I will show, by close scrutiny of just a few museums.

Some museums displaying old paintings are spaces with a grand history of their own. When visiting we may readily move from seeing art to reflecting upon the events that took place long ago in the galleries where we stand. That is not mere idle, flighty speculation, for history can be relevant to seeing the paintings now hanging, especially when this art played an important role in the museum's history. In his discussion of "understanding a work of art," Richard Wollheim argues, "However far we go with setting down what, as we see it, the work means or is, this can never be complete, just because experience, hence our experience of the work can never be exhausted."[23] Or as Stephen Bann writes, in effectively drawing out the implications of this claim: "The search for meaning—the process that is commonly called 'interpretation'—is a virtually limitless one, which can be terminated only by the atrophy of the individual subject's desire to know. . . . To interpret the aesthetic object is inevitably to measure its participation in the multiple codes which govern the collective consciousness."[24] We have a natural desire that our interpretations of visual artifacts be as full as possible, and that requires taking account of the larger context in which works of art are displayed. The analogy that Wollheim draws with "working through of phantasy" will guide our discussion of the multiple codes invoked by art museums.

Henry James's memoir *A Small Boy and Others* gives a finely tuned interpretation of the Louvre: "I had looked at pictures . . . but I had also looked at France and looked at Europe, looked even at America as Europe itself might be conceived so to look, looked at history, as a still-felt past and a complacently personal future, at society, manners, types, characters, possibilities and prodigies and mysteries of fifty sorts. . . . Such were at any rate some of the vague processes . . . of picking up an education."[25] What we view, he suggests, are not just the individual paintings and sculptures on display, but the museum as total work of art. The architectural setting can have a richly suggestive history:

It is necessary for an appreciation of this style to remember the atmosphere in which it grew, the struggles first between Protestantism and Catholicism in the sixteenth century, Henri IV's decision to return to the Roman

Church . . . then the spreading of religious indifference, until it became all-powerful in the policy of Richelieu, the cardinal, and Father Joseph, the Capuchin, who fought Protestants in France but favoured them abroad, in both cases purely for reasons of national expediency.[26]

Knowing that story prepares us to understand the art in the Louvre.

Nineteen Italian pictures acquired by François I, the patron of Leonardo who ruled France from 1515 to 1547, are still in the museum.[27] Louis XIV had a large collection of paintings and many French, Flemish, and Italian drawings. And there was a kind of museum between 1666 and 1671 in the Gallery of Ambassadors, which contained a copy of the Carracci ceiling in the French academy in Rome and some Italian paintings. But this arrangement was ephemeral—and the king did not display his newly acquired thirteen Poussins.[28] The French royal collection remained at Versailles.

During the Revolution the Louvre became a public art museum. "In the . . . Grand Gallery, art was transformed from an old-regime luxury, traditionally associated with conspicuous consumption and social privilege, into national property, a source of patriotic price and an instrument of popular enlightenment," James Sheehan writes.[29] In October 1792, just after the old regime collapsed, the minister of the interior wrote: "This museum must demonstrate the nation's great riches. . . . France must extend its glory through the ages and to all peoples: the national museum will embrace knowledge in all its manifold beauty and will be the admiration of the universe. . . . the museum . . . will become among the most powerful illustrations of the French Republic."[30] The French enjoyed this storehouse of treasures, which showed their greatness. Foreigners who admired art taken from many nations saw how powerful France was.[31] About 5,000 English tourists visited the Louvre in 1802. Joseph Farington's diary gives a detailed account, comparing Titian's *St. Peter Martyr* to Domenichino's *St. Jerome*; offering an elaborate commentary on Raphael's *Transfiguration*, with remarks by his friend Benjamin West; and looking closely at the Mantegna and Terburgh.[32]

In 1803, Dominique Vivant Denon, director of the Louvre, asked Napoleon Bonaparte to inspect the new hanging: "The first time you walk through this gallery, I hope you will find that this exercise . . . already brings a character of order, instruction, and classification. I will continue

in the same spirit for all the schools, and in a few months, while visiting the gallery one will be able to have . . . a history course in the art of painting."[33] By the mid–nineteenth century this gallery had a rich history. In 1855 the English travel writer Bayle St. John wrote about his first visit to the Louvre soon after the barricades of 1848 were removed.

> Instead of being . . . the scene whereon the great tragi-comedy of Power is enacted, the focus of intrigues, and maneuvers, and jealousies, and dark suspicions, and darker actions, the home of royal pride or misery, the gay resort of courtiers and maids of honour, the tomb of virtue, the cynosure of the vulgar, the great manufactory where sickly caprice, or grasping ambition, or gloomy fanaticism, plans war against foreign states, or massacres against heretical or insubordinate subjects,—it has become the tranquil but gorgeous refuge of a prodigious crowd of objects, principally of Art. . . . We see there some fragments, at least, of the wrecks of all civilisations.[34]

The long lines of tourists you see entering nowadays show the lasting importance of Denon's vision. A comprehensive interpretation of the Louvre would need to consider Nicolas Poussin's abortive decorative project for the Grand Gallery, Robert Hubert's paintings of proposed renovations and his fantasy images showing that gallery in ruins, and Samuel Morse's *Gallery of the Louvre* (1831–33), an ideal image showing the art that he most admired.[35] It would need to discuss the many accounts of the museum in fiction, Zola's *L'Assommoir*, for example, which describes "the unbridgeable gap between art and the people."[36] And it would have to describe visits by artists. "I hate to travel," Alberto Giacometti said: "I don't ever need to make a true trip for I find everything I need in one part of Paris, in the Louvre."[37] Many artists and writers have thought of the museum as a treasure house.[38]

Nowadays the Salon Carré, the east entrance to the Grand Galerie, contains the early Renaissance paintings introducing that sweeping historical hanging of masterpieces. Just as a symbolist poem condenses numerous richly suggestive ideas into a few words, so this room's story reveals much about the history of absolute monarchy, the salons, and the triumph of Napoleon. Built by Louis XIV, then abandoned when his court moved to Versailles, it was transformed into a chapel for Napoleon's marriage April 2, 1810. Inspired by the drawings of Gabriel de Saint-Aubin showing the 1765 salon, for example (fig. 3), they envisage the

3. Gabriel Jacques de Saint-Aubin (1724–80). *The Salon at the Louvre.*
Watercolor, 1765. RF 32749. Musée du Louvre, Paris. Photo: Gérard Blot,
Réunion des Musées Nationaux / Art Resource, N.Y.

Salon Carré as described in Thomas Crow's account of the French art world on the eve of the Revolution: "A public sphere of discussion, debate, and free exchange of opinion was something else again. No longer, it seemed, would non-initiates be awed at a distance by the splendor of a culture in which they had no share; a vocal portion of the Salon audience, egged on by self-interested critics, would actively be disputing existing hierarchical arrangements."[39] Imagine the throng of visitors looking at the dense hangings of paintings running high up the walls. That experiment will animate your reading of Diderot's commentary.

Starting at their rented home at 19 Rue La Boétie, just north of the Champs-Elysées, in July 1855, Henry and William James, who were living in Paris with their parents, walked to the Louvre.[40] The thirteen-year-old Henry and his older brother William looked at sights familiar to modern visitors—the bookshops on the quays and the art galleries on the left bank. (In *The Ambassadors* that walk is taken by a middle-aged American, Lewis Strether.) The brothers saw the paintings of Thomas Couture, Rousseau, Paul Delaroche and some now forgotten artists. As Henry James explains, "we were not yet aware of style, though on the way to become so, but were aware of mystery, which indeed was one of its forms—while we saw all the others, without exception, exhibited at the Louvre, where at first they simply overwhelmed and bewildered me."[41] They entered at the Pavillion de Flore, came up the stairs to the Grand Gallery, and then walked east to the room just beyond the Salon Carré, the Gallery of Apollo.

The 1881 Baedeker guide explains that the

> Salon . . . is about 70 yds. in length, was constructed in the reign of Henri IV, burned down in 1661, and rebuilt under Louis XIV. From designs of *Charles le Brun*, who left the decoration unfinished. It was then entirely neglected for a century and a half, but was at length completed in 1848–51. It is the most beautiful hall in the Louvre, and is considered one of the finest in the world. It derives its name from the central ceiling painting by *Delacroix*, representing "Apollo's Victory over the Python," a fine work both in composition and colouring (1849).[42]

Like most first-time visitors, James found the Louvre overwhelming. "I felt myself most happily cross that bridge over to Style," he wrote, the Gallery of Apollo (fig. 4)

seeming to form with its supreme coved ceiling and inordinately shining parquet a prodigious tube or tunnel through which I inhaled little by little, that is again and again, a general sense of *glory*. The glory meant ever so many things at once, not only beauty and art and supreme design, but history and fame and power, the world in fine raised to the richest and noblest expression. . . .

The Galerie d'Apollon became for years what I can only term a splendid sense of things, even of the quite irrelevant or, as might be, almost unworthy.[43]

An inscription notes that the museum was founded by the revolutionary legislature in 1792 and opened to the public on August 10, 1793.[44]

Young Henry James thus learned that imperial cultures demonstrate their power by creating large public spaces containing many exquisitely beautiful works of art. The part of Paris near the entrance to the Louvre was described in "The Swan," a poem published five years later by Charles Baudelaire.[45] Exquisitely sensitive to the overlap of past and present, in responding to Hausmann's modernization he notes that "the Paris of old is there no more—a city's pattern changes, alas, more swiftly than a human heart."[46] He then extends his historical vision to Andromache, widow of Hector, an African woman (associated with his great love, Jeanne Duval), and all exiles. "Paris is changing, but naught in my melancholy has moved . . . everything for me is turned to allegory, and my memories are heavier than rocks."[47] The poem thus "has the movement of a cradle rocking back and forth between modernity and antiquity."[48] Like James's Louvre, Baudelaire's Paris is a container for memories. But for the Frenchman memory "brings not recognition and homecoming, but melancholy and alienation."[49]

Baudelaire thus "mobilizes the dialogic resources of intertextuality in order to reassess the Cartesian *cogito* in the context of melancholy and to propound the truth of the melancholic subject, dissolved in pensiveness, as the modern successor of an outdated classical *self*, the subject of thought."[50] The Louvre has inspired art historians, artists, critics, and creative writers. And some remarkable dreams have been set in this building. Famous paintings like *Mona Lisa* inspire revealing unconscious fantasy play. So too do grand museums. Describing Poussin's landscapes, Wollheim aptly characterizes these museum fantasies: "Thoughts and

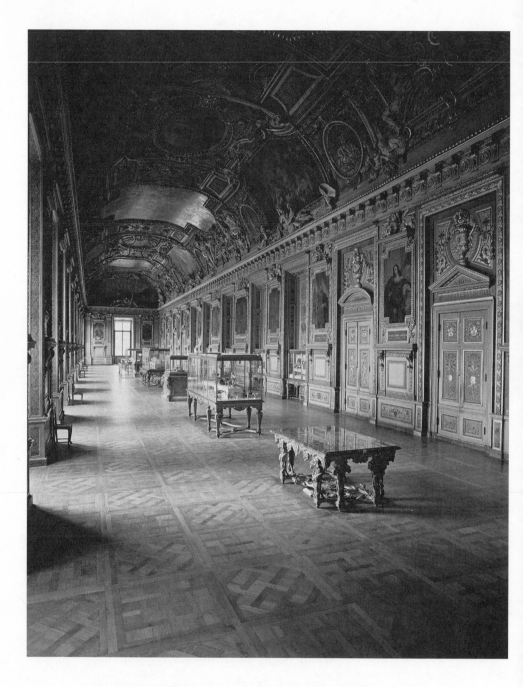

4. Interior view, the Gallery of Apollo. Musée du Louvre, Paris.
Photo: Réunion des Musées Nationaux / Art Resource, N.Y.

feelings that lie unattended to on the edge of consciousness are succes-
sively aroused and becalmed, soothed and teased."[51] The architecture is
a container for a rich array of feelings which knowledge of the museum's
history permits us to articulate. Try this experiment—walk through the
galleries focusing not on the individual works of art but upon the collec-
tion in relation to its setting. When you treat the museum as a container
for historical reflection, you see the art differently.

James was not a sympathetic reader of the poet, whose view of what he
called "the moral complexities of life" he found to show "rather a dull-
ness and permanent immaturity of vision." As he explains: "He knew evil
not by experience, not as something within himself, but by contempla-
tion and curiosity, as something outside of himself, by which his own
intellectual agility was not in the least discomposed, rather indeed . . .
agreeably flattered and stimulated."[52] And yet there is one revealing par-
allel in their literary lives. Both men transcribed unsettling dreams set in
museums.

In *A Small Boy and Others* (1913), Henry James recalls a childhood
memory, "the sudden pursuit, through an open door, along a huge high
saloon, of a just dimly-descried figure that retreated in terror before my
rush and dash . . . out of the room I had a moment before been desper-
ately, and all the more abjectly, defending by the push of my shoulder
against hard pressure on lock and bar from the other side." Then sud-
denly the roles of pursued and pursuer reverse. "Routed, dismayed, the
tables turned upon him by my so surpassing him for straight aggression
and direct intention . . . he sped for *his* life, while a great storm of thun-
der and lightning played through the deep embrasures of high windows
on the right. . . . what in the world were the deep embrasures and the
so polished floor but those of the Galerie d'Apollon of my childhood?"[53]
Very aggressive conflicts occur within the museum.[54] James's last novel,
The Outcry (1911), describes another nearly physically violent confron-
tation. A newly rich American collector pursues an English nobleman:
"He jerked up his arm and guarding hand as before a levelled blow at his
face, and with the other hand flung open the door, having done with her
now and immediately lost to sight."[55] The collector is modeled on J. P.
Morgan, and there is a young connoisseur resembling Bernard Berenson.

We might interpret James's dream by looking upward in the Gale-
rie d'Apollon to Eugène Delacroix's *Apollo Slays Python* (fig. 5).[56] When

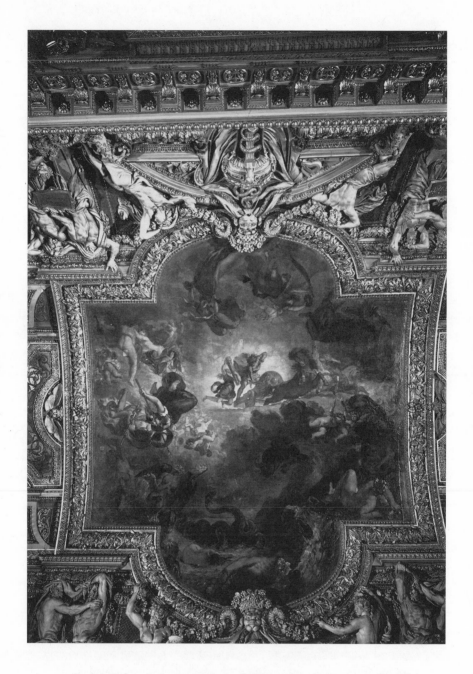

5. Eugène Delacroix (1798–1863). *Apollo Vanquishing Python*, central panel
from the Gallery of Apollo. Musée du Louvre, Paris. Photo: G. Blot /
C. Jean, Réunion des Musées Nationaux / Art Resource, N.Y.

in 1674 Louis XIV made Versailles his official residence, construction in the Louvre was halted. Charles Le Brun was to paint a *Triumph of Apollo*, but this project was suspended, and only taken up again in 1850 when the decoration of the Gallery of Apollo was completed.[57] Delacroix's painting complements the late seventeenth-century images on the ceiling. "The restoration of this prestigious, although never finished and by then dilapidated, part of the Louvre was a central element of art patronage by a government anxious to reassure a wary nation of its respectability."[58] Continuity through change gave the Louvre an impressive ability to adapt itself to radically changing circumstances. *Apollo Slays Python* had been in place less than four years when James visited.

In December 1915, soon after publishing *A Small Boy and Others*, in a high fever (he was dying) Henry James dictated a very strange letter.[59]

> Dear and most esteemed Brother and Sister,
>
> I call your attention to the precious enclosed transcripts of plans and designs for the decoration of certain apartments of the palaces here, the Louvre and the Tuileries, which you will find address in detail to artists and workmen who are to take them in hand. . . . It is, as you will see, of a great scope, a majesty unsurpassed by any work of the kind yet undertaken in France. . . .
>
> Napoleone [He uses the original Corsican form of Napoleon's name.]

His brother William had been dead for more than five years, the Great War had begun and Henry, frustrated by the neutrality of his native United States, became a British citizen. No doubt Henry James would take the side of order on any struggle between the sun god Apollo and his chaos-making enemy. But a more objective observer might have noted that the true division between the good powers of light and the wicked forces of darkness was as difficult to make out as in Delacroix's painting. Just as *Apollo Slays Python* reveals deep uncertainty about the powers of light, leaving it unclear whether the god will slay the still energetic Python, so in James's dream there is an unresolvable ambiguity: Who is pursued and who is the pursuer? A monster chases James, then suddenly reverses directions and is chased by the novelist across "the deep embrasures and the so polished floor . . . of the Galerie d'Apollon on my childhood."[60] Imagine Delacroix's image as projected onto the floor below and you get the setting for this drama.

Apollo Slays Python was interpreted by Théophile Gautier as a picture well suited to the former royal palace.

> On reaching the centre of the gallery, do not forget to look up, and you will be dazzled by Eugène Delacroix's "Apollo Purging the Earth of Monsters," which swarm in the primitive mud. The god, springing upon his golden car, drawn by horses as radiant as fire, as brilliant as light, bends forward and shoots his arrows at the deformed creatures, the abortions of unsuccessful Nature, which writhe hideously in convulsions of agony. His sister helps him in the divine task of making light succeed shadow, harmony, chaos, beauty ugliness. . . . It might be a flamboyant and romantic Le Brun.[61]

In the program distributed by Delacroix when he unveiled the painting, the story seems clear: "Mounted upon his chariot, the god has already shot a portion of his arrows; his sister Diana is flying at his heels and holding his quiver out to him. Already transfixed by the shafts of the god of warmth and life, the bloody monster writhes as it breathes forth the last remnants of its life and impotent rage in a flaming cloud."[62] The artist alludes to the story in Ovid's *Metamorphoses*: "I can aim my shafts unerringly, to wound wild beast or human foe, as I lately slew the bloated Python with my countless arrows, though it covered so many acres with its pestilential coils."[63] But Delacroix doesn't explain that he presents this traditional theme in an untraditional way, making the struggle as ambiguous as in Henry James's dream.

Museums preserve precious art, but Delacroix's *Apollo Slays Python* shows that the forces of destruction are within and not merely external to civilization. In that way, this painting provides an apt commentary on the history of the building in which it is installed. The poignant photographs of the Grand Gallery of the Louvre, denuded of its art in 1914 and again during World War II, show the frailty of even that seemingly very solid institution. In the seventeenth century, allegories straightforwardly identified the king with the triumphant Apollo. Under the old regime, Apollo stood unambiguously for Louis XIV, the sun king who ended civil war and established the absolute monarchy. But during the Second Empire of Louis-Napoleon, after the revolution of 1848 and the French Revolution, such an image inevitably was ambiguous.[64] Apollo struggles—but it is by no means clear that he will triumph over Python,

who is still full of energy. Indeed, just twenty years later Louis Bonaparte lost his throne and a Republic was established. Delacroix, a misanthropic pessimist, would not have been surprised. "Is it not evident that progress, that is the progressive march of things for better or worse, has at the present time brought society to the edge of the abyss into which it can very well fall, to give way to total barbarism."[65] He ridiculed his onetime friend Baudelaire for having been a revolutionary.

In obvious ways Delacroix stands to the old master painters of the seventeenth-century very much as his patron does to the absolute monarch of LeBrun's era, Louis XIV. In a remarkable act of metamorphosis, he both preserves and transforms tradition. As always, T. J. Clark writes, Delacroix "steers the subject towards his own obsessions, makes Apollo's horses rear and bristle, fills the sea with drafting bodies and the stain of serpent's blood. This is an art closed against the world, in a double sense: private imagery, and painting which aims to continue the old tradition as if the nineteenth century did not exist. Of course that could not be done."[66] Not even Delacroix could escape being of his own time. "No public painting, at least in 1851, could avoid the business of allegory altogether . . . But . . . it should be clear what was meant, more or less against the painter's will, by the victory of revolution over monarchy as that of Louis-Napoleon over Socialism. It is a reactionary metaphor."[67] This account suggests that we link the painting to the ambivalent relationship between culture and power expressed in James's dream. A museum containing violent images reveals something of its own history.

Just as museum art deals with destruction, so too it offers a setting for erotic experience, in ways many sensitive commentators have understood. In a letter of 1856 Baudelaire recorded his dream set in a museum. "I find myself in a series of enormous, interconnecting halls — badly lit, their atmosphere melancholy and faded. . . . In a secluded part of one of these halls, I find a very unusual series: drawings, miniatures, photographic prints."[68] This museum is a brothel. Carrying a book, afraid to approach the women, Baudelaire looks at drawings depicting fetuses born to these prostitutes. A living monster sits on a pedestal. In a late essay, the poet describes how "Louise Villedieu, the five-franc whore . . . having accompanied me one day to the Louvre, where she had never been before, began blushing and covering her face with her hands. And as we stood before the immortal statues and pictures she kept plucking me by

the sleeve and asking how they could exhibit such indecencies in public."[69] (The director of fine arts put fig leaves on the sculptures.)[70] This anecdote reminds us that the public collection was relatively inaccessible to poor Parisians.

Where apart from brothels might a man of Baudelaire's time have seen many naked women as in the Louvre? Even today, when visual pornography is readily accessible, museums retain their erotic potency. In her account of the Museum of Modern Art, New York, Carol Duncan writes: "It is de Kooning's achievement to have opened museum culture to the potential powers of pornography."[71] Because they contain many sexy pictures, museums are said to be good places to pick up dates. According to Kant's influential analysis, we respond to art by taking an aesthetic distance on its subject: "The superiority which natural beauty has over that of art, even where it is excelled by the latter in point of form . . . accords with the refined and well-grounded habits of thought of all men who have cultivated their moral feeling."[72] In his ferocious polemical reply, Nietzsche says: "if our aestheticians never weary of asserting in Kant's favor that, under the spell of beauty, one can *even* view undraped female statues 'without interest,' one may laugh a little at their expense. . . . credit it to the honor of Kant that he should expatiate on the peculiar properties of the sense of touch with the naïveté of a country parson!"[73] In the Dresden *Venus* by Giorgione, for example, a picture which fascinated Nietzsche, "her hand covers her pubic hair, but whilst remaining a gesture of concealment it is no longer the classical gesture of modesty. . . . It serves as convention of pictorial seemliness by concealing the sexual fleece, but undermines the convention by depicting hand and fleece in intimate contact."[74] As a Nietzsche scholar notes: "Everything about this picture conspires to make the woman available."[75] Philip Johnson, whose career has so often been linked to museums, also has an un-Kantian view of natural beauty. When young, he "stole into a dark corner of the Cairo Museum with a museum guard for what he later called his first full-fledged, 'consummated' sexual experience."[76] A few decades later, speaking about erotic art, he said that "sex should be in pictures, why not? That slight tumescence that you feel sometimes is part of seeing."[77]

A whole history of museums might focus upon their relationship with erotic experience. *Mona Lisa*, for example, achieved its fame, in ways Mario Praz and other commentators have described in detail, as an icon

for erotic fantasies of aesthetes like Berenson. Paul Barolsky writes, "In the imagination of the Romantics and of some today, the beauty of Mona Lisa is associated with terror, but even so the idea of the connection of her beauty with terror has its roots . . . in Vasari, since he says that Leonardo's artifice in rendering her would create fear in any daring artist."[78] When recently Kimiko Yoshida photographed a transvestite coyly seated in front of the picture, he played on this tradition.[79] If you enter the Louvre as soon as it opens and walk quickly, you will have Leonardo's painting to yourself for about five minutes. "Hers is the head upon which all 'the ends of the world are come,' and the eyelids are a little weary. It is a beauty wrought out from within upon the flesh, the deposit, little cell by cell, of strange thoughts and fantastic reveries and exquisite passions," Walter Pater writes.[80] The mob of tourists who soon arrive to crowd round this small painting, looking at nothing else, have not read Pater and indeed do not know his name, but they are responding to the mystique created in part by his very influential commentary. As Darian Leader says, "The *Mona Lisa* is not so much a painting as the symbol of painting itself."[81] To understand its role it helps to know that in 1695 the painting was in Versailles; that around 1750 it was neglected, but that in July 1797 Fragonard brought it from Versailles to the Louvre. In 1800 Napoleon placed it in his bedroom, but it was returned to the Louvre in 1804.[82] And after it became very famous, this Leonardo was stolen.

Because so many artists and art writers have described the Louvre and even dreamt about their experiences, its galleries have an enormous historical resonance. Knowing what happened there long ago informs present experience. By contrast, the J. Paul Getty Museum in Los Angeles, completed only in 1997, is in a new American city whose most famous indigenous art form is Hollywood movies. You go into the Louvre through I. M. Pei's new pyramid, which takes you into very old buildings (fig. 6). Almost no one enters the Getty by walking. To get into Meier's building, most visitors exit the San Diego Freeway and park in an underground garage. To enter a typical older art museum, you walk up a flight of marble steps to be elevated out of the ordinary world. The Getty tram taking you from the main parking lot up to the museum is an elongated electric version of that grand staircase (fig. 7). As you ascend, you hear the swoosh of a mechanical propulsion system. Or you can walk, and then when the footpath swings out to the left, high above the hill, you

6. I. M. Pei (1917–).
The glass pyramid in
the Cour Napoléon
of the Louvre. Photo:
Erich Lessing / Art
Resource, N.Y.

7. J. Paul Getty Mu-
seum, entrance tram.
Photo: John Linden.
© 2002 J. Paul Getty
Trust.

are almost alone. When again you are close to the tram, the roar of the traffic from the very busy freeway, five lanes in each direction, blurs to become background noise, like the ocean but with a higher pitch. Viewing the nearby mansions of Beverly Hills and Brentwood and the sprawling poorer parts of L.A. in the distance, you may recall that oil from iconophobic Saudi Arabia helps make possible the never ceasing flow of traffic far below.

Almost all of the paintings on display in the Getty could be moved to the Louvre—and the European art in the Louvre might be exhibited at the Getty. But how different would these works of art appear when moved between these settings. Seen in Paris, a Poussin naturally inspires reflection upon the history of French collecting. Set in Los Angeles, that same painting rather leads to thoughts about the new wealth that makes possible the display of European old masters in Southern California. Here then are the two most different large museums of European art imaginable—a former palace housing the first grand public museum and the newest large American museum displaying old master art. At the Getty the art is old but the setting is very new. And so a different museum interpretation is called for. But like the Louvre, the Getty too is concerned with "beauty and art, history and fame and power."

The older Louvre collection came from the French kings and upon Napoleon's imperial adventures. J. Paul Getty, the son of a prosperous Los Angeles businessman, left $700 million to found a museum. "Modern museology," Hilton Kramer has written, "aims to separate the art object from the accidents of ownership and let it stand permanently free in its own universe of discourse."[83] But neither in the Louvre nor at the Getty is this really possible, for you need only look beyond the frames of their paintings to see how art's display depends on what surely are not entirely accidents of ownership. In Paris, as in L.A., the art on display really cannot stand free from its museum context. Like Kramer, philosophers of art following Kant often speak of disinterested aesthetic pleasure. When viewing visual art, so they argue, we detach ourselves from practical concerns. Thinking in those terms makes it impossible to understand museums. The terminology in Louis Marin's epigraph for this chapter would have puzzled James and Baudelaire, but they both understood perfectly well the connection that he makes between museums and power. "The successful unmasking of *things* in order to reveal

(social) relationships," a French leftist writes, "remains the most durable accomplishment of Marxist thought."[84] We non-Marxists can productively borrow that way of thinking for in France, a social historian has recently observed, "things are much the same three hundred years ago as they are today."[85] The monarchs, Napoleon and his successors, the presidents of the various republics—all associated displays of art with the state's interests.

The Getty is privately funded, but its trustees think of collecting as an appropriate way to display the fruits of J. Paul Getty's economic success. In L.A., too, the importance of museum tradition is thus manifest. The Louvre and the Getty, impressive buildings in great cities, display an obvious capacity for conspicuous consumption. The mere materials of painting are banal things with little intrinsic worth. But great works of art are treasures. The museum buildings in Paris and L.A. are indeed grand, but without their art they would be mere empty shells. Why then, for the Getty's trustees as much as for Louis XIV, James and Baudelaire, is there an intimate link between visual art and power? Answering that question is the concern of the next chapter.

2

Art and Power

Words could not express what an agreeable spectacle this (is). . . .
nor could they convey by what sort of magic, as if I had been trans-
ported to strange climes and to the remotest centuries, I found myself
a spectator at those famous events the extraordinary written accounts
of which had so often stirred my imagination. . . . I could find myself
able to converse with the celebrated dead . . . or . . . I could find myself
instantly in the solitude of the fiercest deserts, or just as quickly, in the
fertility of the happiest countryside or the horror of storms and ship-
wrecks, all the while remaining in the midst of the streets of the most
populous city on earth. —JEAN ROU describing the Salon of 1667

H. G. Wells, Michael Crichton, and other science fiction writers describe
time travel. You enter a machine and emerge in the distant future or past.[1]
To what time would you choose to go? Many people would want to view
Christ and His Apostles at the Last Supper. And classicists surely might
ask to see the last moments of Socrates's life. Written accounts merely
tell what happened long ago, but time travel would allow us to actually
see historical events. You could view Christ or Socrates. Wells and Crich-
ton describe travelers who physically move to other times. Time travel
probably is impossible for reasons that physicists are best prepared to ex-
plain.[2] We cannot travel to the Last Supper or the death of Socrates. But
Nicolas Poussin depicted Christ and His Apostles—and Jacques-Louis
David showed Socrates taking the hemlock. And so seeing the *Last Sup-*

per and *Death of Socrates* is like looking back into the past.[3] The pleasure we get from Poussin's and David's art is the same as we experience, admittedly at a lower aesthetic level, when watching the movies with Charlton Heston playing Moses or Gene Kelly and Debbie Reynolds inventing the "talkie" in *Singin' in the Rain.*

We value such visual art because, by permitting us to imagine extending our lives beyond their natural bounds, it transports us to faraway places and to the distant past. That, of course, is only a fantasy—it requires seeing mere pigments as depicting these scenes. But it is a fantasy that we all experience. "Art has no value in itself," a museum director notes.[4] True enough, but by making imaginative travel possible, works of art become treasures, like the precious things in the *Wunderkammer.* Paintings physically present here and now in the museum present the distant past, making imaginative time travel possible. This double character of visual art, its capacity to make present such faraway places or times in its imagery, explains the exalted value placed upon it by princely collectors and their successors, public art museums. And this visual art also often gives us access to what is spatially distant when, for example, paintings in the Louvre depict Holland, Rome, and the Middle East. Nowadays inexpensive photographs are common, so it takes effort to understand how special such pictures seemed in premodern cultures, when they were relatively rare.

In 1667 Louis XIV purchased Poussin's *Israelites Gathering the Manna* and in 1685 he acquired *Landscape with Orpheus and Euridice.*[5] What French king would not have bought these treasures when they allowed you to view Moses in the desert and Orpheus in an imaginary Roman landscape? Such visual art thus was a suitable symbol of political power. The exotic shells, stuffed animals, and rocks in the *Wunderkammer* were rare expensive treasures from faraway places. Horst Bredekamp reports, "In the Prague *Kunstkammer* of Rudolf II, Giambologna's 'Rape of the Sabine Women' and two minor copies of the Laocoön were placed next to a set of antlers, an artistic work of nature seeming to reach out as if alive."[6] The old regime also included paintings and sculptures in *Wunder* and *Kunstkammers* because works of art too really were wonders. "A wide range of objects, natural ones in particular, were considered interesting and desirable almost entirely for their arcane rarity, presumed magical and therapeutic properties, or simply because they were difficult to come

by," Christina Luchinat writes.[7] And Napoleon commanded Denon to loot art from the conquered countries.[8] Not only connoisseurs but also powerful rulers, most of them without any aesthetic interests, thus acknowledged the importance of paintings and sculptures. Art museums show the power of aggressive cultures to move precious objects great distances and organize their public display in grand buildings.

Ernest Fenellosa took paintings and sculptures from Japan to Boston, Isabella Gardner imported art from Italy, and Albert Barnes brought expensive French paintings to suburban Philadelphia. They created museum narratives using material things, displaying their taste and power. In his discussion of imagination, "the part of the human being which dominates, this mistress of error and falsehood," Blaise Pascal reflects upon the disguises of rulers.[9] Along with "guards and foot soldiers," he argues, the king's treasures legitimately move the imagination of his subjects. Roy Strong writes, "Magnificence was . . . an element of fundamental importance to the Renaissance and Baroque court. . . . A prince must be seen to live magnificently, to dress splendidly, to furnish his palaces richly, to build sumptuously or to send grand embassies to other monarchs."[10] In the Renaissance court festival, "the ruler was allegorised in terms of intellectual control and power . . . its fundamental objective was power conceived as art."[11] The prince's carefully arranged collection in effect said, "I am the ruler because I alone have the power needed to create a historical narrative employing precious objects."

And modern museums show the power of democratic cultures. Carol Duncan explains the rise of American museums by saying that "art museums and the high-cultural products they contained . . . conferred social distinction on those who possess them."[12] But she does not say why visual art has this particular power. Our account of imaginative time travel does. In successive rooms you see Christian saints, pagan heroes, English country landscapes, and mid-Western American farms, an experience like channel surfing, which allows television viewers to see in rapid succession a detective show, a 1950s Hollywood musical, and the day's news. You imaginatively travel to many distant times and places, experiencing time travel on foot as you go from galleries devoted to the Egyptians to the Greeks to the Middle Ages and Renaissance, and then on to modernism and contemporary art. To see ancient Greece, you need only just walk a few steps. As J. Paul Getty observed, for an imaginative

collector a fragment of an ancient sculpture "will come alive, as fresh and as beautiful as the day when it was completed by its creator centuries ago. And, when that happens, the collector can, at will, transport himself back in time and walk and talk with the great Greek philosophers, the emperors of ancient Rome, the people, great and small, of civilizations long dead, but which live again through the objects in his collection."[13] Getty's account applies also the premodern *Wunderkammer*, where visitors found that, in Joy Kenseth's words, "it was marvelous to behold the famous events of distant times."[14]

A person survives over time, philosophers say, only so long as there is continuity of consciousness. If my personal identity is defined by memory, then it extends back to include my earliest recollections and into the future so long as my experience continues. But an old painting allows me to imagine extending these bounds of my identity.[15] "To see Rome," Quatremère de Quincy wrote, "is to travel in time and space."[16] Were imaginative time travel possible, then we could see the world as it was before our birth. For example, *Landscape in the Style of Fan K'uan*, an anonymous scroll from the early twelfth century now at the Metropolitan Museum of Art (fig. 8), speaks what Wen Fong calls "a language of crisis." As he says: "The composition builds a sense of tension, an unsettling surreality, by the use of the leaping scale of the three magnitudes—tiny figures, large trees, and enormous mountains—the dwarfed figures appearing trapped in frozen, unnatural space."[17] Standing before this landscape I imagine my life span dramatically extended. This of course is only an illusion, but it is a powerful illusion. Histories of China merely reconstruct events, but Chinese paintings allow us to imagine looking into the distant past.

My analysis equivocates in an important way on *where* in time old paintings take us. Poussin's *Israelites Gathering the Manna*, painted in 1639, takes us to the Middle East in Moses's time. Watching a movie about ancient Rome made in the 1950s, we are aware of the period style, which is unlike that of the recent film *Gladiator*. Similarly, while viewing Poussin's Jews, we see them in the style of his art circa 1639, as if we could look through the picture's surface and see what it depicts. That, indeed, is one legitimate way of responding to any representation, be it a painting or photograph. Watching a television sitcom, we may pretend that we are seeing not actors, but real happenings like those on the news.

8. China, Song dynasty (960–1279), early twelfth century.
Unidentified artist. *Landscape in the Style of Fan K'uan*. Hanging scroll; ink
and light color on silk, 64 7/8 × 40 7/8 in. (164.8 × 103.8 cm). Metropolitan
Museum of Art, gift of Irene and Earl Morse, 1956 (56.151). Photograph,
all rights reserved, The Metropolitan Museum of Art.

But the double character of visual art, its capacity here and now to show what is distant, means that this is not the whole story.

Art historians discuss Poussin's quotations from antique literature and sculpture, his complex compositions, and his stylistic development. Our present concern is with simpler, perhaps cruder ways of understanding his paintings. Just as scholars describe film's primitive power to make Heston, Kelly, and Reynolds present by projecting mere images onto the blank screen, so museum theorists need to explain why Poussin's paintings could fascinate Louis XIV and his courtiers, modern academics, and also tourists visiting the Louvre. Pierre Bourdieu and Alain Darbel note the divisions of museum visitors: "Statistics show that access to cultural works is the privilege of the cultivated class. . . . If it is indisputable that our society offers to all the *pure possibility* of taking advantage of the works on display in museums, it remains the case that only some have the *real possibility* of doing so. In the smallest details of their morphology and their organization, museums betray their true function, which is to reinforce for some the feeling of belonging and for others the feeling of exclusion."[18] True enough—but every visitor from any class sees that old art makes possible imaginative time travel.

The power of art to provide this experience of time travel depends on its survival. That much is self-evident. An entire book, *The Lost Museum: Glimpses of Vanished Originals*, is devoted to works of art which have been burnt, lost, vandalized, blown up in wars, or which have simply disappeared.[19] But there are other more conceptually complex examples of central importance for our inquiry in which seemingly well-preserved art perhaps ceases to exist. According to museum skeptics, art is destroyed in museums. And then, so they imply, these artifacts no longer make imaginative time travel possible. Often places are transformed over time so drastically that they effectively cease to exist. When doing research for his monograph on Terbrugghen, Benedict Nicholson explains, he walked along a canal associated with that painter "ridiculously imagining myself in the artist's shoes. But this section of the canal has been ruined by improvements and traffic; and no amount of historical melancholy could conjure up the atmosphere . . . in his time."[20] Old things usually require active intervention to survive. As Margaret Plant reports of Venice, for example, "important buildings may present the face of the past to the casual visitor, but in many ways they are facsimiles, or heavily face-lifted.

Looking at the Campanile of San Marco, few may realise that it collapsed in 1902 and was rebuilt faithfully."[21] Aged paintings and sculptures require cleaning and repainting and often are significantly retouched or drastically cut down. And in many cases, art that survives physically is not preserved when its context is changed drastically. Queen Elizabeth I called the fourteenth-century church of St. Mary Redcliffe in Bristol, England, "the fairest, the goodliest and most famous parish church in England."[22] After the building survived the Second World War bombing, a traffic circle was constructed nearby. There is no way to walk toward the façade without having your view obstructed by intrusive modern roads. Because its site was defaced, the church of St. Mary Redcliffe, mostly physically intact and still in its original location, no longer survives even though the building is intact. Like Richard Serra's *Tilted Arc*, this church is site-specific.

When Napoleon looted Italy, some Frenchmen wanted to move Leonardo's *Last Supper* to Paris. But transporting this painting would destroy it, because the image is internally related to the room and the nearby church.[23] Much Italian art is site-specific in less subtle ways. In the foreword to her pictorial survey *The Mural Painters of Tuscany*, Eve Borsook remarks that "we are no longer really used to mural painting. Today painting and architecture are rarely conceived together. . . . So accustomed are our eyes to easel pictures that murals are photographed as if they too were independent of any particular setting."[24] Because Cimabue, Giotto, and the other fresco painters worked in response to architectural settings, moving their paintings would destroy them. A great deal of Renaissance art is "fully transitive," as John Shearman writes, which "is to say, one whose subject is completed only beyond itself in the spectator's space, or even completed explicitly by, and in the spectator himself."[25] The same is true, of course, of much baroque public sculpture. Bernini's *Four Rivers Fountain*, for example, "emphasize(s) effectively the centre of the large square without disturbing its unity. At the same time the fountain had to be related to the façade of S. Agnese without competing with it."[26] Removing it from this original Roman site would destroy these intended effects.

In his life of Michelangelo, Giorgio Vasari describes the Sistine Chapel *Last Judgment*: "Christ is seated, and turned with a terrible expression towards the damned, to curse them, while the Virgin in great fear shrinks

into her mantle and hears and sees the ruin. A quantity of figures form a circle, prophets, apostles, and notably Adam and St. Peter, one as the origin of men come to judgment and the other as the foundation of the Christian religion."[27] As James Beck and Michael Daley note, an art historian who flies to Rome, takes a taxi to her hotel, and walks into the Vatican experiences a city dramatically transformed since Michelangelo's time. And thanks to recent restoration "the ceiling is certainly cleaner . . . but . . . is now severely damaged."[28] But what she sees standing among the tourists in the Sistine Chapel is the same painting that Vasari described.[29] It is as if she has traveled back to mid-sixteenth-century Rome. If this art historian drives to Padua, she may continue to imaginatively travel backward in time. Because works of art perform no utilitarian function, we generally aim to preserve them almost changeless, insofar as that is possible. But protecting Giotto's art requires preserving only his paintings, not their surroundings. We are not distracted by the cars parked near the frescoes nor bothered that visitors do not wear thirteenth-century dress. Just as in science fiction people wearing modern clothing visit the past, so when you go to the Arena chapel you need not give up the apparatus of contemporary life to see very old paintings.

Colonial Williamsburg and Versailles are well-preserved old towns. (And there are fake old cities in Disneyland and Las Vegas.) After only a few decades, functioning houses require extensive repairs. A thousand-year-old building requires elaborate intervention to conserve its foundations. Imagine a society that preserves many such villages, changing them as little as possible. Tourists there could visit a medieval French town, an ancient Chinese village, and a Greek city-state. But fully preserving such places on a large scale would hardly be practical. A medieval French town would require up-to-date sanitation; in the Greek city-state, the slaves would be actors. Such old villages would be as self-consciously artificial as Hollywood movies about Anthony and Cleopatra employing English-speaking actors. On Olvera Street in downtown Los Angeles, you dine and shop in a facsimile of Hispanic California.[30] In Piazza San Marco, you walk through a modernized portion of the late-eighteenth-century Venetian Republic. Those settings are more authentic than modern creations of older cultures in theme parks, for a reconstruction of Venice or New York in Las Vegas has no historical or geographical relationship with its source. But since Hispanic California and the Venetian Repub-

lic have not survived, Olvera Street and Piazza San Marco are artificial constructions. Keeping a culture alive demands more than mere physical preservation of its buildings — it requires the continued existence of the way of life associated with those structures. And because a living culture has unity, preserving only fragments may be impossible. A work of art dies once the cultural practices associated with that material object no longer exist.

Paintings are easier to preserve than old architecture. Protecting site-specific works of art like Leonardo's *Last Supper* or the frescoes discussed by Borsook requires only keeping unchanged the immediate surrounding area. Vasari devotes one long paragraph to the Legend of the True Cross in Arezzo (fig. 9).[31] After mentioning that Piero della Francesca inherited the commission, he explains that the fresco, "full of admirable ideas and attitudes," tells the story of the true cross.[32] The clothes of the woman next to the queen of Sheba "are depicted in a very delightful and novel way"; there are many "very true and lifelike portraits"; the Corinthian columns are "magnificently well proportioned"; and the peasant shown listening "could not be more convincing." After parking nearby, you view the same picture as did Vasari. Preserving Piero's frescoes requires conserving only his paintings, not their surroundings.

Unlike such paintings or Roman baroque monuments, most old visual art is not site-specific. When paintings are movable, preserving them requires only keeping their surfaces and, if possible, their frames unchanged. If you turn from reading Vasari, Diderot, and Baudelaire to view the paintings they describe, you may experience a certain marvel. These writers lived in cultures very unlike ours, but much of the art they described survives essentially intact. Diderot's great set piece on Fragonard's *The High Priest Corésus Sacrificing Himself to Save Callirhoé* describes that painting displayed in the Salon of 1765 set in the Salon Carré. Today *High Priest* still hangs nearby in the Louvre. In his Salon of 1846, Baudelaire mentions Ingres's *The Comtesse d'Haussonville* (1845), now in the Frick Collection, New York. Seeing the Pieros, the Fragonard, and the Ingres described by Vasari, Diderot, and Baudelaire, it is as if we have momentarily returned to their eras.[33] Of course this is only a fantasy. Since Piero, Fragonard, and Ingres died long before we were born, we can see only the old objects that they made. But this is an important fantasy because it helps explain why we value art. We care about these artifacts

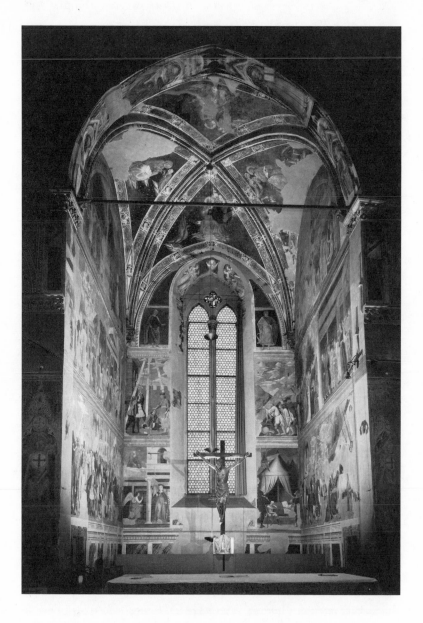

9. Piero della Francesca (ca. 1420–1492). View of the apse, showing
the True Cross cycle by Piero della Francesca, pre-restoration. S. Francesco,
Arezzo, Italy. Photo: Scala / Art Resource, N.Y.

because they allow us to be in contact with the same paintings as were described by Vasari, Diderot, and Baudelaire.

Seeing *Israelites Gathering the Manna* in Paris, I look into the world of the Old Testament. Viewing *Landscape in the Style of Fan K'uan* in New York, I imagine seeing twelfth-century China. Such imaginative time travel is, of course, just a fantasy, but how are we to understand this fantasy? Sometimes I imagine doing something and simply fail.[34] But in other cases I am unsure about my powers. If I confidently claim to speak Italian, that assertion can be easily tested. My declaration that I can imagine looking into the past is more difficult to evaluate. Everyone has experienced a film that fails to "come alive." If instead of being engrossed in the story of a Roman emperor, you see only actors on a set, then you cannot imagine looking into the past. Old art may pose similar problems. If art museums make it possible for us to experience the past, then we ought to value them highly. But perhaps such imaginative time travel is not really possible. Imaginative time travel may be impossible.

Here Ovid is a useful guide. A critical reader may think that some radical transformations described in *Metamorphoses* are incomprehensible. Given the golden touch, for example, when Midas "touched a piece of bread, it grew stiff and hard; if he hungrily tried to bite into the meat, a sheet of gold encased the food. . . . He took some wine . . . the liquid could be seen turning to molten gold as it passed his lips."[35] If you find that metamorphosis unbelievable, then the story of Midas will be impossible to take seriously. That Ovid says that a man can turn everything he touches to gold does not show that this is a coherent way of thinking. Imagine a modern creative writer who tells of a person transformed into a square circle. That story is seriously incoherent. Museum skepticism involves mistrust about the possibility of transformations of works of art. Just as the critical reader of Ovid denies that his stories really make sense, so the museum skeptic denies that old art can survive radical changes of context.

This belief in the power of art to provide imaginative time travel certainly attracts collectors. Ancien régime rulers placed art alongside other wonders in their *Wunderkammers* — and modern democratic states support public art museums. But when viewing *Israelites Gathering the Manna* or *Landscape in the Style of Fan K'uan*, how can I be sure that I am able to look into the past? Suppose that imaginative time travel fails.

Perhaps old objects in museums survive, but the works of art that they are thought to be identical with do not. When we look at old works of art, so I have suggested, we identify with the viewers who originally experienced them, thus extending the span of our own lives. But maybe the belief that we can do that is an illusion.

Visual art can make possible imaginative time travel only if it physically survives. But according to museum skeptics, the old art in our institutions does not survive. If they are right, then in the museum, such art has lost its power. Many intellectuals have argued that God does not exist. If they are right, then there is no real reason to maintain churches and temples as places of prayer. If museum skepticism is plausible, then there would be no rationale for maintaining museums, which are expensive public institutions. What, by analogy with atheism, would be the implications of arguing that old art in museums does not survive? The next chapter takes up that question.

Museum Skeptics

It is logically possible that the world was created just five minutes ago,

intact with us and all our memories, and containing all those bits and

pieces of things we take as evidence for a much older world than we in

fact inhabit. —ARTHUR DANTO

Imagine, as my epigraph from Arthur Danto proposes, that the world had been created five minutes ago. Since it would be impossible to distinguish such a reality from ours, the claim that our world was created very recently is impossible to refute. Danto admits that "few people have taken this argument seriously, except Bertrand Russell, who formulated it."[1] A purely metaphysical argument of interest only to philosophers, it is a variation upon the much discussed argument of museum skeptics.[2] Historians provide a written record of the past—and so does much visual art. No reasonable person could deny that historical writings provide quite detailed accounts, always subject to revision, describing the past as it really was. But many influential commentators have denied that the art collected in museums makes possible imaginative time travel.

According to these museum skeptics, as I will identify them, museums preserve old objects, but fail to preserve the works of art constituted by these objects. This initially may seem a very paradoxical, if not entirely implausible claim. Botticelli's *Birth of Venus* is a physical object. And so if that panel is preserved in the Uffizi, how could the painting not have survived?[3] But as we shall see, in rejecting the identification of the work of art with some such object, museum skeptics appeal to a commonsense argument. I use the phrase "museum skepticism" to allude to an important analogy with epistemology. Just as philosophical skeptics deny that we have knowledge, so museum skeptics reject the claim that museums preserve art. But in one important way, museum skepticism differs from

epistemic skepticism, which is a central concern of philosophers. G. E. Moore writes, "I have clothes on, and am not absolutely naked; I am speaking in a fairly loud voice . . . I have in my hand some sheets of paper with writing on them. . . . I have here made a number of different assertions. . . . I knew for certain, in each case, that what I asserted to be the case was, at the time when I asserted it, in fact the case."[4] For Descartes and his successors—Locke, Hume, Kant—the function of skepticism is to identify the legitimate foundations of our knowledge. No one sane truly believes that they might be dreaming or fooled by an evil demon. By contrast, museum skeptics really do deny that museums preserve art. If their way of thinking is correct, then museum skepticism has real practical consequences. Museum skeptics do not, of course, deny that the museums contain many old objects, but they do reject the claim that this old art gives us true beliefs about the past. If these skeptics are right, then imaginative time travel is impossible. And that means that our museums do not really contain treasures. Unlike epistemic skepticism, this argument thus has a political force.

To understand museum skepticism, we need to understand both the reasons that this view is intrinsically puzzling and why, still, it is worth taking very seriously. René Descartes begins his *Meditations* (1644) with a discussion of epistemic skepticism. With my eyes open, I think that I am looking at my desk and so believe that I have knowledge about the external world. But if my senses are malfunctioning or I am dreaming or there is an evil demon who befuddles me, then all of my beliefs about what I seem to see could be mistaken. Perhaps I am looking at something else or maybe the external world does not exist. Were epistemic skepticism plausible, Descartes claims, then we might have no knowledge. The implications of the equivalent view of art museums are harder to identify. Museum skeptics are not concerned with mistaken attributions. They claim not that some works of art in the collection are forgeries, but that all genuine old art in museums is not what it seems to be. When you put a Raphael in the museum, the museum skeptic argues, then you preserve an old object, but not that painting itself.

Philosophers have seriously considered some extremely counterintuitive metaphysical hypotheses: there is no external world; time is unreal; the self does not exist. The claim that the old art in the museum has not been preserved initially seems equally paradoxical. As an abstract ar-

gument, museum skepticism is hard to defend or refute. But because it arose as a response to the first public art museums, we can best understand this way of thinking by historical analysis. When in 1781 the church of Notre Dame was turned into a surrogate art gallery, already the transformation of the Louvre from palace into art museum was anticipated.[5]

During the 1790s, the first great public art museum was created by intermingling the French king's collection with the loot gathered by the Napoleonic armies. When that happened, Antoine-Chrysostome Quatremère de Quincy argued that "removal of ancient and Renaissance works from their living historical context destroys their meaning."[6] The true Roman museum, he claimed, is composed not only of these movable works of art but also "fully as much of places, of sites, of mountains, of quarries, of ancient roads, of the placing of ruined towns, of geographical relationships, of the inner connections of all these objects to each other, of memories, of local traditions, of still prevailing customs, or parallels and comparisons which can only be made in the country itself."[7] Art cannot survive detached from where it was made and first appreciated. For Quatremère de Quincy "the art of museums, the transfer of works of art from their original intended site to some museum, implied breaking the link that had always existed between creations of genius and society, between art and mores, art and religion, art and life."[8] By taking art out of its context, the museum destroys it. "They were objects behind glass, unconnected with the life of society about them—art split off from life, or as John Dewey would later put it, in a society whose arts began with the museum age, art split off from experience." The work of art exists as such only so long as it remains in its original setting.

De Quincy was not against museums as such—he championed French museums. And because the Elgin marbles had decayed and were inaccessible in Athens, he favored removing them to an English museum.[9] But he did not think that Italian art could survive in Paris. Others shared his opinion. In 1798 Goethe took a similar view: "Italy as it existed until recently was a great art entity. Were it possible to give a general survey, it could then be demonstrated what the world has now lost when so many parts have been torn from this immense and ancient totality. What has been destroyed by the removal of these parts will remain forever a secret."[10] In 1796, hearing of the French confiscation of Italian paintings and sculptures, he feared that "the powers of human arbitrariness . . .

seemed to be triumphing over the laws of Nature."[11] The Italian art world that he had so recently visited was being dismantled. But later he became more optimistic. He believed that "a new or 'ideal body of art' can perhaps be constructed, a *musée imaginaire* in which the physical remnants of antiquity, scattered around the world, can be brought together in the mind and given life again."[12] Goethe hoped that artists would use the new Paris museum as a substitute for Italy.

Canova was more pessimistic. In his 1816 address to the Roman Academy of Archaeology he argued: "It is the destiny of works of art to be bound to a fixed location. Nor can the whole world be traversed by us all; and the desires of the majority would be frustrated if the scholar did not intervene to provide his learned analyses, accounts, and comparisons. . . . Every stone . . . of this capital solicits the scrutiny, the study, and the attention of the scholar and antiquarian."[13] Canova thus was a museum skeptic. For museum skeptics the birth of the Louvre defined a dramatic break in art's history. When Italian art moved to Paris, it ceased to exist. In the 1780s Jacques-Louis David went to Rome to reform French painting with his "*Oath of the Horatii* . . . a classical history painting that seemingly derived from Poussin in all but scale."[14] And in the nineteenth century the French sought to reclaim the French-born Poussin, who chose to spend his career in Rome, as the source for their artistic tradition. What was the proper relationship between art in Rome and Paris? Cultural rivalry was at stake in the debate about museum skepticism.

In premodern Europe, works of art and natural treasures were collected.[15] These collections were organized in what today seem very strange ways. Thomas Kaufmann argues, "In shaping a universal collection, a ruler may not only have asserted his pre-eminence in the world of men through his lavish display of wealth. In possessing the world in microcosm, he may have symbolically represented his mastery of the greater world. . . . he may have believed that in having a theatre of the universe in his collection, he could grasp and control the greater world."[16] Many old paintings now in public institutions used to be in private museums. These *Kunst* and *Wunderkammers* are often identified as the ancestors of our museums. Museum skeptics disagree, noting that the envelope provided by the *Wunderkammer* was very unlike the theories associated today with art collecting. Curators do not believe that properly displaying art permits us to control the greater world. And so to speak of the

preservation of works of art or of the premodern origins of our public art museums raises crucial questions.

Quatremère de Quincy claimed that preserving a work of art requires not just saving that object, but also safeguarding its original context. Moved from Rome, Raphael's paintings and antique sculpture were not preserved because they were part of a larger whole, Italy's visual culture.[17] But there is more to the story. Some objects in our museums—pieces broken from Romanesque church façades, bits of pre-Columbian fabrics, portions of altarpieces—are true fragments. But de Quincy argued that taken out of their original context, even physically intact works of art become debris. Try this experiment the next time that you are fatigued in an art museum. Sit down and notice what happens when you lose your ability to imaginatively synthesize your experience. You may then find yourself surrounded by mere fragments, bric-a-brac that fails to come together to form a unified image of the culture in which it was created. This experiment is easiest to perform in a gallery such as Cluny, which reconstructs medieval French visual culture from bits and pieces of sculpture.[18] But as museum skeptics note, this uncanny experience can occur in any art collection.

Long before Denon, art was frequently moved. Much of the sculpture taken by the French came from the Pio-Clementine Museum, which was created only in 1770.[19] Some of these famous Roman antique sculptures had been unearthed only in the early sixteenth century.[20] And since antiquity, Rome itself has changed drastically. Baroque architecture, for example, affected the way that older Roman art was seen. But de Quincy thought that none of those changes were as dramatic as the movement of art into the museum. According to a song composed in 1798 to celebrate the arrival of the Italian masterpieces in Paris, "Rome is no more in Rome / It's all in Paris."[21] Is that correct? Could the arts of Rome find a new home in the Louvre without entirely losing their identity? Museum skeptics think not. Henry James described the Capitol in 1873: "The legendary wolf of Rome has lately been accommodated with a little artificial grotto . . . Above, in the piazzetta before the stuccoed palace which rises so jauntily on a basement of thrice its magnitude, are more loungers and knitters in the sun, seated round the massively inscribed base of the statue of Marcus Aurelius."[22] Detached from this so richly evocative setting, Italian art would be impoverished.

In art museums, Buddhist sculpture, Christian altarpieces, and pre-Columbian ritual daggers are taken from their original settings and so detached from their intended functions. But these artifacts were not made to be contemplated aesthetically. Francis Haskell writes,

> Museums destroyed the very purpose of the art which they had been called upon to house and to preserve. It was not just that a painting designed to move the devout to prayers might hang next to one designed to move the dissolute to lust. It was rather that each lost its true function once it had been moved from bedroom or chapel to the bare walls of a building which was necessarily devoid of any of the associations of bedroom or chapel.[23]

As Danto says: "Philip IV did not have his portrait executed by Velázquez to have it hang with the Spanish School in the Musée Napoléon or fraternize with Mr. Frick's prize pictures."[24] Museums impose a novel way of seeing old artifacts. "One does not *view* the altarpiece, one prays before it. . . . When one puts the altarpiece in the museum, out of the chapel, onto the wall, it compares unfavorably with the easel picture." When, for example, the Boston Museum installed a medieval Catalonian apse (fig. 10) "as the majestic vehicle of a religious purpose the virtue had gone out of it. It had been 'sterilized.'"[25] Setting old artifacts near to modernist and contemporary art made for the museum implies that they all are part of one history. And exhibiting a great variety of old and new objects in chronological order suggests that museums tell this story of art's development in all cultures. Museum skeptics reject these claims.

What could a culture unfamiliar with bottle racks and white porcelain urinals make of Marcel Duchamp's readymades? "So much of what is contemporary art is so internally related to aspects of contemporary culture that the meanings of objects, intended as vehicles of our cultural identity, will be lost if knowledge of their references and allusions are unknown. It is as though we must transmit the whole of our culture if any part of it—any work—is to be more than a pickled object."[26] To understand their transfer into the art world, you need to recognize that they *are* bottle racks and urinals. And that means that you must be able to identify the originals. Art commenting upon everyday culture by appropriating utilitarian artifacts loses its meaning once those artifacts become unfamiliar. We may plausibly extend Danto's argument to all art. A Greek sculpture is carved for a temple, a Persian carpet woven for ceremonial

10. Unidentified artist, Spanish (Catalan), twelfth century,
Christ in Majesty with Symbols of the Four Evangelists, 1150–1200. Fresco
secco transferred to plaster and wood. 645 × 382 × 282 cm (253 ¹⁵/₁₆ × 150 ³/₈ ×
111 in.); 645 cm (254 in.) at greatest height; 282 cm (111 in.) at greatest depth;
382 cm (150 ³/₈ in.) at greatest breadth. Museum of Fine Arts, Boston.
Maria Antoinette Evans Fund 21.1285. Photograph © 2006
Museum of Fine Arts, Boston.

use in a mosque, a sacred Renaissance painting made for a high altar. Such artifacts were part and parcel of living ways of life. No one ignorant of Greek religion, Islamic culture, or Christianity could fully understand them. When separated from the ways of life associated with its creation, such art loses its function. Displaying objects that have lost their function, turning sculptures, carpets, and paintings into things we appreciate aesthetically, the museum preserves only mere physical artifacts.

Critics often say that museums kill art.[27] In 1861, Théophile Thoré complained that "museums have never existed when art is in good health and creative vitality flourishes. Museums are no more than cemeteries of art, catacombs in which the remains of what were once living things are arranged in sepulchral promiscuity."[28] Manet was young in 1861— and the era of impressionism was about to begin. How odd, then, to think that French art was not in good health. But many later museum skeptics repeated Thoré's complaint. Linking the origin of the art museum during the French revolution to the guillotine, Georges Bataille compares museums to slaughterhouses.[29] And a German writer calls the art museum a place "where each separate object kills every other and all of them together, the visitor."[30] These claims have even made their way into popular thinking. A character in Bruce Chatwin's novel *Utz* says: "An object in a museum case . . . must suffer the denatured existence of an animal in the zoo. In any museum the object dies—of suffocation and the public gaze—whereas private ownership confers on the owner the right and the need to touch."[31] And Bob Dylan observed, "Great paintings shouldn't be in museums. Museums are cemeteries."[32]

Dead art, museum skeptics often argue, is given life only by the gaze of the viewer. Paul Valéry described entering a "wax-floored solitude, savoring of temple and drawing room, of cemetery and school. . . . I am . . . weirdly beset with beauties, distracted at every moment by masterpieces to the right or left compelling me to walk like a drunk man between counters."[33] This museum is a mausoleum. "Only an irrational civilization, and one devoid of the taste for pleasure, could have devised such a domain of incoherence. This juxtaposition of dead visions has something insane about it, with each thing jealously competing for the glance that will give it life." Perhaps Valéry alludes to Charles Baudelaire's famous evocation of the living pillars that come alive when viewed by a receptive passerby. Or maybe he is making a distinction between familiar things

that live for us because we know how to use them and museum hangings, which seem illogical to someone unfamiliar with their conventions. If when you were a child your family performed music in the living room, then concert hall performances may by comparison seem sterile and life-less. If, analogously, you are accustomed to seeing art in domestic set-tings, museums by comparison can seem like morgues. Susan Manning recounts a visit: "We went first into the gallery of British Painting, where there were hundreds of pictures, any one of which would have interested me by itself; but I could not fix my mind on one more than another."[34] When Nathaniel Hawthorne first saw a large public exhibition of art in Manchester, 1857, he was overwhelmed.

Maurice Blanchot had a similar reaction to the museum. "One has but to enter any place in which works of art are put together in great num-ber to experience this museum sickness, analogous to mountain sickness, which is made up of a feeling of vertigo and suffocation. . . . Surely there is something insuperably barbarous in the custom of museums."[35] There is, to quote a Victorian commentator, "a condition of mind . . . pic-ture drunkenness or Museum drunkenness, and this should be carefully guarded against."[36] Or as Theodor Adorno says in his commentary on Valéry's essay, "The natural-history collections of the spirit have actually transformed works of art into the hieroglyphics of history and brought them a new content while the old one shriveled up."[37]

Martin Heidegger also had a skeptical view of the museum's power to preserve art. "The works themselves stand and hang in collections and exhibitions. But are they here in themselves as the works they them-selves are, or are they not rather here as objects of the art industry? . . . Even when we make an effort to cancel or avoid such displacement of works . . . the world of the work that stands there has perished."[38] The museum kills art by removing it from the life of the community. Or as Chateaubriand said in the *Genius of Christianity*, when monuments are moved they "have lost their essential beauty, viz., their connections to the institutions and habits of a people."[39] Some people think innova-tion frightening but others find it exhilarating. Museum skeptics take a pessimistic view.

After a brief sketch of the history of museums mentioning Napo-leon's Louvre and linking museums, imperialism, and nationalism, John Dewey says: "The mobility of tradition and of populations . . . has weak-

ened or destroyed the connection between works of art and the *genius loci* of which they were once the natural expression. As works of art have lost their indigenous status, they have acquired a new one—that of being specimens of fine art and nothing else."[40] Nowadays, he adds, "works of art are . . . produced, like other articles, for sale in the market." Anyone who has visited a dusty old-fashioned museum will understand his complaints. Sartre's novel *Nausea* describes one such provincial institution. "A guardian was sleeping near the window. A pale light, falling from the windows, made flecks on the paintings. Nothing alive in this great rectangular room, except a cat who was frightened at my approach and fled."[41] When Dewey visited Soviet Russia, in the Hermitage he found, by contrast, "groups of peasants, workingmen, grown men and women much more than youth, who came in bands of from thirty to fifty, each with a leader eager and alert. . . . The like of it is not to be seen anywhere else in the world."[42] That trip gave him reason to be optimistic.

Dewey's political analysis was anticipated by John Cotton Dana (1856–1929), director of the Newark Museum. The trouble with these institutions, Dana noted in 1921, is that "they are made in obedience to an ancient fashion. The fashion grew up several centuries ago among kings and other masters of men and wealth. . . . when . . . common people found that they had, through taxes, money they felt held in common . . . they decided to use some of it to buy museums for themselves."[43] This history is hard to overcome. "Unfortunately no one was at hand to tell them that they would get no pleasure or profit out of the kinds of museums which kings, princes, and other masters of people and wealth had constructed." But Dana, like Dewey, was an optimist. Rather than collecting expensive paintings and sculptures, he thought that museums should show useful tools. These institutions "should encourage the movements toward the beautification of its products which" the community develops. But whether because the Newark museum was not influential or because his ways of thinking were out of touch with dominant tradition, Dana's philosophy had little effect. The same is true of Dewey's aesthetic, which influenced the Barnes Foundation, but not museum practice elsewhere.

In surveying antimuseum thinking, I have offered only a limited account of the arguments. In citing Adorno and Heidegger, for example, nothing has been said about the intricate philosophical frameworks in which their claims are embedded. Doing that seems unnecessary because

other writers—Thoré and Valéry are examples—reach the same conclusion by a much simpler route. When analyzing a philosopher's claims, I would hesitate to focus merely on the rhetoric. But because museum skeptics mostly make assertions without argumentation, we can learn a great deal by examining their metaphors. Literally speaking, art is never alive and so cannot be killed by the museum. But the museum skeptics are not speaking literally.

Art is alive when it matters, but dead when it ceases to be important. Hegel famously described the death of art in his time: "No matter how excellent we find the statues of the Greek gods, no matter how we see God the Father, Christ and Mary so estimably and perfectly portrayed: it is no help; we bow the knee no longer."[44] The museum kills art by removing it from the life of the community. To quote Hans Belting's summary of Hegel's analysis: "The art-work is no longer present in the public realm, but, confined in a kind of enclave, draws one's gaze only to itself."[45] Oswald Spengler's *Decline of the West* takes up this idea. "One day Rembrandt's last portrait will cease to exist, even though the painted canvas will still be intact; because the eye that can apprehend this language of forms will have disappeared."[46]

Because museum skepticism is a shocked response to change, it can be a conservative way of thinking. Indeed Hans Sedlmayr, a supporter of National Socialism, defended museum skepticism. From "the old churches, castles and palaces there issues from the end of the eighteenth century onward an endless stream of works of art each, separate and isolated from its context, fragments of what once had been a coherent whole." The obsession with fragments is, of course, a stereotypical romantic obsession. "Torn from their mother soil, they wander, like forlorn refugees, to take shelter in the art-dealer's market or into the soulless institutional magnificence of public or private art galleries. In the museum. . . . things which were originally integral parts of a single whole are shown forth after this heartless process of dismemberment as exhibits."[47] A century earlier, Fredrich Schlegel made the same claim: "Our perception of art must now indeed be fragmentary, since art itself is nothing but a fragment, a ruin of bygone days. Even the corpus of Italian art is today torn and scattered."[48] Celebrating "that which lives, moves, and evolves by an internal energy, over whatever is lifeless, inert, and unchanging," writers of his time thought museums artificial and inert.[49] But writing

from a committed extreme leftist point of view, Walter Benjamin presented a similar idea.[50]

Recent museum scholars tend to be suspicious of André Malraux's art writing. Their dislike for his purple prose is understandable, but he does offer a shrewd characterization of our situation. "While we have come to know cultures other than those which built up the European tradition," he says, "this knowledge has not modified our general outlook to the same extent as the works of art have affected our sensibility. It is in terms of a world-wide order that we are sorting out, tentatively as yet, the successive resuscitations of the whole world's past that are filling the first Museum without Walls."[51] And when he notes, "the works of art that comprise this heritage have undergone a strange and subtle transformation," he gives a plausible characterization of museum skepticism.

De Quincy offered a politically conservative analysis. Denon's Louvre, a product of the Revolution, destroyed the traditional art settings in Italy. Like many conservatives, de Quincy thinks that because an institution is old, it has passed the test of time and is therefore justified. Recent museum skepticism, by contrast, typically invokes a leftist academic alliance linking feminism, gay politics, and multiculturalism.[52] But since the Soviet revolutionaries preserved the museum culture of the old regime and most leftist art historians are not skeptics, something more than a political viewpoint is involved here. In her account of the ritual character of art museums, Carol Duncan, who is a leftist, says:

> Today, it is a commonplace to regard museums as the most appropriate places in which to view and keep works of art. The existence of such objects — things that are most properly used when contemplated as art — is taken as a given that is both prior to and the cause of art museums. These commonplaces, however, rest on relatively new ideas and practices. The European practice of placing objects in settings designed for contemplation emerged as part of a new and, historically speaking, relatively modern way of thinking.[53]

Once we realize that museums are recent creations, then their claim to preserve old art ought to seem problematic. Duncan goes on to note the political biases inherent in the museum. "Whatever their potential to enlighten and illuminate, they work within politically and socially structured limits. . . . Given the ideological power and prestige of art museums,

it is not realistic to think that museum rituals . . . can be moved very far from their present functions." A truly populist art museum, she implies, would be a contradiction in terms.

John Ruskin summarized the way of thinking about museums that Duncan attacks: "The first function of a Museum is to give example of perfect order and perfect elegance, in the true sense of that test word, to the disorderly and rude populace. Everything in its *own* place, everything looking its best because it is there, nothing crowded, nothing unnecessary, nothing puzzling."[54] As a recent commentator notes, for Ruskin "the National Gallery should recognise in paintings the symbolic language by which communities communicate in history by expressions of cultural identity. . . . in seeing art correctly we view history directly."[55] In projecting a political reading of history, museums thus reflect the ideology of the ruling culture. The belief that old art is preserved is part of a mistaken way of thinking that has real practical significance.

Douglas Crimp's *On the Museum's Ruins*, quoting Adorno and Benjamin, presents an argument similar to Duncan's. Once photography enters the museum, "an object among others, heterogeneity is reestablished at the heart of the museum; its pretensions to knowledge are doomed. . . . Just as paintings and sculptures acquired a new-found autonomy . . . when they were wrested from the churches and palaces of Europe and consigned to museums in the late eighteenth and early nineteenth centuries, so now photography acquires *its* autonomy as it too enters the museum."[56] According to Crimp, Robert Rauschenberg's postmodernist 1960s collages of photographs in his paintings mark the end of the museum. "Art as we think about it *only came into being* in the nineteenth century, with the birth of the museum and the discipline of art history. . . . The idea of art as autonomous . . . as destined to take its place in *art* history, is a development of modernism." The museum, ruined by photography, "constructs a cultural history by treating its objects independently both of the material conditions of their own epoch and of those of the present."[57]

With reference to Crimp, Stephen Bann also offers a pessimistic analysis: "The museum . . . is the result of an Enlightenment project. But it is a project which has been fulfilled precisely through its negation: that is to say, from the point at which the didactically assembled objects became also vehicles of feeling and testaments of loss. It is not possible for the

museum to emancipate itself from this dual identity."[58] Pierre Bourdieu extends this way of thinking by contrasting the museum to the art gallery. "The museum, a consecrated building presenting objects withheld from private appropriation and predisposed by economic neutralization to undergo the 'neutralization' defining the 'pure' gaze, is opposed to the commercial art gallery. . . . The whole relation to the work of art is changed when [it] . . . belongs to the world of objects available for appropriation."[59] The claim that we can have detached aesthetic experience is an illusion. Or as Robert Coles puts it, "Money and power have their effect inside as well as outside museum walls. . . . the issue is not money as a sum, but the whole matter of class and its various implications. . . . hence the inability of many of us who are fairly well-to-do to appreciate the utterly intangible, and maybe inexpressible, barriers which present many 'ordinary' people from using their leisure time in a way some of 'us' might consider valuable."[60] Nowadays art museums seek to be inclusive, but their grand appearance is a reminder that they are controlled by the very rich.

Museum skeptics mostly believe that these essentially exploitative institutions cannot really escape from their history. This intimate inescapable association of art museums with power explains why some otherwise sensible commentators make extravagant, obviously implausible claims. In his account of visual rhetoric, for example, Dave Hickey writes: "In the United States, Alfred Barr, in the service of inherited capital, proclaimed the absolute subordination of content to form; while in Germany . . . Reichsminister Joseph Goebbels . . . was orchestrating their perfect match."[61] What real analogy could there be between Barr's museum, which coexisted with quite different institutions and repeatedly revised its agenda, and Goebbels's brutal destruction of art? If you don't like the Museum of Modern Art, you are free to walk on. But what legitimately disturbs Hickey are the parallels between the power of images in democratic culture and in totalitarian regimes.

Inspired by Michel Foucault, many recent museum skeptics argue that art as we know it did not exist before there were museums.[62] Speaking of "the illusion that the modern ideals and practice of art are universal and eternal," Larry Shiner claims that "the category of fine art did not exist before the eighteenth century."[63] Even Michelangelo's "practice and outlook" in the Sistine Chapel, so he argues, was closer "to that

of his fellow artisan/artists than to that of a modern artist who places self-expression and originality above skill and service." Such an analysis is surely inconsistent with Vasari's account of Michelangelo's originality: "Men are stupefied by the excellence of the figures, the perfection of the foreshortening, the stupendous rotundity of the contours, the grade and slenderness and charming proportions of the fine nudes showing every perfection. . . . O, happy age! O, blessed artists who have been able to refresh your darkened eyes at the fount of such clearness, and see difficulties made plain by this marvelous artist!"[64] When Vasari calls his hero as a man with "singular eminence . . . seeming rather divine than earthly," he identifies Michelangelo as a model of artistic "self-expression" in our modern sense. Shiner claims that the birth of museums marks our recent invention of both art and the artist. His account of Michelangelo does not give any good reason to accept that dramatic argument.

No one would deny that the ways in which visual works of art were marketed did change in the eighteenth century. Nor could it be denied that our styles of describing older art differ rather substantially from those of Vasari.[65] And we might agree that the modern museum, closely linked to the intricate interplay between public ownership of art and private collecting, is inconceivable outside of bourgeois society. Donald Preziosi writes, "Since its invention . . . the museum has been central to the social, ethical, and political formation of the citizenry of modernizing nation-states. . . . What they have accomplished . . . [is] nothing less than the disciplining of whole populations through a desire-driven interaction with objects."[66] China has a sophisticated tradition of art writing, collecting, and connoisseurship. But its culture was too different from that of Western society for it to have art museums until very recently.[67]

Museum skeptics offer a dramatic reading of these historical facts. Art plays a central role in contemporary culture as what Preziosi calls "the backbone of the world in which we live and of the subject positions we learn to desire to take up in that world."[68] "The subject," as museum visitors are sometimes identified, then finds in the museum "a series of possible ways in which it can construct its own life as some kind of centered unity or perspective that draws together in a patterned and telling order all . . . diverse and contradictory experiences and desires." Art museums thus falsify our identity.[69] Many recent museum skeptics offer variations on this basic argument. The art museum, it has been claimed, is "a ma-

chine that produces subjects by reconsigning value."[70] Susan Pearce also links museums to the development of capitalism: "The mature phase of market capitalism naturally went hand in hand with the mature phase of public collection and display, in which spiritual, intellectual and property values are united, the educated middle classes confirmed in proprietorship and the state assured."[71] And Stephen Arata says that "by reducing the complex processes, struggles, and uncertainties of the past to a coherent, easily assimilable order, the museum produces . . . a 'reality effect' that serves to put to sleep, not awaken, a sense of history."[72] Real history, these skeptics argue, is far more confusing than the organization of art in the museum suggests.

Eilean Hooper-Greenhill's *Museums and the Shaping of Knowledge* gives a Foucauldian reading of the origin of this institution. Older historians claim "that museums are doing much the same now as they were during the period of the Renaissance *episteme*." She rejects that view. The *Kunstkammer* and other early collections "were constituted with a quite different frame of reference" from the modern museum. "The identity and meaning of material things is seen to be constituted in each case according to the articulations of the epistemological framework, the field of use, the gaze, technologies, and power practices. If the same object had been held as part of the collection of each of the 'museums' that have been discussed, the meaning of the object would have radically changed as it moved from one institution to the next." The concept of art did not emerge until "the 'museum,' placed within the sovereign-discipline-government triangle . . . becomes one among many apparatuses of security and surveillance." This analysis shows that "there is no essential museum" because "the museum is not a pre-constituted entity that is produced in the same way at all times."[73] Without using this abstruse vocabulary, Robert Harbison makes the same claim: "If a museum is first of all a place of things, its two extremes are a graveyard and a department store, things entombed or up for sale, and its life naturally ghost life, meant for those who are more comfortable with ghosts, frightened by waking life but not by the past."[74] Museum works of art are commodities that are dead because they have been withdrawn from the commercial art world.

Museum skeptics note that the art museum imposes a novel historical framework on the art it displays. The museum, Rosalind Krauss says, de-

rives from the Renaissance palace "with its series of rooms *enfilade*. . . . One proceeds in such a building from space to space along a processional path that ties each of these spaces together, a sort of narrative trajectory with each room the place of a separate chapter, but all of them articulating the unfolding of the master plot."[75] Walking through such a museum is like reading an art history book in which individual works of art are presented in historical order. The linear structure of an institution such as the Guggenheim means that, as Shelley Errington says, it is "difficult to organize, display, and therefore for the viewer to conceptualize the history of art as anything other than an illustration of conventional art history's enabling assumption, which is more or less 'one piece of art influences another.' "[76] That in the seventeenth century art was displayed very differently shows how dramatic were the changes introduced by the public art museum.[77]

Duncan, Crimp, Preziosi, Pearce, Hooper-Greenhill, and the other skeptics suggest that museums, essentially manipulative institutions, create a false view of their collections. And since it is a European creation, they link its appearance in other cultures to the imperialistic history of European (and American) world dominance. Great museums are in London, New York, and Paris because England, America, and France had the political power and wealth needed to collect art. According to their defenders, museums, like such other bourgeois institutions as libraries, the police, and hospitals, serve the public good, responding to the demands of citizens whose taxes support them. The institutions are imperfect, but liberals believe that they can be reformed. By preserving Islamic tiles, Chinese porcelain, and Oceanian carvings, museums permit us to observe the diversity of cultures. Freed from performing utilitarian religious functions, these objects reveal their shared qualities as art. "For many who cannot find sustenance in religious belief, the museum . . . has become the world. The museum, in that cultural function, becomes the transitional object, relating the person to the sense of something 'other,' however that other is created in the internal world of the museum-goer."[78] Liberals believe in continuity and progress.

We no longer call art from Africa "primitive." And what used to be called "pre-Columbian art" now is identified as art of the ancient Americas.[79] Acknowledging that the museum is a product of imperialism, liberals think that we can improve this institution. Neither Diderot nor

Baudelaire saw much art outside of France. Kant looked at very little painting or sculpture. Unlike him, Stephen Houlgate writes, "Hegel traveled widely to see as many paintings firsthand as he could—usually in great discomfort. . . . [But] he never visited Greece or Italy."[80] Only more recently has it been easy for art writers and aestheticians to see a great variety of art. Thanks to museums, there has been progress. Museum skeptics reject these arguments. The modern art museum, invented in the mid–eighteenth century by the bourgeoisie, expresses the dominance of that class. Although museums now seek to attract everyone, they remain elitist institutions. In that way the basic situation described by earlier museum skeptics has not changed. Contemporary skeptics tend to be Nietzschean perspectivists. Denying that knowledge can ever be neutral, they think that museums always have ultimately conservative political agendas.

This historical sketch indicates why museum skeptics emphasize the importance of the link between Denon's Louvre and the French Revolution. The execution of the French king and the transformation of the Louvre into a public space mark the end of the old regime.[81] The British Museum was founded in 1759, but because access was limited, Karsten Schubert notes, "it was not a museum in the sense we understand today."[82] But since art museums did appear before the Napoleonic Louvre, museum skeptics need to explain why the ancestors of our public institutions appear in Rome and Vienna before the French Revolution. The establishment of the Capitoline and the Pio-Clementino in the Vatican "signified . . . that the works in them were inalienable and could not be disposed of. This had never been quite clear until now. The Renaissance and baroque popes had sometimes acquired sculpture and paintings for the Vatican palace. . . . But by creating museums specially designed to prevent the dispersal of sculpture from Rome . . . the popes of the eighteenth century were warning foreigners that the most important pieces were always going to remain beyond their grasp."[83] At the entrance, a ceiling fresco by Anton Raphael Mengs shows a figure who "invites History to visit the new museum."[84] But a museum skeptic could suppose that since in Rome and Vienna the political concerns of the French Revolution were anticipated, the birth of the art museum too was prepared for.[85]

Like Ovid, analytic philosophers seek to understand radical change. A

person has new experiences and forgets some of her past; a car has some parts replaced; a nation expands and changes its laws. We speak of *the same person* or *the same car* or *the same nation* in order to identify that person or car or nation which survives these changes.[86] However much Michel Foucault changed his ideas, the author of the early study of madness was *the same person* as the writer of his late books about Greek sexuality. That, after all, is why his name is on the title pages—it is why we can speak of the development of Foucault's thought. We also talk about the identity-over-time of institutions. At one point, the pope ruled a considerable territory. Now the space under his control has shrunk drastically, and the church dogmas have changed dramatically. But Catholics call the present pope the direct successor of St. Peter. With persons and institutions a continuous sequence of relatively small changes can have a large effect. A similar point can be made about the Louvre. Originally the king's palace, it became a museum during the Revolution, and then its identity again changed when Napoleon rose to power, and when France became a Republic. The original buildings have been modified and many new galleries added, but there is enough continuity to speak of identity-over-time. The Salon Carré in the present Louvre is *the same gallery*, much changed, as that room where Diderot saw the salons.

A partially destroyed Persian carpet is rewoven; an altarpiece is damaged; the arms of a sculpture disappear. Would it not then be natural, abandoning all-or-nothing talk about identity, to say that these objects have partially survived? Once we know what physical portions of the carpet, altarpiece, and sculpture have been destroyed, we know all the facts. Instead of talking about survival of works of art in an all-or-nothing way, we could discuss degrees of survival. If this argument is correct, then museum skepticism relies upon bad metaphysics. Parts of a fresco are gradually destroyed. Has it survived? A Manet painting moves from his studio to the home of a collector, who cuts it down; and then to a museum where it is cleaned. Has that work of art been destroyed? A Chinese scroll is partially burnt, collectors add their seals, and it is displayed unrolled in a museum. Does that scroll still exist? There is no reason to assume that there is some definite answer to these questions.[87] Perhaps, then, the basic argument of museum skeptics is no better. That much old art has been moved into museums gives no reason to assume that it has not survived.

Some skeptics claim that museums are essentially paradoxical because they both preserve historical records of the past and aim to be outside of time. Didier Maleuvre argues,

> A monument is an object taken out of history, by history. Yet it stands for history, and is pervaded with historical spirit. A monument's historical character is our knowledge that the object no longer belongs immanently to history: being a monument is, paradoxically, being separated from history. Were the monument to be truly immanent in its historical background it would vanish back into it. On the contrast, in becoming a historical monument, the object is removed from its native ground in history.[88]

The museum collects historical records, seeking to preserve them unchanged. Hannah Arendt took a similar position.

> Even if the historical origin of art were of an exclusively religious or mythological character, the fact is that art has survived gloriously its severance from religion, magic, and myth. . . . Because of their outstanding permanence, works of art are the most intensely worldly of all tangible things; their durability is almost untouched by the corroding effect of natural processes, since they are not subject to the use of living creatures, a use which, indeed, far from actualizing their own inherent purpose . . . can only destroy them.[89]

But this alleged paradox disappears as soon as we consider how museums work. Most physical things decay because they are used. When tools break or become obsolete, they are discarded. But in the museum, works of art serve no function except to be seen. And since viewing a painting does not cause wear and tear, we can prevent changes in these unusual, but not paradoxical objects.

By asserting that the old art has not survived, museum skeptics in effect argue that we have "lost contact with the past." That may initially seem a strange way to describe our situation. The past simply is what is no longer present and so does not exist any longer. What could it mean to assert that we have lost contact with the past? Contrast the ways that historians and art historians deal with the past.[90] Historians reconstruct the past in a written narrative:

The initial aim of the crowd was simply to neutralize the guns and to take possession. . . . A group, including an ex-soldier now carriage maker, had climbed onto the roof of a perfume shop abutting the gate to the inner courtyard and, failing to find the keys to the courtyard, had cut the drawbridge chains. They had crashed without warning, killing one of the crowd. . . . With no white flag available, a handkerchief was flown from one of the towers and the Bastille's guns stopped firing.[91]

Recounting the events, Simon Schama's account of the storming of the Bastille explains how the French Revolution began. Compare Dorothy Johnson's account of Jacques-Louis David's *Cupid and Psyche* (fig. 11), "one of the strangest and most rebarbative works he had ever created . . . decried by some observers as a revolting parody of adolescent love, one that reveals the monstrous, loathsome, and predatory nature of the libidinous adolescent male."[92] Johnson describes that painting presently on view in the Cleveland Museum of Art. The events Schama presents exist now only in his commentary. Other historians offer quite different reconstructions of that historical moment. But the art Johnson discusses is physically present; we can match her description to the object we see.

To speak of worrying about losing contact with the past in the art museum involves identifying a tension in the essential nature of visual art that is very important for museum skeptics. We can see David's painting but may not have access to the work of art he made. If our culture is too unlike his, then it may be impossible for us to comprehend his art even though the physical object he made has been well preserved. Just as only philosophers are interested in Hume's view of personal identity, so only people who read the academic literature are likely to advocate museum skepticism.[93] Given, then, all of the problems involved in reconstructing the arguments about museum skepticism, it is easy to think that this is an inchoate feeling, not a serious reflective judgment. But such a conclusion would be very shortsighted. If art museums permit us to experience time travel when we directly encounter old works of art, then they are very important institutions. But suppose that this old art really is not preserved. Then such time travel is impossible—the art museum cannot preserve the art it displays, so art museums have no real power. If we adopt this conclusion, we might cease to support these institutions.

This debate about museum skepticism may seem like a dispute about

11. Jacques-Louis David, 1748–1825, *Cupid and Psyche*, 1817.
Oil on canvas, 184.2 × 241.6 cm. © The Cleveland Museum of Art,
Leonard C. Hanna Jr. Fund, 1962.37.

personal survival. When Buddhists, Christians, and Muslims claim that we survive the destruction of our bodies, they are not merely claiming that some people believe that they survive. For religious believers, survival is a matter of fact. Is the same true about the survival of art in the museum? That question is not easy to answer, for when museum skeptics claim that old art does not survive, the status of their claim is not easy to understand. Are we dealing with a mere feeling, so that there is no right or wrong answer to questions about art's survival, or is this a matter of fact? Some people more easily adapt to change than others. Some enjoy disorientation provoked by novelty—others do not. And so it is hard to know what that feeling shows. But the antimuseum thinkers claim to be presenting an objective account, not a merely subjective viewpoint. In fact, they claim, the art museum does not preserve art. This is why, as we have seen, very often they give ideological arguments explaining why museum visitors fail to recognize the justice of their claims. Blinded by the concern of art museums to provide aesthetic experience, we fail to grasp the political implications of these institutions. And that, the antimuseum thinkers claim, is why we fail to understand the objective nature of museums.

Skepticism about the power of old art to allow us to experience imaginative time travel thus has important practical implications. For that reason, museum skepticism requires careful critical evaluation. To rephrase a famous statement of Nietzsche, "we need a *critique* of aesthetic values, *the value of these values themselves must first be called in question*—and for that there is needed a knowledge of the conditions and circumstances in which they grew, under which they evolved and changed."[94] Our analysis has shown why many commentators find museum skepticism important, but it does not as yet tell us how to evaluate their claims. To do that, we need to present the claims of museum skeptics in a more precise way. That is the task of our next chapter.

4

Picturing Museum Skepticism

Almost all the important altarpieces from Florentine churches have survived solely in museums. And this fact has so deeply affected our habitual outlook and consciousness that we almost have to force ourselves to remember how little this fundamentally corresponds to the original destination of the work, which also in many ways affected its form.—MARTIN WACKERNAGEL

Fifteenth-century Europeans greatly admired the power of visual art to halt decay in physical objects. Krzystof Pomian writes,

> All agreed . . . that art alone could turn the transient into the lasting. . . . while the subject of the representation sooner or later became invisible, the representation itself remained. The artist was thus seen as a privileged being, in that he was able to conquer time not through a leap into eternity but within the secular world itself, by being the creator of works which were simultaneously visible and long-lasting. This made him an irreplaceable instrument for a prince aspiring not only to everlasting life but also to glory.[1]

Or as J. Paul Getty put it in 1965: "The beauty that one finds in fine art is one of the pitifully few real and lasting products of all human endeavor."[2] In 1446 Piero della Francesca painted *St. Sigismund and Sigismondo Pandolfo Malatesta* in the Tempio Malatestiano, Rimini (fig. 12). Even in its present much damaged state, that fresco still reveals much about Sigismondo's appearance. "The striving for resemblance marks our attempts to make the absent present and the dead alive," Sydney Freedberg writes.[3] Nowadays, when we all possess inexpensive photographs of deceased relatives, it is hard to imagine how precious such representations were when only the very privileged were visually memorialized.

12. Piero della Francesca (ca. 1420–92).
*Sigismondo Pandolfo Malatesta (1417–68), ruler of Rimini,
kneeling in front of his patron, Saint Sigismund, sainted King of
Burgundy (516 CE)*. Mural, 1451. Tempio Malatestiano, Rimini.
Photo: Erich Lessing / Art Resource, N.Y.

We value old art because we believe that it provides a record of the distant past. But the museum skeptic questions that belief. In presenting the argument that old art does not survive its transfer to the museum, we considered the claims that this art's context is changed, that the museum serves political goals, and that historical hangings change how art is seen. In response I urged that these are all changes of degree, not kind. This debate was unresolved because our account of museum skepticism remained inconclusive. Since we are dealing with visual art, a picture will help resolve this dispute. Our picture is borrowed from the philosophical analysis of action, the right place to look because there are significant analogies, as we will see, between this theory and museum skepticism.

At the start of *Analytical Philosophy of Action*, Arthur Danto considers a striking example: "In the middle band of six tableaux, on the north wall of the Arena Chapel in Padua, Giotto has narrated in six episodes the missionary period in the life of Christ. In each panel, the dominating Christ-figure is shown with a raised arm. This invariant disposition of his arm notwithstanding, a different kind of action is performed by means of it from scene to scene."[4] These six raised arms are indiscernible until placed in context by the visual narratives within the framed images. "Disputing with the elders, the raised arm is admonitory . . . at the wedding feast of Cana, it . . . has caused water to become wine; at the baptism it is raised as a sign of acceptance; it *commands* Lazarus; it *blesses* the people at the Jerusalem gate; it *expels* the lenders at the temple. Since the raised arm is invariantly present, these performative differences must be explained through variations in context." To a good approximation, the same hand gesture appears in every scene. And so, Danto concludes, the meaning of Christ's raised hand depends on its context.[5] That hand alone cannot act—Christ acts. But when Christ causes water to become wine, makes Lazarus arise, or blesses, his hand has a privileged role in these actions.

Can a work of art have different meanings in its varied settings in the way that Christ's hand gesture has diverse meanings in its various contexts shown by Giotto? Imitating Danto, let us envisage a painting depicting the life history of a work of art as it changes location. Piero della Francesca's *Baptism of Christ* (1450) was commissioned for the chapel of St. John the Baptist in an abbey in Borgo San Sepolcro, the artist's hometown.[6] In 1808 it was moved to the cathedral and set in an elaborate altar-

piece containing paintings by other artists. Piero's reputation fell, so the local authorities were happy to sell his picture in 1859 to an English merchant. (The frame remains in the municipal *pinacoteca*.) The National Gallery, London, purchased *Baptism of Christ*. In the 1970s, it hung near the entrance but today it is displayed in the Sainsbury wing.[7]

An ingenious artist, the Master of the London Piero's Travels, as he in his modesty prefers to be known, tells that story in his painting *The Travels and Tribulations of Piero's Baptism of Christ*. He shows the journey of Piero's picture from San Sepolcro over the Alps to London, a heroic trip, like the life of a martyr but extending over a much longer time. Just as Giotto's Arena Chapel shows Christ performing different acts at different ages, so *Travels and Tribulations* shows one painting at various times in its career. Influenced by Mark Tansey's storytelling pictures, inspired by Ivan Gaskell's suggestive remark, "paintings exist not in two, but in four dimensions," the Master of the London Piero's Travels presents *Baptism of Christ* five times in varied settings.[8]

Panel 1 shows *Baptism of Christ* joyously received by his patron and contemporaries in an abbey in Borgo San Sepolcro. They are proud to show off this painting by a native son famous for the slowness of his production. The Master of the London Piero's Travels imagines convincingly the appearance of that great artist. This portrait of this calm detached genius is judged to be masterful in its psychological insight. It shows, one critic writes, Piero as he really must have been—calm, almost inhuman in his detachment. Panel 2 presents a forlorn scene, *Baptism of Christ* in the Cathedral of Borgo San Sepolcro in the early nineteenth century.[9] Piero's picture looks a little dusty. But just as the darkest moment in a hero's life comes just before his triumph, so the same is true in the life of this painting. Panel 3 presents *Baptism of Christ*, removed from its frame, packed in the English merchant's house, ready for transalpine shipping, and about to enter its time of glory.

In panel 4, the still-young Bernard Berenson is looking at *Baptism of Christ*. In 1897, after praising Piero's impersonality, Berenson had reservations: "Unfortunately he did not always avail himself of his highest gifts. . . . Now and again those who are on the outlook for their favourite type of beauty, will receive shocks from certain of Piero's men and women. Others still may find him too personal, too impassive."[10] But then in a late book he expressed unqualified approval. Here Berenson looks as

if already prepared to revise his earlier estimate of Piero's achievement. The fifth panel shows the *Baptism of Christ* as it appears today in a place of honor in the new wing of the National Gallery. Commentators find gentle humor in the juxtaposition of the tourist group to the left of Piero's painting with Paul Barolsky, the tall, slim American art writer. "Giotto's images," so Hans Belting says, "do not provide a mirror of the outer world as much as the stage of a drama where actors perform."[11] In our imaginary painting *Baptism of Christ* takes on some qualities of a human agent.

One inspiration for the Master of the London Piero's Travels is contemporary installation art, where, as Julie Reiss puts it, "something could be contributed by the spectator within the structure established by the artist. . . . The visitors helped to create the work, to complete it. The situation provided an active experience for the viewer.[12] The five images of *Baptism of Christ* in *Travels and Tribulations* are indiscernibles with very different meanings. Just as Danto's philosophy of action subtracts out the rich everyday reality described by novelists to focus on the essential structure of bodily movements, so the Master of the London Piero's Travels leaves aside the humanly attractive features of museums to deal with conceptual puzzles.[13]

Christ's raised right hand has quite distinctly different meanings in scenes showing admonition, blessing, and expulsion. Analogously Piero's *Baptism of Christ* appears in every panel of *Travels and Tribulations*, but that object has a very different meaning at the various stages of its career because how we understand a work of art is determined not just through its intrinsic visual qualities, but also by the context in which it is displayed. For the Chinese connoisseur "the aesthetic quality of the painting . . . is enhanced by handsomely designed, well-placed seals. . . . Through the comments of former owners, great critics, or former statesmen, he senses keenly his own continuity with the past."[14] As collectors put markings on paintings they admired, thus adding permanent visual records of the history of ownership to famous scrolls, so museum settings of European art in effect leave traces that can be recovered in *Travels and Tribulations*.

Piero made an altarpiece—and the National Gallery owns a work of art. Although the object made by Piero now is in London, the San Sepolcro altarpiece perhaps has not survived. What has endured is the panel that Piero painted. But how, without physically changing, can that altar-

piece change meaning and metamorphosize into a work of art? Asking that question is like asking how Christ's one hand gesture can in different contexts cause such diverse actions as commanding, blessing, and expelling. The raised hand does not have a fixed meaning, but a significance that depends on its context. Exactly the same is true, so the Master of the London Piero's Travels argues, of Piero's work of art.[15]

But is this parallel between Christ's basic actions and the identity of Piero's *Baptism of Christ* entirely plausible? Christ performs acts with his hand, but nothing that happens to a painting after being completed by the artist can change its meaning. In *Travels and Tribulations* we see a physical object, Piero's panel, at five moments in its history. People perform actions, but this painting is a mere thing. In the Arena chapel the same raised hand appears in six different pictures showing distinct actions. By contrast, *Travels and Tribulations* does not show indiscernibles, it could be argued, but merely records the appearance of one thing at different times in varied circumstances.

Books on Piero della Francesca typically reproduce paintings isolated from their settings. (Often photographs of the original sites of their art in churches provide background information.) Movements of old paintings from churches to museums thus seemingly have no effect on what primarily concerns the art historian, the work of art itself. In the late eighteenth century, Lydia Goehr explains, "museum curators would take a work of art and by framing it—either literally or metaphorically—strip it of its local, historical, and worldly origins, even its human origins. In the museum, only its aesthetic properties would metaphorically remain."[16] When an entire painting is moved, that work of art itself is essentially unchanged. Looking at visual art as art, we isolate it from its larger setting, focusing on aesthetic qualities. Changing styles of display, so orthodox art historians claim, thus have few ultimate repercussions. Museum skeptics, by contrast, argue that the work of art cannot be identified with the mere artifact moved to the museum but must rather be seen in relation to its original site. To understand the art of Italy, you need to go to that country.

To launch an argument like Danto's, you need two things that look similar but turn out to be different.[17] To cite his classic example in aesthetics, Andy Warhol's *Brillo Box* (1964) is indiscernible from the physically identical Brillo box in the grocery. But unlike the ordinary Brillo

box, *Brillo Box* is a work of art. Danto needs two things because he first tells a story in which they seem to be identical and then shows how different these indiscernibles actually are. If you have but one thing, there can be no such narrative. Every thing—what is more obvious?—is identical to itself. That is why a thing cannot be its own discernible.[18] "How many people is (are?) Lydia?" "Two, counting her as one today and another tomorrow." That is a sophistical argument. If we continue the count the day after tomorrow, then there would be three Lydia-stages. If we count every twelve hours, there are six stages. Depending on how we choose to count, you find as many Lydia-stages as you wish. But this confuses person-stages with a person. Lydia, one person, is constituted by many person-stages. Analogously, it could be argued, *Baptism of Christ* is but that one object appearing five times in *Travels and Tribulations*.

But this last claim has less power than it initially seems. As soon as we pick out the same thing at different times, we have indiscernibles. "The raised hand of Christ blessing" and "the raised hand of Christ expelling" are nothing but that same hand picked out at two different times. As soon as we compare and contrast *Baptism of Christ* at two different times, we have genuine indiscernibles, for the painting looks different in different contexts. In one significant way Danto's discussion of Giotto's fresco acknowledges just that fact. In itself Christ's right hand cannot be an indiscernible, for at any time there is but one such entity. But when represented repeatedly in varied contexts, Christ's right hand becomes an indiscernible. The Master of the London Piero's Travels urges that we think of *Baptism of Christ* in exactly the same way.

The basic action, Christ blessing by raising his arm, is what He does. Some actions are caused by other actions, but since "one could not enter the chain of actions . . . if, always as a condition for doing so, one must . . . do something first," Danto argues, there must be some "actions we do but not *through* any distinct thing which we also do."[19] These, then, are basic actions. In the Arena chapel, we see representations of some basic actions performed by Christ, but "clearly there is no event distinct from the raising of the arm in which the blessing consists."[20] His hand gesture cannot be subtracted from the context that makes sense of it. Only because bottles of wine are laid out can Christ's raising of his hand constitute the action, changing water into wine. Piero also did something—he made *Baptism of Christ*. Its creator determines the meaning of a work

of art and so putting *Baptism of Christ* in a new context cannot change its meaning. But noting this is compatible with thinking that the significance of Piero's painting changes with time.

The effect of this line of argument is to suggest that we rethink our discussion of the meaning of a work of art. We describe *Baptism of Christ* differently than did Piero's or Sir Charles Eastlake's or Berenson's contemporaries because new ways of interpreting art have been discovered and because more recent art influences us. This way of thinking both acknowledges that we now see the painting differently and allows that we value the work of art in the National Gallery because its original appearance has been preserved. The Master of the London Piero's Travels is inspired by Philip Fisher's beautifully suggestive phrase: "The life of Things is in reality many lives."[21] *Travels and Tribulations* shows how the significance of Piero's *Baptism of Christ* changed according to its context. But that is not to say that its meaning has changed.

One way to better understand this debate is to compare change in other kinds of things. Buildings are renovated and used for new purposes; nations expand and make new laws; people grow older and travel.[22] The same building, the same nation, and the same person continue to exist while their properties change. In the past two hundred twenty years, the United States of America has banned slavery, established women's suffrage, and extended its territory dramatically. But it is *the same country* as that nation established in 1776 because there is real continuity through these gradual changes. Hagia Sophia, a Byzantine church, was converted by the Muslim conquerors into a mosque in 1453. After the end of the Ottoman Empire, it metamorphosized into a museum preserving both old Christian mosaics and newer Islamic calligraphy. But there has been enough continuity through these changes for Hagia Sophia to survive being, in turn, church, mosque, and museum. The same is true of a painting. We know that Piero's *Baptism of Christ* looks different in museums than in the church it was painted for because we both know how the picture appears today and can reconstruct its original setting.

Museum skeptics, so this argument suggests, offer a dreadfully ahistorical picture of tradition. To suppose that pictures and sculptures only began to change settings in the late eighteenth century, when public art museums were created, is mistaken. Once artifacts become highly valued, they are often sold and readily become loot. Long before there

were museums, Greek art was taken to Imperial Rome, Chinese master-
works traveled frequently, and famous altarpieces were removed from
churches. Museums sometimes emancipate art, permitting us to see as-
pects of paintings and sculptures that were hidden or underappreciated
in their original settings. As Hans-Georg Gadamer writes: "As soon as the
concept of art took on those features to which we have become accus-
tomed and the work of art began to stand on its own, divorced from its
original context of life, only then did art become simply 'art' in the 'mu-
seum without walls' of Malraux."[23] Museums permit us to see more of
painting or sculpture than was accessible in the original culture. "Unlike
its originator, the work of art continues to have a life of its own, remains
forever new, inhabiting a perpetual present," Michael Holly writes.[24] To
again quote Gadamer, "The work of art is the expression of a truth that
cannot be reduced to what its creator actually thought in it."[25] When
Baptism of Christ was moved into a museum, artificial lighting permitted
us to better see it. And comparisons with other fourteen-century altar-
pieces were facilitated.

The artist makes the work of art, and so no changes after he leaves it
aside can be a product of his activity. But how that object changes after
his death can legitimately affect how we understand it. And some fea-
tures of what the artist made become visible only long after his death.
The history of its display, including museum hangings, is relevant to the
art historian because often the posthumous history of art reveals much
about what the artist made. "A work of art always has something sacred
about it. True, a religious work of art . . . on show in a museum can
no longer be desecrated in the same way as one that has remained in its
original place. But this means only that it has in fact already suffered an
injury, in that it has become an object in a museum."[26] The discovery of
the true meaning of a text or a work of art "is never finished. It is in fact
an infinite process," Gadamer argues, because the "true historical object
is not an object at all," but a project of the creative encounter between
an artifact created by the artist and its interpreter.[27]

The philosopher David Wiggins rejects this way of thinking. Once an
artist finishes a work of art, so he claims, "to visit any interference . . . is
to threaten the work with obliteration, or with destruction by replace-
ment, however gradual."[28] But this argument is inconclusive, for it does
not take account of the ways in which posterity may better understand

what Wiggins calls "the artist's conception of his own making of the work" than that artist. In 1967, discussing what he describes as "ancient things rendered relevant through contemporary experience," Leo Steinberg realized that multiscreen films changed how he saw early Renaissance altarpieces and Raphael's frescoes.[29] Noting the influence of Freud and James Joyce, he added: "I am always ready to welcome another artist who conceives his symbolic forms multi-storied." Perhaps even the very ways that we see have changed. "That our vision of art has been transformed by reproductions is obvious. Our eyes have been sharpened to those aspects of painting and sculpture that are brought out effectively by a camera."[30] Our experiences of ancient things have been transformed pretty dramatically by visual technologies unimagined in 1967. Consider, for example, how seeing paintings has been affected by video art and by television images. As Steinberg envisages this process of interpretation, the result of experience of new art is to make him more fully aware of the essential qualities of older art. Recent theorists have sometimes described this situation in a different way. When contemporary art causes us to see older painting in new ways, perhaps it makes no sense to ask whether we see that older art as the artist intended. Some people then conclude that maybe there is no real way of recovering the original intended meaning of old art. But that is not my view.

Steinberg is interested in the ways in which new art and styles of interpretation change how we see older art. Museum hangings also have this effect. Juxtaposing paintings facilitates visual comparisons, but before there were museums or photography, visual comparisons were difficult to make. Eighteenth-century gentlemen on the grand tour were guided by cicerones. On June 27, 1787, in Rome Goethe and his guide, the landscape painter Philipp Hackert, "visited the Colonna Gallery, where paintings by Poussin, Claude Lorrain and Salvator Rosa are hung side by side. Hackert has copied several of them and studies the others thoroughly, and his comments were most illuminating. . . . I shall never rest until I know that all my ideas are derived, not from heresay or tradition, but from my real living contact with the things themselves."[31] But once many tourists came to look at art in Italy, there was a need for more organized ways of presenting art.

Museum skeptics think that the discovery of art and aesthetic experience was a recent event. Art, it is often said, was invented in the late

eighteenth century. In support of this claim, frequently appeal is made to the novelty of the account in Kant's *Critique of Judgement* (1790). If by art we mean objects satisfying no practical function made for purely visual pleasure, then almost all of the older artifacts in our museums are not art. But there is more to the story, for it would be mistaken to conclude that there is no overlap between our concept of art and that of other cultures or premodern Europeans.

The Maori of New Zealand did not have museums. But since the intended response to their carving contains an element of awe and fear —so that, as Sidney Mead writes, "the spine tingles, one's body hair may straighten up, and the whole body trembles with excitement"—one senses that like Europeans, Maori carvers wanted that their art inspire a sense of awe.[32] Until very recently, the Chinese did not have art museums, but Tsung Ping (375–443) described aesthetic pleasure in terms recognizable to Western art lovers: "As I unroll paintings and face them in solitude, while seated I plumb the ends of the earth. Without resisting a multitude of natural dangers, I simply respond to the uninhabited wilderness, where grottoed peaks tower on high and cloudy forests mass in depth."[33] Neither did the Persians have museums. But the miniature *Ksjander Judges the Greek and Chinese Painting* (1449–50), illustrating the rivalry between the Greek artist who painted a scene and his Chinese rival who polished a wall reflecting the Greek painting like a mirror, presents a highly subtle aesthetic.[34] A Chelsea gallery would be proud to show this installation, which like much contemporary art plays with the distinction between copy and original.

In his essay "On the Aesthetic Attitude in Romanesque Art," Meyer Schapiro shows how much overlap there is between our aesthetic concerns and those of eleventh- and twelfth-century Europeans; "We sense that we are in a European world that begins to resemble our own in the attitude to art and to artists. There is rapture, discrimination, collection; the adoration of the masterpiece and recognition of the great artist personality; the habitual judgment of works without reference to meanings or to use; the acceptance of the beautiful as a field with special laws, values, and even morality."[35] And Barolsky calls attention to similar continuity when he describes Michelangelo's concept of "carving himself into a sculpture" as "no mere reflex of nineteenth-century aestheticism . . . for the very metaphor of the perfected self as an idealized

sculpture is rooted in a classical idea. In fact, writing of the Greeks as ideal artists of themselves, Hegel and Pater wrote as belated followers of Plato, Plotinus, Pico and Michelangelo."[36] Vasari's legends about art and artists have an intimate resemblance to ours.

Were space explorers to discover stones looking like Henry Moore's sculptures but carved by aliens, we would have no way of understanding the meaning of these objects. By contrast, we know a great deal about the peoples who made artifacts in New Zealand, China, or Persia, so we know that in many ways their ways of thinking were not so unlike ours. Recognizing that there often have been changes in displays of art, and identifying continuities in those changes, undercuts the psychological roots of museum skepticism. We know that there always have been aesthetic responses to works of art, not just because much relevant historical evidence supports this belief, but also because our eyes tell us that much old art was made to be seen aesthetically. When Walter Benjamin identifies the loss of the aura of paintings, he mistakenly implies that recently there has been a radical rupture with the past. But long before photography, there were many engraved reproductions of paintings. In a famous letter, Albrecht Dürer described pre-Columbian art: "I saw . . . a sun entirely of gold . . . a moon, entirely of silver . . . very odd clothing, bedding, and all sorts of strange articles for human use. . . . I saw . . . amazing artistic objects, and I marveled over the subtle ingenuity of the men in these distant lands. Indeed I cannot say enough about the things which were there before me."[37] He was able to recognize the skill of these artists. The Aztecs used "beautifully chipped flint knives" for ritual human sacrifice. Their knives are decorated with demon faces, "a kind of personification of the fearsome instrument ritually employed to dispatch the victims whose hearts and blood nourished the sun on which the survival of the universe depended."[38] Because we understand the intended use of these artifacts, taking an aesthetic attitude requires bracketing our knowledge of their original function. But like medieval European armor and Persian carpets, Aztec daggers are appreciated as works of art in museums.

Certainly museums do change how we view art. Knowing that, I am very much taken by Carol Duncan's proposal: "I consider art museums neither as neutral sheltering spaces for objects nor primarily as products of architectural design. . . . I see the totality of the museum as a stage setting that prompts visitors to enact a performance of some kind."[39]

I also find her association of art museums with rituals suggestive: "The museum's sequenced spaces and arrangements of objects, its lighting and architectural details provide both the stage set and the script. . . . the situation resembles in some respects certain medieval cathedrals where pilgrims followed a structured narrative route through the interior, stopping at prescribed points for prayer or contemplation."[40] Revisiting a museum, we do get pleasure walking through a well-known place. But ultimately Duncan's parallel between enjoying art and religious practice is limiting. In order to participate in religious rituals, you must be a believer. Otherwise, you are merely enacting the forms, like the young Walter Pater who alarmed a religious friend by proposing to take priestly oaths while believing nothing.[41] But you don't, in a comparable way, need to believe in art in order to enjoy museums.

In church, as in a traditional museum, you are expected to be reasonably well dressed and well mannered and not to raise your voice. If you don't take communion at mass you are an outsider, but in museums, you are free to look at what interests you, and to talk with companions, while offering criticism. Some people care a great deal about art—and many others, the majority, do not. But this division between art lovers and these others is not much like the distinction between believers and atheists.[42] To think that visual art matters is only to say that you enjoy seeing it, not that you have any particular beliefs about the value of aesthetic experience. The religious believer says that there is a God, and this the atheist denies. But there really is no comparable distinction between those who like and those who do not care about art. Aesthetes pay more attention to art than philistines, but we do not necessarily have any interesting beliefs about it that they would deny.

The function of museum rituals, Duncan suggests, is to produce "a sense of enlightenment, or a feeling of having been spiritually nourished or restored," feelings which she naturally associates with religious rituals.[43] My experience is extremely different from hers, for while sometimes museums yield such satisfactions, very often they make me reflect on violent confrontations between the cultures whose art they contain. Every time I see Aztec art, I think of the fate of that society. A great deal of art depicts struggles—Christian martyrdoms, Muslim paintings of warfare, struggling Buddhist sacred figures, Delacroix's *Apollo Slays Python*, and of course contemporary photographs that present dysfunctional lives. Very

often, when enjoying viewing these well-guarded objects I think about the class conflicts that so obviously influence how they were made, collected, and displayed. Oddly enough, Duncan's account is too much influenced by the older views of art, which she rejects. As Henry James well understood, pleasure in museum visits is completely compatible with an acute sensitivity to political concerns. The idea that seeing harmonious objects makes your soul harmonious is only a half-truth. As soon as you consider the costs of achieving such aesthetic harmony, your thoughts naturally wander beyond the painting's frame to reflect upon the history of the museum and its political conflicts.

The museum seeks to preserve the original painting as best as possible. By setting a painting in a novel context, unavoidably that institution changes how we see art. But when we see how *Baptism of Christ* was viewed in differing ways when it moved, we can still imagine how it looked in its original setting. When an old altarpiece, a Buddhist Indian sculpture, or a Maori carving is moved into a museum, some physical thing survives. But since those artifacts may not be identical with the work of art, this does not show that this art also survives. (Perhaps that is why some people call art a creation of the museum.) Consider again our analogy with people. At death, our bodies decay. But if a person is identical with his or her soul, then this destruction of the body is compatible with personal survival.

Some philosophers argue that works of art are not necessarily identical with any physical object. Much art surely represents and is expressive. But if a physical thing cannot have those qualities, then a work of art cannot be a mere physical thing.[44] Paintings are said to express joy or sadness in the way that people possess those emotions. But pigment on panel is not the sort of thing that can be joyous or sad. Works of art can protest the political order or contest influential aesthetic theories. Pigment on canvas, it might similarly be argued, is not the sort of thing that can have such properties. The work of art, we might plausibly infer, is closely associated with some physical object in the way that the mind is intimately linked to the body. Suppose that we conclude that works of art are not identical with the physical objects preserved in our museums. That conclusion would not necessarily give support to museum skepticism. When a Greek sculpture moves from a temple to museum, the only way to locate it is by reference to the carved marble. Pointing to that

work of art, we point to a physical sculpture. Describing the work of art, we describe the physical artifact. And if the physical object is destroyed, then the associated work of art ceases to exist.

An aesthetically fine crucifix by Donatello is both a work of art and an object having deep religious significance for believers. This sculpture was made to serve sacred functions. Suppose there were no longer any Christian believers, but that sacred art still survived. If no one anywhere prays before a crucifix, then perhaps this sacred relic would cease to exist. Even if the artifact is identical with a physical object, preserving that object does not preserve the artifact, for the crucifix has meaning only within a way of life. And when a way of life disappears, only the bare thing remains. Native American art was gathered in museums, but starting in the 1970s, Jeffrey Abt reports, "the native American Zuni tribe legally removed altar god figures from numerous North American and European museums to return the carvings to Zuni shrines, which, according to tribal beliefs, are open to the sky so that the figures may be consumed by the forces of nature."[45] The Zuni culture survives, so this religious artifact can be preserved. There are not any longer believers in the religions of the ancient Egyptians, the pagan Greeks, or the Aztecs. But artifacts from those cultures survive in our museums. They have become art, but the associated ways of life have disappeared. We know the beliefs of the ancient Egyptians, the pagan Greeks, and the Aztecs. But since these cultures have disappeared completely, reconstruction of the meaning of their artifacts may not preserve the objects that they made.

Artifacts may become inaccessible if the culture in which they were created no longer lives. Imagine that Catholicism were to die out completely in Italy. The forlorn empty churches disappoint tourists and so the government hires actors to pretend to celebrate mass. Catholicism would not have survived—for a religion to survive there must be believers. Rebuilding central European synagogues after the Holocaust was a highly significant act of remembrance, but unless believers again animate them, Jewish culture has not survived in those countries. African ritual masks are preserved in art museums, but preserving the physical artifacts in the art museum after the tribe is destroyed perhaps does not preserve the ritual mask, for these ritual masks cannot survive the end of the culture in which they were used. The rise of Islam left Orthodox Christian

frescoes stranded in Constantinople and elsewhere in the former eastern Roman Empire. Does this art survive? By the time of the Renaissance, the pagan Greek world had long disappeared. Were the Italian humanists wrong to think that this antique art still was accessible? Islamic architecture survived in Cordoba and Grenada to be incorporated into Spanish churches. Can that art survive in an alien cultural context? Would it survive if Muslims reclaimed their patrimony? These questions are very hard to answer. The Muslims and Christians were generally not interested in each other's cultures, while the Renaissance was deeply concerned with pagan antiquity. But it is not obvious what these differences tell us about art's survival. And so it is not clear how to relate these precedents to changes occurring when art moves into museums.

It is clear from this discussion that no purely abstract response to our museum critics can be entirely emotionally or even intellectually satisfying. No one who does not already believe that museums preserve art will be convinced by our account. A rationalist might be a little discouraged to discover that after so much debate our questions about museum skepticism remain, as yet, unresolved. But that pessimistic conclusion would be premature. Our present inability to resolve the argument only shows that the right terms of debate are as yet not identified. In order to show that museums preserve old works of art we need to develop an appropriate historical analysis. We will show how the art museum built upon tradition, adding to its collections of European old masters art from Asia and modernist European and American art. And we will see how this European institution was successfully transplanted to America. Like the art it contains, the art museum has undergone dramatic metamorphoses. In surviving those changes, that institution has been transformed radically.

No mere philosophical argument can resolve the puzzles of museum skepticism because we are dealing with an important but elusive feeling. Change, which can be exhilarating, very often is stressful. This I think is why none of the many museum skeptics I have quoted actually argues in any detail for that position. An image is not an argument. As suggestive as it is, *Travels and Tribulations* cannot by itself tell us how to understand museums. But in identifying the philosophical issues at stake and giving reason to reject skepticism, our account of this imaginary picture

will suggest how to develop a proper philosophical argument. To fully understand how we can identify the changes produced when paintings are moved, what is required is not just a bare, ahistorical analysis, but close study of the history of the public art museum. That is the task for the remainder of this book. Chapter 5 discusses the general structure of art museums, and then the remainder of the book presents a sequence of case studies.

5

Art Museum Narratives

Nothing about museums is as splendid as their entrances—the sudden
vault, the shapely cornices, the motionless uniformed guard like a wit-
tily disguised archangel, the broad stairs leading upward into heaven
knows what mansions of expectantly hushed treasure.

—JOHN UPDIKE

A museum based upon Vasari's *Lives* would start with Cimabue and
Giotto and end with Michelangelo and Titian, focusing on the High
Renaissance, with a small annex devoted to Flemish art. After Vasari's
time, the list of canonical figures expanded. In 1841, for example, Paul
Delaroche's mural for the École des Beaux-Arts, Paris, included Correg-
gio, Veronese, Antonello da Messina, Andrew del Sarto, Michelangelo,
Titian, and others of Vasari's heroes, but also such later artists as Caravag-
gio, Claude Lorrain, Murillo, Paul Potter, Rembrandt, Rubens, Ruisdael,
Terborch, Van der Helse, Velázquez, and Gaspard and Nicolas Poussin.[1]
And nowadays many museums add non-European art.

 Imagine that thanks to a time travel machine Giorgio Vasari is able
to visit our museums. In the galleries devoted to older European art, he
finds familiar paintings by Giotto, Mantegna, Raphael, Leonardo, and
himself. But the arrangement of these rooms surprises him. His *Lives* has
a historical perspective. As Barolsky describes Vasari's organization, "All
artists are defined as either coming before Giotto and thus lacking his
virtue or following him as 'disciples' and thus absorbing it."[2] But Vasari
hardly expected that much of the art he describes would be removed from
churches or palaces and exhibited in museums. Personal collections are
usually displayed in aesthetic hangings. In my home, for example, an ab-
stract painting by Emilio Vedova is next to a print by Alphonse Legros,
and a nineteenth-century Chinese scroll hangs alongside a Jacques Callot

engraving. Like such private displays, the older public hangings typically were designed to be aesthetically pleasing. Johann Zoffany's *The Tribuna of the Uffizi* (1777–78), for example, shows a variety of antique sculpture, and a very dense hanging of paintings by Pietro da Cortona, Guido, Holbein, Michelangelo, Raphael, Guido Reni, Rubens, Titian, and other artists.[3] By contrast, most public museums employ historical hangings.

Were a loan exhibition to present Manet's *Olympia* (1863), Mi Yu-jen's *Cloudy Mountains* (1140s), and Sean Scully's *A Bedroom in Venice* (1988), paintings from the Musée d'Orsay, the Metropolitan, and the Museum of Modern Art, New York, we would expect some explanation of how these seeming disparate works of art are connected. You might enjoy these masterpieces without seeking to relate them. But when seeing them in one gallery, it would surely be natural to seek visual connections. Knowing that cloudy mountains were for Mi Yu-jen "an auspicious symbol relating to the concept of good government" and that Scully's title, alluding to a Turner, shows ideal harmony, suggests how to construct a unifying narrative.[4] All three painters are political artists. But here we return to the essential tension that has motivated our discussion of museum skepticism. In a museum, you may focus on one work of art in visual isolation without looking at nearby paintings. But when you do look around, then it is natural to relate that one picture to others. Museum narratives thus need to be accompanied by what we have called, following Wollheim, an "envelope," some "theory of art" explaining the visual connection of these objects.

Michel Foucault described his amusement at Borges's fable describing a Chinese encyclopedia dividing animals into those "(a) belonging to the Emperor, (b) embalmed, (c) tame, (d) suckling pigs, (e) sirens, (f) fabulous, (g) stray dogs, (h) included in the present classification, (i) frenzied, (j) innumerable, (k) drawn with a very fine camelhair brush, (l) *et cetera*, (m) having just broken the water pitcher, (n) that 'from a long way off look like flies.'"[5] Imagine art museums organized in equally eccentric ways displaying paintings according to size, from smallest to largest; according to color, grouping Chinese, Indian, and Italian pictures with red together; or according to birthdate of the curator responsible for acquisition. An effective installation inspires us to see connections between art on display. By contrast, these imaginary classifications do not suggest any

interesting visual principles of ordering. Museum hangings based upon such classifications are unlikely to be employed.

The easiest way to make the case for museum skepticism is to observe that modern installations dramatically change how we view individual older paintings. By presenting works of art in a historical perspective, museums dramatically transform our visual thinking. "Meaningful juxtapositions can be made as part of the museum's program," Sherman Lee points out.[6] But then there is an obvious conflict between focusing on individual works of art valued for their own qualities and as items in a historical survey. Wollheim writes, "It has been, over the centuries . . . within the tradition of the West, a natural concern of the artist to aid our concentration upon a particular object by making the object the unique possessor of certain general qualities."[7] When paintings are set in a historical narrative, as illustrations of the development from the quattrocento through to the baroque and the rococo, then to some degree we treat them as examples of period styles. "In the Western tradition," Ernst Gombrich writes, "painting has indeed been pursued as a science."[8] In the Uffizi, for example, you walk from the Cimabue and Giotto, to the Uccello, and on to the Raphaels, Titians, and the Caravaggio seeing a story of progress. And the same story is told with different paintings in the state museums at Berlin, Florence, London, Paris, Stockholm, and Vienna.

Nowadays churches containing masterpieces function as museums. But when art tourists at Assisi discuss the frescoes in loud voices, the Franciscans remind them that they are in a place of worship, not a museum. Giulio Lorenzetti's *Venice and Its Lagoon* devotes thirteen pages to S. Maria Gloriosa dei Frari, telling the story of the building, façade, and interior, and walking the visitor to the many paintings and sculptures by the various altars. That church has become like a museum. On the high altar, for example, is Titian's *Assumption* (fig. 13), described by Lorenzetti:

> With this work, superb for its daring conception and dimensions, for its vibrant colouring, its rhythmical balance of mases and lines, Titian has reached one of the highest expressions of that heroic, ideal transfiguration of classical rhythm, which he too sometimes drew his inspiration from.
>
> WALL TO THE R.: on a sham-leather fresco background . . . appears the splendid mass. of the MONUM. to DOGE FRANCESCO FORCARI. . . .

WALL TO THE L.: against a red drapery fresco . . . the MONUM. TO DOGE NICOLO TRON.[9]

But there is no historical narrative in this display. Art in churches usually remains in its original setting. Typical museums, by contrast, change hangings regularly. As Kirk Varnedoe has said, "Because we believe that there's a story to be told doesn't mean we believe that there's one story graven in stone that one will always understand."[10]

Literary critics discuss the ways in which our experience of literature and history are informed by the literary structures of this writing. Just as words form sentences whose sense and reference depend on their components, so too visual works of art set together have meanings that they do not possess in isolation. As Mieke Bal puts it, comparing a museum installation to a statement, "the utterance consists not of words or images alone, nor of the frame or frame-up of the installation, but of the productive tension between images, caption (words), and installation (sequence, height, light, combinations)."[11] We may attempt to restrict ourselves to what Clement Greenberg called tunnel vision, focusing on one painting, occulting our observation of the art surrounding it.[12] Doing that is valuable, sometimes even necessary. But Bal identifies our more typical experience when she asks, "What happens . . . when one painting, in a particular museum room, ends up next to another, so that you see the one out of the corner of your eye while looking at the other?"[13] What happens, of course, is that you see the grouping of paintings as defining an implied narrative sequence.

Alternate displays then project different interpretations. In the 1960s, installed at the entrance to the second floor galleries of the Museum of Modern Art, New York, *Guernica* told an episode in the history of modernism, leading you toward Abstract Expressionist art. Today in the Reina Sofia, the Madrid museum of modern art, a short distance from the Prado, where Goya's *The Third of May* is on display, *Guernica* is part of another story. Sometimes a contrast is made between neutral settings, which show art as it really is and hangings projecting interpretations by description. The National Gallery, London, juxtaposes a sacred scene, altarpiece, and a portrait by Giovanni Bellini and Cima da Conegliano. "As a visitor," Nicolas Serota argues, "one is conscious that grouping in this way places a curatorial *interpretation* on the works, establishing re-

13. The marble iconostasis, through the arch the high altar with Titian's
Assumption, fifteenth century. S. Maria Gloriosa dei Frari, Venice.
Photo: Erich Lessing / Art Resource, N.Y.

lationships that could not have existed in the minds of the makers of these objects."[14] His claim is unconvincing. Since they are near contemporaries, probably these relationships were apparent to these Venetian artists themselves. The curator's aim, Serota adds, "must be to generate a condition in which visitors can experience a sense of discovery in looking at particular paintings . . . in a particular room at a particular moment, rather than finding themselves standing on the conveyer belt of history." But once paintings are in a museum, how can we avoid experiencing them in a historical sequence? Just as there is no neutral way of describing art just as it really is, so no hanging does not project some interpretation.

Ovid tells Tereus's story. Hungry, he ate food provided by his wife Procne, not knowing that she, avenging his rape of her sister Philomela, was feeding him the body of their son Itys. We can describe such tragic situations by use of narrative sentences, sentences which "refer to at least two time-separated events though they only *describe* (are only *about*) the earliest event to which they refer."[15] Narrative sentences provide true descriptions of events that are unknown to the participants, identifying the ultimate consequences of actions that are as yet unknown when they act. Tragedy, Danto adds, "is often generated by the fact that agents lack a piece of knowledge the *author* of a tragedy . . . will disclose to the audience, whose feelings are engaged by the realization that they know something the character does not." The food that seemed tasty to Tereus became repulsive as soon as the vengeful Procne identified its source.

"In 1869, the greatest twentieth-century French painter was born": nobody knew that until 1906, when Henri Matisse's importance became obvious. Describing one moment of history in terms known only at some later point, narrative sentences are the spine of history writing.[16] T. J. Clark says that Jacques-Louis David's *Death of Marat* (1793) marks the origin of modernism. "My candidate for the beginning of modernism— which at least has the merit of being obviously far-fetched—is 25 Vendémiarie Year 2 (16 October 1793, it came to be known). That was the day a hastily completed painting by Jacques-Louis David, of Marat . . . was released into the public realm."[17] Here we find another narrative sentence. In 1793 it was too early to be aware that modernism was beginning. Michael Fried offers yet another narrative sentence when he writes: "In a series of remarkable paintings made by staining thinned-down black paint into unsized canvas in 1951, Pollock seems to have been on the verge

of an entirely new and different kind of painting. . . . The man who . . . explored and developed the new synthesis of figuration and opticality sketched out in Pollock's stain paintings of 1951 was Morris Louis."[18] "In 1951, Pollock anticipated Morris Louis's stain paintings": in 1951, no one could have seen that. And Gombrich employs a narrative sentence when he places Constable's *Wivenhoe Park* in the history of landscape painting. A generation earlier, he writes, Gainsborough declined a similar commission, finding "the mere imitation of a real view unworthy of the artist who is concerned with the children of his brain, the language of the imagination."[19] "Gainsborough inaugurated the tradition of English landscape painting": that statement could not have been understood in Gainsborough's era. Narrative sentences identify causal connections. Historians write narrative sentences, making their proposed causal connections explicit. And museums make such connections implicit in their hangings. An imaginative curator could illustrate Clark's commentary by presenting *Death of Marat* as the first painting in a history of modernism. And an exhibition called "Constable's Sources" could include a Gainsborough.

In the old-fashioned hangings of the Wallace Collection, London, or the Musée Condé, Chantilly, the Poussins are near paintings by other earlier or later artists from outside France. These museums do not employ historical hangings. In the Metropolitan Museum, by contrast, the Poussins are next to the pictures by Claude Lorrain and Sebastian Bourdon, other Frenchmen who worked in Rome during the seventeenth century. And at the Louvre, Poussin is set in the history of French art. But Poussin did not paint for such settings. On July 25, 1665, during the visit to Paris on which Bernini presented his unsuccessful proposal for a new Louvre, he visited Paul Fréart de Chantelou. That collector owned eleven Poussins, including the second version of the *Seven Sacraments*. When Bernini entered the room, only *Confirmation* was uncovered. The pictures were unveiled and moved near to the window. He said that *Extreme Unction* was like "a great sermon, to which one listens with the deepest attention and goes away in silence while enjoying the inner experience." Bernini studied these pictures for an hour, looking at *Baptism* "for a long while sitting, and then again . . . on his knees, changing his position from time to time in order to see it better."[20]

Like Piero's *The Baptism of Christ*, *Seven Sacraments* have moved re-

peatedly. Put on the art market during the French Revolution, in 1798 they were acquired by the Duke of Bridgewater, whose descendants have loaned them to the National Gallery of Scotland. When I first saw them in Edinburgh around 1990, they were in a haphazard hanging. Then at the Poussin retrospective in Paris, 1994, *Seven Sacraments* illustrated his stylistic development. Now in Scotland they are alone in a small gallery with floor tiles imitating those depicted in the paintings with a bench like that in the paintings. Few viewers devote as much attention to the individual pictures as Bernini did—and no one normally sees them one by one. In the present dramatic presentation with the floor in the represented scene extended into the gallery, they function as installation art. Although they were not intended to be installed in that way, showing Poussin's paintings in this sequence is a useful way to identify their distinctive features.[21]

Philip Fisher notes the important analogy between viewing sequences of works of art and reading art history: "That we walk through a museum, walk past the art, recapitulates in our act the motion of art history itself, its restlessness, its forward motion, its power to link. . . . In so far as the museum becomes pure path, abandoning the dense spatial rooms of what were once *homes*, or, of course, the highly sophisticated space of a cathedral, it becomes a more perfect image of history."[22] Earlier I made a similar, but less general claim: "In the 1970s . . . the very layout of the Museum of Modern Art, which took me from Cézanne and Monet through cubism to abstract expressionism, illustrated *Art and Culture*. . . . The 1984 redesign of the museum reflects a changed estimate of Greenberg."[23] A walk in an art museum is a historical narrative under another name, for you need but describe what you see as you walk to write a history. And just as you may momentarily put down a book between chapters, so too in museums a resting point is desirable. Stepping out of the narrative in the galleries, you momentarily stop before continuing your historical march. Alexander Sokurov's exhilarating film *Russian Ark*, a continuous visual narrative set in the Hermitage, illustrates this experience.

The museum's derivation from the Renaissance palace may influence hangings. Rosalind Krauss notes, "One proceeds in such a building from space to space along a processional path that ties each of these spaces together, a sort of narrative trajectory with each room the place of a sepa-

rate chapter, but all of them articulating the unfolding of the master plot."[24] Whatever the plausibility of this historical analysis, the analogy between walking through a museum and reading art history is very suggestive. In museums, as in books, individual works of art are presented in a narrative. Ivan Gaskell speaks of "how meaning might be generated by the juxtaposition of" works of art. "No object," he rightly notes, "is perceived in isolation and that how any given object is perceived is vitally affected by its juxtaposition to other objects is a truism of curatorial practice."[25] But of course not all hangings are successful interpretations. At the Louvre in fall 2000 you had to walk through the gallery of Spanish paintings to get to the rooms containing ethnographic art. And in fall 2001, the uptown Guggenheim in New York devoted the main gallery to art from Brazil, with Norman Rockwell's paintings in a side gallery. Just as an ill-ordered book is frustrating, so too a museum with poor transitions is fatiguing.

Before the late eighteenth century, museums intermingled artifacts found today in natural history museums—wondrous stones, fossils, stuffed animals, and art from cultures without writing—with works of art.[26] Indeed, in some museums built in the nineteenth century, the Carnegie Institute in Pittsburgh or the Glasgow Art Gallery and Museum for example, one large building still contains both paintings and stuffed animals. On the first floor of the Carnegie, you walk past the small gallery near the entrance, enter the hall of sculpture with plaster casts, and then see the minerals, gems, and fossils. In Glasgow you look down from the old fashioned close hanging of paintings to view armor and firearms. By contrast, Denon displayed painting and sculpture according to national schools, separating art from the objects associated with natural history museums.[27] Hegel described that practice, saying that he wanted the museum to show not only the external history "but the essential progress of the inner history of painting. It is only such a living spectacle that can give us an idea of painting's beginning . . . of its becoming more living . . . of the progress to dramatically moved action and grouping."[28] Most large public museums follow this basic model.

Just as the acknowledgments of a book set its tone, so a museum entrance readies you to view the collection. "There is nothing more discouraging to the would-be museum visitor," an older commentary claims, "than to arrive inside the door and find himself confronted by a seemingly

interminable flight of stairs which must be mounted before he attains his object."[29] On the contrary, since museums originally were homes of the muses it is appropriate that upon entering you walk up stairs, as if going into an antique temple or a church. What better place to learn the history of the institution that you are entering? Detached from any utilitarian function, in museums, art is set outside the everyday world. At the entrance you usually find a free floor plan, which maps the displays, restrooms, café, and shop (fig. 14). These little charts deserve serious attention, for they tell much about these institutions.[30] A museum ought to have a transparently clear floor plan, making it easy to return to a work of art.[31]

In Boston, Minneapolis, and Cleveland, the original entrances are replaced by side doors opening into the modern wings, arrangements well suited to contemporary art, which is more informal than old master painting. Tadao Ando's Pulitzer Foundation, St. Louis, and its neighbor, the Contemporary Art Museum designed by Brad Cloepfil, have ground floor entrances, encouraging visitors to feel that they are immediately accessible. At most older institutions you ascend stairs to enter. You come into the Prado, the National Galleries in London and Washington, D.C., and the Altes Museum, Berlin by stairs outside the building. Reversing this well-entrenched convention, some museums ask you to descend. I. M. Pei's main entrance to the Louvre takes you down through the grand pyramid and then underground across the courtyard, to come up in one of the three sections named after figures associated with the building: Richelieu, Sully, Denon. And you enter the Museum of Contemporary Art, Los Angeles, through a courtyard, going down stairs. When you are in the galleries, the artificial lighting and absence of windows remind you that you are underground, a perverse arrangement in a city famous for its sunlight.

Once you enter a museum, then usually you choose what narrative to follow. The uptown Guggenheim Museum in New York is a spiral, but even there you can either walk up or to take the elevator directly to the top and come down. Shelley Errington argues that the linear structure makes it "difficult to organize, display, and therefore for the viewer to conceptualize the history of art as anything other than an illustration of conventional art history's enabling assumption, which is more or less 'one piece of art influences another.'"[32] And in the Sheldon Memorial

14. Screen shot from the "Visitor Information" section of the
Metropolitan Museum of Art Web site, specifically, ground floor plan
at http://www.metmuseum.org/visitor/vi_fl_ground_english.htm.
© 2000–2005, The Metropolitan Museum of Art.
All rights reserved.

Art Gallery, Lincoln, Nebraska, Henry Hitchcock explains, "the visitor is
offered a single path—or, at least, not more than one choice of path—in
moving through . . . (the galleries), while, on the other hand, any one of
them can be cut out from the circulation for rehanging without making
the other galleries unapproachable."[33] But most museums offer multiple
paths. Typical American art institutions have an original older building,
usually in a classical architectural style, joined to a more recent addition.
Some have rational plans, but most have grown by accretion. Only a very
few—the Museum of Modern Art, New York, is the most important
example—are rich enough to rebuild completely when remodeling.

Many visitors to the Metropolitan Museum go straight up the main
stairs to look at European art. But if you begin in the galleries of Asian
art, European painting then looks different. At the main entrance, you

go left to view the Greek sculptures and vases or up the grand stairway to the old master European art, the historical core of the collection. Going to the left, you walk through a gallery devoted to prints to arrive at the Islamic wing. On the far side, you enter the large new wing devoted to modernist and contemporary art. And going down the stairs, you reach the rooms devoted to the arts of Africa and Oceania. But if you go right at the entrance and take the elevator down to the basement, then you enter the new galleries presenting fashion. In the Frick Collection, New York, you can turn to the left to head directly to the Fragonards, or walk through the courtyard to the long room containing *The Polish Rider*, continuing on to the Piero della Francesca *Crucifixion*. If you first look at the early Renaissance religious paintings, Frick's sensual Fragonards may look different. In the Louvre's Grand Gallery, walking west takes you to the later art. And the basic arrangement of the Prado also is chronological, with fifteenth- and sixteenth-century painting (and sculpture) on the ground floor; seventeenth- and some eighteenth-century painting on the second floor, and eighteenth-century painting on the top floor.

Museum skeptics correctly identify ways in which moving old art into museums can involve changes for the worse. But often placing art in museums improves how it is seen. And once we are familiar with a hanging, we tend to resist change. "Many pictures have now hung for far longer in museums than in the churches or the palaces for which they were originally designed. Their new associations cluster around them as evocatively as their old ones. . . . Bizarre juxtapositions which would have astounded earlier patrons and collectors can acquire a new validity of their own."[34] In Venice many paintings in the Academmia come from churches. Bringing together paintings originally set some distance apart makes it easier to compare these Bellinis, Titians, and Giorgiones. And of course museums make it natural to do wider-ranging visual comparisons. In Cleveland, a short promenade takes you from the Chinese scrolls to landscapes by Claude and Poussin, encouraging reflection on the differences between European and Chinese ways of representing nature.

Everyone who visits museums is aware how they are organized, but because this information I present has not been formally analyzed, spelling it out is important. As yet there exists neither a systematic collection of museum floor plans nor a general history of museum hangings.[35] Mary

Anne Staniszewski points out that art historians "have rarely addressed the fact that a work of art, when publicly displayed, almost never stands alone: it is always an element within a permanent or temporary exhibition created in accordance with historically determined and self-consciously staged installation conventions."[36] They have not taken much interest in the history of hanging arrangements.[37] "From Courbet on, conventions of hanging are an unrecovered history," Brian O'Doherty notes.[38] That is unfortunate, for very often knowing a work's display helps us understand visual art. As Andreas Beyer writes, "There is no doubt that the sequence of works of art, their distribution, their hanging or positioning, even their illumination and wall color—in short, the manner of their display—are the essential preconditions to enable them to express something."[39] But because of the division of labor between curators and historians, only rarely is such information discussed.

Kevin Lynch's *The Image of the City* explains how urban dwellers orient themselves: "People tended to think of path destinations and origin points: they liked to know where paths came from and where they led. Paths with clear and well-known origins and destinations had stronger identities, helped tie the city together, and gave the observer a sense of his bearings whenever he crossed them."[40] Lucid museum displays, by analogy, allow visitors to find their place in the collection, but awkward hangings leave us disoriented and frustrated. And just as it is unsettling to find unpredicted material in a book, so it can be surprising to see an out-of-place painting in a static collection. Once I was astonished to see Poussin's *Arcadian Shepherds* on loan from the Louvre in the Frick Museum. Mary Douglas posits, "Some symbolic scheme of orientations may be necessary for people to relate to one another in time and space."[41] Just as painters often put the most powerful figure at the center, so museums commonly give their most valued art privileged positions. At the Norton Simon Museum, Pasadena, Giovanni Battista Tiepolo's *The Triumph of Virtue and Nobility over Ignorance* is at the end of a very long sequence of galleries devoted to older European painting. On the other side, in the nineteenth-century galleries, Manet's *The Rag Picker* occupies this position. On the first floor of the Prado, Spanish painting occupies the central galleries, with Velázquez's *Las Meninas* at the far end of the largest gallery off the middle. And in the National Gallery, London, Piero's *The*

Baptism of Christ is visible from a distance, reminding us of its impor-
tance. Flanked by Piero's *Nativity* and *St. George*, this hanging stresses
links between Southern and Northern European art.[42]

Everyone knows the interpretative language applied in art writing to
individual paintings. Finding a vocabulary characterizing art in the mu-
seum is, as yet, much more difficult. In his classic account of the Caravag-
gios in the Cerasi Chapel, S. Maria della Popolo, Leo Steinberg remarks
on the difficulty of photographing the effect of walking in to view the
paintings at a glancing angle.[43] Only in the late nineteenth century did
the academic vocabulary for interpretation by description evolve, so it
is not surprising that as yet we lack ways to describe experiences in the
museum that we all know but are not readily able to articulate. Rudolf
Wittkower explains how Annibale Carracci's frescoes in the Farnese Gal-
lery, Palazzo Farnese, employ highly complex illusionistic effects: "Since
all this decoration is contrived as if it were real—the seated youths of
flesh-and-blood colour, the herms and atlantes of simulated stucco, and
the roundels of simulated bronze—the contrast to the painted pictures
in their gilt frames is emphasized, and the break inconsistency there-
fore strengthens rather than disrupts the unity of the entire ceiling."[44] A
good large color photograph makes it possible to understand this fresco.
But compare Wittkower's description of Francesco Borromini's S. Carlo
alle Quattro Fontane, Rome: "While the triads of undulating bays in
the diagonals are unified by the wall treatment—niches and continuous
mouldings—the dark gilt-framed pictures in the main axes seem to cre-
ate effective caesuras. Borromini reconciled in this church three different
structural types: the undulating lower zone . . . ; the intermediate zone
of the pendentives . . . ; and the oval dome."[45] No one picture could
adequately show the church. Describing an art museum is more like de-
scribing San Carlo than the Farnese Carracci ceiling.

To explain a hanging you need to identify spatial relationships among
paintings, walking your reader through the gallery. In Cleveland, for ex-
ample, when stepping back to see Caravaggio's *Crucifixion of St. Andrew*
you look across to the next gallery. In the distance you view Poussin's
Holy Family on the Steps. Poussin famously said that Caravaggio came into
the world to destroy painting. The hanging encourages reflection on this
rivalry. When you turn around you see Tintoretto's *Baptism of Christ* and
so think about the importance of Caravaggio's Venetian sources. And on

the right side of *Crucifixion of St. Andrew* is a painting by his follower Georges de la Tour. An interpretation of Caravaggio's place in art's history thus is implicit in the organization of this gallery. Well-organized museums encourage such searches for apt visual conjunctions.[46]

Seeing art in a historical hanging often can influence commentary. In his review of the 1931 Matisse retrospective at the Museum of Modern Art, New York, Meyer Schapiro wrote:

> In hanging the paintings of Matisse in chronological order, the directors of the Museum of Modern Art have offered us a spectacle of development which is of the greatest interest. We see within the works of a single man the radical transformation of art. . . . It has the character of . . . two revolutions—the first in the sudden turn from an impressionistic style to an abstract, decorative manner . . . the second, towards 1917, in the return to naturalism.[47]

The hanging made it natural to develop this historical analysis of Matisse's self-sufficient stylistic development. Displaying Matisse's *Luxe, calme et volupté* in the Musée d'Orsay close to a painting it quotes, Cross's *L'Air du soir* (1894) makes a different point, showing a source for his original art.[48] And recently in an exhibition at the Kimbell in Texas juxtaposing masterpieces by Matisse and Picasso, a different narrative was presented, focusing on the rivalry between two near-contemporaries.[49]

Knowing the original site of a picture can be important. Piero della Francesca's *The Flagellation of Christ* remains in Urbino, an out-of-the-way town.[50] To see it you enter the Palazzo Ducale, walk upstairs, and proceed through the rooms leading to Guardaroba del Duca to enter a small room. In London's National Gallery, a Piero is a foreign object, but the Palazzo Ducale is in Piero's world, for the landscape around Urbino looks like the background of *The Baptism of Christ* and Piero's painted architecture is similar to the doorframe of the palazzo. The West Lake, Hangzhou, long an important center for Chinese art, is a perfect subject for painters working with ink brush on rice paper. Walking in the summer rain, you realize how a long scroll captures the effect of moving around the lake. And you learn that ink on paper is the perfect medium for showing mists. Chinese scroll paintings in American museums look different after you visit China.

Where a picture is displayed often influences how it is written about.

The Raphael *Sistine Madonna* effectively changed "from Church icon to museum picture" when in 1753 it was taken from a Piacenza church to Dresden, where Protestants devoted much attention to this painting. "In effect, the Germans created the work anew," Belting writes.[51] The only German-owned Raphael, it was discussed by many Protestant scholars and admired by Winckelmann.[52] The picture was important to Goethe, Wagner, and Nietzsche—and to one of Freud's patients: "She remained *two hours* in front of the Sistine Madonna, rapt in silent admiration. When I asked her what pleased her so much about the picture she could find no clear answer to make. At last she said: 'The Madonna.'"[53] Saved from the fire bombing of Dresden near the end of World War II, *Sistine Madonna* is displayed in a setting that very consciously alludes to its history of interpretation.

Who owned art also legitimately influences how it is interpreted. Much can be learned about seventeenth-century tastes by studying the collection of Charles I, who was that rare creature: an aesthete king. "The absolutist form of government was felt to be an importation from the Continent, even more so the culture of the London court. Voices were heard saying that the king had been deceived to the detriment of the country through gifts of paintings, antique idols and trumperies brought from Rome."[54] For him, as for Louis XIV, art was a political tool. "The humiliations experienced by the French monarchy during the Fronde played a determinant role in its return to protection and political use of the arts."[55] Sometimes our understanding of the political significance of art depends on its fate after leaving the artists' studios. Impressionism, T. J. Clark remarks, "became very quickly the house style of the haute bourgeoisie, and there are ways in which its dissolution into the decor of Palm Springs and Park Avenue is well deserved: it tells the truth of this painting's complaisance at modernity."[56] It is impossible to fully understand Impressionist painting without some knowledge of its present day collectors.

And *how art has been installed* long before we view it can justifiably affect our experience.[57] Mina Gregori notes that Caravaggio's *Amor Vincit Omnia* (1601–2), "Love Triumphant," sometime between 1629 and 1635 was "in a gallery so that it was the last picture a visitor would come upon, and . . . covered by a curtain, probably not only for reasons of decency and morality, but also to enhance the surprise aroused in the spectator

by this provocative nude painted from life." [58] Since the claim that Caravaggio made homoerotic pictures appears only in the modern literature, that old hanging deserves analysis.[59] In April 1997, *Amor* was still in the West Berlin museum created after the war but with the rationalization of the German museums after the unification of that country, that collection is being redone. Velázquez's *Venus with a Mirror*, to consider a related example, once hung "salaciously from the ceiling over its owner's bed," according to Alexander Nehamas.[60] That knowledge changes how we now see it in the National Gallery, London. Nicolas Poussin's late *Eleazer and Rebecca at the Well*, in the Fitzwilliam Museum, Cambridge, is displayed without any indication of its provenance. But this picture was long owned by Anthony Blunt, a fact that has inspired debate about the attribution.[61] Some critics think that his spying infected his art writing.

Temporary hangings also can be revealing. Seeing Jackson Pollock's *Autumn Rhythm (Number 30)* next to the famous photographs of the artist at work by Hans Namuth at the recent retrospective at the Museum of Modern Art, New York, was different from viewing it in its present home, the Metropolitan Museum of Art.[62] In those photographs, which had a significant effect on the conception of Pollock as an action painter, we watch the painting being made. This work of art was made on the floor, a radical act of experimentation. Today it is hung like a traditional easel painting. A few years ago the Museum of Modern Art, New York, hung together a small Jackson Pollock and a similar-looking painting by Janet Sobel, whose name which does not appear in the usual survey texts. The wall card read: "Back in 1944 . . . [Pollock] had noticed one or two curious paintings shown by Peggy Guggenheim's by a 'primitive' painter, Janet Sobel [who was, and still is, a housewife living in Brooklyn]. Pollock (and I myself) admired these pictures rather furtively." [63] The museum expects some visitors to be erudite enough to recall Clement Greenberg's essay.

The lesson revealed by these examples deserves spelling out in a general way. Here our intuitive analysis may gain authority from appeal to the literature of phenomenology. How you see one painting can depend in subtle ways upon what other art is in the room. How you view that room influences what you expect to see when you walk further. And how you look at works of art in other galleries, in turn, is affected by the experience of entering the museum and, sometimes, by what you see in the

streets immediately outside. Because this knowledge of hangings tends to remain merely implicit, I aim to make it explicit.[64]

Edmund Husserl's account of our horizon of expectations usefully describes this way in which visual experience involves both seeing what is here-and-now and having an awareness of what lies beyond the immediate perceptual field. The identity of any object involves "a series of intuitive recollections that has the open endlessness which the "I can always do so again" (as a horizon of potentiality) creates. Without such "possibilities" there would be for us no *fixed and abiding* being, no real and no ideal world."[65] Maurice Merleau-Ponty explains this point in a clearer way: "I anticipate the unseen side of the lamp because I can touch it—or a 'horizontal synthesis'—the unseen side is given to me as 'visible from another standpoint,' at once given but only immanently. . . . the perceived thing is . . . a totality open to a horizon of an indefinite number of perspectival views which blend with one another."[66] Looking at the front of a building, you know that moving will reveal its sides. You would see an indiscernible flat movie set differently. In a museum, to borrow this phenomenological vocabulary, we may speak of a horizon both literally, to encompass what we see when we walk beyond one picture and also figuratively, to describe the very real influence of reading about that picture.[67]

But after drawing extended attention to the influence of museum floor plans and the influence of these various hangings, I would not overemphasize their ultimate importance. What is most remarkable about Denon, Francis Haskell writes, "is not so much the scope of his collection or the intellectual interest he showed in its historical importance as the genuine feeling that he seems to have had even for those works which least conformed to conventional taste."[68] Because the natural concern of the artist is, in Wollheim's words, "to aid our concentration upon a particular object by making the object the unique possessor of certain general characteristics," the ultimate goal of the curator is to have us attend to the individual artifacts.[69] Nothing prevents you from walking directly to some favorite painting, taking little note of the museum flow plan. Nor need you read the wall labels. And even when an exhibition is arranged chronologically, it is usually possible to walk to the end and then view the art in reverse chronological order. Perversely reading a book from back to front takes effort, but refusing to follow the ordering imposed by a

curator is easy. After a few visits to the National Gallery, London, going in chronological order, David Finn "got the idea of walking through the museum in the opposite direction. It took an enormous wrench not to begin at the beginning," he reports, but "it was as if I were seeing that part of the museum for the first time."[70] His instructive experiments remind us that the historical hangings of our museums influence—but do not entirely determine—how we see the art they display.

6

Isabella Stewart Gardner's Museum

Metamorphosis . . . is an image of simultaneous but divisible multiplicity; and throughout its history it maintains associations with the belief that human identity itself is multiple.—LEONARD BARKAN

A teenager enjoys her carefully chosen CDs; a middle-class person scrupulously picks a car, clothing, and house; meticulously assembled old master drawings identify you as a person with money and an eye. A seventeenth-century collector gathered objects to "distinguish himself from many of his contemporaries," Jay Tribby writes. "They enabled him to see himself and to represent himself to others as someone who was like the objects he collected: someone, that is, who was worthy of note."[1] And modern collectors define their identity in part by the things that they choose to surround themselves. Monks may be too unconcerned with possessions, and medieval peasants perhaps owned too few things to think in these terms. But most middle-class people define their identity, in part, in terms of their possessions.[2]

Some theories of collecting are essentially reductive. Werner Muensterberger writes, "Possessiveness, when it appears as a symptom, is always a secondary phenomenon, implying anxiety. During early childhood, when there is much need for touch and warmth and the acknowledge[ment] of being wanted, lack of it results in deep insecurity, in greediness, in oral erotism and castration fear."[3] No doubt many art lovers are odd people, but this analysis shows a curious refusal to take collecting seriously on its own terms. "Few human activities provide an individual with a greater sense of personal gratification than the assembling of a collection of art objects that appeal to him and that he feels have true and lasting beauty,"[4] according to J. Paul Getty, who offers a more plausible view of collecting. It is natural to find pleasure in material things near to us. "I am what I own": That sounds like a vulgar slogan,

15. Titian, *Europa*, installation view.
© Isabella Stewart Gardner Museum, Boston.

and no doubt some people interpret it in vulgar ways. But even an austere philosopher might enjoy her copy of the *Philosophical Investigations* because she remembers Emerson Hall at Harvard University. And an aging radical might treasure his first edition of *La Société du spectacle* because it reminds him of youthful enthusiasms. For many people, collecting visual art influences how they define their personal identity.

When an old work of art moves from one culture to another, inevitably the envelope in which it arrives undergoes modification. In a remarkable metamorphosis, at the end of the nineteenth-century many Italian Renaissance paintings moved to America. Owning an old master picture can change the life of its possessor, and, when in a public museum, this work of art may affect visitors. The history of Titian's *Europa* (1559–62), whose subject is metamorphosis, tells much about two people associated with it, Bernard Berenson and Isabella Gardner (fig. 15).[5] Berenson provided the envelope in which *Europa* arrived in Gardner's museum. The Isabella Stewart Gardner Museum, Boston, is "designed in the style of a fifteenth-century Venetian palace."[6] Gardner died in 1924, but her collection remains essentially as she left it. As the brochure you receive as you enter explains, "Isabella Stewart Gardner believed that works of art

should be displayed in a setting that would fire the imagination. Her arrangement of the collection is not chronological or by country of origin but designed purely to enhance the objects. To encourage visitors to respond to the works themselves, she left many art treasures unlabeled, a practice that continues to this day." Unlike a public museum, her collection thus has a frankly personal arrangement. In the Titian room on the third floor is one of the best Italian paintings sold by her adviser, Berenson. When he found that it was available, he wrote to her: "Cable, please the one word YEUP= Yes *Europa*," and she did.[7]

Europa is often justly praised as one of this great colorist's best pictures, but nowadays pleasure in Titian's extraordinary painterly technique cannot entirely overbalance awareness of his unpleasant subject. Holding the horns of the bull abducting her, Europa is watched by spectators on the distant shore who are too distant to rescue her. She is the victim of Jupiter, who disguises himself as a bull. As Ovid tells: "The girl was sorely frightened, and looked back at the sands behind her, from which she had been carried away. Her right hand grasped the bull's horn, the other rested on his back, and her fluttering garments floating in the breeze."[8] In the painting the bull is not yet aggressive. "There was no menace in the set of his head or in his eyes; he looked completely placed." But soon Jupiter will drop his disguise and Europa's father will look for her.

Europa beautifully represents a rape—and Titian equates the luscious Europa with the beautifully painted image of her. His picture is both highly sensuous and a little silly.[9] Why is viewing this image with bright colors and rapid, fluid brush-stokes pleasurable?[10] The Gardner catalogue says that "Titian has rendered with uncompromising realism the ignominy of Europa's situation."[11] That claim is puzzling, for what counts as a *realistic* depiction of a god disguised as bull with his victim riding on his back? "As she surrenders," Erwin Panofsky more plausibly writes, "she both embraces the bull and tries to preserve herself."[12] The viewer also is an aggressor, notes Paul Hills: "In Ovid's fables gods are made flesh or beast. . . . Titian's painterly technique is extended to realize states of becoming and their attendant terrors and exhilarations. . . . the blush of Europa turns the sky to flame."[13] Europa is helpless, her legs parted, her right breast exposed, her body turned toward us, her head shielded by her left hand. In the J. Paul Getty Museum's *The Abduction of Europa* (1632), a very different image, Rembrandt's bull is in motion,

and so she holds on for dear life. The title given this Titian by the Gardner museum is misleading—*Rape of Europa* would be more accurate. It is surely dubious to claim that the god "is disguised as a white bull to attract the princess" or that he "woos . . . Europa."[14] In fact, as in some other late Titians, there is an intimate relation between aggression and the erotic pleasures of looking.[15] A full account of *Europa* needs to consider the spectator. Laurie Adams writes, "Following a pronounced diagonal of sight, Cupid stares at Europa's open legs, accented by the V-shaped arrangement of her drapery. . . . At the same time as the observer's gaze is pulled in by perspective and pose, it is countered by the returned stare of Zeus and the dolphin. Titian humorously evokes the ambivalent looking aroused by the primal scene."[16] In seeing her, we resurrect infantile memories.

Vasari's brief account of *Europa* appears in his list of the Titians painted for Charles V and his successor, Philip II: "He also painted Europe crossing the sea on a bull. These paintings are now in the possession of the Catholic king, who values them highly for the vivacity of the figures and the natural colouring."[17] Comparing Titian's other mythological scenes painted for Philip II, *Diana and Callisto*, *Diana and Actaeon*, the *Punishment of Actaeon*, and *Europa*, Sydney Freedberg extends that analysis. "Each [picture] is composed with regard to the structure of the others, making complementary relations of a characteristically classical kind. . . . I assume their installation as a set. . . . The *Punishment* and the *Europa*, in which the landscapes play a major role, are complementary to the first two paintings in this respect, and to each other in the sense that their similar designs are inverted in direction."[18] This group of Titians is dispersed, but one record of *Europa*'s place in Philip II's collection remains in Spain—its depiction at the back of Velázquez's *The Fable of Arachne* (1644–48).[19]

Berenson says nothing about these modern feminist and psychoanalytic concerns. *The Venetian Painters of the Renaissance* (1894) tells how "stirred with the enthusiasms of his generation . . . Giorgione painted pictures so perfectly in touch with the ripened spirit of the Renaissance that they met with the success which those things only find that at the same moment wake us to full sense of a need and satisfy it." In late works like *Europa*, Berenson adds, Titian "was, in his way of painting, remarkably like some of the best French masters of the end of the six-

teenth century. . . . Titian and Shakespeare begin and end so much in the same way. . . . They were both products of the Renaissance, they underwent similar changes, and each was the highest and completest expression of his own age."[20] He does not describe its subject. Venetian painting attracts modern viewers, Berenson writes, because "we, too, are possessed of boundless curiosity. We, too, have an almost intoxicating sense of human capacity. We, too, believe in a great future for humanity." Newly rich American collectors were surely flattered to be told that they were spiritually akin to Giorgione's Venetians.

Berenson was the right man in the right place at the right time. A generation earlier, James Jackson Jarves, a pioneering American writer about and collector of Italian art, had difficulty selling his fine collection of early Renaissance pictures to Yale College for a very low price.[21] When in 1904 Henry James returned to Boston, he found the new art museum positively uncanny, noting how someone from another culture "has not *seen* a fine Greek thing until he has seen it in America."[22] Developing the American market for Titian's art required an appropriate theory. Berenson provided it. When he was young, the great new book on Italian art was Walter Pater's *The Renaissance: Essays in Art and Culture* (1873). Pater, in turn, got his facts from the pioneering survey histories of Joseph Crowe (1825–96) and Giovanni Cavalcaselle (1820–97) and his conceptual framework from Hegel. Crowe and Cavalcaselle did an enormous amount of research on Flemish and Italian painting but their historiography was straightforward. Hegel's lectures on aesthetics, published soon after his death in 1831, gave a more challenging analysis.

Pater was not an art historian but a philosopher who taught classics. *The Renaissance* looks both backward and forward. The essay on Winckelmann summarizes German aesthetics, and "The School of Giorgione" brilliantly anticipates modernist painting. Traditionally, Pater notes, it was said that paintings told stories. But such storytelling does not identify the specifically visual qualities of such art. "In its primary aspect, a great picture has no more definite message for us than an accidental play of sunlight and shadow for a few moments on the wall or floor: it itself, in truth, a space of such fallen light, caught as the colours are in an Eastern carpet, but refined upon and dealt with more subtly and exquisitely than by nature itself."[23] Painting communicates not by reference to its content, but by use of the medium. "The mere matter of a picture, the

actual circumstances of an event, the actual topography of a landscape—should be nothing without the form, the spirit, of the handling . . . this mode of handling, should become an end in itself, should penetrate every part of the matter."[24] Here he anticipates abstract art. "In the subordination of mere subject to pictorial design, to the main purpose of a picture, (Giorgione) is typical of that aspiration of all the arts towards music . . . towards the perfect identification of matter and form."[25] But his wonderful philosophical speculation was surely too esoteric to inspire collectors.

Attributing to the short-lived Giorgione various paintings now given to Titian or lesser contemporaries, Pater frankly admits that he is interested less in Giorgione than in Giorgionesque art. "The School of Giorgione" is presenting "an influence, a spirit or type in art, active in men so different as those to whom many of his supposed works are really assignable."[26] Pater's view of aesthetic pleasure is subversive: "Every moment some form grows perfect in hand or face; some tone on the hills or the sea is choicer than the rest; some mood of passion or insight or intellectual excitement is irresistibly real and attractive to us,—for that moment only. Not the fruit of experience, but experience itself, is the end. To burn always with this hard, gemlike flame, to maintain this ecstasy, is success in life."[27] This coded homoerotic language had an important influence on his wayward pupil Oscar Wilde.[28] But even before Wilde's arrest, hostility to aestheticism was shown in a malicious parody of Pater, W. H. Mallock's *The New Republic* (1878).

> I rather look upon life as a chamber, which we decorate as we would decorate the chamber of the woman or the youth that we love, tinting the walls of it with symphonies of subdued colour, and filling it with works of fair form, and with flowers, and with strange scents, and with instruments of music. . . . what does successful life consist in? Simply . . . in the consciousness of exquisite living . . . in the making our own each highest thrill of joy the moment offers us.[29]

This caricature of an aesthete rejects Victorian praise for progress.

Pater's critical perspective on contemporary England and his love of art were widely shared by many people who were neither gay nor aesthetes. His novel *Marius the Epicurean*, describing the transition from the pagan to Christian era in Marcus Aurelius's Rome is an allegory about Christian England. Seeing a worn-out horse being taken to slaughter, Pater's

narrator reflects: "I could have fancied a human soul in the creature . . . it would figure to me as the very symbol of our poor humanity, in its capacities for pain . . . the very power of utterance and appeal to others seeming to fail us, in proportion as our sorrows come home to ourselves, are really our own. We are constructed for suffering!"[30] Simplifying Pater's ideas, Berenson used them to explain why Americans should collect old master art. Attracted to the aesthetic way of life presented in *Marius*, "my spiritual biography," as he identified it, Berenson called the book a defense of "the art, namely, of so relieving the ideal or poetic traits, the elements of distinction, in our everyday life—of so exclusively living in them—that the unadorned remainder of it, the mere drift or *débris* of our days, comes to be as though it were not."[31] That very misleading reading leaves completely aside its moral argument.

For the aesthete, Pater says, sensuous experience is the highest source of knowledge. "Not the conveyance of an abstract body of truths or principles, would be the aim of the right education of one's self . . . but the conveyance of an art—an art is some degree peculiar to each individual character; with the modification . . . due to its special constitution."[32] Knowing the limitations of his own powers of abstract reasoning, Berenson welcomed Pater's argument that philosophical analysis matters less than the immediate sensuous appeal of art. Not a subversive thinker, he took from Pater what suited his needs—and discarded the critical perspective on Victorian values. Not surprisingly, the men had an uneasy relationship. When the young Berenson asked if he could attend Pater's lectures, Pater "declined—with courtesy but obviously in confused surprise: they were not public lectures—not really lectures at all. . . . Berenson seems to have remained conscious all his life of having received a snub," Michael Levey reports.[33] Pater, austere and unworldly, decorated his bare Oxford rooms with a few reproductions. Berenson, an aesthete without social conscience, lived in a grand art-filled house much visited by scholars and celebrities.[34]

The Renaissance set Venetian painting in a history in which art of each epoch expresses the deepest inner feelings of a culture. Greek sculpture shows beautiful, untroubled figures in perfect bodies; Christian art presents an entirely different worldview. In Fra Angelico's *Coronation of the Virgin*, Pater writes, "all that is outward or sensible . . . is only the symbol or type of a really inexpressible world, to which he wishes to direct

the thoughts. . . . Such forms of art, then, are inadequate to the matter they clothe; they remain ever below its level."[35] Berenson, by contrast, argues in *The Florentine Painters of the Renaissance* that nothing could be "more rejuvenating than . . . the happiness on all the faces, the flower-like grace of line and colour, the childlike simplicity yet unqualifiable beauty of the composition. . . . And all this in tactile values which compel us to grant the reality of the scene."[36] Replacing Pater's complex analysis with a simpler account, Berenson says relatively little about the Christian content of Renaissance art. In his commentary on Piero della Francesca's *Resurrection*, for example, Berenson says that when we learn that "where there is no specialised expression of feeling—so attractive to our weak flesh—we are left the more open to receive the purely artistic impressions of tactile values, movement, and chiaroscuro."[37] Nothing here about the spiritual significance of Christ's resurrection.

Writing to Gardner, Berenson praises *Europa* without discussing its iconography or the ambiguities of its subject: "What a beauty. Titian at his grandest, Rubens at his strangest, you have both matchless artists' dominant notes singularly combined in this one picture. No wonder Rubens went half mad over it. I beseech you look at the dolphin, and at the head of the bull. There is the whole of great painting!"[38] Great art is universal. Berenson links Piero's "space-composition" with that of contemporary French painters, observing "the exquisite modelling of Cézanne, who gives the sky its tactile values as perfectly as Michelangelo has given them to the human figure [and] Monet's communication of the very pulse-beat of the sun's warmth over fields and trees." But he does not develop such comparisons.

In aesthetic experience Berenson seeks what he calls "ITness," the sense of being at one with what is viewed. "I have never enjoyed to the utmost a work of art of any kind . . . without sinking my identity into that work of art, without becoming it, although, as in certain pictures and drawings of the sixteenth and seventeenth centuries we see tucked into a corner a tiny figure of the artist at work, so a miniscule observer is always there, watching, noting, appreciating, estimating, judging."[39] This is pure mysticism: "IT is incapable of analysis, requires no explanations and no apology, is self-evident and right. One may sing about it but not discuss it."[40] As Berenson frankly acknowledges, his personal pleasure in ITness was erotic. "My yearnings were for a mystical being in

youthful female shape with whom I could aspire to unite myself . . . what I wanted was only to become one with the woman of my love, nay—to be absorbed by her, to end in her."[41] It thus is unsurprising that he had no concern with *Europa*'s unpleasant erotic subject. Viewing great art, he thought, "can take us away from ourselves and give us, where we are under its spell, the feeling of being identified with the universe, perhaps even of being the soul of the universe."[42] To the extent that the bliss of ITness can be provoked by nature, what need have we of expensive works of art? How odd that Berenson, whose business involved distinguishing between better and worse paintings, took such a passionate interest in this mystical state that blurred conceptual distinctions.

Born Valvrooyenski in 1865 in Latvia, like many emigrants Berenson changed his name. Son of a South Boston peddler, he attended Boston Latin school and then, thanks to a patron, went to Harvard University, studying languages and literature. In *Sketch for a Self-Portrait*, Berenson describes the moment when he chose to be a connoisseur. He and a friend decided to "give ourselves up to learning, to distinguish between the authentic works of an Italian painter of the fifteenth or sixteenth century, and those commonly ascribed to him. . . . we must not stop till we are sure that every Lotto is a Lotto, every Cariani a Cariani, every Previtali a Previtali."[43] By 1899, he earned $15,000 a year.[44] Berenson rented Villa i Tatti outside Florence in 1900 for less than $200 a year, purchased the house and fifty acres of grounds, which included neighboring farms, for $28,000 in 1907, and built a great library and art collection. Thanks to his fame, political connections, and good luck, he survived the Second World War hiding nearby. He died in 1959 rich enough to leave I Tatti with an endowment to Harvard.

Berenson often expressed uneasiness about his commercial activities— and critics complain that he robbed Italy of its patrimony. Connoisseurship, Richard Wollheim writes, was "temporarily discredited by Bernard Berenson, who made it serve profit and the self-aggrandizement of the rich."[45] I think that complaint misleading. Long before Berenson, Italian art was sold, often without the permission of local governments. The Pieros in the National Gallery, London; the Titians in the National Gallery of Scotland; and much of the Italian art in the Louvre, the Prado, and German museums were exported in ways that today would be illegal. These collections made it possible for people who cannot visit Italy

to see paintings from that country. Berenson was very well paid because collectors needed his mostly reliable attributions.[46] He had many rivals. If Berenson became the richest and most famous connoisseur, that is because on the whole his judgments were reliable. His defenders, denying that he was inspired by financial considerations to manipulate his attributions, acknowledge what is obvious—being paid a percentage on sales certificates created potential conflicts.

The capitalist, Marx writes, aims "to produce not only a use-value, but a commodity also; not only use-value, but value; not only value, but at the same time surplus-value."[47] That too is a metamorphosis. Just as Titian depicts the god become bull (and rapist) in *Europa*, so Gardner's museum shows accumulation of surplus value become works of art. The profits produced by making of commodities make collecting possible—the creation of the museum thus is akin to an aesthetic process. But we non-Marxists may hesitate to moralize about this process. Titian became wealthy by selling his art. Was it wrong for him to profit from his skill? Collectors often resold his paintings. Was that wrong? If not, then was it wrong for Berenson to profit from his hard-won expertise by selling art to Gardner? Thanks in large part to him, many American museums have excellent old master collections. Unlike Berenson, Gardner inherited wealth.[48] In 1896 she paid a hundred thousand dollars for *Europa*, establishing a new price level for Italian Renaissance pictures. A decade earlier, to give a useful comparison, Berenson's prolonged stay in Europe after college graduation cost $700, a sum contributed by a group of wealthy sponsors, including Gardner.[49] But compared to, say, Pierpont Morgan, a truly grand collector, she had a relatively limited budget.[50]

Assimilation was the road to upward mobility for American Jews of Berenson's generation. Nowadays we think that anyone of Jewish descent, whatever their religion, is a Jew. But in Berenson's time, many Jews believed that they could assimilate. He became an Episcopalian in Boston and then a nominal Catholic in Italy. In 1888 he described the men singing in a Berlin synagogue as looking like they were "selling old clothes to each other."[51] In 1938, enraged by the influence of German-speaking refugee art historians then arriving in America, he wrote: "I suppose they will end by putting Jews in all places and I look forward to learning that by act of Congress all lectures, lessons, articles, books, etc., etc. dealing with art shall have to be delivered in Yiddish."[52] He was, I should

add, ferociously anti-Fascist. His only excuse for becoming a connoisseur, Berenson wrote, is "that like Saint Paul with his tent-making and Spinoza with his glass-polishing, I too needed a means of livelihood. . . . Those men of genius were not hampered in their careers by their trades."[53] How odd to think of Paul's preaching or Spinoza's study of philosophy as careers![54] In becoming a connoisseur, Berenson cut himself off from Jewish culture. Revolting against their prosperous philistine gentile families, Roger Fry and Kenneth Clark turned to study the art of Italy. Berenson's personal transformation was much more dramatic.

Art writing is often linked with commerce. Meyer Schapiro bitterly criticized Berenson's commercial dealings. Unlike Berenson, Schapiro was not much involved with art dealers. He did not need to be, for he was a Columbia University professor in the first generation of American Jews who were free to pursue academic careers. Schapiro praised the abstract expressionists, arguing that in a modern mass culture, we value the free self-expression found in their paintings.[55] And then just as Berenson's essays gave Gardner reason to purchase *Europa*, so Schapiro's writing helped build the market in Jackson Pollock and Mark Rothko.[56] But saying this is not to criticize Schapiro. As Gaskell points out, "*All* the parties — dealers, collectors, museum scholars, conservators, academics, and editors — *together* constitute the system as it functions."[57]

Noting Berenson's inability to develop the ideas of his early work and observing critically the connoisseur's uneasiness with Jewishness, Schapiro argues that, unwilling to discuss his own social role honestly, "in repressing this side of his experience he also cut off reflection on what was most intimate in his character. Because he would not bring into the open his deeper concerns, his writings about himself and his world lack the authenticity, the searching conscience he valued in some of his favorite authors."[58] Because he wrote with intense feeling about Cézanne and van Gogh, Schapiro found Berenson's refusal to look seriously at these painters dismaying.[59] Berenson greatly admired Degas, thinking his drawings equal to Michelangelo's; and he once praised Matisse. But he was not very interested in modernism. Schapiro complains that Berenson "is unaware, or insufficiently aware, of the depths of the human struggle towards self-mastery, freedom, and creativeness, its innumerable secret ties with institutions, events, and everyday life, and of the presence of the human, in its good sense, in vulgar experience and in the life and arts of

the less civilized peoples."[60] Unlike Berenson, Schapiro was concerned with the ties of art to everyday life and in art of "less civilized peoples." Berenson's "life enhancing values" may explain quality in Renaissance painting, but they have little to do with much of the art Schapiro lovingly described—the Romanesque sculptures at Moissac and Arshile Gorky's abstract expressionist pictures, for example.

That said, there is something irrational in Schapiro's response to Berenson. He compares Berenson to Stalin, Mussolini, and Hitler, who also disliked modern art. That statement is infelicitous, for Berenson's reasoned objections to modernism have little to do with the dictators' hatred for contemporary art.[61] Noting that Berenson changed his Christian name and, also in one document, the name of his birth town, Schapiro finds one "possible root of Berenson's early and continuing concern with identifying the uncertain author of a painting or his native school. . . . His original name and home, inseparable from the consciousness of self and social place, were now a troubling thought. Through his interest in old Italian art he was able to surmount it effectively in transposing the questions: Who am I? Where do I come from? to the challenging problem of the identity of artists."[62] But immigrants commonly Americanized their names.[63] Berenson himself ascribed his curiosity about origins to "his early reading of the Hebrew Old Testament."[64] Since most connoisseurs did not change their names, this reductive analysis is surely unsatisfactory. Schapiro's Marxist-inspired study of Romanesque and impressionist art took him far from his Jewishness. Is that reason to criticize him? It is easy to see why Schapiro had problems with Berenson, but hard to provide an objective perspective.

Sydney Freedberg, another historian of art of Jewish origin associated with Harvard University, interpreted Berenson in a much more sympathetic way: "In the multilayered cultural construct that the young Berenson was—East European, American, Bostonian, Harvardian, temporary Episcopalian, and ineradicable Jew—it was the last that was the bedrock substance on which all the rest was overlaid. . . . Berenson was made of the spiritual stuff of a Prophet of the Old Testament."[65] Comparing and contrasting the various objects to which he attends, the connoisseur arrives at "a complex synthesis . . . the product of quantitative observation." A purely visual thinker, he aims "to translate the visual work "*by means of words*."[66] In devoting long close attention to attribution of Italian paint-

ings, Berenson made himself into a work of art, giving to his personality that polish, distinctive individuality and expressive intensity that marks a major painting or novel.[67] No less than the old master Italian painting he studied, the individuality that Berenson thus created was like that of a distinct work of art. Shaping and defining itself by constant interaction with visual art, Berenson became an original.[68]

Schapiro the socialist was understandably repelled by Berenson's worldliness.[69] But a less worldly connoisseur could not have achieved what Berenson accomplished. His remarkable metamorphosis transformed a poor immigrant American into a wealthy resident of Italy whose fortune, house, collection, and personal style made banal economic concerns appear unimportant. Believing that he might have become a great art historian had he attended less to commerce, Berenson didn't want to think of himself as a disguised salesman.[70] Like many self-made rich people, he sought to erase his past, to pretend that he was not a Valvrooyenski. This was a natural ambition for an art lover who enjoyed seeing the pigment of *Europa* become an image of Europa. Severe moralists find such role-playing intolerable. You are who you are and no one else—to imagine that you can deny your personal history is to refuse, at some level, to acknowledge your true identity. Pretending may corrupt, but playful metamorphosis can be immensely suggestive.

Berenson's fullest study of a single painter was his early book on Lorenzo Lotto, a surprising subject since he was free to write about the greater Renaissance masters: "The expression Titian gave to the ideals of his own age has that grandeur of form, that monumental style of composition, that arresting force of colour, which make the world recognize a work of art at once, and for ever acclaim it a classic; but with all these qualities, Titian's painting is as impersonal . . . as Bellini's. . . . This insensibility, this impersonal grasp of the world about him, Lotto lacked."[71] There is something of Berenson in this description of Lotto.[72] His reading of *The Renaissance*, unconvincing if taken literally, was very well suited to his practical goals: "All that remains of an event in general history is the account of it in document or tradition; but in art, the work of art itself is the event, and the only adequate source of information about the event, any other information, particularly if of the merely literary kind, being utterly incapable of conveying an idea of the precise nature and value of the event in art."[73] He takes the attitude of a

collector, assuming incorrectly that pure looking can provide absolutely authentic evidence about the origin of a painting.

Creating the Isabella Stewart Gardner Museum involved fruitful collaboration between Berenson and Gardner. Without her early support, Berenson never could have become a connoisseur; without her critical eye, this remarkably good collection would not have been assembled. We know a great deal about Berenson's views of art history. Because Gardner was not a professional writer, her intentions are harder to tease out from her correspondence. "Mrs. Gardner's certainty that her sensibility should be forever evident in the museum suggests a peculiar kind of intellectual humility more than vanity: that this should always read as one woman's view of things."[74] According to one story based upon a destroyed diary, she would lie on a bearskin rug, imagining herself Europa.[75] The fabric she chose to set off Europa was silk from a dinner dress.[76] Maybe that shows her proto-feminist interpretation of the picture, but perhaps she was being economical. In old age, she feared poverty.

Collectors like Gardner can transform themselves when they identify with previous owners of their works of art. And we museum visitors may also change if we imagine ourselves becoming that collector whose art we have come to visit. We might thus speak of the metamorphoses of collectors, art historians, and museum visitors. "To create a self is to succeed in becoming *someone*, in becoming a *character*, that is, someone unusual and distinctive."[77] Consciously modeling himself upon Marius the Epicurean, Berenson transformed himself into something like a work of art. And in thus practicing the art of living, Berenson provided a model for museumgoers. When we visit grand collections, privileged to enjoy precious objects as if they were our possessions, we too metamorphosize. Robert Coles describes a working-class boy who "delighted in imagining himself lord and master of" the Gardner.[78] Entering the Gardner collection, you too can momentarily have the illusion of becoming a friend of Mrs. Gardner if you are willing to play that role.

Earlier we were concerned with the way that visual works of art can extend your identity by allowing imaginative time travel. Here we are interested in how they can allow you to imagine becoming a different sort of person. At the movies the hero is in danger and we, identifying with her as we eat popcorn, are afraid. She triumphs, and so we also are pleased.[79] In playing this game we do not, of course, confuse ourselves

with the beautiful actor—when we enter the Gardner we do not really believe that we have become Gardner. But when we walk up the stairs to see her Rembrandt *Self-Portrait* on the second floor or go up another floor to see *Europa*, then her house has momentarily become our dwelling. Enjoying art can be an aesthetic activity in which we ourselves become like artworks. People who make collecting their ruling passion may define themselves in terms of the objects they gather. S. N. Behrman posits, "It would be gratifying to feel, as you drove up to your porte-cochere in Pittsburgh, that you were one with the jaded Renaissance Venetian who had just returned from a sitting for Titian."[80] When these collectors open their museums to the public, if we identify with them, we too define our identity with reference to these precious objects. David Ross, former director of the Whitney Museum, played this role in the Frick Museum: "Walking by the Vermeer in the hallway on the way out, I thought it was the greatest little thing: 'And here's my Vermeer. I'm going to put on my coat, check my tie, and look at my Vermeer, and I'm going to go out and have dinner.'"[81] And John Walker, director of the National Gallery, Washington, described a similar experience: "When the doors are closed a metamorphosis occurs, and the director or curator is transformed into a prince strolling alone through his own palace with an occasional bowing watchman accompanied by his dog the only obsequious courtier."[82] Of course such identifications may fail. Reflecting on the ruthlessness of Henry Clay Frick, I sometimes wonder if collecting old master art is worth its human price. Just as I may find a movie dispiriting because I despise the hero, so a collection may put me off. The brochure given to Gardner visitors notes that Gardner wanted a setting "that would encourage visitors to develop their own 'eye for art.'" True enough, but we see her collection on her fixed terms, with *Europa* too high and too far from the window. The generosity of the rich is not usually democratic.

Berenson's art writing identified and interpreted valuable old master paintings but it did not suggest how to display them. Gardner's museum was her personal creation, charming because, as Kenneth Clark notes, "it represents perfectly the cultural ambitions of the 1890s—artificial, backward-looking, contemptible to the modern-minded."[83] A memorial to a period style, like the Gustave Moreau Museum in Paris and other private collections now open to the public, her fascinating house is very closely linked to its creator. "At worst, the effect can be narcissistic, self-

ish, and shallow. At best, a place like the Gardner confronts its audience with complex relationships between private experience and public history."[84] When visiting the Louvre, by contrast, you are in a large space designed for public access. Few visitors entering the Grand Gallery imagine themselves encountering Louis XIV. But once you read about the Louvre's history and intricate relationship with the monarchy, Napoleon, and French politics of the nineteenth century, then, as we have noted, your experience is subtly changed.[85] You learn, for example, that in the Salle des Caryatides Molière's *Le Docteur amoureux* was first performed for Louis XIV on October 24, 1658; that in the Salon Carré the 1760s salons, the subject for Diderot's art criticism, were held; and that in the Salle des Empereurs the paintings and sculptures looted by Napoleon were gathered to be admired by the Parisians.[86] In an often retold story, just before Cardinal Mazarin's death his secretary the duc de Brienne overheard him remarking that he would soon no longer be able to enjoy his collection: "Good-bye, dear pictures that I have loved so much, which have cost me so dear!"[87] Since some of Mazarin's paintings remain in the Louvre, it is possible to identify with him. "Did he fear he was headed for Hell or did eternal happiness seem to him a mere trifle beside the joys his art had given him?" Garmain Bazin asks.[88] At any rate, like Gardner, he was a real art lover.

The history of art museums and their commentators is defined, I am suggesting, by a sequence of identifications. *Europa* shows a metamorphosis. Pater identified with Winckelmann; Berenson, who sold the painting to Gardner, identified with Pater's Marius. We museum visitors, finally, in identifying with Gardner and the other collectors who organized the great American public creations, are able to imagine ourselves the proud possessors of the art that we see. Titian's *Europa* thus is appropriately associated, to allude to my epigraph at the start of this chapter, with the belief that human identity itself can be multiple.

Ernest Fenollosa's History of Asian Art

Shall I be able to conduct you through this vast Cyclopean edifice . . .
this enormous pile . . . that resembles nothing which has ever yet ap-
peared in France or England or the world? One of those vast palaces, it
is, of Oriental dream, gigantic, endless, — court upon court, chamber
on chamber, terrace on terrace, — built of materials from the east and
the west and the north and the south. . . . guarded by monsters winged
and unwinged, footed and footless. . . . a giant dreamland, but still
barbaric, incoherent, barren! — JAMES HUTCHINSON STIRLING

Walking clockwise around the main floor of the Cleveland Museum of
Art, you trace the history of art from the Egyptians and Greeks, on
through the Middle Ages to the Renaissance. And then after passing the
original main entrance, you arrive at the Baroque gallery and go on to
modernism and contemporary art in a trajectory that takes you back to
your starting point. European tradition is thus presented in one continu-
ous narrative.[1] But that is not the whole story presented in Cleveland.
Sherman Lee, the most famous director, was a specialist in Asian art. "We
can never see a Chinese work of art as a Chinese does; much less can we
hope to know it as it was in its own time. . . . But here are thousands of still
meaningful and pleasurable works of art, part of our world heritage —
and we should not permit them to be withheld from us by philologists,
swamis, or would-be Zen Buddhists."[2] Cleveland's collection is down-
stairs in part because there is no ready way to fit Indian sculpture and
Chinese scroll paintings into the narrative of European art.

Walking through European galleries, coming across an unfamiliar
painting, you see where it belongs in this sequence. You see the history
of art unfolding. But when you enter Asian galleries, then probably your

experience is different. Is this obsession with progress, a European ideal, a way of marginalizing non-Western art? "The essence of Orientalism is the ineradicable distinction between Western superiority and Oriental inferiority," Edward Said writes.[3] We want to avoid cultural chauvinism. Chinese critics are said to be unable to tell apart European paintings that a trained Westerner finds it easy to distinguish.[4] Maybe our inability to see Chinese art as having a proper history merely reflects similar provincialism.

Ernest Fenollosa (1853–1908), born just twelve years before Bernard Berenson, was the first American to write interestingly about Asian art. Son of a Spanish émigré musician and a woman from Salem, Massachusetts, he learned about European art at Harvard College from Charles Eliot Norton. Like Walter Pater, Fenollosa was inspired by Hegel—he studied the *Logic* at college. And thanks to another Harvard man, the zoologist Edward Morse, in 1878 he became professor of political economy and philosophy at the University of Tokyo.[5] His timing could not have been better for Japan, having suddenly taken an interest in Western culture, momentarily turned away from its own artistic tradition. The absence of a vital indigenous aesthetic theory made Fenollosa's lectures popular.[6] Isabella Gardner and other Bostonians visited him.[7] As Berenson persuaded rich Americans to purchase Italian Renaissance art, so Fenollosa showed collectors why they should take an interest in Oriental art. He assembled cheaply an important collection that was purchased and donated to the Boston Museum.[8] And he advised Charles Freer, whose weighty holdings now are in the Smithsonian Institution, Washington, D.C.[9] Fenollosa's writings vividly communicate his excitement. "Perhaps the most powerful aesthetic grip that will seize the astonished traveler in Japan will burst upon him as he . . . enters the broad open doors of Kakushiji's Kondo and faces the forth-food breadth of the great stone altar with its trinity of colossal statues in shining black bronze," he wrote.[10] "It does not seem extravagant," he added, "to say that its aesthetic value would alone repay a student the whole time and expense of a trip from America to Japan."[11] It is easy to understand why he was a very successful lecturer.

Nowadays we distinguish between art dealers, curators, and academic historians, but in the late nineteenth century these dividing lines were not yet clear. Comparing the careers of Fenollosa and Berenson is reveal-

ing. Berenson, relatively free to export Italian art, worked closely with dealers. In Japan, by contrast, once Fenollosa inspired a serious indigenous revival of interest in tradition, export of masterpieces like some paintings he sent back to Boston was forbidden. Berenson described an October 26, 1894, visit to the Museum of Fine Arts, Boston, where he discovered that the twelfth-century Chinese paintings "had composition of figures and groups as perfect and simple as the best that we Europeans have ever done." [12] He collected Asian art but never wrote seriously about it. Because of the important trade connection with Japan, it was natural for Boston to take a lead among American cities in the collecting of Asian art. But even so late as 1895 a local writer dismissed the sculpture of China and Japan. [13] Art of Asia thus was a relatively late addition to the museum. Warren Cohen explains, "While employed by the Boston Museum of Fine Arts, Fenollosa assembled, installed, catalogued, and exhibited an extraordinary collection of Japanese art. The collection and his lectures and writings stimulated interest in Boston and everywhere else he spoke." [14] Thanks in large part to him, by 1929 the museum owned 92,467 Chinese and Japanese works of art. [15]

In 1890, aged thirty-seven, Fenollosa returned to America to write and lecture. His discussion of Chinese and Japanese literature, so Ezra Pound claimed, was "the basis for a new donation, for a new understanding of 'the East.' " [16] Pound thought that Fenollosa offered "a universal scheme or logic of art" which "as easily subsumes all forms of Asiatic and of savage art and the efforts of children as it does accepted European schools." [17] Fenollosa's analysis of the Chinese language was unsound, but his art historical writings remain of value. His great pioneering survey, *Epochs of Chinese and Japanese Art: An Outline History of East Asiatic Design*, has many plates but no proper scholarly apparatus, with only a few notes and some references to other scholars: "We are approaching the time when the art work of all the world of man may be looked upon as one, as infinite variations in a single kind of mental and social effort. . . . A universal scheme or logic of art unfolds, which as easily subsumes all forms of Asiatic and of savage art and the efforts of children as it does accepted European schools." [18] Published posthumously in 1912, it was meant to be one part of a universal world art history.

J. M. Roberts's *The Pelican History of the World* is a universal survey. [19] Creating the art historical equivalent, a narrative history of world art, an

analysis that includes all cultures, has proven difficult.[20] Explorers from other cultures traveled very extensively before Columbus, but they did not create a world system.[21] But starting in 1492, every place became part of one unified culture. Fernand Braudel writes, "It was from all over the world . . . that Europe was now drawing a substantial part of her strength and substance. And it was this extra share which enabled Europeans to reach superhuman heights in tackling the tasks encountered on the path to progress."[22] The 1992 exhibition *Circa 1492: Art in the Age of Exploration* showed art of many societies not as yet in contact.[23] The arts of Asia are the product of cultures as complex as the West but with an essentially independent development. "Here was . . . a civilization virtually known to the West," Lawrence Chisolm writes, "a civilization which had risen, flourished, and declined, its artistic height a match for anything produced in Western history."[24] It has a continuous artistic tradition, "The China that is a world power today is the direct descendant of Neolithic, proto-Chinese cultures established in the Yellow River valley more than four thousand years ago." And so a history of Asian art required radical extension of traditional art historical narratives.[25] Berenson's aesthetic, adapted from Walter Pater's *The Renaissance*, extends a long heritage going back to Vasari. For Fenollosa, by comparison, there were no models in European languages for his history.

As long as Europe has been in contact with Asia, there was trade.[26] Baron Denon's personal collection included pre-Columbian and Oceanic art, "art of savages" as it was then called.[27] But not until late in the nineteenth century was non-European art displayed in public museums. The time will come, Fenollosa wrote, "when it will be considered as necessary for a liberally educated man to know the names and deeds of man's great benefactors in the East . . . as it is now to know Greek and Latin dates and the flavour of their production."[28] The nineteenth-century rediscovery of medieval European art and the more recent revival of the baroque filled what in retrospect appeared an obvious gap in the story of European art. But adding non-European art to the museum proved more difficult because its visual relationship to the existing collection was unclear. Arthur Danto described his shocked reaction to an exhibition of Japanese art. "I recall the almost cleansing impact of those clear forms and pure designs and light, unlabored atmospheres. I also recall the almost visceral revulsion I felt for the canvases of the High Venetian period

I walked past upon leaving the Japanese show: they seemed indecently *fat*."[29] Since Asian painting looks very different from European art, how should it be presented within the museum?

Some writers believe that, appearances notwithstanding, all art shares deep values. If this way of thinking is correct, then the museum should show Eastern and Western art in one unified narrative. Rudolf Arnheim, for example, says that in Piero della Francesca's *Resurrection* Christ "is located at the center of the picture, and his position is strictly frontal — that is, symmetrical. . . . The resurrection is not interpreted materially as a transition from death to life. . . . Piero's picture sets the unrest of temporal material life in opposition to the monumental serenity of Christ, who, as the top of the pyramid, rules between life and death."[30] If such principles of visual order are universal, then art of all cultures is transparently available to us.[31] You do not need to know who Christ is to understand Piero's picture. Roger Fry, similarly, claimed that "Chinese art is in reality extremely accessible to the European sensibility, if one approaches it in the same mood of attentive passivity which we cultivate before an Italian masterpiece of the Renaissance, or a Gothic or Romanesque sculpture."[32] Italian art shows the Virgin, while Chinese painting "may represent some outlandish divinity, but it is expressed according to certain principles of design and by means of a definite rhythm." And in an African fetish, "the vivid gesture of the hands holding the bowl, the head bowed forward with infinitely patient resignation, and the strange melancholy of the almost unseeing eyes: everything here — even the most surprising distortions — hangs together and co-operates in the realization of the idea."[33] Underneath their obvious and dramatic surface differences, he claims, all visual cultures really share the same values.

Were this ecumenical view correct, then the introduction of non-European art into the museum would raise no problems. But neither Arnheim nor Fry offer any convincing argumentation for their obviously counterintuitive position. If, on the other hand, non-European art possesses aesthetic values quite different from Western painting, then it might be inaccessible in our museums. " 'Art in India,' and 'art' in the modern world mean two very different things. In India, it is the statement of a racial experience, and serves the purposes of life, like daily bread."[34] Seen by Europeans, much non-European art has obviously exotic fea-

tures.[35] Persian carpets were made for prayer, and so turning them into domestic decorations destroys their intended function.[36] Since there were no public art collections in non-Western cultures, however we display their art we are imposing our standards. In the Philadelphia Museum of Art, for example, Rogier van der Weyden's *Crucifixion Diptych* is juxtaposed with Islamic carpets of the same era, the reds of the painting picked up by those in the rugs.[37] The visual effect is very striking, but of course these works of art have nothing in common. When Italian and German art circa 1500 is displayed in one gallery, we see revealing stylistic contrasts between cultures aware of one another. But adding Indian sculpture or Chinese painting would hardly be satisfactory. There are points of contact between Europe and India, Africa, and Islam, and so it would be possible to selectively add artifacts from these cultures to the older narratives.[38] But that procedure fails to respect the autonomous historical development of these visual cultures.[39]

Western historians can effectively describe Asia. John King Fairbank's *China: A New History* (1992), for example, treats that country as a self-sufficient culture whose identity has remained sufficiently stable to treat its development as a unit from Neolithic times to the present. Tracing the heritage of Confucianism into the 1980s, he links "Mao's sinification of Marxism . . . with the failure of Taiping Christianity. . . . The early Buddhist missionaries ran into the problem that has faced all purveyors of foreign ideas in China ever since: how to select certain Chinese terms . . . and invest them with new significance without letting the foreign ideas be subtly modified, in fact sinified, in the process."[40] Chinese painting has not yet received "the attention it merits," James Cahill claimed, because it has not been sufficiently collected or reproduced in the West.[41] But as he then admits: "while many of the artistic problems dealt with by the Chinese painters were essentially the same ones that have occupied Occidental artists, modes of representation and expression were often very different." Michael Sullivan says that for Chinese landscape painters visible forms are outward manifestations of the Tao. Cézanne only showed visual sensations but the Chinese "intuitively felt these same forms to be the visible, material manifestations of a higher, all-embracing Reality: the Word made—not flesh—but Living Nature."[42] That description makes Chinese art seem exotic indeed. T'ang Chih-ch'i

(1579–1651) defines *i* ("free" or "untrammeled") with reference to "the wonders of landscape (painting, the antique, the arresting, the fully realized, the harmonious) — these qualities are easy to identify. Only the term *i* is extremely difficult to analyze. . . . there may be a pure *i*, an elegant *i*, a refined *i*, a subtle *i*, a profound *i*. . . . nothing has ever been *i* and murky, *i* and vulgar, *i* and indecisive or base."[43] He also seems to come from another world, as when he writes, "Painting perfects culture and promotes right relationships; it exhausts all the divine transformations (in nature); it fathoms the abstruse and the subtle, attaining everything accomplished by the Six (classic) Arts, and makes its circuit with the four seasons."[44] Insofar as these claims are very difficult for nonChinese readers to grasp, can we really understand Chinese art?

Most writers agree that European and Asian art exemplify dramatic different aesthetics. According to Lee: "The preconditions for landscape include a non-anthropomorphic nature philosophy. . . . In China nothing occurred to seriously interrupt or reverse the steady growth of a generally accepted philosophy of nature that provided a perfect climate for great landscape painting."[45] That suggests that Asian and European art are essentially different. Danto writes, "We cannot take over the moral beliefs of the East without accepting a certain number of factual beliefs . . . that such a system of moral beliefs presupposes. But the relevant factual beliefs cannot easily be assimilated to the system of beliefs that define the world for us."[46] Analogously, perhaps we cannot fully appreciate Chinese painting without adopting Daoist or Confucian beliefs. Art in China and in the West serves different functions. According to Jacques Gernet, Chinese religious life "contained nothing in the nature of what we Western people of today would call religious sentiment. That is to say, that any kind of dialogue between Man and God, or mystical outpourings addressed to a personal deity, are entirely foreign to it."[47] And that means that this Asian art is very unlike ours. "The aim of most religious acts was either to regulate Space, to keep it literally in place . . . or to regulate Time, inaugurate it, renew it. . . . religious beliefs and practices seemed to express a lay conception of the world rather than that duality between the sacred and the profane that is so familiar to us."[48] This cultural difference explains why Christian missionaries had difficulties making converts. Craig Clunas reports, "The crucifixion, a central

moment of human and divine history to the Jesuits, which they had to explain to potential converts, was a distressing scene which Chinese artistic canons refused to admit as a subject of art at all."[49] Religious differences define dramatically different styles of art making.

Museums generally present European painting in historical hangings because the tradition running from Giotto to Constable defines a sequence with a self-evident visual order. Older European art writing treats the history as the story of progress in illusionism. Developed in antiquity by Pliny, and revived by Vasari, this way of thinking was influentially reworked by Ernst Gombrich.[50] Can a similar historiography be developed for Chinese art? Gombrich writes, "The Chinese consider it childish to look for details in pictures and then to compare them with the real world. They want, rather, to find in them the visible traces of the artist's enthusiasm."[51] Gombrich's *Art and Illusion* tells the story of figurative art in Europe. If China also has such a tradition, it starts before the Renaissance, and does not break in the Middle Ages. The Chinese may use different schemata for the development of illusionism, or what Gombrich calls making and matching. But if they also achieve naturalism, then they also must modify schemata in a slow step-by-step process. If Asian art also has such an ordering, then it should be displayed in separate historical hangings.

Gombrich's sophisticated systematic analysis places the paintings of Giotto, Masaccio, Piero, and their successors in sequence. Set European paintings alongside roughly contemporary Chinese artworks.[52] The difficulty of such comparisons suggests that there is no real equivalent to Gombrich's history in China.[53] In order to have a tradition, artists must have some common goal.[54] And what gives especial value to art that progresses is that "the artist . . . is automatically taken out of the social nexus of buying and selling. His duty lies less with the customer than with Art. He must hand on the torch, make his contribution; he stands in the stream of history—and this is a stream which the historians set in motion. . . . The idea of progress brings in an entirely new element."[55] Gombrich contrasts the medieval ideal of the craftsman with a Renaissance way of thinking which defines, still, our Western conception of the artist. "From Florence to Rome, from Rome to Paris, from Paris to New York, the problems of interest might change from realism to expression

or the articulation of the unconscious, but the momentum of the revolution that started in Florence was never spent. Deep innovation gives grand success in the marketplace for craftsmen and artists alike."

But China too had an art market. "In Rome, Nanjing, Yangzhou and Amsterdam in 1630," Clunas notes, "a contemporary painting was often a discrete physical entity. It could be, and was, moved about. Whatever transactions brought it about, which might involve money, it was in both cultures equally a potential commodity, enmeshed in market relations."[56] These cultures shared mercantile values. The calligrapher Song Lian (1310–81) said: "If there were no writing there would be no means to record things; if there were no painting there would be no means to show things. . . . Thus I say that writing and painting are not different Ways, but are as one in their origin." Here we find echoes of familiar European debates. "It was not innovation as such that counted," Gombrich says in refining his analysis, "but systematic progress towards the goal of *mimeses*. . . . It was in this respect that 'art' became approximated to science: both were capable of demonstrable solutions to problems."[57]

Progress was valued because Europeans wanted to know more than their ancestors did. "For many centuries . . . painting was regarded as *the* cumulative discipline."[58] Indeed, "the history of technological progress and of scientific advance is . . . to some extent the history of rational choices within an open society."[59] And Gombrich introduces a broader discussion of cultural differences. "Some idea of progress . . . is inseparable from the Open Society. . . . Its champions, therefore, can be forgiven when they look with exasperation at their opponents who fight for the status quo at any price." In Europe illusionistic art, experimental science and democratic politics are linked together. China, by contrast, never created Western-style science or democracy.

Chinese art historians seem not to have developed a systematic analysis of these issues. Sometimes they do make cross-cultural comparisons, as Susan Bush does here: "In the West, poetry and painting tended to be compared in periods of pictorial realism. . . . Poets . . . envied the painters' descriptive power. Chinese painting always strove for the status of poetry, not of science. . . . most Chinese art critics remained consistent in their low estimate of formal likeness."[60] And they do discuss one revealing example, the art Jesuits brought to China. James Cahill writes, "The European artists were not, to Chinese eyes, very good at

depicting landscape. Their portraits and paintings of the Virgin might seem dazzlingly real, like images in a mirror, but their pictures of rocks and trees and mountains, which demanded more than illusionistic technique, cannot have seemed very convincing as representations. Any good Chinese artist, drawing on his native tradition, could have painted rocks that looked more like rocks in nature than these."[61] Possibly the Chinese merely found European paintings unfamiliar. But maybe the Chinese thought that their art offered an alternative to European naturalism. Michael Sullivan writes, "What the Chinese artist records is not a single visual confrontation but an accumulation of experience touched off perhaps by one moment's exaltation before the beauty of nature. . . . This kind of generalisation is quite different from that of Claude Lorrain and Poussin, whose idyllic landscapes deliberately evoke a long-forgotten golden age."[62] The goals of Chinese and European painters are too different to permit proper comparison.[63]

Now and then in histories of art in China there are references to progress.[64] But on the whole Chinese historians do not focus on that concern.[65] Yu Shao-sung (1931) summarizes Chinese tradition: "Our country has never possessed any true history of painting and calligraphy [that] narrates the whole development of different schools through the ages and describes their success and failure, rather than only recording the practice and behaviour of the painters and calligraphers."[66] What alternative would then be possible for an historian of Asian art? The older English-language histories of Chinese painting do not answer this question.[67] The six-volume *Chinese Painting: Leading Masters and Principles* by Osvald Sirén, for example, lists names of many artists, describes many individual works, and identifies various period styles. But it is not a proper history. And Wen Fong opens his history of Chinese painting from the eighth to the fourteenth centuries by remarking: "Anyone who looks at a fourteenth-century Yüan dynasty (1279–1388) literati . . . landscape painting knows that what he is seeing is a totally changed world form that portrayed in the monumental landscape images of the early Sung dynasty (960–1279). . . . To chronicle and somehow explain this phenomenon is the purpose of this book."[68] It might seem that he means to offer a history. But then he adds: "there is a critical difference between the Chinese approach to painting and the Western approach. . . . Western pictorial representation was directed at once toward the conquest of

realistic appearance. . . . Pictorial representation for the Chinese, on the other hand, attempts to create neither realism nor ideal form alone." If Chinese art is not much concerned with realism, then what history can it have?

The best solution to these dilemmas was adopted by Fenollosa. Seen superficially the subjects of the West and Asia look different, for Western art expresses a Christian worldview, while the art of Asia presents Buddhist doctrines. But ultimately the arts of the two cultures were essentially similar, for both are forms of cultural expression. Fenellosa championed the art of Asia by using Hegel's philosophy. His strategy will seem less paradoxical if we realize that in the late nineteenth century Hegel's ways of thinking provided an accessible lingua franca for art writers.[69] To understand Fenellosa's starting point, look not at Hegel's writings or the modern commentaries on them, but at popularizing discussions from the nineteenth century.[70] Like Jacques Lacan today, Hegel was used in personal ways.[71] He gave historians license to speculate. "An artist . . . understands himself (and is understood by others in his community) *as an artist* to the extent that he understands his activity to be a reflection on that which the community takes as definitive for itself. The artist is *reflective* about the truth of what is ultimate for his community."[72] That theory could be readily adapted to any culture.

According to Hegel, art is one essential way that a culture expresses itself. Among the ancient Egyptians, for example, "the soul of the statue in human form does not yet come out of the inner being, is not yet speech, objective existence of self which is inherently internal,—and the inner being of multiform existence is still without voice or sound, still draws no distinctions within itself, and is still separated from its outer being, to which all distinctions belong."[73] Hegel had a relatively circumscribed knowledge of visual art, believing that Africa had no history, and so no art worth notice, and that Chinese art "never get beyond formlessness" because Chinese "religious ideas [are] incompatible with any real artistic formulation."[74] He took an interest in Dutch painting and visited Holland. But, although he wrote evocatively about entering Venice, that account was cribbed from guidebooks, for Hegel never got to Italy. He did visit the famous museum in Dresden. But there was no public gallery in Berlin, where he taught, until August 1830.[75]

Notwithstanding these limitations of his experience, Hegel had a

vision of art history. He "came to see that he needed a universal or world history if he was to be able to make his claims about the absolute, self-grounding structure of modern life work."[76] And so it is natural to extend his aesthetic to a theory of world art history. Hegel made disparaging remarks about non-Europeans: "The Chinese, Indians, and Egyptians, in their artistic shapes, images of gods, and idols, never get beyond formlessness as a bad and untrue definiteness of form. They could not master true beauty because their mythological ideas, the content and thought of their works were still indeterminate, or determined badly, and so did not consist of the content which is absolute in itself."[77] He claimed that China had no history. "The *Sun*—the Light—rises in the East," and this symbolizes the course of history. "The History of the World travels from East to West, for Europe is absolutely the end of History."[78] But Fenollosa extended Hegel's aesthetic of cultural expression while dropping his view of the superiority of European art.

According to Terry Pinkard, the artist presents "the truths of a part of the culture. These 'truths' need not cohere with each other; they may be mutually exclusive."[79] And so let us include in the museum not only medieval European sculpture, but also art from other cultures. For Hegel, works of art, not just attractive decorations or precious commodities, express the inner life of a culture. Significant art is part of the evolutionary development of the World Spirit, which comes to fullest self-awareness when scholars understand this art; and all art expresses its culture. "With Hegel one needs to remain fairly flexible in one's attitude, sometimes following his theory as if it were a fairy story—the mind and its adventures in the world of raw matter—but then the images resolve themselves into sharply focused thought."[80] When non-European art was added to the museum, scholars like Fenollosa could still hold onto his basic expressionist analysis.[81] Maori carvings, African masks, Persian carpets and pre-Columbian sculpture express the values of these cultures in the way that classical Greek carvings express the world of Apollo and Venus.

Rejecting the concern of earlier scholars with "study of literary sources" rather than "art itself," Fenollosa presents a full history of Chinese, Korean, and Japanese art.[82] Denying that the Japanese merely copied Chinese art, he provides a full account of the creative periods of both cultures set in social and political context, writing, "Our plan is to take the most creative and dominant work of a period and describe it."[83]

Earlier accounts looked at the materials of Asian art. By contrast, Fenollosa "conceives of the art of each epoch as a peculiar beauty of line, spacing, and colour which could have been produced at no other time."[84] Nowadays most histories of Japanese and Chinese art do not make reference to Hegel. Fenollosa says: "If Hegel's theory that all forms of existence tend to pass into their opposites needed historical confirmation, a better example could not be found than what happened to Japanese society in the twelfth century."[85] And when he describes the role of Zen Buddhism in China, he calls its view of nature "a sort of independent discovery of Hegelian categories that lies behind the two worlds of object and subject."[86] These remarks mark his distance from the present. As a true Hegelian, Fenollosa was essentially concerned with progress. In Asia and Europe religion and so also art develop. "Buddhism, like Christianity—and unlike Mohammedanism—has been an evolutionary religion, never content with old formalisms," he wrote.[87] Fenollosa inherits Hegel's Orientalist tradition. Art in the West and East has distinct developmental patterns because the Islamic world holds them apart.

Like Berenson, Fenollosa was a connoisseur whose writing provided a guide for collectors: "Art is supreme beauty, and thus is essentially epochal. The long weak periods . . . merit only passing notice. . . . Art is like a great island world, of which all but the tall peaks are submerged below a very useful sea of oblivion."[88] Many details in his account have not withstood the test of time. For example, the hypothesis that there is a link between early China and the art of Australasia, creating a "Pacific School of Art," is no longer accepted.[89] Fenollosa is an important pioneering writer whose interpretative manner now reveals a period style.[90] In principle *Epochs of Chinese and Japanese Art* aims to develop a parallel history, showing how this painting and sculpture developed within its own culture. In practice, however, Fenollosa frequently supports his analysis by parallels with the development of European arts.

The figure in Freer's *Standing Zkwannon*, a copy of a painting by Wu-Tao-tzu, looks like "the Sistine Madonna of Raphael."[91] Hangchow, the great Chinese art center near Shanghai, "was a sort of splendid Venice."[92] And the trees of the Japanese master Geimai "have an atmospheric breath like that of the modern Frenchman, Corot."[93] Sesshu's draftsmanship is compared with "the masculine breadth of Rembrandt and Velázquez, and Manet, the brush work of Sargent and of Whistler. . . . The near-

est actual touch to it in Western work is the roughest split quill draw-
ing of Rembrandt."[94] Sometimes his comparisons extend to parallels
between Western and Asian religion, as when Zen Buddhism is com-
pared to "the Swedenborgian doctrine of 'correspondences' " or God the
Father with "the Chinese 'Emperor of Heaven.' "[95] China develops more
quickly than Europe, in a history Fenollosa understands with reference to
Western parallels. "The Wordsworths of China lived more than a thou-
sand years ago."[96]

Cross-cultural comparisons reappear also in recent commentaries. For
example, Wu Hung introduces his account of the screen in Chinese
painting with reference to Roman Jakobson's distinction between "the
metonymic and *metaphoric* . . . two different devices or operations in
language."[97] Using that analysis, he makes a broad contrast between
European and Asian art: "While the Renaissance visual mode dwells on
a symmetrical relationship between the natural world and its pictorial *re-
presentation*, the dominant mode in Chinese painting is asymmetrical and
emphasizes the metaphorical linkage between painted images and the
observed world and between painted images themselves."[98] When, simi-
larly, Clunas introduces his account of early modern Chinese pictures, he
offers an elaborate critique of any "neat binary West/East dichotomy."[99]
After presenting Donald Preziosi's political critique of Western art his-
tory, he is ready to discuss Ming dynasty pictures.

Such comparisons are inevitable because a writer needs both to identify
an exotic tradition and to show its similarities with what is familiar. Just
as art historians introduce Asian painting with reference to familiar con-
cerns of European art, so in *The Chinese Cookbook* Craig Claiborne and
his coauthor Virginia Lee explain Chinese cooking by reference to famil-
iar traditions. They describe "regional cookery of China," for example,
with reference to contrasts between "North and South Italian cookery"
and what they call the three domains of France: "butter, oil and fat."[100]
Similarly, in her *Classical Indian Cooking* Julie Sahni explains the variety
of regional cuisine in Hegelian terms: "Indian food is the reflection of the
heritage of its people. It represents its historical development, religious
beliefs, cultural practices, and above all, its geographical attributes. . . .
The unifying factor that brings all these varied cuisines under the heading
of 'Indian food' is the ingenious way that fragrant herbs and amalgama-
tion of spices are used in all the regions."[101] Chinese art, analogously,

though very different from Europe's, is similar enough to belong also in the museum.

Ironically the real limitation of Fenollosa's history is that it is insufficiently Hegelian. In his *Aesthetics* Hegel develops a highly suggestive theory of Christian art. "The true content of romantic art is absolute inwardness, and its corresponding form is spiritual subjectivity with its grasp of its independence and freedom."[102] Christian art expresses its culture not merely in the subjects it depicts but also, and more essentially, in its choice and employment of its media. Painting "becomes a reflection of the spirit in which the spirit only reveals its spiritual quality by canceling the real existent and transforming it into a pure appearance in the domain of spirit for apprehension by spirit."[103] The nature of Western art is bound up with Christian beliefs about a deity who exists apart from the world in which His incarnated Son came to redeem sin. A truly Hegelian theory of Asian art would need, analogously, to relate its media to the worldviews of those cultures. The Chinese, Fenollosa says, added a new writing material, paper, black ink, and hair pencils. This new medium replacing bronze, stone, and wood allowed "freer images conceived first in terms of separated and highly decorative lines."[104] But he doesn't explain how this medium affects the spiritual content of Asian art. For Hegel, it has been said, "philosophy mediates between the concrete embodiments of human historical existence represented in specific histories as a content for which it seeks to find an adequate form of representation and mode of emplotment."[105] The trouble with Fenollosa's Hegelian history is that it fails to find an adequate representation and mode of emplotment for Asian art.

Fenollosa never discusses Buddhist theology in any detail. On the standing Buddha at Horiuji, he says, "the finest feature was the profile view of the head, with its sharp Hanhose, its straight clear forehead, and its large—almost negroid—lips, in which a quiet mysterious smile played, not unlike Da Vinci's *Mona Lisa*'s. Recalling the archaic stiffness of Egyptian Art at its finest . . . In slimness it was like a Gothic statue from Amiens."[106] In his account of Japanese Buddhism, he remarks: "Athens and Florence were frankly pagan. Loyang and Hangchow were half-pagan. But the Kioto of Engi practically worshipped in one vast temple."[107] He does not say much about Buddhism in itself, but compares Japan to Europe in the time of Charlemagne and Pope Leo

the Third. His stylistic analysis says nothing about the religious significance of this sculpture. In the end, his ways of thinking remain all too Eurocentric.[108]

The ultimate limitations of Fenollosa's history and the writings of his successors are reflected by our public galleries. In the Metropolitan Museum of Art, at the top of the grand stairway you can either walk straight ahead into the old master European collection or go instead to the right, to see the art of China, Korea, and India.[109] In the Museum of Fine Arts, Boston, the art of China, Korea, and Japan is on two floors, in a setting that does not emphasize historical development. In the Philadelphia Museum of Art, Asian art occupies its own wing on the second floor, above the American collections. In the Minneapolis Institute of Arts, which has an excellent collection but very awkward organization, the Asian collection is between twentieth-century European and American painting and sculpture and classical art. Smaller museums tend to set Asian and Islamic art in adjoining rooms. In the Saint Louis Art Museum, for example, the galleries for ancient sculpture lead to Islamic art and the section devoted to Chinese and Japanese art. In the Toledo Museum of Art, the gallery devoted to American art 1700–1900 leads to one room with Indian art and another with the arts of China, Korea, and Japan. In the Brooklyn Museum, the second floor includes art of China, Japan, Korea and also Islamic art.

Such smaller institutions display the same narrative as Gombrich's *The Story of Art*, which gives Chinese and Islamic art a chapter in the midst of the Christian Middle Ages: "Before we return to the Western world and take up the story of art in Europe, we must at least cast a glance at what happened in other parts of the world during these centuries of turmoil. . . . craftsmen of the West, who were not permitted to represent human beings, let their imagination play with patterns and forms."[110] Chinese and Islamic arts have little in common, apart from being non-European. But in a book, as in a museum, one needs a structure, however arbitrary. The start of this chapter described the introduction of Asian art into the museum as marking dramatic change. We need only look back to Denon's Louvre, where adding paintings by Giotto and other Italian "primitives" was a challenge, to see that public art museums have vastly enlarged their scope. But it is important, also, to note the limited changes actually produced by this expansion. In my many visits to

the Asian collections in Boston, Brooklyn, Cleveland, Kansas City, Los Angeles, Manhattan, Pasadena, and San Francisco, I have never encountered crowds. Judging by the tastes of its visitors, the American art museum remains Eurocentric. Introducing the art of China and Japan into the art museum has not changed the way that painting and sculpture is understood. Fenollosa did influence American art education through the teaching of his follower Arthur Dow.[111] But within the museum, Asian art remains a specialist concern, whereas European old masters are seen as leading to modernist abstraction. The number of historians with a serious knowledge of non-European art remains relatively small. Nowadays the international style, the manner adopted by ambitious artists from all cultures, is conceptualism, a Western style from the 1960s, which owes nothing to Asian art. In contemporary galleries, as in the museum more generally, European tradition dominates.

What might mark the coming of age of Asian art history is a study of Western art that made significant reference to Asian examples. And what would mark the coming of age of Asian art in the museum would be displays giving non-Western art as serious a place as the painting and sculpture of Europe and America. "Philosophy has really arisen only twice," Danto has noted, "once in Greece and once in India."[112] But while within English-language philosophy, the Greeks provoke serious ongoing discussion, Indian philosophical writing remains a concern only for specialists. In the 1950s, D. T. Suzuki's Zen Buddhism was much discussed in the New York art world. "The art historian of this era will have to assign Suzuki's lectures a primordial role in the era's cultural life," wrote Danto.[113] But those lectures had no significant lasting effect upon American art writing. Danto's *Mysticism and Morality*, notwithstanding its close sympathetic reading of Asian authors, is extremely pessimistic about the relevance of that knowledge for Western culture: "The factual beliefs [the Eastern writers] take for granted are, I believe, too alien to our representation of the world to be grafted onto it, and in consequence their moral systems are unavailable to us."[114] In visual art the situation is decisively different, for we can appreciate art of any cultures aesthetically, while knowing that such a way of thinking distorts its original intended significance. But here we return to the concerns of museum skepticism.

Inspired by *The Travels and Tribulations of Piero's Baptism of Christ*, let us imagine a similar painting telling the story of an Asian work of

16. *Burning of the Sanjo Palace, from the Illustrated Scrolls of the Events of the Heiji Era (Heiji monogatari emaki)* (detail). Japanese, Kamakura period, second half of the thirteenth century. Hand scroll, ink and color on paper, 41.3 × 699.7 cm (16 ¼ × 275 ½ in.). Museum of Fine Arts, Boston. Fenollosa-Weld Collection, 11.4000. Photograph © 2006 Museum of Fine Arts, Boston.

art. *Burning of the Sanjo Palace* (late thirteenth century; fig. 16), which Fenollosa attributes to Sumiyoshi Keion, shows the Japanese civil war. Lee describes it as a "masterful depiction of raging fire, turbulent crowds, and powerful chargers."[115] The Master of the London Piero's Travels tells the story of this picture's life in *The Travels and Tribulations of Burning of the Sanjo Palace*. Panel one presents the painting in its original setting. Japan took the Chinese narrative scroll and, making "of it a great narrative tool," used it to show exaggerated violent activity.[116] After conquering China, the Mongols tried to invade Japan, in expeditions illustrated in similar pictures. Panel 2 shows *Burning of the Sanjo Palace* being photographed in Japan in the early 1880s just before Fenellosa purchased this neglected picture. In panel 3, we see *Burning of the Sanjo Palace* making the long ship trip to America. Panel 4 presents it as seen by Fenollosa in

the Boston Museum of Fine Arts. Noting how the struggling figures show types "familiar to-day on the streets of Tokyo," Fenellosa compares a mosaic showing Alexander the Great at Naples, relating the composition to that in Degas's pictures of jockeys and "modern moving pictures," and the mounted knights to "the prancing steeds of Phidias' Pan-Athenaic frieze." [117] Fenollosa took the Japanese side in her war with Russia, believing that Japan preserved "the best in Chinese ideals." [118] Photographs of that war, he adds, give a less vivid idea "of the Japanese military soul" than does this picture. [119] Panel 5 depicts *Burning of the Sanjo Palace* in the new Asian galleries, where the painting again is relatively neglected, for most visitors focus on European art.

The Travels and Tribulations of Piero's Baptism of Christ shows how an Italian altarpiece became a famous London work of art. *The Travels and Tribulations of Burning of the Sanjo Palace* depicts the longer journey taking a Japanese scroll to America. *Baptism of Christ*, a sacred work, was taken to a museum. *Burning of the Sanjo Palace* underwent a different, more dramatic metamorphosis. In San Sepolcro, as in London, Piero's painting was set on the wall. Our Japanese scroll, by contrast, meant to be shown privately, is unrolled and set in a vitrine for public display. Just under half a meter high, it is seven meters long, and so any normal illustration shows only a small section. In describing imaginative time travel, old European paintings allow museum visitors to extend their identity. *Burning of the Sanjo Palace* imaginatively transports us into an exotic culture. Within Europe and America there is a great deal of continuity. Like our remote ancestors, we Americans and Europeans live within an essentially Christian culture whose political and cultural systems are the products of long development. But although Asian art thus is comparatively exotic, in some ways, the secular *Burning of the Sanjo Palace* speaks more immediately to our present concerns than *Baptism of Christ*. A secular person who loves violent Hong Kong movies might enjoy this scroll.

Much Italian Renaissance painting tells Catholic stories. A curator groups baroque paintings in one gallery to show their shared period style. By contrast, because Chinese scroll paintings, Indian statues and European oil paintings produced at the same time are not stylistically similar, juxtaposing them would create a confused exhibition. [120] European (and American) art, from fourth-century BC Athens to the present, is linked to a tradition of aesthetic theory running from Plato to Danto. When, by

contrast, we look at Buddhist or Islamic art, then the problems raised by museum skepticism become more serious. The distance of these cultures from ours is greater and so interpretation of its art is correspondingly more difficult. If it is difficult to know whether *quattrocento* Italian altar-pieces are preserved in the museum, what can we say about these non-European artifacts? Set in this essentially European institution, can non-European art survive? Even the most basic ways of defining the content of museums come from Europe. "It was in nineteenth-century Europe and North America that 'Chinese art' was created," Clunas writes.[121] Since Chinese (and Indian, Islamic, African, pre-Columbian, and Pacific Oceanic) ways of thinking are very different from ours, placing their artifacts in art museums invites misunderstandings.

Some analytic philosophers argue that competing, genuinely incommensurate worldviews are ultimately inconceivable. Translation is always possible, and so however different two languages are, their ways of thinking are mutually translatable.[122] Their claim can be applied to art. After visiting a show of European oil paintings, Cahill entered the Chinese "painting galleries and (was) shocked at how small and flat and hard to penetrate the Chinese pictures suddenly appeared, even to someone like myself who knew them well."[123] And "a noted Chinese artist and connoisseur," going through the National Gallery, Washington, D.C., "from Italian primitives to Picasso," complained "that the paintings all looked more or less alike, besides not exhibiting much variety in their brushwork."

If such initial mutual incomprehension might be succeeded by a more catholic vision of alternative art styles, then we have reason to be optimistic about the expansion of the art museum. Ultimately it ought to be possible for the arts of Asian to enter this institution created by Europeans on an equal footing. History gives us reason to be optimistic. European art history starts with Vasari, but within living memory medieval sculpture, Dutch portraits, and baroque paintings—art forms unknown to or scorned by him—entered the museum and became subjects for scholarly investigation. Why should that process not continue? The next two chapters discuss that question.

8

Albert Barnes's Foundation and the Place of Modernist Art within the Art Museum

America is . . . the country of the future, and its world-historical importance has yet to be revealed in the ages which lie ahead. . . . It is a land of desire for all those who are weary of the historical arsenal of old Europe.—G. W. F. HEGEL

In what envelope does modernist art arrive in the museum? It was not sufficient to say that modernism follows older art in strict chronological order. Many commentators argue that there is a break between earlier and later art. If they are correct, then chronological displays give a false unity to museum collections. Michel Foucault, for example, says that *"Déjeuner sur l'Herbe* and *Olympia* were perhaps the first 'museum' paintings, the first paintings in European art that were less a response to the achievement of Giorgione, Raphael, and Velasquez than an acknowledgement . . . of the new and substantial relationship of painting to itself, as a manifestation of the existence of museums and the particular reality and interdependence that paintings acquire in museums." [1] In the early 1860s, Michael Fried has plausibly claimed, "in order to secure the Frenchness of his own work—one of the chief imperatives of his enterprise at that time—[Manet] found himself compelled to establish connections of different degrees of explicitness between his paintings and the work of those painters of the past who seemed to him authentically French." [2] But notwithstanding these frequent allusions to earlier art, Manet does break with tradition. He painted for the museum—but Giorgione, Raphael, and Velázquez did not.

Philosophers distinguish between direct knowledge, what they call ac-

quaintance, and knowledge by description, which gives knowledge of history. As Bertrand Russell explains: "By a 'denoting phrase' I mean a phrase such as any one of the following: a man, some man, any man, every man, all men. . . . The distinction between *acquaintance* and *knowledge about* is the distinction between the things we have presentations of, and the things we only reach by means of such denoting phrases."[3] For example, I know about Rome circa 1956 by acquaintance, for I was there. But because Denon died long before I was born, I know him only by description. Analogously I understand directly visual art belonging to a living tradition, in the way I know what has taken place in my lifetime. But I know what is more distant historically, by contrast, only through a bookish act of reconstruction. This distinction between knowledge by acquaintance and by description points to a difference in kind between contemporary art and older works of art in the museum. I know Sean Scully's aesthetic by acquaintance because I know him. But because Piero is historically distant, I may legitimately wonder if I correctly view his paintings.

If this argument is correct, then there is a difference in kind between contemporary and older art. In any event, as we have seen, the claim that there is one story of art is controversial. Ernst Gombrich titled his survey history *The Story of Art* because he found enough continuity in the development of European painting from Cimabue to Constable and impressionism to speak of one tradition. The curator John Elderfield extends this way of thinking to modernism: "I had a painting teacher whose own teacher was taught by Sickert who was taught by Degas who was taught by Ingres, and so it went on. Despite everything, I confess to clinging to the idea that it is all one art school."[4] They believe that the story of European art presented in museums is a continuous narrative running from earliest times to the present. Matisse too took this view, as Jack Flam explains: "It would be wrong to think that there has been a break in the continuity of artistic progress from the early to the present-day painters. In abandoning tradition the artist would have but a fleeting success, and his name would soon be forgotten."[5] There is but one significant tradition, the entire history of painting. "Matisse . . . sought . . . restoration (or reparation) of the narrative element of fictional art as part of his attempt to repair the break with the past that modernism seemed to have created," Elderfield writes.[6] Even in the twentieth century a sufficiently

gifted artist could overcome the threatened break in the tradition. "To paint imperative pictures that gave to narration a commanding role . . . would be to rejoin modern art to the loftiest products of the Western tradition." If tradition be defined by narrative continuity, then what keeps it alive is such constant innovation.[7]

Narrative sentences are the hidden scaffolding holding together the public art museum. In the Museum of Modern Art, New York, for example, a decade ago you walked through an installation described by Clement Greenberg's canonical account of modernism: "I do not think it exaggerated to say that Pollock's 1946–1950 manner really took up Analytical Cubism from the point at which Picasso and Braque had left it when, in their collages of 1912 and 1913, they drew back from the utter abstractness for which Analytical Cubism seemed headed."[8] But it took a long time for the Modern to adopt Greenberg's way of thinking. "Everyone learned a lot at the museum," he wrote in 1957, "but you did not feel at home in it. [In the 1930s] Alfred Barr was . . . betting on a return to 'nature,' and a request of the American Abstract Artists to hold one of their annuals in the Museum was turned down with the intimation that they were following what had become a blind alley."[9] Barr's exhibition catalogue *Cubism and Abstract Art* (1936), for example, argued that "an 'abstract' painting is really a most positively concrete painting since it confines the attention to its immediate, sensuous, physical surface far more than does the canvas of a sunset or a portrait."[10] Unlike Greenberg's account, that analysis hardly prepared you to appreciate Jackson Pollock. And in 1946 Barr claimed that Peter Blume's minor *The Eternal City* anticipated *Guernica*.[11] Compared with the single-minded Greenberg, Barr, the most influential American curator of modernism, made some dubious claims and sometimes had shaky taste.[12]

Both Barr and Greenberg played an important role in establishing a place for modernist art in the museum. Without Barr's curatorial skills *and* Greenberg's theorizing, the history of American art would be very different. Together they established ways of thinking that gave essential support to the Abstract Expressionists and their successors. But before Greenberg published criticism or the Museum of Modern Art was created, Albert Barnes was a major champion of modern art. Bernard Berenson and Ernest Fenollosa were gifted writers who influenced museums through collaborations with collectors. Barnes, the first American

to create a great permanent modernist collection, also wrote books on Cézanne, Matisse, and Renoir.[13] Both curator and art writer, he published a treatise on aesthetics, *The Art in Painting*, and *The French Primitives and Their Forms: From Their Origin to the End of the Fifteenth Century*, organized a journal and worked out an original conception of the modernist museum.[14]

A provincial nouveau riche Philadelphian who began by collecting William Glackens, Barnes had the energy and intelligence to become a great champion of Soutine. His collection focused on impressionism, early Picasso and Matisse—after that period, he didn't respond to the best new art. "According to Barnes, Picasso in his Cubist days was pulling people's legs," Pierre Cabanne writes.[15] Fascinated by African American culture, in 1925 Barnes said, "The white man in the mass cannot compete with the Negro in spiritual endowment."[16] He supported some African American painters and left his collection to a black university.[17] You need but compare Barnes's foundation to the sadly eclectic collection assembled by committees from the Carnegie International exhibitions in Pittsburgh to see what a good eye he had. In the 1920s, the Carnegie First-Class Prize winners were Abbott Thayer, Ernest Lawson, George Bellows, Arthur Davies, Augustus John, Henri Eugène Le Sidaner, Ferruccio Ferrazzi, and Felice Carena; and, also, I admit, Matisse and André Derain.[18] (A couple of years later, Pittsburgh bought a minor Picasso.) The Carnegie was ambitious, looked to Europe, and had money. But when the self-educated Barnes was assembling a monument to his taste, these committees chose "names" of the day.

By all accounts Barnes was a very difficult, extremely willful man, sociable only on his own terms. Like his judgments of taste, his writing is dogmatic—Barnes mentions other critics only to dismiss their claims. Had he been less independent, he would not have assembled so spectacular a collection. But when Matisse visited Merion, he found Barnes's installations infinitely preferable to the hangings of the more respectable Philadelphia collectors. Russell reports,

> Quite apart from the very high quality of much that was on show, he was delighted by the candor and the straightforwardness with which it was installed. . . . Matisse even liked the promiscuity with which great works of art were shown out of context and in the company with objects that

differed from them both in kind and in date. This was . . . "the only sane place" for the display of art that Matisse had as yet seen in America.[19]

And Barnes was the only collector anywhere who had the vision to commission a mural by Matisse, and the skill and determination (and money) to persuade the artist to execute such a commission. When, in the course of that difficult project, Matisse described Barnes as like himself, only cruder, he revealed something important about his champion.

Ruthless in his pursuit of the best, unlike most collectors Barnes also had a serious interest in progressive politics. The contention of his foundation, he wrote, "has been that art is no trivial matter, no . . . upholstery for the houses of the wealthy, but a source of insight into the world, for which there is and can be no substitute, and in which all persons who have the necessary insight may share."[20] Barnes used his collection for educational purposes. And he took a strong stand on one great issue of the day: "[As] knowledge of the great art achievements of the Negro becomes more generally diffused there is every reason to look for an abatement of both the superciliousness on the part of the white race and of the unhappy sense of inferiority in the Negro himself, which have been detrimental to the true welfare of both races."[21] In his dedication address at the foundation, John Dewey said: "I know of no more significant, symbolic contribution than that which the members of this institute have made to the solution of what sometimes seems to be not merely a perplexing but a hopeless problem—that of race relations."[22] Barnes believed that his collection could serve this goal.

Like Roger Fry, whom he denounced in his journal, Barnes was interested in African art. He hired Paul Guillaume and Thomas Munro to write *Primitive Negro Sculpture*, a book about sculpture from his collection. They wrote, "If negro sculpture is to be enjoyed at all, it will probably be through its plastic effects. In other ways it is apt to be unmeaning or even disagreeable to civilized people. But in shapes and designs of line, plane and mass, it has achieved a variety of striking effects that few if any other types of sculpture have equaled."[23] Other writers were discovering this art. Fry, for example, said: "Negro art aims at expressing one thing only, the vital essence of man, that energy of the inner life which manifests itself in certain forms and rhythms. Negro art is the most purely spiritual art we know of. . . . It is the expression of an intensely animated

religion which conceives of everything as due to the action of spirits."[24] Kermode writes that such art writers identified art "as having 'a life of its own,' supplying its own energy, and possessing no detachable meanings . . . containing within itself all that is relevant to itself."[25]

Like Fry, Barnes was a formalist. That too shows his period style. "Unlike the ordinary man, whose feelings spur him to produce practical changes in the things he sees, the artist expends his energy in sharpening his vision, refining and deepening his perceptions, discovering a richer plastic and human significance in the object of his interest."[26] He thought that form and its abstraction from life are of central importance, Mullen writes: "In actual life 'form' is 'the characteristic impression left in the mind by experience' and such 'forms' are possessed by every human being. They are the ideas we store in our mind of objects or situations after they have become meaningful for us."[27] Barnes makes few references to social history, is not much interested in the subjects of art, and offers no account of historical development.

Barr's 1926 review of Barnes's *The Art in Painting* begins on a very positive note: "This is an important book because it presents a systematic and confident statement of what is central in the 'modern' attitude toward painting. Its five hundred pages are the expression of an energetic critic, of an experimenter in the education of art-appreciation, and of the owner of the finest collection of modern paintings in America."[28] But then the complaints begin. Barr notes historical errors which "are too frequent to catalogue" and—most damagingly—Barnes's taste.[29] Formalism, Barr argues, leads Barnes to mistakenly find very similar designs in "an Entombment by Titian and a still-life by Cézanne."[30] The price of emphasis upon cultural unity is a refusal to acknowledge any differences between old master and modernist art. Greenberg, who also was a formalist, provided a very different account of modernism: "Realistic, naturalistic art had dissembled the medium, using art to conceal art; Modernism used art to call attention to art. The limitations that constitute the medium of painting . . . were treated by the Old Masters as negative factors that could be acknowledged only implicitly or indirectly. Under Modernism these same limitations came to be regarded as positive factors, and were acknowledged openly."[31] He argued that modernism arises dialectically from old master art. In making explicit the concerns that the old masters left implicit, the modernists extend tradition. A good Hegelian, Green-

berg sees the story of art as a history of continuities. Like his narrative sentence linking cubism and Abstract Expressionism, this influential analysis of the relationship of modernist to old master art informs museums. Barnes's simpler formalism, by contrast, inspired historical displays projecting a modernist aesthetic onto the old masters. In his foundation old and new art from Africa and Europe enters into a dialogue on equal terms. There are no names or titles in this aesthetic hanging. And high art is alongside humble decorative objects.[32]

Matisse's "Notes of a Painter" (1908) explains how he responded to old master frescoes: "A work of art must carry within itself its complete significance and impose that upon the beholder even before he recognizes the subject matter. When I see the Giotto frescoes at Padua I do not trouble myself to recognize which scene of the life of Christ I have before me, but I immediately understand the feeling that emerges from it, for it is in the lines, the composition, the color. The title will only serve to confirm my impression."[33] This formalist way of viewing is exemplified by the Barnes Foundation. "Here there is no hidden meaning, no reference to, nor hint of, anything else. . . . Here appearance is everything," Roberto Calasso describes the implications of such a style of visual thinking.[34] Matisse's claim that the subject of sacred Christian works could be transparently presented formally invokes a modernist ideal.[35] I do not believe that Giotto would recognize this description of his fresco. Matisse goes on to make his famous statement about dreaming of "an art of balance, of purity and serenity, devoid of troubling or depressing subject matter." This is an accurate description of his *Merion Dance Mural* (1932–33). Before you identify the scene, you understand the feeling emerging from the lines, composition, and color.[36]

Barnes's foundation is both forward and backward looking. He believed modernism created aesthetic harmony: "Variety in color, which is exemplified in the highest degree in Giorgione and Renoir, depends for its aesthetic effect on a controlling sense of harmony: without that variety becomes clash and chaos. . . . In Matisse, colors which taken in isolation might seem harsh, crude and displeasing merge into an ensemble which is extremely rich."[37] But he also looked back to the community life associated with Renaissance frescoes and to churches like the Orvieto Duomo (1290), described here by John White: "In walking down the nave, each column, almost six feet in diameter, is so sited as to overlap

the beginning of the corresponding apse. The column being closer to the eye, the apparent diameters of the two forms almost coincide, so that the convex curve runs smoothly on into its concave counterpart."[38] And his foundation anticipates installation art, fashionable in the 1980s when Barbara Kruger, Robert Gober, and Paul McCarthy created room-filling assemblages of objects. "Something could be contributed by the spectator within the structure established by the artist. . . . The visitors helped to create the work, to complete it. The situation provided an active experience for the viewer."[39] Giotto, Barnes says, is said to mark "the beginning of the Florentine tradition. . . . His use of perspective opened up a world of values possible only by the ingenious utilization of deep space; his modeling added lifelike three-dimensional qualities to figures and endowed them with conviction; he replaced the over-decorative static Byzantine linear pattern of light in folds of draperies by a few simple folds preponderantly vertical."[40] Like the Orvieto architect and installation artists, Barnes created a total work of visual art (fig. 17).

Barnes, like Matisse, was a great believer in the unity of artistic tradition. "He has always maintained that the moderns are directly in the great tradition, and he is after certain Old Masters through whom he can trace the continuity of that tradition," A. H. Shaw explains.[41] In a 1943 catalogue essay on Chinese painting, for example, Barnes claims: "Human nature is the same always and everywhere. In every age and every culture human beings have the same basic needs, encounter the same world and the same problems, expend time and effort in seeking the same satisfaction. . . . To recognize essential humanity . . . we must look beneath the surface, disregard the adventitious, grasp the essential."[42] "All great artists work in a tradition," he wrote, for "a tradition is simply a way of seeing that has been shared."[43] That also was Matisse's view. Believing that Giotto and the other old masters were doing the same thing as he was, with different subjects and a different context, late in life he copied their paintings in his style.

Many people think that way of thinking mistaken. The idea that modernism involves a break with the traditions of visual art has become a cliché. Nochlin describes "that sense of social, psychological, even metaphysical fragmentation that so seems to mark modern experience—a loss of wholeness, a shattering of cocoon or disintegration of permanent value that is so universally felt in the nineteenth century as to be often iden-

17. Main Gallery, Barnes Foundation. © 2002 The Barnes Foundation.

tified with modernity itself." [44] Barnett Newman, for example, criticized "those critics . . . who have made careers for themselves as 'friends of modern art' by broadcasting the sophism that the values of modern art were a continuation of the great tradition of European painting begun in the Renaissance. Impelled, perhaps, by the Englishman's innate aversion to revolution, these critics devoted themselves to talking everybody out of its revolutionary character." [45] He certainly thought that his art broke with tradition. More recently Hans Belting has taken a similar view: "Traditional and modern art are certainly not to be thought of as a single entity. Rather, they should become the object of questions which, by virtue of the retrospective view possible today, admit them both as historical phenomena." [46] If Newman and Belting are right, then it is unclear what place modernism has in the museum narrative.

When Gardner created her museum, she could rely on established taste in old masters and a well-developed tradition of theorizing about visual art. Barnes, by contrast, had to develop his museum and theory of modernism almost from scratch. Gardner created a first-rate if chaotic collection. Barnes did something much more interesting—he designed an installation that exemplified his theory of art. One good way to get a sense for his intelligence is to compare a once distinguished, now forgotten rival. After discussing van Gogh, Gauguin, and the French avant-garde, Thomas Craven's *Modern Art: The Men, the Movements, the Meaning* (1934) devotes dismissive chapters to Matisse and Picasso. Quoting Barnes's account of *The Joy of Life*, Craven then describes the painting as "A large and vacant picture built around a naked triangle. . . . In the center of the triangle is a cluster of leaping foetuses; on the right side, smudges and some irregular patches attached to stems—presumably trees. . . . The design . . . in its present dimensions . . . is a vapid tour de force." [47] Matisse, he complains, is "opposed to any participation in the real world." (Craven championed George Grosz and American regionalism.) By contrast, Barnes expresses the recent consensus when he writes: "Matisse is a very great artist, a man of keen sensitiveness, vigorous intelligence, and enormous erudition . . . from his fecund imagination have come a wealth of plastic achievements unequalled by those of any other painter of his generation." [48] And so it is surprising to find that when there is so much interest in Matisse, Barnes remains unread. [49]

The dedication of the most famous American treatise on aesthetics

reads, "To Albert C. Barnes, in gratitude." In the preface of *Art as Experience*, after thanking Meyer Schapiro, John Dewey says that "my greatest indebtedness is to Dr. A. C. Barnes. . . . I have had the benefit of conversations with him through a period of years, many of which occurred in the presence of the unrivaled collection of pictures he has assembled. . . . I should be glad to think of this volume as one phase of the widespread influence the Foundation is exercising."[50] This is not merely a polite reference to a friend (and financial supporter). Dewey repeatedly mentions Barnes's publications, and Barnes, in turn, dedicated *The Art in Painting* to "John Dewey, whose conceptions of experience, of method, of education, inspired the work of which this book is a part."[51] Elsewhere he wrote: "It is universally acknowledged that, throughout his career, Dewey's supreme interest has been in the operation of intelligence to free human powers and enrich human experience. . . . My topic . . . is the application of this method to aesthetics."[52] In 1926, Barnes and Dewey looked at art together in Madrid, Paris, and Vienna.

Richard Rorty described Dewey as "just the philosopher one might want to read if one were turning from Kant to Hegel, from a 'metaphysics of experience' to a study of cultural development."[53] But the recent revival of interest in Dewey has not led art historians to look at Barnes. "Pictures can express every object and situation," Dewey wrote, "capable of presentation as a scene."[54] Philosophers of art take Dewey very seriously but have almost nothing to say about Barnes.[55] The same is true of Dewey's biographers, who tend to be oddly apologetic about this relationship. For example, Steven Rockefeller writes, "Barnes had a reputation for being an extraordinarily difficult personality who frequently became angry, arbitrary, and abusive in his dealings with people. However, he had great respect for Dewey who seemed to be the only person who could restrain him and bring him to reason."[56] That is not correct. Barnes did have other loyal friends and collaborators. Sometimes he is dismissed entirely by recent commentators on Dewey. Alan Ryan wonders, "It is . . . strange that Dewey, who was in thought and deed a democrat through and through, could have tolerated the autocratic, changeable, and wildly aggressive Barnes. However, Dewey had a taste for the company of oddballs of all sorts, and . . . a policy of giving possible charlatans the benefit of the doubt."[57] That too is misleading. Barnes, though arrogant and autocratic, was no charlatan. Even Barnes's collection, his

obvious great achievement, has its detractors, among them Ryan: "Barnes had his paintings arranged in a very particular, not to say very unorthodox fashion. They are displayed so as to produce a whole wall of color and mood. . . . The collection is wonderfully disconcerting, not least because of the near invisibility of some wonderful things and the mind-boggling juxtapositions that Barnes's wall arrangement sometimes produces."[58] In fact, Barnes recreated in a personal way the hanging style of premodern art collections.

Barnes's and Dewey's ideas about art are similar enough that when composing this account, turning back and forth from *Art as Experience* to *The Art in Painting*, often I found myself momentarily uncertain which author I was reading. Barnes's aesthetic is dated, but in historical context he, like Heinrich Wölfflin and Roger Fry, secularized old master Christian art by means of formal analysis. Dewey's goal, "to restore continuity between the refined and intensified forms of experience that are works of art and the everyday events, doing, and sufferings that are universally recognized to constitute experience," also speaks to this concern.[59] And when he goes on to note that we give "domestic utensils" and similar utilitarian things "places of honor in our art museums," it is natural to recall that Barnes placed craft implements around paintings in his museum.[60] For Barnes, Ryan writes, "from an aesthetic point of view, a painting was to be engaged with as an experienced object, not primarily to be thought about as a social or historical product."[61] Dewey's desire to eliminate the usual barriers between "art" and "life," which made him so critical of traditional art museums, shows his sympathy with the physical arrangement of Barnes's foundation: "Our present museums and galleries to which works of fine art are removed and stored illustrate some of the causes that have operated to segregate art instead of finding it an attendant of temple, forum, and other forms of associated life."[62] He rejects the idea that only experts can respond intelligently to art. "The dream of America is community, is communication, is art—the American dream is an exacted relationship."[63] Dewey sought "a conception of fine art that sets out from its connection with discovered qualities of ordinary experience."[64] Both his aesthetic and his politics gave him reason to find Barnes an invaluable ally.

A 1913 photograph of the apartment of Leo and Gertrude Stein, 27 Rue de Fleurus, Paris, shows Henri Matisse's *The Joy of Life* (1905–6).[65] The

room is densely hung with paintings by Picasso, Matisse, and Felix Vallotton, and three Cézanne watercolors. In 1914 Leo and Gertrude Stein divided their collection and Leo took *The Joy of Life*. After being resold it was purchased by Barnes. Today the painting is in Merion, where, Pierre Schneider reports, "it seems destined to remain even more deeply hidden away than the rest of the extraordinary collection in the Barnes Foundation, for it has been relegated to a passageway, or rather a dark and narrow stairwell, where it is almost impossible to view it properly."[66] This is hardly a subtle point. *The Joy of Life* is in the worst viewing position of any picture in the museum. Coming up the stairs, as you turn up to see it, the people descending block your view. Then when you ascend to look down on it from the top of the stairs on the second floor, you must look across from a distance in awkward lighting. Every detail in a major painting is significant because an artist seeks to control what he makes. Most museums grow by accretion, depending on a succession of curators. But the foundation is a relatively small collection organized solely by its creator. And so it is reasonable to ask whether the odd position of *The Joy of Life* is intentional.

Barnes was determined to alienate the art world and all too effectively succeeded. Given that he was impossibly difficult, it seems appropriate that he perversely placed *The Joy of Life* in an impossible viewing position. For many years that was my unthinking supposition. But upon reflection, this presupposition seems unconvincing. Barnes took great care with his installation. The lighting and the relationships of paintings and works on paper are very nicely calculated. When Barnes cannot sleep, a reporter wrote in 1928, "he puts on his dressing gown . . . and in the gallery he studies his pictures and sometimes spends hours arranging one to suit his taste."[67] This, surely, is how we would expect an obsessive connoisseur to behave. And so it cannot be mere happenstance that *The Joy of Life* is on the stairs, as if Barnes had just been too lazy to find some more suitable setting.

Until recently *The Joy of Life* was available only in black and white reproductions. Had the painting been more accessible, perhaps it would have become more familiar to art historians. As it is the picture has a certain mystique. Whatever art writers say about its sources, *The Joy of Life* remains extremely hard to understand.[68] Matisse's slightly later, well-known masterworks unpack this composition, which is too rich to be

fully satisfying. When acquired by Barnes in 1927, it was hung downstairs. But by the time Matisse visited the foundation in 1930 it was already on the stairwell.[69] The painting must therefore have moved to this awkward site just before Matisse arrived. Barnes knew that *The Joy of Life* was a masterpiece, so why did he put it there? To answer that question, we must look back to Matisse's most important earlier installation.

In 1910 the Russian collector Sergey Shchukin hired Matisse to make three paintings for his house. Matisse described his plan:

> I have to decorate a staircase. It has three floors. I imagine a visitor coming in from the outside. There is the first floor. One must summon up energy, give a feeling of lightness. My first panel represents the dance, that whirling round on top of the hill. On the second floor one is not within the house; in its silence I see a scene of music with engrossed participants; finally the third floor is completely calm and I paint a scene of repose.[70]

Unfortunately he made a very serious miscalculation—Shchukin's house had only two floors. *The Dance*, painted for the first floor, and *Music*, for the second, remain in the Hermitage. Matisse radically repainted the picture originally intended for the third floor. Now retitled *Bathers by the Stream*, it is in the Art Institute of Chicago, but a work on paper preserves the original image intended for the third floor.[71] Anticipating this installation, *The Joy of Life* also brings together three distinct spaces. In the center, at the far distance, is the ring of dancers; in the middle layer, lovers and a musician; and at the front, reclining figures. For Shchukin that richly condensed conception has in effect been unpacked into three pictures. Barnes could not have envisaged the intended arrangement of the three panels. But he was aware that Matisse painted Arcadian scenes. And so he knew enough to move *The Joy of Life* from downstairs to its present position.[72]

Imagine that Moscow installation constructed as Matisse planned. Walking up that imaginary three-story staircase, you would begin on the ground floor looking at the top of the hill shown in *The Dance*. Going up one floor, you would seem to come down the represented hill, seeing in *Music* the edge of the hill near the top of the painting. And finally as you come to the top of the stairs, you would seem to arrive at the bottom of that hill. As you physically moved upward, you would seem to be descending the depicted hill. Showing an ideal place far apart from

our conflict-filled life, Matisse reveals utopia by means of the content of his images. This is not just an ideal place, but somewhere far from our world. In the subtle Shchukin installation, the illusionistic picture spaces are visible from, but far away from our world. "How could we be talking *up* when the successive images appear as if we were moving *down* a hill?" it asks.[73] We must be looking into another world!

Picasso's and Braque's cubism was much imitated, but Matisse's concern with utopian space was not the source for ongoing modernist tradition. And so we may better understand his ways of thinking by scrutiny of Vladimir Nabokov's *Pale Fire*, which also links real and fictional worlds. That novel contrasts so-called reality, where the commentator Charles Kinbote lives and writes, with the deliberately unreal world created by the poet John Shade. Reality and illusion — the poem and commentary — *are* related. Things, people and also literary texts move from one world, reality, to another fictional place. And if you follow the notes, you learn that in Arcadia the crown jewels are hidden, as Kinbote's commentary says, "in a totally different — and quite unexpected — corner of Zembla," that is reality.[74] The solution of that literary puzzle helps explain Matisse's similar way of thinking. Just as reality and fiction are subtly linked in *Pale Fire*, so too in Matisse's Shchukin installation the real stairs that you climb and the imaginary hill depicted in the painting are related. (How very Nabokovian that this installation never existed.) Nabokov and Matisse think about Arcadia in similar ways because they are interested in the logical relationship between appearance and reality. There is no causal connection between their utopias, but solving the puzzle in *Pale Fire* helps you understand Matisse's installation.[75]

Dewey discusses *The Joy of Life* (fig. 18) in a way that supports my analysis. The experience that is its source, he remarks, "is highly imaginative; no such scene ever occurred. It is an example as favorable to the dreamlike theory of art as can be found. But. . . . to become the matter of a work, it had to be conceived in terms of color as a medium of expression; the floating image and feeling of a dance had to be translated into the rhythms of space, line, and distributions of light and colors."[76] And Barnes devotes a four-page formal analysis to *The Joy of Life*. "The outstanding feature . . . is an all-pervasive feeling of color-movement. This movement and pattern are appropriate to the subject-matter — an Arcadian scene of nudes dancing, playing music and reclining at ease in

18. Henri Matisse, *The Joy of Life*, no. 719.
Photograph © 1992 The Barnes Foundation.

a landscape." After contrasting the central triangle, the yellow ground
with the dancers and reclining nudes with the triangles above at left and
right, he notes that "taken together these two enframing triangles seem
like an open stage-curtain hanging from the top of the picture and drawn
aside to reveal a vista of landscape." In this "decorative color-pattern,"
"background, middle ground and foreground are united on equal terms
to yield a total effect not unlike that of a poster or brightly-patterned
banner."[77]

Once Barnes intuited Matisse's interest in Arcadian scenes, he ac-
knowledged this discovery by installing *The Joy of Life* in its seemingly
awkward position. How pleased Matisse must have been to see that
Barnes had placed his picture on the stairs! Barnes does not say this. But
his installation does. Either he moved *The Joy of Life* because he intuited
something like my analysis, or its peculiar permanent positioning in his
very meticulously planned museum was merely an afterthought. When

you go up the stairs past *The Joy of Life*, then on the second floor you look across to the top of that mural. In the installation for Shchukin, *The Joy of Life* is unpacked. *Dance Mural* continues that unpacking one stage further. In *The Joy of Life* and *The Dance*, the dancers move in a closed circle. In his mural Matisse focuses close in on that line of figures. The dancers in *The Joy of Life* are in the distance; in the *Mural*, the much larger dancers remain distant. Either you view them looking up from the floor of the hall or, after walking up the stairwell, you see them at your own level across the open space.

In the 1930s, Marxists and other politically conscious critics thought that easel painting was obsolete.[78] And so it was natural for Barnes to invite Matisse to Merion to commission a mural. Compared with the great Matisses installed nearby, *The Dance* is minor.[79] Who, turning to see *The Joy of Life*, would compare *The Dance* with that masterpiece? Disappointed by the mural, Barnes did not describe his difficulties with Matisse in his book on the artist.[80] He does tactfully explain why he gave the artist this commission, and how he evaluated it: "Matisse . . . is by temperament primarily interested in the decorative aspects of things. . . . This bent and practice involves a sacrifice of the more profound inter- pretative values, both human and plastic, characteristic of the greatest artists."[81] After offering substantial criticism, Barnes describes Matisse as "far and away the foremost painter of the day. . . . a very great artist, a man of keen sensitiveness, vigorous intelligence, and enormous erudition; he is intensely alive and adventurous."[82] Given their recent difficulties, this seems high praise indeed. In 1934 he told Matisse that he was coming to appreciate the mural more. Barnes deserves credit both for holding his temper and for his good judgment. It must have been awkward to live with a painting that he did not entirely admire and which, unlike his others, could not be moved.

Barnes had created some of these problems. He refused to remove the two large paintings by Matisse and a Picasso on the wall underneath, take off the sculpted frieze directly under the mural, or replace the frosted glass above the doors with clear glass, so that the outdoor greenery could be visible.[83] Still Matisse thought his mural a great success, saying "It is of a splendor that one cannot imagine until one sees it."[84] What he de- sired, his drawings show, was that the mural structure the large two-story gallery space. That requires an essentially blank background, because the

viewer must not be distracted. Looking at the mural reproduced in isolation from the present context or as displayed when the Barnes foundation collection toured, is misleading. Matisse wanted that his dancers seem to go across the edges of the mural, moving freely over the walls, creating a decorative effect. But because of an error in reading the blueprint, he had to redo this composition completely. John O'Brian writes, "The design Barnes desired seem to him to accord with his Giottesque ideals. In it, as in *Le bonheur de vivre*, the circling dancers were joined to one another in a collective activity; they were participating in a notion of community, a concept central to Barnes's educational ideas. The final design eschews these qualities."[85] The need to rework the original composition created insuperable problems.

Matisse had hesitated to undertake this commission, feeling that his talent was not suited to such site-specific mural art. He was motivated, in large part by financial necessity. (Like Barnes, Matisse was a self-made man who could be tight.)[86] He tried, and failed, to match the Giottos in Padua. A Renaissance painter collaborated with his patrons. That it was difficult for Matisse to create such a relationship even with so initially sympathetic and knowledgeable a collector as Barnes shows how problematic was this attempt to continue tradition.[87] But Matisse learned from the unhappy experience. The Vence chapel, planned in exhausting detail, partly paid for by the artist, was more successful because Matisse's visual conception was uncompromised. When working on that project, Matisse reflected back on the experience at Merion. "That old cow Barnes how he tormented me!"[88]

These problems with *The Dance* point to larger difficulties with the foundation. Barnes was passionately interested in education, but in the end he was not the right person to run a school. He wrote extensively about art, but not in a way that encouraged intellectual intercourse. And his commission for Matisse yielded limited results because the two men were not effective collaborators. In the end, Barnes's foundation had surprisingly little effect upon either the development of museums or American art. It was Barr's Museum of Modern Art that provided the much-emulated model. Barnes's hanging now seems old-fashioned, a throwback to the aesthetic hangings of premodern private collections. And when Greenberg's dialectical theory of modernism became the position everyone read and rejected, no attention was paid to Barnes's writ-

ings.[89] When the Philadelphia establishment turned against him, he, in return, restricted admission to his collection. Believing that great art belongs to the public, we find Barnes's possessive attitude off-putting. In a sad but not entirely unpredictable way, Barnes's aggressive refusal to engage in dialogue has had posthumous consequences. The foundation is about to be dismantled and moved to Philadelphia. This is unfortunate since the destruction of Barnes's museum is unnecessary, for all that is required for its preservation is some practical way to accommodate visitors.

Were the Gardner Museum folding or the Frick being absorbed by the Metropolitan, distinguished defenders of these institutions would come forward. Were a real estate developer destroying the Vence chapel, then art historians would protest. But because Barnes so effectively alienated the art world, his institution has few champions. There is little interest in preserving his installation. Barnes professed a paternalist interest in black culture, but willing his precious collection to a small, intellectually provincial African American university with no history of interest in visual art effectively guaranteed that his legacy would not be adequately protected. Might this history have been different? Probably not, for looking back the problems inherent in Barnes's way of thinking are obvious. Museums had long organized their old art in historical hangings, so when they added modernist painting and sculpture, naturally it was displayed in the same way. Like Gardner's museum, another private collection opened to the public, his foundation is a throwback. Barnes's books are no longer read, but his collection remains fascinating. Because he was so aggressive, the fate of his museum is not entirely surprising. He loved art but showed this love in ways that were unhappily possessive. Unwilling to enter into dialogue, he has not inspired commentators to evaluate his achievement. How odd that a man who so often professed to believe in tradition was so aggressively self-destructive. For we historians of museums, failures can be as revealing as the successes.[90]

9

The Display of Absolutely
Contemporary Art in the
J. Paul Getty Museum

Picture to yourself a vast amphitheatre such as could only be a work

of nature; the great spreading plain is ringed round by mountains. . . .

It is a great pleasure to look down on the countryside from the moun-

tain, for the view seems to be a painted scene of unusual beauty rather

than a real landscape, and the harmony to be found in this variety

refreshes the eye wherever it turns.—PLINY THE ELDER

Most museum visitors rapidly pass interesting paintings by second-rank figures in order to plant themselves in front of famous Titians or Raphaels. But, so Charles Baudelaire argues, they should also attend to pictures showing contemporary life, which have the quality of being present. Then, as if prophesying impressionism, he identifies the aesthetic value of such art: "The pleasure which we derive from the representation of the present is due not only to the beauty with which it can be invested, but also to its essential quality of being present."[1] Baudelaire sketches a relativistic account of the dual nature of beauty. Old master art pleases because of its classical beauty, and images of contemporary life delight because they show the beauty of the here-and-now. Styles of beauty change, but both of these components of beauty are found in all successful modernist art. "I defy anyone to point to a single scrap of beauty which does not contain these two elements," he wrote.[2] Baudelaire's analysis of beauty shows how contemporary art also challenges the museum skeptic. New art is entirely present, so we cannot lose contact with it. But what is its relation to older art? What, that is, is the relationship between

hangings of older art, which comes from temporally distant worlds, and that absolutely contemporary art that gives pleasure in presenting the here-and-now?

Ernest Fenollosa enlarged the museum by adding Asian art. When Barnes and curators of his generation added modernist painting and sculpture, the museum expanded almost as far as possible. If we think of contemporary art as coming immediately after modernism, then adding galleries for the very newest art would suffice to complete this expansion. But Baudelaire points to real conceptual problems with such thinking. "Modernism came to an end," Arthur Danto argues, "when the dilemma recognized by Greenberg between works of art and mere real objects could no longer be articulated in visual terms, and when it became imperative to quit a materialist aesthetics in favor of an aesthetics of meaning."[3] We are living in "posthistorical" times. Contemporary art is not just what comes after modernism, in the way that postimpressionism follows impressionism. No longer can we think of the story of art as an ongoing process, a narrative—like Gombrich's story of art or Greenberg's account of modernism—in which one work of art leads to the next.

Shifters—words such as *now* and *here* whose reference depends on context—are very interesting to philosophers. To understand someone's remark, Danto has noted, "one must fill in the conversation in which it gets uttered and see what movement of thought the sentence advanced."[4] And to understand what a shifter refers to, we need to know who is speaking and to whom their words are addressed. As Hegel explains in the section of *The Phenomenology of Mind* (1807) titled "Sense-Certainty," "to the question, What is the Now? We reply, for example, the Now is nighttime. To test the truth of this certainty of sense, a simple experiment is all we need: write that truth down. . . . If we look again at the truth we have written down, look at it *now, at this noon-time*, we shall have to say that it has turned stale and become out of date."[5] Like Baudelaire, he is interested in how we understand the here-and-now. To relate their analysis to the art museum, we need to grasp the relationship between older and contemporary art. Danto, who had "a kind of political vision," imagined the whole history of art shown ahistorically, in a structuralist diagram in which mannerism, the baroque, and the rococo (along with all other styles) would be treated as essentially equivalent.[6] Suppose that

all paintings are described by qualities; G "is representational" and F "is expressionist," using the style matrix.

F	G
+	+
+	−
−	+
−	−

If some new painting has the quality H, then the revised chart reads:

F	G	H
+	+	+
+	+	−
+	−	−
−	−	+
−	+	−
. . .		
−	−	−.

Every other painting in existence becomes non-H, and the entire community of paintings is enriched. . . . It is this retroactive enrichment of the entities in the artworld that makes it possible to discuss Raphael and De Kooning together, or Lichtenstein and Michelangelo. Once Lichtenstein made pop paintings, it was retroactively possible to see the Raphaels and De Koonings, which had seemed very different, as sharing the property "not–Pop art."[7]

Recently such structuralist ways of thinking have been in the air. As Michael Holly writes, "Cultural historians are not particularly interested in political events that can be diachronically plotted along the standard time line of historical evolution. Instead their focus is a synchronic or structural one."[8] Danto's matrix returns us to Albert Barnes's timeless perspective on art history, a way of thinking that has been much criticized. Structure, it has been claimed, "has always been neutralized or reduced, and this by a process of giving it a center or of referring it to a point of presence, a fixed origin."[9] If no such center can be securely located, then any structure will be arbitrary. Danto had a different problem. Concerned to identify the essence of art, he soon became dissatisfied with this model, which does not provide a historical perspective on that

process. From the curator's perspective, the limitation of structuralism is that it provides no suggestions about how to organize the museum. Subtracting out, as it were, history, the style matrix does not show how to place contemporary art in the posthistorical museum. Once Greenberg's analysis informed museum practice, then even after modernism ended it was natural to extend his historical way of thinking. Andy Warhol and the other pop artists came after abstract expressionism, and so are displayed in later galleries, linked to that tradition by appropriate narrative sentences. Although Danto's posthistorical artists work when art no longer develops, they do make distinctive-looking visual art.[10] For all of his debts to abstract expressionism, for example, Sean Scully creates novel forms of painting. Robert Mangold's art is rooted in 1960s minimalism, but he paints differently.[11] Cindy Sherman photographs unlike the surrealists. Thus it is natural to exhibit Scully, Mangold and Sherman as if the story of art were continuing.

How can contemporary painting and sculpture be integrated into the museum? The most satisfying solution to this question has been proposed not by a writer or curator, but by the architect Richard Meier in his 1997 J. Paul Getty Museum. That claim will initially seem very surprising. Apart from a Martin Puryear sculpture at the top of the tram and some paintings in the auditorium and restaurant, there is no contemporary art in the public spaces or the permanent collection.[12] The Getty shows only European art made before 1900, so it will initially seem paradoxical to credit this institution with any role whatsoever in displaying contemporary art. But first appearances can be deceiving. The Getty's trustees decided to collect only art of the Greco-Roman antique and of Europe from the early Renaissance through 1900.[13] The former director Deborah Gribbon and her precursor John Walsh describe this policy: "It may appear perverse that in a city whose Euro-American population is now a minority, and where people with African, Asian, and Latin roots predominate, the Getty Museum plans to continue collecting only art of the European tradition. But we see this as an advantage. We assume that there will always be a place for such a museum in the archipelago of specialized museums in Los Angeles, not for the sake of a white audience but for everyone."[14]

J. Paul Getty (1892–1976) grew up in Los Angeles and made his fortune in the oil business, playing a major role in the exploration of Saudi Arabia.

"In 1933, Ian Saud's finance minister, Abdullah ibn Sulayman, signed an agreement with the American company Standard Oil of California . . . to start exploration for oil . . . A Qu'ranic verse. . . . allowed the possibility of separation/co-operation between Muslims and non-Muslims so long as each party kept its religion to itself."[15] From early on he looked at art, visiting the Louvre and the National Gallery, London in 1909. "I was a good, almost a model Cook's tourist," Getty wrote. "I faithfully made the rounds of the museums and galleries."[16]

A great lover of decorative art, Getty did not assemble a major selection of paintings. In his will, he said nothing about how his museum was to be organized. When, after his death, wise management rapidly increased the value of his inheritance, ambitious collecting became possible.[17] The Louvre shows the strength of a very old culture. The French kings, Napoleon, and their successors built the collection and the buildings. Michel Laclotte explains, "In France collecting works of art was thought of as part of kingship. It was inseparable from monarchy, a sport of kings, as horse racing is called in England."[18] The Getty, by contrast, displays the new wealth created by one individual. Most great paintings and sculptures by the most desired old masters and early modernists were already in museums in countries that forbid export. And so the Getty is probably the last major new museum focused on premodern European art.[19]

In his later years Getty lived in Europe, but now his fortune returns to Los Angeles.[20] Had his museum been in downtown L.A., as some urged, to complement the L.A. County Museum, it would have been just a minor provincial institution. In Brentwood, by contrast, the Getty is something altogether more ambitious than a nice collection in an accessible location. Meier's architecture offers a remarkably original museum interpretation, showing how absolutely contemporary art can be incorporated into a narrative of art history. "Just as one can best appreciate the layout of Rome from its elevated landmarks," Meier has written, "so does the hilltop site of the Getty Center offer the best place to see and understand Los Angeles."[21] He designed a Roman villa set in Southern California: "In my mind I keep returning to the Romans . . . for their sequences of spaces, their thick-walled presence, their sense of order, the way in which building and landscape belong to each other. The material substance of the Getty Center will come out of the history and regional tradition of Southern California."[22] J. Paul Getty also was fascinated by

Roman culture, an enthusiasm that is relevant to interpretation of the buildings. "The works of art I own . . . are vital embodiments of their creators. They mirror the hopes and frustrations of those who created them—and the times and places in which they were created. Although the artists may be long dead, and even the civilizations in which they worked long disintegrated, their art lives on."[23] This conventional way of thinking is employed by his museum in radically untraditional ways.

You enter a typical older art museum by walking up marble steps to be elevated out of the ordinary world. The Getty tram is an elongated elec-tric version of that grand staircase. As the *New York Times* architectural critic noted, this vehicle "almost resembles public transport," which is a surprise in Los Angeles.[24] In the 1960s a forest fire jumped the freeway and burnt off the land, so there are no large native trees on the property. The site of 742 acres is mostly steep and chaparral-covered. The build-ings (on a twenty-four-acre plot), clunky-looking from below, appear ele-gantly sleek from the plaza (fig. 19). From an Italian hill town, you look down upon farmland. The Getty sets you above a cityscape.[25] Both ac-knowledging the importance and power of precedent and undercutting tradition, it effectively deconstructs the traditional art museum. "Richard Meier saw in this project an opportunity to reestablish his connection with ancestors such as John Soane, Carl Friedrich Schinkel, Wilhelm von Klenze."[26]

The stairs on the far side of the very large entrance pavilion look like an unfolded Frank Stella relief sculpture. Most museums turn inward, sepa-rating their collection from the external world. After you enter the Louvre or National Gallery, only occasionally do you glimpse the outside world. The Cleveland Museum of Art and the Nelson-Atkins in Kansas City have inner courtyards surrounded by galleries. And Gardner's museum is built around a roofed quadrangle allowing light to enter the galleries. The Getty, by contrast, is a sequence of pavilions, rooms pulled apart and set outdoors. Between the galleries is an outdoor fountain. Using the California climate to good advantage, Meier transforms the familiar re-lationship between museum interior and exterior space. Traditional art museums have solid walls. The Getty uses "honey-colored travertine, a stone of which much of Rome was built," 295,000 pieces mounted so that each can vibrate separately in an earthquake.[27]

The supports beneath the temporary exhibition pavilion are not the

19. Entrance to the J. Paul Getty Museum. Photo: Alex Vertikoff.
© 2000 J. Paul Getty Trust.

Corinthian, Doric, or Ionic columns of classical architecture, but marble-covered struts. And the arch in front of the Research Institute is not proper classical architecture, but a decorative frame of the view.[28] Moving slowly, you focus on the paintings, and then walking more swiftly you experience the galleries as a sequence of themes and variations. In the exquisitely proportioned empty spaces, the varying heights and sizes of the galleries provide great visual pleasure. And the conspicuous absence of signage makes the building feel like a grand private residence.[29] After the Getty, traditional museums feel intolerably busy. In the very high painting galleries, your eye is drawn upward. Above the room proper is what amounts to a second story, the high tapering lantern. And above that lantern, moving louvers control the intense light. Shifting clouds cause the louvers to swing back and forth and the strong natural illumination is supplemented by artificial lighting.

The collection is housed in three buildings. After touring the North Pavilion, containing art before 1600, you walk through a passageway to the East Pavilion showing painting from 1600 to 1800. Then you go outside on a balcony before getting to South Pavilion, which displays

20. Museum terrace and city view, J. Paul Getty Museum.
Photo: Marcelo Coelho. © 2002 J. Paul Getty Trust.

art of 1600 to 1800. Entering the first pavilion, you see marble-covered walls hanging in mid-air, as in Piranesi's imaginary Roman scenes, unsupported from below at the corner where they meet. "To the Getty staff, views to the city, specifically framed by the architecture, constantly remind them to whom they are responsible: the community at large," Harold Williams explains.[30] Even on a rainy occasion, glass-enclosed passageways and bridges allow you to look outward. And on more typical bright sunny days, visitors linger outside on benches. Between the East and South Pavilions, large marked photographs identify buildings and mountains visible in the panorama (fig. 20).

When a museum has a long history, interpretation requires study of its past. Recalling James's and Baudelaire's fantasies when walking from the Grand Gallery through the Salon Carré to the Gallery of Apollo, your experience of the art is enriched. The Getty is the anti-Louvre, a grand collection of paintings and sculptures in a new building in a city that itself is essentially a twentieth-century creation. Imaginatively transport-

ing us to distant places, the old art in the Louvre shows France's power. The Getty paintings and sculptures demonstrate the economic strength of America, but that political might is displayed in a very different way. In our democratic consumer culture, movies and television permit everyone to imagine looking into faraway places and times. The Getty transforms Los Angeles into a work of art, incorporating views of that contemporary place into the collection. This expensive museum turns that city into a spectacle.

We see the Getty under the spell of a perspective unavailable to Denon's contemporaries, who thought that the looted art in his Louvre demonstrated that Paris had become the new Rome. Here in an unexpected way we return to Danto's discussion of indiscernibles and the nature of art. Imagine someone who in 1980 climbed the Getty's hill in Brentwood. This person would see the same view visible today from the museum, but without Meier's architecture, those vistas could not be identified as elements in that art collection. The Getty's paintings and sculptures might be shown in the Louvre, for in isolation, subtracting out the setting, they look like the art in Paris. But viewed in context, in L.A. these works of art look very different because these older paintings and sculptures are natural to relate to the landscape vistas visible between the gallery pavilions.

A landscape picture is an image of the outside world adorning the walls of our indoor world. The Getty turns its vistas into posthistorical landscape pictures framed by the windows. The galleries for the permanent collection form three-quarters of a circle, so you complete the collection by looking at the city below. Meier thus actively encourages the visitor to look outward and think of the landscape as an additional work of art. You go between the North Pavilion and the East Pavilion on a closed passageway. Then as you move between the East and South Pavilions, you walk outdoors, guided still by another overhead structure. You see the San Diego Freeway headed north into the Valley, look east toward downtown L.A. and beyond, and south toward the ocean. And to the west of the museum, the Getty Research Institute completes the circular form.[31] Driving in L.A., you get only a sequence of partial views, but from the Getty you observe the entire city. At night you view the band of car lights approaching and receding, in the middle distance the queue of planes approach the airport, and on a clear day you can look far out to sea. Constable's *Wivenhoe Park* in the National Gallery allows you to

imagine contemplating an English landscape far from downtown Washington, D.C. At the Getty it is easier to transfer aesthetic ways of seeing to the external environment because the city is right at hand. The museum provides a variety of framed and unframed vistas. Entering the North Pavilion, you look through very large windows. Between the North and East Pavilions, there are some smaller windows in front of circular seating. Between the East and South Pavilions you see an unframed view bounded only by the walls and the platform. And from the south end of the South Pavilion, you get a more confined viewpoint.

Gentlemen on the grand tour who looked at landscapes as well as the art of Italy tried to see the relationship between this art and the places it depicted.[32] And we often get pleasure viewing pictures because we see landscapes as looking like those depicted by Claude or the Dutch masters, and we view Paris streets as if they were paintings in the style of Manet and Pissarro. Attending both to paintings and vistas, Getty visitors emulate these aesthetes. What you see before entering the galleries, between pavilions, and before and after exiting is as important as the collection. Meier said, "The Getty Center is proposing that art can be something elevated, set a little apart from everyday life. But in the same gesture, the Getty is also making Los Angeles accessible to people in a new way."[33] Entering a traditional museum, we walk up the steps to have aesthetic experience. In its setting high above L.A., the Getty builds upon that tradition. Critics who complain that it lacks masterpieces fail to see that although the collection may be limited, Meier's museum is revolutionary. As he says: "The spatial experience should allow for the contemplation of works of art from close up, and from a distance, but there has to be a periodic interval allowing the viewer to see nature, to see natural light, and to have a kind of syncopated rhythm of experiences as one moves through the museum. Otherwise museum fatigue takes over."[34] Eighteenth-century connoisseurs used reducing glasses to make the country look like the scenes depicted by Claude, converting English landscapes into aesthetic objects. Set high above Los Angeles, the Getty also is another instrument providing an aesthetic viewpoint.

Like Gardner's highly personal building and Barnes's very inventive hanging, Meier's architecture teaches us a new way to see art. And that is a great achievement. "By landscape," Humphry Repton wrote in 1807, "I mean a view capable of being represented in painting."[35] Late-

eighteenth-century gardeners loved to draw analogies between painted depictions of landscapes and real three-dimensional gardens. Painting, Kant said, comes in two forms, *"painting* proper . . . and *landscape* gardening. . . . The latter consists in . . . decking out the garden with the same manifold variety . . . as that which nature presents it to our view, only arranged differently and in obedience to certain ideas."[36] A landscape garden was like a painted scene you could walk into. Describing his museum, the Metropolitan, John Pope-Hennessy appealed to this tradition: "I hoped that when visitors left the gallery, they would have the sense I had after arranging it, that the real world, looked at from the hedonist standpoint of Monet and Manet and Renoir, is a more enjoyable place than one had thought."[37] Canaletto's paintings helped visitors to see Venice aesthetically, and the impressionists showed that Paris and its suburbs could be seen as a work of art. Treating the Getty's vistas as readymades, views right at hand that need only have attention called to them to become works of art, Meier is certainly appealing to this tradition.

In calling the Getty a posthistorical museum, I allude to Danto's conception that ours is a posthistorical period. Medieval European art, Islamic decorations, Indian sculpture, and Chinese paintings were gradually added to the museum. But when the only kinds of previously uncollected objects entering the museum are contemporary works of art, then that expansion has finally ended. Baudelaire's painter of modern life "watches the river of life flow past him in all its splendour and majesty. He marvels at the eternal beauty and the amazing harmony of life in the capital cities. . . . He gazes upon the landscapes . . . of stone caressed by the mist or buffeted by the sun."[38] He would find plenty to see looking from the Getty. Usually only conservatives praise aesthetic experience, but I prefer to understand the Getty vistas by reference to Guy Debord's conception of the spectacle: "In societies where modern conditions of production prevail, all of life presents itself as an immense accumulation of *spectacles*. Everything that was directly lived has moved away into a representation."[39] Debord's ferocious leftist politics are dated, but in describing what happens when the world is turned into an image, he predicts what might be called the Getty effect: "The spectacle corresponds to the historical moment at which the commodity completes its colonization of social life. . . . Commodities are now *all* that there is to see; the world we see is the world of the commodity."[40] In department stores, we

see commodities on display. The Getty presents objects that we cannot purchase.

In 1997, as if in unconscious echo of Baudelaire's account of beauty, Harold Williams wrote: "I trust the Getty will always be in and of the moment."[41] But in calling attention to this effect, I hesitate to interpret it politically. Delacroix's *Apollo Slays Python*, showing the conflict between order and chaos, makes a statement about the relationship between Denon's museum and the royal French palace. Henry James's dream and Baudelaire's poems provide immensely suggestive ways of understanding the Louvre. The Getty too will become a container for a rich array of feelings. It is too early to do more than predict how this young museum will be understood. But considering the strange metamorphoses that took oil to Southern California, making possible the ever-bustling traffic that you see from Meier's building and the wealth needed to construct his museum and assemble its collection, encourages conjecture.

Adrian Stokes's *Stones of Rimini* (1934) describes the Tempio Malatestiano, Rimini. The relief sculptures by Agostino di Duccio in this fourteenth-century church reveal the history and role of stone in Mediterranean life. The source of the sculpted material in vegetation, its creation under the sea pressure, and the carved images of a watery world led Stokes to fantasize Venice and Rimini engulfed by the sea. "Imagine rows and rows of serpents in horizontal glide across the piazza, not stopping or turning at St. Mark's, but rearing up their wet scales to coil them about the porphyry and serpentine pills, to lay their eggs in the recesses of the massive foliage of the capitals, to leave their slime upon the porphyry head of Justinian and slither down the sheeted walls." The end of the world is at hand. "Sea and sea-life mount the shore still higher without hard to the land because of the infusion of air and moonlight in the heavy water. The mysteries of ocean and of earth, taut now and exemplified to the last atom, at peace, together they are forging the new element which shall the better sustain the offspring of dust and water, the living form, their offspring of a now-remembered marriage before the feud."[42] The history of this carved stone comes to the surface in the sculpture of Agostino.

Noticing the little *Saint Cyricus* by Francesco Laurana (one of Stokes's heroes) at the entrance to the Getty galleries, I think of oil, another product of dead vegetation under prolonged pressure, which made pos-

sible the collection and display. Sigismondo, the merciless warrior ruler
of Rimini, paid for the Agostino's sculpture. "The Tempio Malatestiano,
like Sigismondo himself, was a divided structure. On the outside, a clas-
sical Albertian esthetic prevails. . . . On the inside, the Tempio Mala-
testiano is animated with reliefs comprising an elaborate iconographic
program."[43] Then, as now, there are natural associations of great art with
ruthlessness. Getty, it should be said, like Sigismondo was a divided per-
sonality. A very gifted businessman who had a real passion for art, "he was
a virtuoso of remote control, of using his money and his expertise to make
extraordinary things happen far away, while seeing them in his imagi-
nation. It was a most unusual talent."[44] His near contemporary Norton
Simon, another successful businessman, was more fruitfully ruthless in
his art dealings.[45] The Norton Simon Foundation, a few dozen miles away
in Pasadena, has a superior collection, but its building does not project
a challenging interpretation.

The second floor of the Getty concludes with James Ensor's *Christ's
Entrance into Brussels in 1889*, four-and-a-half meters wide, another work
of art which could inspire reverie. Here, in a very literal way, the mu-
seum's narrative of the history of painting comes to a halt. As Perrin Stein
describes it, "In nightmarish fashion, elements of pre-Lent carnival and
political demonstrations merge with Christ's procession. Threatening to
trample the viewer, the crowd pours into the foreground, which is ar-
ranged in a steep, wide-angle perspective."[46] The collection ends before
cubism, expressionism, and abstract art, just when the traditions of rep-
resentation became problematic. Think of a scene from a famous L.A.
novel, *The Day of the Locust*: "Across the top, parallel with the frame,
he had drawn the burning city. . . . Through the center, winding from
left to right, was a long hill street and down it, spilling into the middle
foreground, came the mob carrying baseball bats and torches. . . . In the
lower foreground, men and women fled wildly before the vanguard of the
crusading mob."[47] The Getty painting, does it not, anticipate the crowd
scenes in Hollywood movies? And *Christ's Entrance* also looks backward
historically, to just a quarter-century before Ensor made this picture.
When Baudelaire visited Brussels his initial lecture on Delacroix was a
success but then, very in character, he determined to alienate his audi-
ence: "This is the second time I have spoken in public, and it was in front
of you, at my first lecture, that I lost what might be called the virginity of

the word, which, I might add, is no more of a loss than the other."[48] In "Belgian Civilization," Baudelaire makes a savagely sardonic comment on the provincial city: "The Belgian is highly civilized. He is a thief and a slyboots and he sometimes catches the pox, so he must be highly civilized . . . He never wipes his arse, but wears a coat and trousers, a hat, even a shirt and boots. . . . What's more, he can copulate standing like any well-trained monkey."[49] *Christ's Entrance* certainly provides a suggestive perspective on the city that we see from the Getty.

The Louvre occupies the center of Paris. The Getty, by contrast, on the wealthy west side of Los Angeles, high enough so that you can see downtown, is far from the sites of political power, local or national. The power of the Louvre derives self-evidently from the French state. L.A. holds classes at a distance—as you see from the Getty, which is democratically accessible.[50] The literature shows the difficulty of bringing this institution in focus. Some problems are linked to the difficulties of understanding Los Angeles, "the city that American intellectuals love to hate."[51] No one worries about whether New York, the center of world finance and the middlebrow Broadway culture, can also support high art. But in Tinseltown, a rich young city, lack of serious collecting traditions means that great hopes are invested in this institution. That the Getty turns its vistas into absolutely contemporary works of art is very appropriate for a museum in a city without much history.

Quatremère de Quincy and his contemporaries argued that art could not survive the move from Italy to Paris. Now, when the Louvre is so well established, it is hard to recapture that shocked response to change. But since the Getty is our Louvre, a museum filled with old art recently moved to a new site, not surprisingly much reportage is a catalogue of complaints—worries about the cost, about the location, about the collection, about its elitism.[52] Every institution has its limits—and a grand new museum needs time to define its identity. But one feels that these critics are not just describing the Getty but trying to express their inchoate sense of larger issues.[53] One curator complained that my account failed to consider the much-discussed practical problems with Meier's building. True enough, but in judging a work of art do we ask about practical qualities? Judged as a functional building, Gardner's museum has problems. But seen as a work of art, as she intended, it is splendid. The same is true of the Getty. Much of ambivalence involves uncertainty about how to respond

to democratically accessible luxury—not the baroque excess typical of populist culture, but the austere high-maintenance space of high modernism. The museum offers the democratically accessible luxury of good clear spaces and lucid hanging conditions. Only a few intellectuals will think of Pliny the Elder when they climb the hill in Brentwood or recall that originally museums were homes of the muses when they enter the main building. But every visitor understands the power of the Getty vistas. Unless you observe how the building draws on history, you get a deeply impoverished analysis. A museum gathers precious beautiful objects, so we have reason to the collection. But as James's dream about the Louvre shows, defining the line between rational reasons for caring about art and the ways in which art involves irrational concerns with power and political prestige is not easy. Premodern collections displayed the power of the ruler. As John Onians writes, "The person who called himself emperor . . . needed to demonstrate his right to that position by his displays of knowledge and power."[54] Power literally came from above, as when, for example, the Alhambra, an elegant building with gardens and flowing water, was set on a mountain above Granada, "a place whence physical force and control came: popular riots in the lower city were stopped by the Berber guard from the Alhambra. . . . It was . . . the seat of symbolic power."[55] Such political symbolism remains important, but our society works differently.[56] Meier's museum offers the democratically accessible luxury of good clear spaces and lucid hanging conditions. And the well-guarded collection can afford to dispense with glass on pictures, but not everyone can go everywhere. The more open the space, the more guards are needed to define boundary lines.

In first-century Rome, Onians explains, "everybody, from the emperor to the ordinary citizen, was able to spend some time in an environment that was entirely artificial, a world of fiction no longer subject to the laws of nature."[57] But that did not happen again until the nineteenth century. In Rome, Bettina Bergmann writes, "*seeing* offered the sole means of contact with the powerful. Thus the behavior of spectators themselves became theater."[58] Like those Romans, we stand at the end of an epoch. Harold Williams, a Getty administrator, explains why we value museums: "I think the artistic and cultural sector has tremendous strength and is positioned to take a primary role in building community. . . . It's crucial that we emphasize art and culture not only to foster an apprecia-

tion of one another but, just as important, to open the door to a deeper understanding of oneself."[59] The museum is a European invention, but as it encountered non-European peoples and displayed their arts, it successfully adapted.[60] Like bourgeois democracy, successful museums are admirably supple.

Charles I and Vivant Denon would have been fascinated by Getty's career. They could have understood his collection, but what would they have made of this museum? They certainly understood political power, but Meir's symbolism would puzzle them. Like the Barnes Foundation, the Getty is a unique museum. No major public museum is trying to imitate Albert Barnes's old-fashioned installation, and few if any other institutions can even contemplate replicating the extremely expensive Getty structure. Meier's building is an extreme demonstration of how to make possible aesthetic experience in the immediate present. But however instructive such a unique museum is for the theorist, what can it tell us about the general fate of that institution in our posthistorical era? To answer that question, we need to consider more typical present-day art museums. That is the task of our next chapter.

10

The End of the Modern
Public Art Museum

A TALE OF TWO CITIES

The spectacle is *capital* accumulated to the point where it

becomes image. —GUY DEBORD

Our earlier museum interpretations focused on curators, collectors, and architecture. Extending that discussion in a natural way, we here consider the relationship of museums to their host cities.[1] The previous chapter described how Los Angeles appears from the Getty. Now I indicate how the histories of two cities legitimately influence interpretation of their museums. "Commerce between mobile and static (lacking in modern streets)," so Adrian Stokes writes, "provides the clue to Venice, to Giorgione and to all the greatest art."[2] Following Stokes and his great precursor John Ruskin, recent scholars have shown that the art of Venice cannot be understood without knowing the physical situation of the city.[3] Reflections in water, clouds, and the local architectural styles affect our experience of painting from Venice. The city "is a space just as highly expressive and significant, just as unique and unified as a painting or a sculpture."[4] Analogously, so I will argue, we cannot fully interpret American museums without grasping their relationship to local urban culture. Just as Venetian painting is site-specific, so too is the art collected in our cities. Here I extend the phenomenological analysis from chapter 5. To fully understand an individual work of art, you need to walk in the museum. And to properly understand that institution, you need to drive around its host city.

Here the orientation of our history changes in a significant way. Gardner's and Barnes's museums are highly personal institutions. And Meier's architecture employs the Getty's unusual wealth to create a unique dis-

play. These museums thus are too singular to be models. And so to trace
the fate of the display of public art, we turn to more typical institutions.
American public museums are heavily affected by local conditions. In
Detroit, a major older collection suffers because it is tied financially to
a declining city. In Fort Worth, by contrast, a new wealthy institution
has an impressive Louis Kahn building with a very ambitious collection.
When you look to other countries, the museum's history is still more
complicated. A sociological account of the modernist museum would
need to study a great variety of such institutions. But I am interested
in what necessarily happens to the public art museum once the expan-
sion of its collection has been completed. And so just as Arthur Danto's
analysis cited in chapter 4 looks at the essential nature of human action,
not the variety of activities discussed by novelists, so here I abstract away
from merely provincial concerns to give a general analysis. The philo-
sophical historian must be selective. "Pragmatic historiography, written
under the impulse to serve some cause, some practical end, rises above
the universal variety inasmuch as it moves from a poetic to an oratorical
mode of conceiving its task, from the vision of the ideality of the whole
to an awareness of the uses to which a vision of the whole can be put."[5]
Synecdoche, as Hayden White characterizes this mode of writing, is both
a necessary and a convenient strategy.

I present my general account of the present state of public museums
with reference to Pittsburgh and Cleveland, cities that I know firsthand.
To properly understand their displays, you need to learn their history.[6]
Pittsburgh and Cleveland, only 140 miles apart, have similar histories.
Once major early-twentieth-century industrial centers, as they decay and
lose population, they seek new identities. The great high tide of capital-
ism briefly dramatically elevated the local economies and then quickly re-
treated, leaving art collections to mark that moment of magnificent pros-
perity.[7] They developed very different museums, and comparing their
histories and institutions is very revealing. Modernist and contemporary
art, so we saw in the past two chapters, has been a prominent recent
concern of museums. Pittsburgh's Carnegie Museum of Art was an im-
portant pioneer showcase for contemporary art, and its fate is of general
interest. Usually museums develop without self-conscious published re-
flection, for curators generally have neither the inclination nor the time to
verbalize their concerns. But in Cleveland a very articulate director, Sher-

man Lee (1918–) and an influential aesthetician, Thomas Munro (1897–1974), spelled out the working assumptions of the modernist museum.

The Seattle of the late nineteenth century, Pittsburgh is where many American fortunes were made very quickly.[8] The downtown, the Golden Triangle, is formed where the Monogahela and Allegheny rivers come from the East and meet to form the Ohio. These rivers were the basis for the local economy when coal and iron ore were shipped to busy mills, making the heavily polluted city a natural destination for workers, European emigrants, and African Americans from the South. The collections of newly rich Pittsburghers and their children ended up elsewhere—in Henry Clay Frick's Manhattan museum; in Andrew and his son Paul Mellon's National Gallery, Washington, D.C., and the Yale Center for British Art; and in the Phillips Collection in Washington, D.C.[9] Andrew Carnegie wanted that the Pittsburgh museum bearing his name exhibit contemporary art. Uninterested in building a collection, he did not provide a substantial endowment. (In the late twentieth century, a relatively modest permanent collection was established.) A branch of the Carnegie is devoted to Andy Warhol, but apart from hosting annual exhibitions of a local organization, the museum has never developed strong relationships with Pittsburgh's artists.[10]

Starting in 1896, every three years the Carnegie International presented new contemporary art from New York, Europe, and (in recent years) other continents.[11] Some jurors were distinguished—Henri Matisse (1930), Alfred Barr (1934), and Marcel Duchamp (1958). But on the whole the selections of these committees were surprisingly undistinguished. In 1952, in the heyday of abstract expressionism, for example, Ben Nicholson, Marcel Gromaire, and Rufino Tamayo were the top prizewinners.[12] More recently jury selections have been closely aligned with mainstream art world taste. Now a formulaic show, the International includes senior painters and sculptors, a number of midcareer figures, and younger artists. After the opening, it does not attract large audiences—the real desired public is curators and New York art dealers and critics. In the early twentieth century, shows of contemporary art were a novelty, but the proliferation of such exhibitions and easier travel has made the Carnegie International less important. Once Manhattan became capital of the art world, regional exhibitions were less important. If you visit New York's galleries, you know most of the art that will be in

the show. And once many other survey shows were created, Pittsburgh's International no longer was especially significant. Because the visual culture has changed dramatically, in ways that no one anywhere anticipated, Andrew Carnegie's once bold vision has not withstood the test of time.

Cleveland's history of involvement with the visual arts is more complex. A village with only a few hundred inhabitants in the early nineteenth century, by 1910 it became the sixth-biggest city in the United States, ruled by WASP industrialists from New England who lived in close proximity, summered and wintered elsewhere, and traveled to Europe together.[13] The Cleveland Museum of Art was founded in 1916, some decades after its rivals in Boston, Washington, D.C., New York, and Pittsburgh.[14] Immigrants—Jews, Germans, Irish, Italians, Eastern Europeans, and African Americans from the South—changed city politics dramatically, gradually coming to dominate local affairs. But they did not gain control of the museum. As recently as 1971, "of sixteen members" of the board, "no less than ten are related in some way to founders, past trustees or benefactors of the museum, to say nothing of each other."[15] Like its art collection, the board thus preserves history.

When Cleveland's museum was young, a paternalistic view of culture dominated American culture. At its opening in 1916, Charles Hutchinson said: "May this museum reveal to those who enter its portals the universal beauty of all about us, and inspire us all in the Art of Arts—the Art of Living."[16] And in 1914 Frederick Harris Goff, president of the Cleveland Trust Company, expressed agreement "with Andrew Carnegie's 'gospel of wealth,' which advised successful men to exercise a trusteeship . . . on society's behalf by administering their wealth as a public trust during their lifetime for the benefit of the public welfare."[17] Officials elsewhere also spoke in moralizing terms. When in 1927 the Detroit Institute of Arts opened a new building, the director of the arts council described its mission in terms that Henry James would have recognized: "The beauty of art and the spiritual and moral beauties which lie beyond and above the beauty of art alone, are as essential in the life of a community as are the material comforts and modern facilities and improvements which it is the pride of every prosperous, enlightened community of today to furnish its citizens."[18] The director William Valentiner argued that his collection was valuable because "we learn to appreciate the most diversified viewpoints, because their ideas appear to us in the pure barb of highest

beauty. . . . It is not art alone, but the unalterable depth and intensity of the human sentiment, which underlies all true art, that enables us to understand the spirit of past ages."[19] Many early-twentieth-century American museum officials believed that the public would be improved by contemplating beautiful art.

Sherman Lee, an outspoken aesthete, inherited this tradition. His institution, he said, "played under different rules than the market . . . as the art museum was a non-profit entity, it also was to be a *public* good, not a *majority* one . . . its place in the society was based on the quality of its services, not the quantity given or the sheer numbers receiving."[20] It cannot, he added, "become the Disneyland when it must be an authentic wilderness area." Looking backward, Lee said, it is "poetic justice that the rise of the art museum parallels that of industrialization. One can almost conceive of the art museum as a guilt-offering by industrial society, a place to preserve what is threatened with destruction."[21] The world annihilated by prosperous manufacturing culture is preserved within the art museum. "From this peculiarly American association of art, museums, and art education comes the concomitant fervor and near-religious aura about art, and by extension old religious questions are posed as aesthetic questions: the definition of art, the relation of art to society, the corruption of art by money, the artist and integrity, and even art as a species of salvation."[22] That much of this account seems highly critical. Insofar as Americans understand art in essentially religious terms, have we not condemned to falsity its intrinsic aesthetic values? "Lee . . . inherited as director of The Cleveland Museum of Art all the character traits which we have outlined as peculiar to the American historical situation and which a Marxist might amusingly call the internal contradictions of bourgeois aesthetics in its hypercritical American state." However much he desired his visitors to be aesthetes, that was impossible. And so Lee assembled a great collection and supported art education to justify that activity.

Lee himself describes his dilemma in a pithier but not altogether different way: "The arts have had a hard time in American society. The tensions of the frontier and of industrial urbanism are well known and have not been the happiest environment for such assumed luxuries as the arts."[23] A curator buys the best art available, leaving it to the education department to justify this policy. In 1976, near the end of his directorship, Lee wrote: "Neither Marxism nor capitalism need account for the

trying and annoying peculiarities of art within their theories. They need only endure art in practice, an accommodation possible to both but so far only partially achieved under capitalism."[24] His elliptical reference to Marxism alludes to a much-discussed problem. Karl Marx thought it a puzzle that the greatest art was created in the premodern Greek culture. Why, he wondered, was art from later more advanced societies not superior? "The Greeks were normal children," he said. "The charm their art has for us does not conflict with the primitive character of the social order from which it has sprung."[25] Here we get to the problems of historicism. As Arnold Hauser explains, Marx "taught that every spiritual creation . . . derives from a certain particular aspect of truth, viewed from a perspective of social interest, and is accordingly restricted and distorted."[26] Art changes with the times, and so an adequate aesthetic must not restrict itself to a fixed point of view. But because Marx was not especially interested in visual art, he did not develop these ideas.

In dealing with this peripheral concern of Marxists, Lee doesn't say anything about a more obvious and central concern, the relationship between his institution and its support system. As we noted when discussing Gardner's collection, it is natural to see museum art as the product of a metamorphosis. Within the capitalist economy, some few businessmen become wealthy. All that then really survives in our public galleries, the museum skeptics say, is the accumulation of surplus value transformed into precious works of art. To understand that metamorphosis, as when we seek to comprehend how a god can become a person or a person a thing, we need a plausible narrative. When, for example, Atlas, the largest mortal, ruler of a distant land, refused to admit Perseus to his kingdom, that god "produced in his left hand the horrid head of Medusa. Atlas was changed into a mountain as huge as the giant he had been. His beard and hair were turned into trees, his hands and shoulders were mountain ridges, and what had been his head was now the mountain top."[27] Just as Ovid tells how Atlas became trees and stone, so Marxists explain how surplus value becomes precious works of art. In arguing that old art is not preserved, museum skeptics offer a history of such artifacts. What art museums really contain, they imply, is only accumulated capital. This may seem a purely metaphysical argument, as abstract as Bertrand Russell's claim that the world might have been created five minutes ago. But once

you study auction catalogues, this Marxist equation of precious art with accumulated capital will seem obvious.

Historicism is always a difficult position to maintain consistently. "Always historicize!"—what is the truth value of Fredric Jameson's statement?[28] Insofar as historicism means, by definition, that truth in interpretation depends on the times, it is hard to treat it as an eternally valid position. And as Saisselin notes, our concept of art certainly changes with the times: "The historical nature of the arts conflicted with a traditional approach to their discussion founded upon supposedly universal and valid rules and standards of judgment. . . . The conflict was resolved by taste."[29] The museum cannot be understood apart from its historical and political context. "The arts were historical in nature, there were no universally valid rules; but taste might nevertheless create order out of historical chaos by being able to distinguish between what in a work of art was specifically historical and what was universal." It includes diverse art forms, set all within one large building, allowing us to observe their shared universal qualities. When the support system that made possible Lee's career changed, then so too did that very pure institution. The result, so we will see, is that the story of his modernist "ivory tower" museum has come to an end.[30]

After brief early collaboration with Albert Barnes, which yielded a book he coauthored with Paul Guillaume, *Primitive Negro Sculpture* (1926), Thomas Munro became curator of education at Cleveland's museum (1931–67) and professor of art at Case Western Reserve, the local university.[31] Well-read in philosophy and art history, he worked out both a definition of art and a theory of its development. Munro published many books and played a major role in the development of the *Journal of Aesthetics and Art Criticism*, the leading American academic journal devoted to that branch of philosophy. Much influenced by John Dewey, he thought that the boundaries between art and nonart were relatively arbitrary. "Art," he wrote, "is a name which is applied to many different kinds of human product and activity."[32] Focusing on older European painting, earlier philosophers defined art as mimesis. Munro notes that Brancusi's quasi-abstract sculpture poses problems for any such account. Since formal definitions are too narrow to cover the art in the museum, he seeks a neutral analysis, not "a special set of assumptions, which would

unfit it for use by persons with a different point of view."[33] His definition applied to old master European paintings, the art of Asia (he published a book titled *Oriental Aesthetics*), and contemporary sculpture. He wrote, "The art museum is an institution devoted in large part to facilitating the experience of works of art, through aesthetic enjoyment, scientific study, or practical use. It should therefore be of interest to the aesthetician to observe what goes on there."[34] Being a philosopher working for a museum gave Munro a special perspective. "Most of the philosophical classifications of the arts," he correctly observes, "would not work very well as applied to museum collections."[35]

Munro wrestles with the religious and metaphysical elements in older aesthetic theories. They cannot be concealed, he allows, but should be distinguished "from the more empirical elements which are more widely acceptable."[36] He asks an important difficult question: "Does the history of the various arts . . . disclose any persistent trend or large-scale process?"[37] The modern museum, he rightly says, too easily isolates art. "It tends to build up the conception of a work of art as something isolated, autonomous, detached from the flow of cultural history and unrelated to events in other fields."[38] Munro, by contrast, sets visual art within a cultural history. After surveying the immense variety of earlier theories, he models his analysis upon Darwin's account of natural evolution. "In the arts as in organic life, that which descends through long periods of time is the *type* rather than the individual."[39]

Munro's extremely ambitious survey yields a universal history, an account adequate to art of all cultures. Fenollosa's striking synthesis offered a broad perspective built upon close interpretation of many examples of Asian art and extensive cross-references to European developments. By contrast, Munro's abstract account does not focus on examples. His discussion of laws of change in art, comparing China and ancient Greece, is very vague:[40] "Art as a whole is becoming one diversified tradition, a constituent stream or set of merging streams in the total flow of cultural change."[41] Because each civilization had something to contribute, a visitor learns how earlier visual cultures lead up to the present. Munro describes abstractly how the art historical narrative found in the Cleveland Museum of Art appeals to visitors. "By showing him how many great styles of art the human race has produced, each with its own dis

tinctive values, we hope to enlarge his range of enjoyment."[42] This evo-lutionist plan presents "the development of culture to the point where people can think and plan collectively in general, long-range terms."[43] Between philosophy and art history Munro found a place for aesthetics, an old discipline that he believed could be given new life by becoming the foundation for a scientific system of art education.

In their writings, there was a striking division of labor between Lee and Munro. Lee took some interest in art education but was skeptical about its value, writing, "One-shot class tours are still the bread-and-butter effort of the museum for mass education. . . . However, on bal-ance . . . such tours have had no visible impact on the mass improvement of visual literacy."[44] Establishment of visual education in the schools, he said, would be preferable. But that, he admitted, was a utopian prospect: "An art museum's a place for looking at works of art. The idea that it's an instrument of popular education is a nineteenth-century idea, handed down by the Victorians."[45] Lee was a connoisseur and Munro a phi-losopher—in Cleveland they had different roles. The museum selects, preserves, and exhibits art, Munro wrote, and "the educational depart-ment . . . has the task of helping to present and interpret this cultural heritage."[46] Education matters because "in learning to perceive a great variety of complex forms and subtle qualities of line, shape, and color," the visitor "acquires visual powers which carry over into daily life." Like Roger Fry, Munro thought that art taught visual discrimination. And he believed that art was good for children. Museums are "one way to prevent delinquency or nervous tensions, and to produce a happy, well adjusted type of boy and girl."[47]

Art museums can readily present their collections as forms of cultural expression, for it is easy to see that Chinese, Indian, and Italian art dis-play different values. But teaching connoisseurs' skills to school visitors is more difficult. Traditionally only the privileged learned to identify and enjoy the very best high art. Like Bernard Berenson, the curators serve the very rich, and so within art history, connoisseurship has acquired a bad name.[48]

Courbet had tried . . . to put an end to the connoisseur. . . . But he failed, of course. . . .

"Long live the Revolution!"

"Still! In spite of everything!"

These are Courbet's instructions to the connoisseur. . . . They don't seem to me to have dated.

Many academics who reject T. J. Clark's particular leftist politics would agree with this statement. Great art is expensive, so connoisseurship is unavoidably associated with privilege. We all make distinctions between better and worse when judging fast food or television sitcoms. But because no one has discussed the relationship between this commonplace practice and high art, most museum visitors have no way of understanding the selection of the collection. And since connoisseurship has always been associated with elite culture, great effort would be required to popularize it. Doing this was not an interest of either Lee or Munro. Nor have other curators pursued that concern. And so "populist connoisseurship" remains an oxymoron.[49] That has made the life of Cleveland's museum more difficult.

Munro's publications, which mostly offer a highly abstract philosophical argument, are not on the whole visually sensitive. The announced concerns of his *Toward Science in Aesthetics: Selected Essays* (1956) mark his distance from present day art history: "It is widely recognized that aesthetics is no longer a branch of speculative philosophy, devoted to the vain attempt to set up universal laws of beauty and good taste, but first of all a descriptive inquiry which seeks to find out and state the facts about works of art as a kind of observable phenomenon, in relation to other phenomena of human experience, behavior, and culture."[50] Munro believed in progress. And he thought that his universal aesthetic could describe all art in a neutral way. "One comes to regard the [African] statue," he wrote, "not as a distorted copy of a human body, but as a new creation in itself, recalling the human form in a general way, but independently justified by its own internal logic, by the necessity and harmony of its parts."[51] The very title of his book *Primitive Negro Sculpture* marks its distance from the present. "The savage artist," as Munro identifies the African sculptor, created something that is meaningful "today, in the light of modern art and science."[52] Nowadays art writers do not believe that the history of art is a story of progress. Feminists and multicultural writers do not think that aesthetics can be a science. And no one speaks of savage or primitive art.[53]

Because Munro had an unpromising definition of art and an unconvincing narrative of art's history, his aesthetic proved inadequate when, near the end of his life, styles of art changed decisively. As Eleanor Munro indicates, her father's career crossed a crucial moment of transition: "The goal of Modernist art and art education had been an evangelistic one, right for an optimistic age. . . . a breach widened between my father's generation and immigrant and younger scholars. . . . He wouldn't be alone, in coming decades, to feel bewilderment, then painful disappointment, as he saw the tissue of Modernist confidence come apart."[54] Her affectionate but clear-eyed account links the rise and decline of Cleveland with the museum and his style of art education. Munro's aesthetic repressed awareness of what happened right under his nose in his city and in the art world.[55] And what he repressed, even within his family, was any mention of his wife's origins. Described in one recent memoir as "a beautiful southern belle from Alabama," in fact she was Jewish.[56] "Her whole married life," her daughter writes, "had been an exile from truth."[57]

Refusing to take an honest historical perspective, Eleanor Munro argues, was the ultimate limitation of her father's aesthetic: "The Holocaust was the *reductio ad horrem* . . . of the nineteenth-century Social Darwinism and eugenics theory, to which my father's Christian ancestors and Modernist educators paid innocently hopeful mind."[58] After the era of the Cleveland WASP industrialists ended, other groups took control of Cleveland as, within the art world, Munro's modernism was replaced by quite different theories. What should be learned, Eleanor Munro suggests, is that what is repressed can return to haunt you. The "enlightened [robber barons,] . . . following Dewey's advice, hired my father to set up a broad-based educational program through which the museum, in accord with old evangelical and modern educational principles, would extend its benefits to the whole city."[59] Rebelling against her father (whose nurturing influence she acknowledged), Eleanor Munro became a pioneering feminist art critic.[60] Thomas Munro's ideas were implemented in the Cleveland Museum of Art but, according to Ralph Smith, "did not substantially influence subsequent thinking about art education."[61] We philosophers of art do not read him. That fate is not surprising— few intellectuals attract serious posthumous attention. What is unusual is how this fall in his reputation was directly linked with broader institutional changes. Fifty years ago, Munro's account of art education sup-

plied a very useful way of thinking about the public art museum. You need only look at the origins of American museums to understand why art education was so important. After newly rich Clevelanders, like their contemporaries from other cities, went to Europe, they wanted to imitate old wealth and assemble treasures. But as practical-minded people who believed that art should serve the community, they needed a justification (or rationalization) for this activity. The English gentry collected for their own pleasure, resisting demands for the creation of a national gallery. But the less confident newly rich Americans felt that art they purchased should benefit the public. Private property merely serves the goals of its possessors, but once privileged individuals endow public institutions, they acknowledge a concern for the community.[62]

A recent publication by the museum responds to this history when it says: "A private institution operated wholly for public benefit, the Museum opens its doors to all."[63] Funded by donors, it serves the public. But the paternalistic Clevelanders who endowed this museum were not really giving up control, for through their trustees they retained authority over the institution they funded. Munro's theory of social evolution supplied a perfect rationale, an ideology if you will, for such collectors. "Just as the individual in his motives and aims remains unconscious that he is rationalizing, for the most part the members of a social group also are unaware of the fact that their thought is conditioned by material conditions of life."[64] Many Marxists reject the very notion of aesthetic experience. Terry Eagleton writes, "The construction of the modern notion of the aesthetic artifact is . . . inseparable from the construction of the dominant ideological forms of modern class-society . . . But . . . the aesthetic . . . provides an unusually powerful challenge and alternative to these dominant ideological forms, and is in this sense an eminently contradictory phenomenon."[65] But in examining the contradiction here between private property and the public good we need not go that far, for a more subtle way of thinking about art and ideology is provided by Hegel, whose writings were the essential source for Marx's thinking.

Art, so Hegel says, is a form of social expression: "A Bach cantata, for instance, conveys a certain vision of God, of Christ and man's salvation. But it does not portray, describe or offer a representation." Hegel's suggestive claim requires unveiling. "The message or vision is one we see in [art], and any statement of its content is the fruit of interpretation and

subject to challenge and perpetual reformulation." The form and content of art expresses the culture in which it is made, each culture's art displaying distinctive values. "The work of art has a certain inner luminosity, as it were. It manifests the spiritual at every point on its surface, through its whole extent. Everything in it is there in order to show forth the Idea."[66] The Idea, to use Hegel's jargon, is what art expresses. When he describes Greek sculpture as a form of cultural expression, although Hegel does not mention museums, his account easily suggests why public collections of art have social value.

> The perfect plasticity of gods and men was preeminently at home in Greece. In its poets and orators, historians and philosophers, Greece is not to be understood at its heart unless we bring with us as a key to our comprehension an insight into the ideals of sculpture. . . . in the beautiful days of Greece men of action, like poets and thinkers, had this same plastic and universal yet individual character both inwardly and outwardly. They are great and free.[67]

Art reveals historically or culturally distant societies. Francis Haskell explains that one nineteenth-century tradition of illustration, for example, sought "to make the past appear as natural as possible to the modern reader. Another tendency soon came to the fore which was based on exactly the opposite premise. Here, too the original sources had been carefully studied . . . but they were used in such a way as to suggest that the past had been remote, picturesque, exotic."[68] A fourteenth-century altarpiece teaches us about Italy's history, and Chinese scrolls inform about an exotic culture. And such art displays to us our common human nature, for beneath all of the obvious superficial differences between present-day Americans and Renaissance Italians or premodern Chinese, we discover universal cultural traits.

Before there were public museums, already the concerns of art education were anticipated by collectors. "A fabulous gemstone might be admired for its size, rarity, brilliance and cut, but it provided no information or insight into human history and conduct or the mysteries and meaning of the faith. . . . The appreciation of a picture, by contrast, was possible only through careful study and experience, the results of which were conveyed in a literary language."[69] Then as now, old art was valued because it displayed the values of long vanished cultures. Admiring art

while rejecting the worldview of the culture which created it leads either to focus on pure aesthetic pleasure or, alternatively, to valuing that art because of what it tells us about exotic cultures. According to J. Keith Wilson, for example, in Dong Qichang's *The Blue Bian Mountains* (1617) in the Cleveland Museum, "blocks representing forms seen from different points of view are combined to achieve a complex, three-dimensional vision. The overall effect is not unlike that found in cubist works painted centuries later in the West."[70] We enjoy the scroll because it is beautiful. And the artist's concern to achieve "both a radical synthesis of what came before" and to show "far more about a place than can be seen with the eye" tells about Ming culture. Aesthetic ways of thinking isolate art from its context. Art education, by contrast, values art for what it teaches about exotic societies. But in either case, we acknowledge that *The Blue Bian Mountains* comes from a distant world.

Examined critically, all of these claims are surprisingly problematic. Art typically reveals its culture only very selectively. If you want to understand Renaissance Italy or premodern China, it is best that you read their histories. Were art museums primarily concerned with such education, then they might amass inexpensive study collections. But in Cleveland, as in other ambitious museums, the curators are connoisseurs. Their collections are not designed to facilitate art education because there is no reason to think that the best art provides the best telescope for looking into distant cultures.[71] As curator, Lee sought to collect the best art, but as museum director he needed to justify that activity. Compromise was required—here he faced problems that have not gone away. Gardner and Barnes, independently rich individuals, created highly personal art museums, frank expressions of their taste. The Cleveland Museum is a public collection, and so within that institution, art education functions, I believe, as an obvious rationalization, the expression of a guilty conscience. The prosperity of Cleveland's collectors depended upon the labor of immigrant workers. And so these industrialists wanted to believe that their museum served the public good. No doubt in 1916 this was a plausible belief. But when their city changed dramatically, such paternalistic ways of thinking no longer were plausible. These changes are part of a larger shift in sensibility found everywhere, but because the city of Cleveland has declined so dramatically, the museum's fate is linked with that visible local change.

In the 1970s, it was natural to contrast two models for American museums, Thomas Hoving's Metropolitan and Sherman Lee's museum. "What has come to be known in this country as the museum crisis," Grace Glueck wrote in 1971, "has crystallized around two personalities of different education, background and belief."[72] Hoving, a patrician populist and brash showman, did whatever it took to bring crowds to his museum. If "Harlem on My Mind," which really was an exercise in sociology, not an art show, created controversy, then so much the better. In his response, Lee remarks: "The art museum is assumed to have once been in the center, the vortex of society, and to have now drifted away. . . . By their texts the authors consciously or unconsciously attest to their loss of faith in works of art to move men to order, compassion and delight."[73] In the late 1960s, Hoving has recently said, "I was interested in anything that made a news splash or changed the public perception of the stodgy, gray old lady of the Metropolitan Museum of Art, whether in statements to my colleagues or flamboyant exhibitions or, the most fun, acquisitions."[74] As he puts it, "with the same zest with which I had manipulated image into reality in my Parks days" — he was New York City Parks Commissioner under Mayor Lindsay — "I managed to get across the point that most other directors — especially Sherman Lee of Cleveland — were holding back the entire profession from its leap into the modern era."[75] When he speaks of "my almost desperate urge to be wanted," he describes not only himself but also his museum.

Lee, by contrast, had the taste, endowment, and trustees required for a very pure museum. In 1975 he wrote: "The social uses of art need no defense as long as these uses are not confused with the real thing. When they are, strong defensive measures are essential and, by their very nature, are liable to be unpopular."[76] In 1970, as if in anticipation of this statement, Rodin's *The Thinker* on Cleveland Museum's grounds had been bombed (fig. 21).[77] For local radicals, Lee said, "the Museum was probably seen as the cultural face of the 'establishment,' an error born of frustration and misidentification."[78] But here surely he was mistaken — his museum *was* the face of the establishment. How could he have made this mistake?[79] However much one sympathizes with his desire to keep it "above the fray of social and political contention," that was not honestly possible. Lee's failure here to think through the implications of his own sociological analysis is revealing. Unlike Hoving's Metropolitan, Lee's museum

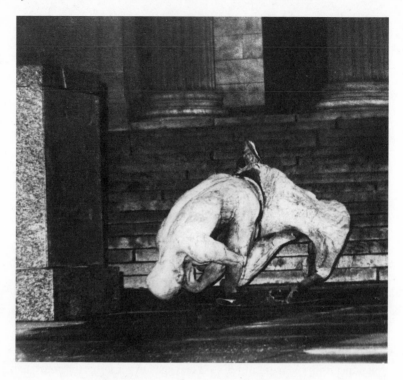

21. Auguste Rodin, 1840–1917. *The Thinker*, ca. 1880.
Bronze, green patina, 182.9 × 98.4 × 142.2 cm. Gift of Ralph King, 1917.42.
© The Cleveland Museum of Art, 2002.

chose to stand apart from its community. "Do visit," it seemed to say, "but only on our terms."

This contrast in personal styles of Hoving and Lee was made more striking by accidents of local geography. The Metropolitan is in a very rich part of Manhattan, while Lee's Cleveland Museum is alongside a decaying African American neighborhood, site of the 1966 riots. Although trained at Princeton University as a medievalist, Hoving is not known for scholarly publications. Lee, by contrast, a graduate of Case Western Reserve University, worked in Detroit and Seattle before becoming curator of Oriental art at the Cleveland Museum. His *History of Eastern Art*, a magnificent synthesis offers not only a magisterial account of the arts of Japan, his specialty, but also a full survey of the architecture, painting, and sculpture of China and India. Nowadays few administrators write

books. In part this change reflects the changed situation of museum directors, who are much busier than in Lee's day. But putting the comparison in those terms hardly does justice to Lee, who, judged by any standard, was a very exceptional figure.[80]

Lee "has made his views on museums so clear and convincing," his friend the philosopher Nelson Goodman wrote, "that nothing more is needed to strengthen his case, or would be likely to lessen the widespread and stubborn opposition to it."[81] Perhaps that was correct thirty years ago, but now Hoving's vision of the museum has prevailed. This is true even in Cleveland, where Lee's daughter Katherine Lee Reid is director of the museum. As Lee himself noted, when Goodman was invited to address the American Association of Museums in 1979, his words "fell on obviously deaf ears."[82] The American public art museum has transformed itself from a center of high culture and art education into a pleasure palace, and so now Lee's writings define a vanished period style. When recently a commentator said, "the Getty Center is meant for public use and pleasure," she identified in a frank plausible way the present goals of public art museums. "In a century where the engines of both education and the postindustrial economy are beginning to liberate the middle class from the suffocating insularity of low-paid, unskilled labor, the arts have become common property."[83] The art museum is *the* public space, a place to dine, shop, and hear lectures and music.

Once art tourists visit museums like the Getty, they seek similar luxurious public spaces in their hometowns. Every large institution follows this general model, which is not to criticize the administrators—who only respond to larger forces outside of their control—but to note an irresistible trend. Sherman Lee has no real successors, because nowadays museums everywhere are run differently. "Unlike a cat who may have the privilege to sit and simply look pretty, a museum is expected to return some benefit to the community in exchange for the support that the community provides," Stephen Weil writes.[84] The real internal contradiction of present-day bourgeois aesthetics is that museums need to attract the public and funding in a democratic culture while presenting collections using a top-down bureaucracy that comes from the old regime. The older "envelope in which works of art invariably arrived" in Lee's modernist museum, and Munro's theory, without which this art would be "the mere thing itself," are no longer adequate. The physical works of art in Cleveland are pre-

served, but insofar as we have no adequate envelope to encompass them, no plausible theory of their function, we may legitimately worry about whether this art has survived. Louis Althusser writes, "As Marx says, it is in ideology that men 'become conscious' of their class conflict and 'fight it out'; in its religious, ethical, legal and political forms, etc., ideology is an objective social reality; the ideological struggle is an organic part of the class struggle."[85] Earlier I expressed considerable ambivalence about the validity of museum skepticism. But here, I would add, the present history of the Pittsburgh and Cleveland museums shows why this point of view remains attractive. Lee's interpretation of art museums has failed, and as yet no developed alternative account is available. This great collector of Asian art has unadventurous taste in contemporary painting and sculpture. Recently the museum has attempted to repair this omission, purchasing new art and exhibiting shows of younger artists. But here, as in Pittsburgh, this strategy is obviously problematic. Contemporary art is extremely expensive, and Cleveland has no well-established tradition of collecting. Inevitably, the museum is competing with very well endowed institutions in New York City, and also now in Europe. Such important collectors as Agnes Gund and Philip Johnson came from Pittsburgh, as does Peter Lewis, who has played a major role supporting the Guggenheim Museum. But these people have not, for whatever reason, played a major role within the Cleveland Museum of Art. The museum would do better, in my opinion, to focus on strengthening its great collections of Asian and old master European art.

Looking back at Lee's Cleveland Museum of Art, we may think he failed to think through these dilemmas. But here, in truth, we return to the problems of historicism. In Lee's day, his aesthetic yielded first-rate practical results; he had every reason to trust that way of thinking. But the world has changed. In Lee's time, Cleveland's museum could rely on its endowment. But now when loan exhibitions have grown much more expensive, when contemporary art has become very costly, and when the expectations of museums have changed, it has had to change. Only those institutions capable of radical innovation will survive. Museums remain ideal places for reflection, but when directors seek to maximize the number of visitors, scholars' concerns cannot dictate policy. Nowadays these institutions use blockbuster exhibitions, concerts, films, lectures, shops, and restaurants to attract visitors. Doing that is necessary, for few people

come just to see the permanent collections. But insofar as they exist in order to display art, the problems with that policy are obvious, as Lee well understood. Restaurants, shops, and movie theaters are commercial establishments. The museum's claim for public support depends on its collection, not these auxiliary support systems.

What is most needed is finding ways of enlarging the audience for visual art. If provincial museums had many more visitors, then they would attract better financial support. But since no one knows how to effectively persuade more people to see visual art, by default they enlarge their audiences by creating attractive public spaces. Conservatives love to recall the good old days when museums had simpler restaurants, no shops, and few blockbuster exhibitions. Such nostalgic people tend to remember the good things about the past—and to forget the very real problems. Under the old regime, European life was freer in some ways (not just for the elite) than within democratic bourgeois culture. But since that world of aristocratic privilege will never come back, fantasizing a return to the past is impractical. Neil Harris asks: "If attractiveness and public appeal become the museum's objectives, how in effect does it differ from any commercial institution which exists chiefly for the purpose of selling?"[86] Not at all, for like a store, it must sell its product, art exhibitions. As a visitor, I happily wander in traditional museums without crowds. And I love blockbuster shows especially so long as they are not crowded. Of course my thinking is obviously inconsistent, but saying this is merely to express my own bias. Like Lee, I am an elitist.

Public institutions everywhere imitate Hoving's Metropolitan. They have to do so, because treating the museum just as "a place for looking at works of art," to cite Lee's phrase, is no longer viable. Under the pressure of economics, the art museum has changed decisively. In tracing the end of the modernist public art museum, Lee's great institution provided my obvious model. But here I do not mean my narrative to be unnecessarily dramatic. Just as many old-fashioned collections survived after 1793, so in Cleveland and elsewhere traditional concerns remain important. Connoisseurs wander in the galleries; scholarly exhibitions are organized; and many people look at art without stopping to shop, see movies, or hear concerts. This bourgeois institution allows visitors to choose how to employ its collections, but its orientation has changed decisively. That is why I speak of the end of the modern art history museum.

Here, as in our discussion of Berenson, the relationship between art and privilege is not easy to unravel. According to liberals, there is nothing necessarily wrong with fairly earned privilege. "While the distribution of wealth and income need not be equal, it must be to everyone's advantage, and at the same time, positions of authority and offices of command must be accessible to all," John Rawls writes in *A Theory of Justice*.[87] Since Giotto's day, European high art has almost always been intimately linked with capitalist culture.[88] Perhaps some future utopian society will create museums of high art fully accessible to all, but until then we museum lovers must live with our conflicts: "Always historicize." Denon's style of looting is not now permissible; Berenson's theory of tactile values is no longer accepted; Barnes's analysis of modernism is outdated; Fenollosa's history of Asian art requires radical revision. And yet we still value the museums they helped create. But Denon, Berenson, Barnes, and Fenollosa are distant enough that it is unnecessary to criticize them. The problems of historicism are most pressing when we look close to the present. We enjoy Caravaggio's painting without worrying too much about the fact that our commonplace views of feminism and racial tolerance were foreign to the Catholic culture that his art glorifies. "In the old China women were first of all the product and the property of their families. Until well into the present century their subjection was demonstrated and reinforced by the custom of footbinding," as John Fairbank reminds us.[89] Still we enjoy Chinese art. And we greatly admire Henri Matisse's painting while allowing that his lifestyle was antediluvian.[90] We take a historicist perspective on Caravaggio, Chinese painting, and Matisse.[91] But in critiquing the period style of Lee and Munro, the situation is different, for we are concerned with figures whose influence extends into the immediate present. It is easy, as museum skeptics show, to moralize about art museums.

Since Denon, like capitalism—with which it is so closely associated—the public museum has depended upon constant expansion. The end of the cold war and the incorporation of the former socialist countries into the free market economy have led to the creation of Western-style art museums in China and the developing countries. But that cannot continue endlessly.[92] Nor do new major forms of art remain to be added to the museum. What will happen next? Danto argues that art's history has ended. Our analysis suggests that the story of the museum's expansion

has also ended. Here, taking a larger perspective, these trends deserve to be linked. Capitalism is "a profit-driven system of accumulation and incessant search for new technologies to increase productivity," Megnad Desai writes. "As such it is prone to cycles, crashes and panics. It is the best arrangement for the alleviation of poverty and misery, even as it destroys jobs and restructures economics."[93] A market economy requires new discoveries like portable computers, cell phones and Web-based consumer services. Like artistic tradition and the museum, our culture has kept going only by unceasing metamorphoses.

Hegel, a Marxist philosopher complained in 1968, "was unable to penetrate to the real driving forces of history."[94] That claim seemed plausible then, but now, when almost all of the communist states have disappeared, Hegel may provide a better guide to our dilemmas than Marx. "Unless a form of life develops some way of reflecting on its reason-giving activities," Pinkard writes, "it cannot generate the kinds of self-undermining skeptical discreditings that then *require* and make possible their resolution in some later form of life having its own distinctive account of itself and its own set of reflective institutions."[95] For our museum culture to advance, it must inspire self-critical reflection. And that requires a political perspective. Often philosophers of art have an uneasy relationship with their colleagues who write about politics. When in the late 1950s Danto discussed Marxism in Columbia University lectures, he discovered that FBI agents were sitting in. They must have been very disappointed, for his academic commentary was unsympathetic to Marx. In fall 1968, right after the campus uprising, Danto began discussing the philosophy of action by explaining that he would consider actions like raising one's arm, our example used in chapter 4, not political activities. At that point, half of his students left the room.

Hegel wrote about art, history, metaphysics, and also political economy. Unlike him, Danto has shied away from philosophizing about politics.[96] That may seem a surprising omission, since the *Nation*'s art critic frequently acknowledges a deep debt to Hegel.[97] In his account of Warhol, Danto has described the transition point that made Lee's and Munro's ways of thinking obsolete. Many people find such moments difficult to comprehend.[98] In Ovid's time, for example, "the Greek/Roman pantheon had fallen in on men's heads. The obsolete paraphernalia of the old official religion were lying in heaps, like old masks in the lumber room

of a theater, and new ones had not yet arrived."[99] The *Metamorphoses* "establish a rough register of what it feels like to live in the psychological gulf that opens at the end of an era." Old enough to have remembered Depression-era visits to the Detroit Museum of Art, Danto recognized early on that the modernist tradition was finished. Historiography dealt with change and so it is unsurprising that he was well prepared to understand that metamorphosis. When the public art museum was born, that radically novel institution was very hard to comprehend. Understanding the end of the modern art history museum in the early twenty-first century may be equally difficult. But here Danto's aesthetic can aid us.

Hegel's argument that history has come to an end, a minor late addition to his system, became a central theme in the famous exegesis by Alexandre Kojève: "Post-historical animals of the species *Homo sapiens* (which will live amidst abundance and complete security) will be *content* as a result of their artistic, erotic and playful behavior."[100] Visits to America and the USSR between 1948 and 1958 gave Kojève the sense that already posthistorical life was being realized. Then his esoteric analysis came to popular attention thanks to Francis Fukuyama's *The End of History and the Last Man* (1992), which argues that modernizing industrialization inevitably leads to liberal democracy: "As the twentieth century comes to a close there is little real alternative to liberal democracy and market capitalism as fundamental organizing principles for modern societies."[101] Fascism and communism, the obvious alternatives, failed completely; while disaster is possible, in the future neither radically novel political cultures nor major international wars are likely. The end of history, Fukuyama writes, "will mean the end . . . of all art that could be considered socially useful, and hence the descent of artistic activity into the empty formalism of the traditional Japanese arts."[102]

Fukuyama and Danto are Hegelians who locate endings of history at almost the same moment. Fukuyama's political history involves the triumph of one system. Danto's end of art's history marks the coexistence of all possible ways of art making. For Fukuyama, capitalism proved its superiority; according to Danto, Warhol's generation revealed the essence of art. Fukuyama and Danto both think that the end of history is a relative good. Fukuyama argues that liberal democracy is better than its major rival, communism. And as art's history ends, so Danto claims, the struggles of the abstract expressionists are replaced by happy play. There is

an internal connection between Fukuyama's and Danto's ways of think-
ing. Warhol's *Brillo Box* could be made only in a prosperous democracy
with consumer products in its grocery stores. Danto was not tempted to
link the end of art's history to Fukuyama's speculation about the end of
history. Danto develops a philosophical argument, but Fukuyama does
not. And so Danto's account is not vulnerable to empirical counterargu-
ments, as Fukuyama's all too obviously is.

Now as in Fenollosa's time, very different theorists are influenced by
Hegelian ways of thinking about the end of history. It is hard to imagine
two more different near contemporaries than Danto, who was born in
1924, and the ferociously dogmatic Guy Debord (1931–94), founder of
the Situationist International. But when Debord writes, "the revolution-
ary project of a classless society, of a generalized historical life, is also the
project of a withering away of the social measurement of time in favor of
an individual and collective irreversible time which is playful in charac-
ter,"[103] his intellectual relationship with Danto (and Fukuyama) is appar-
ent. Danto quotes Kojève—we find "preserved indefinitely . . . art, love,
play, etc.: in short everything that makes man *happy*," a Marxist vision of
what happens when, as Danto explains, "history comes to an end, but not
mankind—as the story comes to an end, but not the characters, who live
on happily ever after, doing whatever they do in their post-narrational in-
significance."[104] That too is not unlike the future that Debord envisaged.
A long book would be needed to trace the roots of Marx's *détournement*
of Hegel's philosophy, which derives from Schiller's vision of aesthetic
education: "With beauty man shall only play, and it is with beauty only
that he shall play. . . . man only plays when he is in the fullest sense of
the word a human being, and he is only fully a human being when he
plays."[105] "What Schiller is demanding," his translators remark, "is the
restoration of the wholeness and harmony of the individual Greek."[106]
He points, so the Marxist Georg Lukács said, "to the principle whereby
*man having been socially destroyed, fragmented and divided between differ-
ent partial systems is to be made whole again in thought.*"[107] Or as Thomas
Greenwood wrote in 1888, "art-education means instructing both young
and old in the appreciation and enjoyment of that which is beautiful."[108]
Like Munro, Schiller believed in art's healing power. But is that belief
still justified?

We aesthetes may be happier if we do not look too closely at the histori-

cal processes in which the art we love was accumulated. Nowadays determinedly multicultural, the museum remains, as under Denon, essentially paternalistic. Since it shows old art in displays implying that there is a continuous tradition, a story of art running into the present, this institution itself remains essentially linked with the past. Survivals from the old regime like the constitutional monarchies found in some European democracies, museums hope that visitors will be charmed by the splendor of a visual culture in the selection of which they have no share. Like the old regime, these institutions are controlled by the very rich. Saint-Simon's *Memoirs*, fascinating tales of ruthless intrigue, provide a good guide to the corrosive social politics of these extremely hierarchical institutions. In 1917 John Cotton Dana, director of the Newark Museum, presciently said that if the "development of American art museums into remote palaces and temples—filled with objects not closely associated with the life of the people who are asked to get pleasure and profit from them, and so arranged and administered as to make them seem still more remote—it may be said that if this development has been as natural and inevitable as has been suggested, then no one can be charged with responsibility for the fact, and not much can be done to correct the error."[109] Like the visual art that they display, museums are products of elite cultures. Just as they exclude all but the best art from their collection, so they enforce elaborate social exclusions.

Like Renaissance painters who depict themselves in a corner of their pictures, I note my small place in this history. I came from Pittsburgh in 2001 to take up the newly endowed Champney Family Professorship. Like the museum, I thus am dependent upon Cleveland old money. Had I not moved, I would still have written this book, but the last chapter would not have focused on Cleveland's museum. My heart always beats faster when I enter, so why am I not more thankful for that privilege? Perhaps my problem is that visiting Cleveland teaches too much about the price of these beautiful works of art. Driving from my pied-à-terre to the office, I pass the Jewish cemetery and the larger cemetery where the more famous gentiles are buried, a reminder of local anti-Semitism. Commuting from Pittsburgh, I am aware of the obvious connection between the wealth of the museum and the poverty of Cleveland. Accumulated surplus value amassed by the local capitalists has been transfigured

to become aesthetically beautiful art in the museum. You don't need to closely study Marx to understand that process, not when so politically mild-mannered a historian as Francis Haskell speaks despairingly of "the link . . . which is now vaunted with such obsessive insistence, between money and art."[110] And if I, a relatively privileged professor, also feel this way, then what about the minority people who guard the collection and work in the cafeteria, but have almost no presence on the staff?

I focus on Cleveland for in looking from the museum to the city you *see* the ethical dilemmas posed by public art collections. When I sought out Munro's books in the Case Western Reserve Library, most of them were in long-term off-campus storage. That university has not effectively memorialized either Lee, one of its most distinguished graduates, or Munro. Cleveland guards its art but tends not to preserve its history. The grand mansions of the museum founders are destroyed, but their names remain, carved on the entrance wall. And their collections remain but their world, like Lee's and Munro's, has disappeared. Earlier I spoke of the way that the Louvre inspires reflection upon violent confrontations between the cultures whose art it contains. Now we can extend that analysis. The Cleveland Museum of Art should inspire a social historian who is fascinated by the class conflicts. Certainly no one interested in old art can view the disappearance of the past with complete indifference. And yet this is not my entire story.

Lee helped produce a great museum in Cleveland, a place whose collection remains of passionate interest. But since his way of thinking and Munro's is obsolete, for art museums to prosper they need a new interpretation. Indeed, the situation gives cause for reasonable hope as Katherine Reid prepares plans for a massive renovation of the building. Recently one museum director has convincingly spelled out why we should be optimistic: "The task facing museums is an ambitious and even daunting one: to make the visits they provide as beneficial as possible to as many people as possible. They have the resources to do this. They occupy magnificent buildings, many in enviable locations, with untold riches on display and in store. They have staff with great learning and a love for their subjects."[111] Reading the literature, I am struck by the many stories of the saving powers of art. Marilyn Perry tells of a very difficult time in her life when, young and penniless, she was "as yet without friends"

in London. "When I think of that period, its terrors and uncertainties are countered by the welcoming warmth of the Wallace Collection and the beauty of the pictures that had become my dearest companions."[112] Then she adds something important: "It is the capacity to move us, to inspire love, that distinguishes art from all other objects." Ernst Gombrich presents a similar anecdote about an anonymous political refugee who "during sleepless nights . . . took a walk through the Louvre, as he remembered it."[113] Anyone who cares about museums has had similar experiences.

At the end of *Metamorphoses* Ovid explains how very optimistic he is about the fate of his poem. "My work is complete: a work which neither Jove's anger, nor fire nor sword shall destroy, nor yet the gnawing tooth of time. . . . with my better part I shall soar, undying, far above the stars, and my name will be imperishable."[114] He was not optimistic enough when he said that people would always read his verse "over the lands Rome has subdued." But how could Ovid have envisaged his influence upon Shakespeare, Poussin, and a whole host of other artists and writers coming long after imperial Rome fell and Latin no longer was a living language? "If there be any truth in poets' prophecies," he writes, "I shall live to all eternity, immortalized by fame." But not even Ovid could have envisaged Roberto Calasso's *The Marriage of Cadmus and Harmony*, which rewrites his mythologies from a post-Nietzschian perspective.

Following Ovid, I speak with optimism about the future of art museums. For more than two centuries they have survived dramatic social changes to flourish everywhere. When Hoving came to the Metropolitan, he recognized that the museum needed to dramatically expand its audience. But he was not the sort of administrator interested or capable of offering a serious intellectual defense of his practice. And so my goal will be to provide a model for that new posthistorical art museum. This chapter almost ended on an unhappily pessimistic note. The happier conclusion will suggest how a genuinely democratic public art museum might be realized. The public art museum, a creation of the late eighteenth century, permitted art from the old regime to survive into a new era of democracy, mass literacy, and industrialization. And then the swift enlargement of the collections, synchronized with the dramatic expansion of capitalism, turned this Western European institution into a univer-

sally admired display of world art. The museum thus shows an amazing capacity to rework its interpretation. The history of art has ended; the historical expansion of the museum has been completed; and high art must cohabit and compete with the novel culture of mass art. The coming change in this institution will be so radical as to mark a break in its history. Let us consider how that might occur.

Conclusion

The whole form and tenor of philosophical thought in the West was determined, once and for all, by the fact that its initiating—and finest—texts were dialogues. —ARTHUR DANTO

Brilliantly imaginative popular novels by the science fiction writer Harry Turtledove, a former medieval historian, describe alternative worlds. He imagines what might have happened had the South won the American Civil War or Constantinople not fallen to the Muslims. Much can be learned about real history from such speculation. Imagine a Parisian critic circa June 1789 who, rightly suspecting that vast political changes are soon coming, envisages future museums. Reading the Enlightenment literature, anticipating democracy, she expects mass literacy to destroy the old regime. Inspired by Jacques-Louis David's recent pictures shown in the Salon Carré, she imagines open political debates invoking contemporary art. Future painters might, she thinks, directly challenge official policy. She envisages political art advocating the abolition of slavery, democratic elections, and women's rights.

Under the inspiration of the salon, this Frenchwoman constructs a prescient theory nicely relevant to our posthistorical art museums. She thus anticipates the analysis of Thomas Crow, who convincingly argues that although the esoteric subjects of David's *Oath of the Horatii* (1785) and *The Lictors Returning to Brutus the Bodies of His Sons* (1789) (fig. 22) are from Roman history, these were political works of art referring to contemporary life. Crow writes: "A large public had been conditioned . . . to see in the history of early Rome metaphors for contemporary political conflicts. . . . But it should be clear by now that it would be a mistake to see the possible political significance of the *Horatii* as ending or

22. Jacques-Louis David (1748–1825).
The Lictors Returning to Brutus the Bodies of His Sons. Oil on canvas,
323 × 422 cm. Musée du Louvre, Paris. Photo: G. Blot / C. Jean, Réunion
des Musées Nationaux / Art Resource, N.Y.

even primarily residing in its subject matter. This is where most previ-
ous accounts have gone wrong."[1] David's paintings are revolutionary on
a formal level. *Horatii*, for example, divides the salon audience into those
who understand and those who don't by refusing "to find form for the
relationships between men and women which are central to its narra-
tive content. David . . . does not show the relationship either between
the Horatii themselves or between them and Rome, he only asserts it; he
cannot demonstrate it, he can only declare it, and the strain involved is
written into the picture—is finally its message."[2] But they comment on
contemporary politics only indirectly. Our imaginary French critic en-
visages paintings like Géricault's *Raft of the Medusa* and David's *Death*

of Marat, which make explicit the implicit political concerns of David's early masterpieces.

Describing the salons as a public space in the making, Crow notes that aesthetic values ceased to be defined in an authoritarian way: "A public sphere of discussion, debate, and free exchange of opinion was something else again. No longer, it seemed, would non-initiates be awed at a distance by the splendor of a culture in which they had no share; a vocal portion of the Salon audience, egged on by self-interested critics, would actively be disputing existing hierarchical arrangements."[3] The Salon was "not a spectacle for passive onlookers, but an opportunity for active audience participation and judgement."[4] The obvious connection between such discussions of art and everyday democratic political debate suggests why these shows prepared for the Revolution.[5] In a public space, Jürgen Habermas plausibly says, anyone has the right to judge art on exhibition, for culture is publicly accessible, with aesthetic values defined by free discussion.[6] This of course is a utopian ideal. In practice the fall of the old regime soon led to Napoleon's authoritarian government. But it is an important ideal.

In bringing together people of all classes, the pre-Revolutionary salon anticipated the transformation of the French king's palace into Denon's public museum. And once people began to talk freely about this art and its political significance, then it was a short step to broader discussion. This was the Enlightenment dream—a genuine public sphere of conversation accessible to all citizens. In such a space, it would be possible to talk about politics and public policy, about philosophical issues, and about values, using the art on display as a reference point. "The fundamental organizing idea of justice as fairness . . . is that of society as a fair system of cooperation over time, from one generation to the next. . . . In their political thought, and in the discussion of political questions, citizens do not view the social order as a fixed natural order, or as an institutional hierarchy justified by religious or aristocratic values."[7] In the absolute monarchy only the king and his agents speak freely in public. But in a democratic community there are many competing voices.[8] Letters to the editor are one manifestation of such political freedom. Often, of course, they are foolish or intemperate. But if you believe in free speech, then you should welcome uncensored dialogue.

Could this imaginary critic visit our public art museums, she would

be both fascinated and perhaps a little disappointed. Astonished by the collections and pleased at the political art, she would also be frustrated, I think, by the obvious ways in which contemporary museum culture replicates the worst features of the old regime. Like the absolute monarchy, art museums are top-down institutions. The public has no voice in establishing policies. The Enlightenment's promise that art might serve as a source for conversation about free public values has been lost. Instead we have academic art history written by specialists whose research is popularized in survey classes and museum education. Anyone with liberal instincts is likely to be of two minds about our situation. As an aesthete, I love to wander in grand collections, very thankful for the curators' labors, fully aware that most high art is not of passionate interest to the public. But as a believer in the accountability of public institutions, I am uneasy about my pleasures. Were museums run in democratic ways, they would not devote much attention to Nicolas Poussin's early paintings, Islamic carpets, or Sean Scully's abstractions, art of ardent interest to me. Were they to give the public what it wants, there would be more loan shows of impressionist paintings, the most popular high art. Leroi Neiman's kitsch would attract more visitors than Richard Serra's sculpture and Norman Rockwell would outdraw Max Beckmann.

Is my vision of a public museum space devoted to genuinely democratic talk about visual art anything more than utopian fantasy? To think about this difficult-to-answer question, a historical perspective is essential. As Crow notes, often "painting and sculpture had served a public function in the past."[9] The story of the presentation of Duccio's *Maestà* on June 8, 1311, in Siena is justly famous. "On the day on which it was carried to the Duomo, the shops were locked up and the Bishop ordered a great and devout company of priests and brothers with a solemn procession . . . and then behind were the women and children with much devotion."[10] "The reason all of Siena accompanied it from the studio of Duccio to the cathedral," Sherman Lee suggests, involved awareness of "its quality as a work from the greatest master of the city."[11] Other such stories about high art can be told. In 1501, for example, Leonardo da Vinci showed the cartoon for his *Virgin and Child with Saint Anne*, which "not only seemed marvelous to other painters, but also to the people in general."[12] But court society excluded the public from places where affairs of state are conducted, for in grand houses the "arrangement of rooms . . .

is . . . an expression of the *co-existence of constant spatial proximity and constant social distance, of intimate contact in one stratum and the strictest aloofness in the other.*"[13] Physical proximity of diverse classes did not yield social intermingling. In Naples during the 1647 revolt against Spanish rule, "on every street corner . . . there were continual discussions of public policy; and endless schemes for a new government . . . were expounded no less by the ignorant than by literate people."[14] That sounds like the free exchange in Crow's salon or modern democratic debate, which, of course, was precisely what worried the authorities.

Before the salon, Crow writes, "the popular experience of high art, however important and moving it may have been to the mass of people viewing it, was openly determined and administered from above."[15] These shows were "the first regularly repeated, open, and free display of contemporary art in Europe to be offered in a completely secular setting and for the purpose of encouraging a primarily aesthetic response in large numbers of people," Crow writes.[16] They thus were important precedents for our Carnegie Internationals, Whitney Biennials, and other public displays of contemporary art. Reconstructing contemporary response to the salons is extremely difficult. According to Crow, "Virtually all we know about the real public of the exhibitions we know from the tracts and brochures of those few who claim to speak on its behalf; the real crowd in the Salons has, for us, no concrete character of its own."[17] Our commonsense identification of "the public" with all adult citizens, in contrast to the political elite or other special interest groups, is itself a modern conception. This also is true, I would add, of attempts to identify the public for modern exhibitions. We reviewers of the Carnegie Internationals and Whitney Biennials know how hard it is to reconstruct public response.

The art museum is a place into which the public is admitted for a nominal fee, but it is not yet a true public space, a place encouraging genuine debate. Once the old regime was abolished, artists became relatively free to pursue their social and political concerns in a public sphere of discussion. In his account of high art Crow asks: "What is to be made of the continuing involvement between modernist art and the materials of low or mass culture?"[18] He is discussing the uses of mass culture *within* high art, but here I answer his question by contrasting museum art to mass culture. If you seek truly democratic art, look to popular culture, for rock

music and Hollywood films create open-ended discussion, debate, and free exchange of opinion. Like athletes, mass artists compete freely for public attention. But whereas everyone but a few intellectuals knows the rules of football, high art remains essentially esoteric.[19] If my imaginary French critic wanted to see truly public discussion and debate, she would not look in museums. The salon offered "a rare occasion in the cultural life of the Old Regime for such a heterogeneous audience to assemble in an unregulated space."[20] Nowadays a truly heterogeneous audience appears not at museums but in movie theaters, at rock concerts, and in front of televisions and Web sites. As 1960s radicals correctly understood, so long as high art consists of expensive unique or limited edition artifacts, it will remain essentially elitist.

If a time-travel machine could bring Vasari to our museums, he would not be surprised at the Renaissance art they contain. But were he taken to a pop music concert or a film, he could make no sense of those experiences. The salons, Crow says, brought together a mix "of classes and social types. . . . their awkward, jostling encounters provided constant material for satirical commentary."[21] So too do modern mass entertainments. Consider, for example, a 1954 news report describing the debut of a superstar: "A 19 year-old Holes High graduate, he . . . already has a disc out. . . . The odd thing about it . . . is that both sides seem to be equally popular on popular, folk and race record programs. This boy has something that seems to appeal to everybody."[22] Elvis Presley became famous because his music brought people together. No high artist had even a remotely comparable role. Pollock's paintings were esoteric, and so the theories about them are explained in art history classes, but almost everyone understands Elvis's lyrics. Carol Brightman explains, "In traditional blues . . . the singer addresses the audience directly. Here is where I am. Here is my pain, my sorrow, my joy, my memory. Here is what I know. Alternatively, when a performer steps aside from his or her character and renders it *critically* . . . the listener is invited to see the song itself as play."[23] We often use popular art to stage debates about politics, cultural change, and values. As Bruce Springsteen said: "You do your best work and you hope that it pulls out the best in your audience and some part of it spills over into the real world and into people's everyday lives. . . . I always thought that was one of the things popular art was supposed to be about."[24] We talk about race, homosexuality, and feminism; about our

children, families, and parents; and about a myriad of other topics in the terms provided by this music.

In Denon's time, Kant and Hegel wrestled with the distinction between natural wonders and works of art. Then it was necessary to dissemble the *Wunderkammer* and create two new institutions, the natural history museum and the public art museum. Today we face a new challenge, understanding the relationship between mass art and high art. Noël Carroll, whose analysis has heavily influenced mine, writes: "We enjoy reading, seeing, and listening to the same things, and then talking about them. We enjoy working references and allusions to them into our conversations."[25] Consider, for example, how gay people are presented on *Will and Grace*; the terms of racial debate in the rap music of Eminem; the response to 9/11 in Bruce Springsteen's *The Rising* and Steve Earle's *Jerusalem*; the Holocaust as presented by *The Pianist*; the paranoid vision of politics in Alfred Hitchcock's films and the *The Matrix*; the lawyers and police of *Law and Order* and doctors shown on *ER* and *Scrubs*; the stories of love told by Nirvana and Radiohead; the view of everyday New York public life shown on *Seinfeld*; the cynical political perspective in *South Park*; the history of feminism as told by Ani DiFranco's music and *A League of Their Own*; the romantic nostalgia projected by Roy Orbison; the picture of Cleveland in *American Splendor*; the populist sympathies of Johnny Cash; and the view of presidential politics offered by *Doonesbury* and *The West Wing*. Compared with this mass culture, which has an enormous worldwide audience, high art is socially marginal.

No scholarly exegesis is required to interpret contemporary mass art, for it is made to be immediately accessible to everyone. Fielding Dawson points out that "the comic strip—a feature perhaps overlooked in your daily paper—is a creation unique to American cultural life and has, for a century, commented on the way we see and view ourselves as it has fulfilled its daily appointed task of amusement and distraction."[26] We all understand it directly because it is about us. If you are unsure how to deal with your children, your love life, or politics, as almost everyone sometimes is, you will find advice somewhere in mass art. Popular films, music, and television teach us how to discuss ourselves. By contrast, apart from a very few academics, no one talks about everyday life with reference to Piero or Poussin. "Though we are perfectly willing to learn about life from literature and painting . . . no one would ever project directly

the content of a work of fine art onto the world. The fine arts . . . bear an indirect, interpretative relationship to the world. . . . It is precisely for this sort of interpretation that the popular arts do not seem to call."[27] Nor does painting by the best senior American abstract artists—Agnes Martin, Sean Scully, and Robert Mangold—provoke the public debate that David's *Oath of the Horatii* inspired.

High art becomes the subject of popular concern only under exceptional circumstances, as when, for example, public funding for Richard Serra's *Tilted Arc* or Robert Mapplethorpe's photographs caused debate. Within our art world, there is much contention, but only rarely are these disputes relevant to the larger public. Museum audiences are large but mostly not well informed about what they see; the art world's engaged audience is surprisingly small. *Artforum*, the most important American critical journal, has a circulation of about 20,000. And *October*, which played a powerful role defining taste, has only 3,000 subscribers. By comparison even modestly successful mass films, pop music, or television shows have enormous audiences. *Artforum* and *October*, usually inaccessible to outsiders, leave it to newspaper critics to provide popularizing commentary. Andy Warhol, Robert Mapplethorpe, and Cindy Sherman, the best-known recent American artists, are not as famous as even minor movie stars.

To properly understand the relation between high and mass art, a philosophical perspective is required.[28] As knowing subjects, we are casually related to the world by our representations. Science explains how perception links us to external reality, and philosophy demonstrates that our mental representations both exist within the world as mental states and *as representations* are outside of that physical realm. A mental representation of my PowerBook, for example, is some brain state that makes it possible for me to see the machine on which I am writing. In that way, it has often been noted, mental representations are like figurative works of art that are both physical things and, as representations, stand-ins for what they depict. We have a dual relationship to the world because we are both *within it* as physical beings and *outside it* insofar as we are only aware of external reality through our representations.

Cartesian skepticism is possible because there is a gap between our representations and the world that they mirror. A representation seemingly stands for something, and so questions about whether representations

accurately represent can always arise. If our mental representations are not veridical, then we have no knowledge. Drawing an analogy between such skepticism and museum skepticism, we considered the double character of visual art. A painting depicts some distant time and place. But that well-preserved artifact is present in our museum here and now. Mental representations show what is present—and old art permits imaginative time travel. But like mental representations, works of art could fail to satisfy these demands. The program of naturalism in epistemology, Danto writes, aims "to collapse the distinction between intra-worldly relations and the sort of relation which is knowledge."[29] By analogy, it is possible to collapse the distance between what art represents and its identity as mere physical object in the museum.

Visual art was traditionally thought to be a treasure like gold or rare fossils, so we have argued, because it made possible imaginative time travel. Denying that old art is preserved in the museum, museum skeptics claim that imaginative time travel is impossible. Rejecting the claim that old art has a double character, they assert that these representations cannot put us in contact with the past. Here again our analogy with epistemic skepticism is important. What could be more obvious than that right now I see this computer on which I am writing? But if Cartesian skepticism is correct, then that belief could be mistaken. Does Poussin's *Seven Sacraments* allow us to imagine seeing Christ? That too seems obvious, but if museum skeptics are correct, then we are impotent to look into the past. One well-known twentieth-century response to skepticism was to deny that there is any gap between our mental representations and the external world. Such diverse figures as John Dewey, Martin Heidegger, and Ludwig Wittgenstein (in his later philosophy) denied that the mind mirrors the world. As Richard Rorty says in his well-known summary of this tradition, "the notion of an unclouded Mirror of Nature is the notion of a mirror which would be indistinguishable from what was mirrored, and thus would not be a mirror at all."[30] Whatever the problems with this anti-Cartesian epistemology, which has been much discussed, it offers, by analogy, a very suggestive view of the museum.

Did visual art not have a double character, all of the artifacts displayed would be completely present here and now. And then the belief that old art allows imaginative time travel would be mistaken. We believe that interpretation of old art is required because we are at some distance from

the artist's culture. Speculation is needed to understand Caravaggio's nonformalist use of figures projecting into the viewer's space, Giotto's relationship to his Byzantine precursors, and Poussin's references to contemporary French politics. Suppose, rather, that this older painting was directly accessible to us. High art would become like mass art. And that, I want to suggest, could be liberating because then museum art could again become part of a living culture. Critics of Thomas Krens, the controversial director of the Guggenheim, "fear that he is taking the museum the way of commercial television, reducing high culture to the lowest common denominator under the guise of postmodern populism."[31] What more damning judgment is there, it is implied, than relating the museum with television? But I would argue that Krens should rather be praised for understanding that only when high art is as popular as mass culture can it compete with these novel media.

Museum skepticism expresses a legitimate worry that we are losing touch with the past. Were that to happen, imaginative time travel would become impossible and so the museum would lose its reason for being. Losing touch with the past means that although the old objects in museums appear to be preserved, they are just fragments, bits and pieces of cultures that have vanished entirely. We see things at a distance and so may be unsure if sight provides reliable knowledge. Touch, by contrast, by revealing what is right at hand, seemingly allows certainty.[32] Mass art, too, is right at hand. Not allowed to touch art in museums, we think of it as putting us in touch with the past by revealing *here and now* what an artist made *then and there*. A Greek pot, Romanesque carved head, or Chinese scroll presents temporally distant cultures, allowing us to imaginatively traverse vast expanses of time. At least that is true if the museum skeptics are wrong. But perhaps the visual cultures of pre-Columbian America, China before it made sustained contact with Europeans, and Africa until colonization are now impossible to reconstruct. And maybe the same is true even of less exotic societies. Not just Renaissance art, but even abstract expressionism employed styles of thinking that are dramatically unlike ours. And so perhaps art made in these earlier cultures has become unrecoverable.

Our present analysis suggests how museums might respond to this concern. Anyone who has populist sympathies will envy the availability of mass art. How then can we make high art equally accessible? Mieke

Bal, Norman Bryson, Michael Ann Holly, and Keith Moxey have urged that art history should turn away from reconstructing the past and ally itself with the study of popular visual culture.[33] Heinrich Wölfflin argued that "archaic Greek art" or the sculptures from Chartres "must not be interpreted as if (they) had been created today."[34] Instead of asking how they affect modern viewers, he argues, we must evaluate these works of art in historical context. This, of course, is how orthodox art historians think. Rejecting that viewpoint, Holly and Moxey argue that we can have "an interdisciplinary dialogue, one that is more concerned with the relevance of contemporary values for academic study than with the myth of the pursuit of knowledge for its own sake."[35] Abandoning the old ideal of "full and final knowledge of the world," we should acknowledge that "the shape of art historical interpretation was always determined by those authors whose interpretations most effectively captured the imagination of a contemporary audience."

The real claim of Holly and Moxey, to appropriate Walter Pater's famous phrase, is that *all art approximates to the condition of contemporary art*. What gives support to this way of thinking, they argue, is the inability of art historians to achieve objectivity in judging the past.[36] And as Bal puts it in her discussion of Caravaggio, reconstruction of the historical significance of his pictures "leaves one aspect unaccounted for, the very aspect I feel compelled to attend to: What do these paintings mean to today's culture?"[37] As Nietzschean perspectivists working in the tradition of Foucault, Bal, Bryson, Holly, and Moxey abandon traditional ideals of objectivity.[38] Their claims deserve careful scrutiny, but here I am less interested in evaluating them than in considering the consequences of this way of thinking for art museums. If we collapse our historical distance from old works of art, then the concerns of museum skeptics would be definitively resolved. Like mass art, the paintings and sculptures in the museum would then be immediately available. Bal, Bryson, Holly, and Moxey thus offer an effective response to the museum skeptics' worry about being cut off from art of the past.

One reason that earlier scholars were not tempted by this way of thinking is that until very recently, most art historians tended to be dismissive of popular culture. Even so catholic a figure as Meyer Schapiro complained that the "art of advertising . . . now commands the public surfaces in the streets and buildings. Like almost all art today, it is addressed to the

individual observer, but as a consumer of commodities. . . . Can true art ever replace in the public sphere this insincere and clamorous commercial art?"[39] But thanks to Andy Warhol and the many recent artists who have followed his example, a more flexible view of relationship between high art and consumer culture is possible. In offering this analysis, I am not glorifying mass culture. Most comic strips, films, and television shows are very banal, as indeed was most of the painting reviewed by Diderot. Because museums aim to preserve only the best, they give a misleading view of the cultural level of the past. That mass art be of high quality is neither a necessary nor a sufficient condition for it to serve the social function that I have described. Nor am I overestimating the level of salon conversations. No doubt most people had very prosaic discussions — as do most museum visitors today. Diderot was no more a typical salon viewer than is Arthur Danto an average visitor to the shows he reviews. My imaginary French critic envisages an accessible public space where you are free to speak your mind, unconstrained by authority. That is an important political ideal, in her time and in ours. As Kant says in "What is Enlightenment?" (1784): "If only freedom is granted, enlightenment is almost sure to follow."[40] Out of conversation, so we hope, wisdom will emerge. We think free exchange an intrinsic good. But like political democracy, Crow's public space is an ideal whose practical realization might prove very disappointing. If history is any guide, most probably we get better art when it is administered from above.

There were precedents for this free verbal exchange under the old regime. "If one looks at the origins of modern art history and art criticism, which are in the Renaissance, it is noticeable that really it arose out of conversation."[41] And in the early eighteenth century, "Watteau represented conversation as an aesthetic activity in its own right."[42] Talk enjoyed a privileged status because it showed "an aristocratic notion of equality among members of the same class." What was added on the eve of the Revolution, Crow implies, was the belief that talk among all classes deserved serious attention. Watteau "assumes a tacit agreement with the viewer, an agreement that is basic to the civilized social relationships that he pictures in his art. He assumes that the viewer will respond to his paintings, that this response will be like a dialogue and not like a monologue."

Conversation was important for many eighteenth-century intellectu-

als. In his dialogues on religion, for example, David Hume said: "There are some subjects . . . to which dialogue-writing is peculiarly adapted, and where it is still preferable to the direct and simple method of composition. Opposite sentiments, even without any decision, afford an agreeable amusement; and if the subject be curious and interesting, the book carries us, in a manner, into company and unites the two greatest and purest pleasures of human life — study and society."[43] And in his Salon of 1767, Diderot staged extended conversations within Joseph Vernet's landscapes. He captured the volatile quality of exciting dialogue without the confining sense of permanence usually given by written transcriptions by thinking "of his mind as a theater. Just as a theater has space for the audience and a stage divided into several planes," so these pictures become sets.[44] Like the actor Diderot described, whose "gestures of despair are memorized and have been prepared in a mirror," in conversation we are on stage.[45]

Reading Jane Austen or Muriel Spark, I look forward to sharing my thoughts with friends. Silent reading is a solitary activity for even if I am among family, friends, or with strangers, I alone am aware of the words.[46] Hearing a symphony or seeing a play, by contrast, are essentially social activities. Even if alone, I am aware that others are present. Museumgoing, too, is a social experience, for in a public space, it is natural to talk with companions or overhear comments of other visitors. Like mass art, museums thus make possible far-ranging conversations. At the Getty, I learned from John Lee, an art dealer who admired James Ensor's *Entry of Christ into Brussels*. In Haarlem, Aneta Shine helped me to understand Frans Hals's late group portraits. At the Morgan Library, Richard Kuhns showed me how to see more in Renaissance drawings. I learned at a Robert Mapplethorpe retrospective because Lydia Goehr accompanied me, got a new perspective on Poussin looking with Arthur Danto, and came to better view the Carracci thanks to the abstract painter David Reed. I argued with Paul Barolsky about the Jacob Bassano at the Norton Simon Museum; looked in the Shanghai Museum with Ding Ning; saw Cleveland's Jacob Ruisdael with Richard Wollheim under the spell of a lecture that he had just presented; and was fascinated when Mark Cheetham discussed Canadian art in Toronto. And I had a marvelously revealing dispute with my mother at a Morris Louis retrospective.

Everyone who spends time in museums has such discussions, which are

tied to the here and now, to a moment and place and to the presence of particular individual personalities, in a way that most art writing is not. Such intercourse typically deals with one painting or, at most, comparisons with nearby art. A lecture, by contrast, because it is usually based upon slides, can have wide-ranging visual references.[47] Because they are improvised, conversations allow informal experimentation with frank, tentative consideration of alternatives. It is fun to speculate with friends in ways that would be inappropriate in print or in a lecture. In museums, you can talk about whatever you see, but in academic publications, only qualified specialists normally offer judgments. Art history writing, typically retaining the flavor of the lecture hall, has the form of a monologue. In museum conversations, by contrast, several voices enter into dialogue. You need not rigidly pin down your intended meaning but can entertain diverse possibilities. In conversation the problem of museum skepticism is resolved.

It is natural to associate dialogue with the Enlightenment, for what better way to realize the ideal of a public space in which all are permitted to speak than by allowing diverse points of view to coexist within one essay? Conversation allows the presentation of varied positions, without the felt need to identify one unique authorial point of view. But apart from Roberto Longhi's amazing dialogue in which Caravaggio learns about his great successor Tiepolo in the afterlife, it plays little role in the literature of art.[48] For someone deeply fascinated by museums, academic art history can seem a little disappointing. In his *Social Contract*, published near the end of the old regime, Jean-Jacques Rousseau argued that the people, always virtuous in their desires but often mistaken in the judgments, must be forced to be free. Analogously, so it is often said, since false consciousness causes people to prefer kitsch to great art, properly educated museum visitors would have enlightened tastes, those of the cultured elite. Museums impose their taste, which curators believe has objective validity, trying to educate the masses. But there is no good reason to think that if everyone had the leisure (or other necessary preconditions) they would arrive at the taste of the elite.[49] Only free discussion could reveal truly general aesthetic values. Just as Rousseau's ideal of a face-to-face community each member of which can identify the common good was utopian, so too this vision of free conversation about museum art may seem quixotic. But one legitimate goal of philosophical re-

flection, after all, is to provide a critical perspective on our institutions. In showing the limitations of present museums, our account suggests how these public spaces might become democratically accessible. But here this analysis needs to be put in a historical perspective. We need to look at how we experience change.

Samuel Pepys's *Diary*, written in the 1660s, tells of his upwardly mobile London life, providing, in the words of Claire Tomalin, "the first full and direct account ever of a man starting uncertainly on a professional career and finding, to his own surprise, that work is one of the major pleasures of life. . . . It is full of music, theatre, sermons, paintings, books and scientific devices." [50] But even as you recognize a social world much like ours, how exotic are his artistic culture, morality, and politics. The first cell-phone conversation took place only thirty years ago.[51] And the cheap fax machine was introduced just in 1984.[52] Recently I reread an essay I wrote in 1965, astonished that I had *typed* it. Some art in my house dates from the seventeenth century, but the digital technology for playing recorded music is very new. When I was a child, my parents took me to Europe on ships. Recalling the lifeboat drills, I feel like a Henry James character. And memories of older people come from more distant worlds. My nana described her childhood in Austria before the Great War; my father, his childhood as son of an Idaho homesteader; my teachers Danto, Wollheim, and Richard Kuhns, World War II. "Our collective memory is already beginning to fade away," James Gleick notes.[53] In 1926, after identifying such recent inventions as the telephone, the airplane, and radio, John Cotton Dana compared them with the museum, which is based upon conventions "well established more than a hundred years ago." [54] How quickly everyday life has changed! Even those born late in the twentieth century are aware of change. My daughter began collecting Beatles CDs around 1995 and soon moved on to Nirvana. The Beatles, figures of my generation, are her heroes, but already Kurt Cobain feels historically distant. No wonder museum skepticism has such a powerful hold on our imagination.

It is impossible to understand the art museum without reflection upon such examples. We preserve old art because it makes the past real to us. The more quickly life changes, the stronger our desire to hold onto the past and the more crowded are museums. They have become so important because, in our culture that is changing so rapidly, the threat of

losing contact with the past has become very pressing. In a culture on more familiar terms with its own past, our need for these institutions would be less pressing. This analysis shows what the art museum could become and suggests why it ought to change, but it does not demonstrate how this institution will actually evolve. Recently I made a distinction between philosophy, which "aims to be necessarily true, while literature, by allowing us to metaphorically assume the identity of the hero, is about its reader."[55] Some accounts of paintings describe actual objects, I noted, but others present merely imaginary works of art. As Paul Barolsky has said, "our understanding of art, far richer than the sum of the documented facts, is itself fictive."[56] In analyzing museums a similar distinction can be made.

Philosophical accounts of identity describe the real nature of things, while Ovidian metamorphoses are merely fictionally plausible radical changes. Tracing the real history of the art museum, showing how Lee's palace for connoisseurs has been transformed into a public space, we indicated how the Cleveland Museum of Art has actually changed. And then this conclusion presented a metamorphosis, a story about how the public art museum might, so we speculated, transform itself. Philosophers discuss what is—and writers of fiction like Ovid tell us what might be. That seems an obvious and dramatic contrast, but in fact nothing in our account allows us to securely anticipate how the museum will actually develop. And that means that this account of the museum making high art as accessible as mass culture is as yet impossible to classify. Does it describe a merely fictional metamorphosis, as I suggested earlier in introducing my imaginary Frenchwoman, or a real transformation that a philosopher might study? It is too soon to answer that important question. And so we do not know whether our prophetic account of the museum is just a literary conceit, or a genuinely possible change in its identity.

Here we touch upon the liberating power of utopian thinking. "Ovid's myths run deeply beneath the surface of art history," Barolsky writes, "springing forth in metamorphosed form, which is why we sometimes do not recognize their Ovidian origins."[57] Precisely because we cannot be certain how the art museum will change, present speculation may influence its development. And since its history depends on many improbable personalities, surely speculation is appropriate. What political work of art is bolder than Denon's Louvre, that violently creative response to

the Revolution which brought painting and sculpture from Italy to Paris? What modernist painting is more imaginative than Barnes's foundation, whose very excesses show his love of art? And what posthistorical work of art is as innovative as Meier's Getty museum? We museum interpreters need to be equally bold as the creators of these institutions, for only a radically utopian analysis has any hope of doing justice to this extraordinary organization. What could justify and sustain posthistorical museums is the capacity to inspire truly democratic conversations. Only such radically novel institutions could preserve the achievements of Denon, Gardner, Barnes, Meier, and Lee and Munro, transforming the older museum, giving new life to this institution. Utopian visions are the necessary grounding for critical analysis. If the tradition traced in this book offers a reliable guide, then this institution will survive only by learning to adapt in radically new, essentially unpredictable ways. And that is why the metamorphosis described by my imaginary Frenchwoman may not be mere fantasy. The history of the art museum traced in this book gives us every reason to be very optimistic about its future.

Notes

Acknowledgments

1. Barolsky, *Michelangelo and the Finger of God*, xvi.

2. Carrier, *The Aesthete in the City*, 85, 88.

3. Lee, *Past, Present, East and West*, 67.

4. Carrier, *Sean Scully*, 80.

5. Danto, *Connections to the World*, 273.

6. "Wish You Were Here: The Art of Adventure," Cleveland Institute of Art, October–December 2003.

Overture

1. Ovid, *The Metamorphoses of Ovid*, 138.

2. See Barkan, *The Gods Made Flesh*, 19.

3. Ibid., 17.

4. Feldherr, "Metamorphosis in the *Metamorphoses*," 175.

5. Ovid, *The Metamorphoses of Ovid*, 43.

6. Ballard, *The Crystal World*, 78–79.

7. Warner, *Fantastic Metamorphoses*, 5.

8. Allen, "Ovid and Art," 340.

9. Ransmawy, *The Last World*, 33.

10. Bynum, *Metamorphosis and Identity*, 30.

11. Wheeler, *A Discourse of Wonders*, 205.

12. Ovid, *The Metamorphoses of Ovid*, 87.

13. Ibid., 82–83.

14. Woolf, *Orlando*, 86–87.

15. Wollheim, *The Thread of Life*, 7, 10.

16. A good clear summary appears in Glover, *The Philosophy and Psychology of Personal Identity*.

17. Ovid, *The Metamorphoses of Ovid*, 257.

18. Wollheim, *Art and Its Objects*, preface. This preface was suppressed after the original edition.

19. Danto, *The Transfiguration of the Commonplace*, 101, 125, 135. This way of

thinking about art can be viewed as a secularization of a very traditional way of understanding political power: "There was a visible, material, exterior gold circle . . . with which the Prince was vested and adorned at his coronation; and there was an invisible and immaterial Crown . . . which was perpetual and descended either from God directly or by the dynastic right of inheritance" (Kantorowicz, *The King's Two Bodies*, 337).

20. Wollheim, *The Thread of Life*, 33.

21. Danto, *Connections to the World*, 213.

22. Wheeler, *A Discourse of Wonders*, 15.

23. Kuhns, "Reflections of the Metaphoric Power of Metamorphosis."

24. See Carrier, *Poussin's Paintings*, 106–15.

25. See Carrier, *Sean Scully*, chapter 8.

26. See the analysis of Caravaggio in Carrier, *Principles of Art History Writing*, chapter 3; the account of David in Carrier, "The Political Art of Jacques-Louis David and His Modern Day American Successors"; and the discussion of Pollock in Carrier, *Rosalind Krauss and American Philosophical Art Criticism*, 80–81.

27. Descartes, *Philosophical Writings*, 61.

28. Ibid.

29. The division of Lydia Goehr's *The Imaginary Museum of Musical Works* into two parts, "the analytic approach" and "the historical approach," helped me formulate this analysis.

30. See Haskell, "Winckelmann et son influence sur les historiens," 83–99.

31. Borges, *Collected Fictions*, 241. I use this story unable to judge the accuracy of its claims; on its accuracy, see Kemal, *The Poetics of Alfarabi and Avicenna*.

32. K. Clark, *Leonardo da Vinci*, 14. See Carrier, "Why Were There No Public Art Museums in Renaissance Italy?"

33. Giovanni Grimani, it has been claimed, created "virtually the first, public museum of modern Europe" in 1581 (Perry, "The Renaissance Showplace of Art," 215). But his house was not much like a modern public art museum. "Organized to host the family's antiquarian collections, these rooms suggest that his eccentric taste was more than experimental" (Tafuri, *Venice and the Renaissance*, 9). In *The Rare Art Traditions*, 163–67, Alsop notes other premodern public museums. But these are scattered examples; the public art museum takes root only in the eighteenth century.

34. In his letter dated December 2, 1893, Engels argues that voting laws, immigration policy and the relatively prosperous domestic model explain the absence of a strong social party in America. See Engels, "Why There Is No Large Socialist Party in America," 457–58.

35. See von Scholsser, *Raccolte d'arte e di meraviglie del tardo Rinascimento*, 14.

36. Rossi, *The Uffizi*, 5. See also I. Rowland, *The Culture of the High Renaissance*, and Barkan, *Unearthing the Past*.

37. See Alsop, *The Rare Art Traditions*, 164.

38. Pearce, *On Collecting*, 126. See also Bann, *Under the Sign*.

39. On premodern art museums, see Filipczak, *Picturing Art in Antwerp, 1550–1700*, chapter 7.

40. On the relation between art museums and natural history museums, see Yanni, *Nature's Museums*, chapter 1.

41. Findlen, *Possessing Nature*, 393.

42. Kant, *The Critique of Judgement*, 166–67.

43. Moore, *Principia Ethica*, 189–90.

44. Hegel, *Aesthetics*, 1.59. See Potts, "Political Attitudes and the Rise of Historicism in Art History."

45. See Avineri, *Hegel's Theory of the Modern State*, 66–67.

46. Bjurström, "Physiocratic Ideals and National Galleries," 37. See also Bredekamp, *The Lure of Antiquity and the Cult of the Machine*.

47. McClellan, *Inventing the Louvre*, 4.

48. Schubert, *The Curator's Egg*, 17. On early museum audiences, see Crane, *Collecting and Historical Consciousness*, 108.

49. Quoted in Schuster, "The Public Interest in the Art Museum's Public," 53.

50. See Pommier, *Les Musées en Europe à la veille de l'ouverture du Louvre*; Laclotte, "A History of the Louvre's Collection"; and Hautecoeur, *Histoire du Louvre*.

51. McClellan, *Inventing the Louvre*, 1.

52. Findlen, *Possessing Nature*, 395. See also Lugli, "Inquiry as Collection," and Schulz, "Notes on the History of Collecting and of Museums," 5–18. I have learned from Balsinger, *The "Kunst-und Wunderkammern"*, which remains mysteriously unpublished.

53. Sheehan, "From Princely Collections to Public Museums," 170–71.

54. See Henrich, *Judgment and the Moral Image of the World*, chapter 4.

55. Hardimon, *Hegel's Social Philosophy*, 190.

56. Hegel, *Hegel: The Letters*, 653.

57. Hegel, *Aesthetics*, 2:870.

58. Wyss, *Hegel's Art History and the Critique of Modernity*, 104.

59. Hardimon, *Hegel's Social Philosophy*, 45.

60. McClellan, *Inventing the Louvre*, 140, 145.

61. See Haskell, *History and Its Images*, 248.

62. De Tocqueville, *The Old Régime and the French Revolution*, 19–20.

63. See Denon, *Pages d'un journal de voyage en Italie (1788)* and Denon and el-Gaharti, *Sur l'expédition de Bonaparte en Égypte*.

64. Grasselli and Rosenberg, *Watteau*, 434.

65. See Lichtheim, *A Short History of Socialism*.

66. Lichtheim, *Marxism*, 404, 406.

Chapter 1: On Entering the Louvre

1. Nowadays museum hangings change frequently. I have not generally dated my examples, which are based upon more than twenty years of remembered visits.

2. Nehamas, *Nietzsche*, 108.

3. Here I extend Carrier, *High Art*, 97–102.

4. Wittkower, *Art and Architecture in Italy 1600 to 1750*, 160.

5. Stokes, *The Critical Writings of Adrian Stokes*, 3:335.

6. Danto, *The Madonna of the Future*, 94.

7. Steinberg, *Michelangelo's Last Paintings*, 6.

8. Jameson, *The Political Unconscious*, 13.

9. T. J. Clark, *The Painting of Modern Life*, 250. See also Carrier, *Writing about Visual Art*, 14–17.

10. Carrier, *Poussin's Paintings*, 131–32.

11. See Rosenberg, *Nicolas Poussin*, 506.

12. Bal, *Double Exposures*, 89.

13. Duncan, *Civilizing Rituals*, 95.

14. Levi, "Art Museums and Culture," 389.

15. Goethe, *The Autobiography of Johann Wolfgang von Goethe*, 346–47.

16. Greenblatt, *Learning to Curse*, 180.

17. Preziosi, *Brain of the Earth's Body*, 89.

18. Buck, "Museum Authority and Performance," 310.

19. Gaskell, *Vermeer's Wager*, 90.

20. Newhouse, *Toward a New Museum*, 142, 217.

21. D. Davis, *The Museum Transformed*, 74, 174.

22. Bazin, *The Museum Age*, and von Holst, *Creators, Collectors, and Connoisseurs*.

23. Wollheim, *The Thread of Life*, 233, 232.

24. Bann, "Meaning/Interpretation," 128.

25. James, *A Small Boy and Others*, 352.

26. Pevsner, *An Outline of European Architecture*, 321.

27. Gowing, "A History of the Louvre's Collection."

28. Schnapper, "The King of France as Collector in the Seventeenth Century," 199–200.

29. Sheehan, *Museums in the German Art World*, 51.

30. Quoted in McClellan, *Inventing the Louvre*, 91.

31. See Haskell, *The Ephemeral Museum*, chapter 2.

32. Farington, *The Diary of Joseph Farington*, 5:xiii, 1825, 1832, 1852. On Farington, see the editors' introduction, *The Diary of Joseph Farington*, vol. 1.

33. McClellan, *Inventing the Louvre*, 140. Before the Revolution, Denon had traveled extensively in Italy; see Denon, *Pages d'un journal de voyage en Italie (1788)*. In the company of Napoleon's army, he traveled to Egypt in 1798; see Denon and el-Gabarti, *Sur l'expédition de Bonaparte en Égypte*, and also, for the political context, Honour, *The Image of the Black in Western Art*, 28. The fullest account of his career and collecting is the exhibition catalogue Rosenberg and Dupuy, *Dominique-Vivant Denon*. See also Gould, *Trophy of Conquest*.

34. St. John, *The Louvre, or Biography of a Museum*, 10.

35. See Blunt, "Poussin Studies VI"; Kloss, *Samuel F. B. Morse*, 127–30; Radisich, *Hubert Robert*, 131–33; and Jullian, "Le thème des ruines."

36. Nochlin, "Museums and Radicals," 36.

37. Giacometti, *Écrits*, 255.

38. See Galard and Charrier, *Visiteurs du Louvre*.

39. Crow, *Painters and Public Life in Eighteenth-Century Paris*, 15.

40. Morton, *Americans in Paris*, 27.

41. James, *A Small Boy and Others*, 345, 346–47, 348, 348–49.

42. Baedeker, *Paris and Environs*, 141.

43. A modern account notes that "the influential figures who wrote about the ceiling, from Delécluze to Gustave Planche, expressed a few reservations at most. . . . 'We know that when we look at one of M. Delacroix's paintings we must pass lightly over the details . . .' wrote Delécluze. . . . Charles Tillot's remarks are more interesting because he identifies the difficulties peculiar to decorative painting. . . . Should one go further and see in *Apollo Slays Python* an allegory for Delacroix himself, his work, and his ongoing struggle? As Lee Johnson has rightly noted, the idea occurred to certain critics at the time; he reports Auguste Vacquerie's words as follows: 'Assigned to paint the triumph of light—he who has caused light to triumph in the French school—he was sure to win. . . .' It is less certain that Delacroix cleverly insinuated either himself or allusions to contemporary political and social developments into the battle of the god of the arts.

This intertextual narrative looks back and forth from the picture itself to the various commentaries" (Jobert, *Delacroix*, 215–16).

44. See Duncan, *Civilizing Rituals*, 22.

45. The elaborate literature on the poem is usefully summarized in Gasarian, " 'Le Cygne' of Baudelaire."

46. Baudelaire, *The Complete Verse*, 172.

47. Ibid., 176.

48. Benjamin, *The Arcades Project*, 356.

49. Holland, *Baudelaire and Schizoanalysis*, 160.

50. Chambers, *The Writing of Melancholy*, 207.

51. Wollheim, *Painting as an Art*, 213.

52. James, *Selected Literary Criticism*, 27–28.

53. James, *A Small Boy and Others*, 348–49.

54. See Boon, "Why Museums Make Me Sad." At the time of the dream, late 1910, James had been depressed. "Since the dream contained a vigorous moment of self-assertion and putting to flight of a frightening other-self (or brother) it may have helped restore to James . . . confidence and faith in himself" (Edel, *Henry James*, 445, 551).

55. James, *The Outcry*, 140.

56. Here I follow Tintner, *The Museum World of Henry James*, 4–5.

57. See Laclotte, "A History of the Louvre's Collection."

58. Rubin, "Delacroix and Romanticism," 42.

59. Edel, *Henry James*, 547, 552.

60. James, *A Small Boy and Others*, 349.

61. *The Travels of Théophile Gautier*, 39–40.

62. Baudelaire, *The Painter of Modern Life and Other Essays*, 55.

63. Ovid, *The Metamorphoses of Ovid*, 41.

64. See Hannoosh, *Painting and the Journal of Eugène Delacroix*, chapter 5.

65. Ibid., 169.

66. T. J. Clark, *The Absolute Bourgeois*, 141.

67. Ibid.

68. Butor, *Histoire Extraordinaire*, 12.

69. Baudelaire, *Intimate Journals*, 92.

70. Baudelaire, *Oeuvres complètes*, 1:1511.

71. Duncan, *Civilizing Rituals*, 123. See also Duncan, *The Aesthetics of Power*, part 2.

72. Kant, *The Critique of Judgement*, 158.

73. Nietzsche, *On the Genealogy of Morals*, 104.

74. Melville, *Erotic Art of the West*, 110.

75. Shapiro, *Archaeologies of Vision*, 62.

76. Schulze, *Philip Johnson*, 41–42.

77. Quoted in Freedberg, *The Power of Images*, 340.

78. Barolsky, *Why Mona Lisa Smiles*, 62.

79. See Spitz, "Tattoos and Teddy Bears."

80. Pater, *The Renaissance*, 98.

81. Leader, *Stealing the Mona Lisa*, 4.

82. Sassoon, *Becoming Mona Lisa*, 42–43.

83. Quoted in Duncan, *Civilizing Rituals*, 69.

84. Lefebvre, *The Production of Space*, 81.

85. Ladurie with Fitou, *Saint-Simon, and the Court of Louis XIV*, 141.

Chapter 2: Time Travel in the Museum

1. The novelist and literary critic George Leonard's work-in-progress *Extinction* (www.georgeleonard.com) has drawn my attention to a surprising fact: Time travel in fiction is a recent innovation. In H. G. Wells's *The Time Machine* (1895), a famous early example, the travel moves forward. Earlier examples include Edgar Allan Poe's "A Tale of the Ragged Mountains" (1843). (See John L. Flynn, "Time Travel Literature," www.towson.edu/-fllynn/timetv.html.) To conceive of time travel going backward in time, Leonard suggests, you need to remove Christian taboos about going backward in time and add the Romantic conception of a new relationship with the past, particularly the medieval past. The art museum thus is associated with a larger change in sensibility. "As the world shrinks and homogenizes, the museum grows more and more responsive, takes us to other realities," Leonard argues (correspondence, April 2001). According to Karen Hellekson (*The Alternate History*, 13, 19), the first literary work in which a time traveler causes events he went to study dates from 1881. And the first science fiction story to describe an alternate world is L. Sprague De Camp's *Lest Darkness Fall* (1941).

2. The scientific evidence, pro and con, is surveyed in Nahin, *Time Machines*.

3. When seeing a photograph, it has been argued, we see its subject. Seeing Carjat's photograph of Charles Baudelaire, I see the poet as he appeared in 1862. Photographs more than paintings inspire this way of thinking because there is a straightforward causal relationship between the image and their subject. A sophisticated discussion appears in Maynard, *The Engine of Visualization*.

4. Lee, *Past, Present, East and West*, 45.

5. C. Wright, *Poussin Paintings*, 260, 261.

6. Bredekamp, *The Lure of Antiquity and the Cult of the Machine*, 48.

7. Luchinat, *Treasures of Florence*, 10. In *Wonders and the Order of Nature*, 261, Lorraine Daston and Katherine Park discuss how the categories art and nature functioned in the *Wunderkammern* and were transformed in modernist culture.

8. Recently there was a large exhibition devoted to his career; see Rosenberg and Dupuy, *Dominique-Vivant Denon*, and Chatelain, *Dominique Vivant Denon et le Louvre de Napoléon*. Wilhelm Treue's *Art Plunder* draws analogies between Napoleon's and Hitler's art looting.

9. Pascal, *Pensées and Other Writings*, 16, 18.

10. Strong, *Splendor at Court*, 72.

11. Strong, *Art and Power*, 40.

12. Duncan, *Civilizing Rituals*, 54. Douglas, *Natural Symbols*, is one source for her concept of ritual.

13. Getty, *The Joys of Collecting*, 22.

14. Kenseth, "A World of Wonders in One Closet Shut," 93.

15. The differences between the ways reading history might cause us to imagine the past and the experience of visual art is discussed in Carrier, "Art History." My argument is not Eurocentric. A Chinese connoisseur could, in an exactly comparable way, reflect on the difficulties of understanding a European painting.

16. Quoted in Schneider, *Quatremère de Quincy et son Intervention dans les Arts*, 167.

17. Fong, *Beyond Representation*, 102.

18. Bourdieu and Darbel, *The Love of Art*, 37, 112.

19. R. Adams, *The Lost Museum*. See also Berenson, *Homeless Paintings*.

20. Benedict Nicholson quoted in Haskell, "Benedict Nicolson," 227.

21. Plant, *Venice*, 1.

22. Rossiter, *The Blue Guides: England*, 173.

23. See Steinberg, *Leonardo's Incessant Last Supper*.

24. Borsook, *The Mural Painters of Tuscany*, xii.

25. Shearman, *Only Connect . . .* , 59.

26. Wittkower, *Art and Architecture in Italy 1600 to 1750*, 168.

27. Vasari, *The Lives of the Painters, Sculptors and Architects*, 4, 142.

28. Beck with Daley, *Art Restoration*, 102.

29. On restoration, see Carrier, "Restoration as Interpretation: A Philosopher's Viewpoint."

30. Banham, *Los Angeles*, 151–52, notes that the street, probably not the site of the original pueblo, was constructed in 1929. He finds it "a very good and colourful tourist trap . . . many of the flanking buildings are genuinely as old as they look."

31. Here I extend Carrier, *Principles of Art History Writing*, 27–29.

32. Vasari, *The Lives of the Painters, Sculptors and Architects*, 1:194–95.

33. Are Shakespeare's plays or Mozart's operas accessible? That theatrical and operatic works are performed raises complex additional questions.

34. See Carrier, "Three Kinds of Imagination."

35. Ovid, The Metamorphoses of Ovid, 249.

Chapter 3: Museum Skeptics

1. Danto, *Analytic Philosophy of History*, 31. See Dummett, "The Dewey Lectures 2002: Truth of the Past," 28–29.

2. I know of no museum skeptic who has discussed this form of skepticism.

3. Some philosophers deny that paintings and sculptures are physical objects; see Wollheim, *Art and Its Objects*. That is an esoteric claim. Museum skeptics offer a quite different argument.

4. Moore, "Certainty," (1959), 27.

5. Wrigley, *The Origins of French Art Criticism*, 13.

6. This is the argument of de Quincy, *Lettres à Miranda sur le Déplacement des Monuments de l'art de l'Italie*. See also Shiner, *The Invention of Art*, 184, and Sherman, "Quatremère/Benjamin/Marx."

7. Quoted in Haskell and Penny, *Taste and the Antique*, 110.

8. Saisselin, *The Enlightenment against the Baroque*, 137–38.

9. S. Lavin, *Quatremère de Quincy and the Invention of a Modern Language of Architecture*, 272–73.

10. Quoted in Holt, *The Triumph of Art for the Public*, 76–77.

11. Boyle, *Goethe*, 364, 611.

12. Haskell and Penny, *Taste and the Antique*, the source of my quotation of Quatremère, reveals the complicated history of rearrangements of these objects in Rome. The *Horses of St. Mark's*, for example, were looted by the Venetians from Constantinople in 1204.

13. Springer, *The Marble Wilderness*, 89. An energetic defense of Canova's viewpoint appears in Johns, *Antonio Canova and the Politics of Patronage*.

14. Scott, "Introduction—'Pour la gloire des arts et l'honneur de France'," 10.

15. My discussion has been influenced by Greenblatt, *Marvelous Possessions*, and Fisher, *Wonder, the Rainbow, and the Aesthetics of Rare Experiences*.

16. Kaufmann, *Court, Cloister, and City*, 179.

17. Taken to its extreme, we might think "all museums are fragments or part objects" (Preziosi, *Brain of the Earth's Body*, 118).

18. See Bann, *Romanticism and the Rise of History*, 145–50.

19. Springer, *The Marble Wilderness*, 23.

20. See Krautheimer, *The Rome of Alexander XII*.

21. Haskell and Penny, *Taste and the Antique*, 108.

22. James, *Italian Hours*, 141.

23. Haskell, "Museums and Their Enemies," 13.

24. Danto, *Beyond the Brillo Box*, 212; Danto, *Embodied Meanings*, 356.

25. Acton, *Memoirs of an Aesthete*, 244.

26. Danto, "Looking at the Future Looking at the Present as Past," 9.

27. One useful source is Maleuvre, *Museum Memories*.

28. Quoted in Haskell, *The Ephemeral Museum*, 6.

29. See Hollier, *Against Architecture*, xiii.

30. This writer is cited but not named in Pach, *The Art Museum in America*, 12.

31. Chatwin, *Utz*, 20.

32. Quoted in Shelton, *No Direction Home*, 210.

33. Valéry, *Degas, Manet, Morisot*, 203.

34. Manning, introduction to *TK*, xiii.

35. Blanchot, *Friendship*, 45.

36. Greenwood, *Museums and Art Galleries*, 29.

37. Adorno, *Prisms*, 185. Zuidervaart gives a useful gloss: "Adorno uses "hieroglyphic script" to describe how, as humanly produced aesthetic objects, artworks hint at more than can be pinned down in their organized sensuousness, even though they make their suggestions only in their sensuousness and organization" (*Adorno's Aesthetic Theory*, 188).

38. Quoted in Maleuvre, *Museum Memories*, 47.

39. Ibid., 16.

40. Dewey, *Art as Experience*, 9.

41. Sartre, *Nausea*, 83.

42. Dewey, *Impressions of Society*, 30, 42.

43. Dana, *The New Museum*, 118, 73.

44. Hegel, *Aesthetics*, 1:103. See Houlgate, "Hegel and the Art of Painting."

45. Belting, *The Invisible Masterpiece*, 20. For Hegel there are no fragments in museums because the romantic work of art, properly seen, expresses the whole culture. He thus is not a museum skeptic.

46. Quoted in T. J. Clark, *Farewell to an Idea*, 237.

47. Sedlmayr, *Art in Crisis*, 88–89. See also Wood, *The Vienna School Reader*, 36–37.

48. Schlegel, "Descriptions of Paintings from Paris and the Netherlands in the Years 1802 to 1804," 60.

49. Abrams, *Natural Supernaturalism*, 431.

50. Benjamin, "The Work of Art in the Age of Mechanical Reproduction." See also Foster, "Mnémonique des musées, amnésie des archives."

51. Malraux, *The Voices of Silence*, 127, 47.

52. Most feminists or academics interested in gay politics and multiculturalism are not museum skeptics.

53. Duncan, *Civilizing Rituals*, 13, 133.

54. Ruskin, "A Museum or Picture Gallery," 247.

55. Trodd, "Culture, Class, City," 41.

56. Crimp, *On the Museum's Ruins*, 36, 75, 98, 204.

57. Ibid., 204.

58. Bann, "Art History and Museums," 239.

59. Bourdieu, *Distinction*, 373–78.

60. Coles, "The Art Museum and the Pressures of Society," 199.

61. Hickey, *The Invisible Dragon*, 54.

62. See Batkin, "Conceptualizing the History of the Contemporary Museum."

63. Shiner, *The Invention of Art*, 5, 10, 47. In her account focused on German literature, *The Author, Art, and the Market*, Martha Woodmansee develops a similar analysis.

64. Vasari, *The Lives of the Painters, Sculptors and Architects*, 4:127, 130, 108.

65. Changes in the styles of art writing are discussed in Carrier, *Principles of Art History Writing*.

66. Preziosi, "Collecting/Museums," 281, 284.

67. See Beurdeley, *The Chinese Collector through the Centuries*.

68. Preziosi, *Brain of the Earth's Body*, 104, 106. A full defense of this claim would involve discussion of the rise of bourgeois culture. "In distinguishing civil from political society, Hegel recognized the emergence of a new social configuration: a separate private social sphere, within which agents lived for themselves, without participating in political affairs. The heart of this new sphere was the modern market economy" (Hardimon, *Hegel's Social Philosophy*, 190).

69. These speculative claims deserve to be set against the empirical research of Paul DiMaggio, as summarized in his contribution to the panel discussion, "The Museum and the Public," 39–50.

70. Ostrow, "The Cultural Politics of Preservation," 123.

71. Pearce, *On Collecting*, 139.

72. Arata, "Object Lessons," 217.

73. Hooper-Greenhill, *Museums and the Shaping of Knowledge*, 80, 104, 194, 183, 191. Like most other skeptics who appeal to Foucault, she never critically evaluates his analysis. See Shapiro, *Archaeologies of Vision*.

74. Harbison, *Eccentric Spaces*, 140.

75. Krauss, "Postmodernism's Museum without Walls," 343.

76. Errington, *The Death of Authentic Primitive Art*, 22.

77. See Filipczak, *Picturing Art in Antwerp*, chapter 7.

78. Kuhns, *Tragedy*, 147.

79. At least in Cleveland. I owe this point to my student Seema Roa.

80. Houlgate, "Hegel and the Art of Painting," 62.

81. Sidney Morgenbesser of Columbia University once asked: "Name one event *not* due to the rising bourgeoisie." His joke points to the obvious problems with such a sweeping analysis.

82. Schubert, *The Curator's Egg*, 17. Could museums both express bourgeois ideology, as museum skeptics argue, and help us have aesthetic experience? Maybe museums preserve the old art they display only in part—possibly the case against the museum is only partly true. In practice museum skepticism is an all-or-nothing position.

83. Haskell, "The Dispersal and Conservation of Art-Historical Property," 236. On the history of the collection, see Pietrangeli, "The Vatican Museums," 14–25.

84. Daltrop, "Museum Pio-Clementino," *The Vatican Collections*, 116.

85. It has been argued that "the internal reconfiguration of absolutism" at this time "made it possible for the first time to think of the art museum as a non-private space with rational, educative or national demands" (Prior, *Museums and*

Modernity, 32). This analysis depends upon too abstract a characterization of absolutionism to carry conviction.

86. See Parfit, *Reasons and Persons*.

87. Suppose an art insurer decides to pay claims only when 50 percent of a work of art is destroyed. That practical decision says nothing about the concerns of museum skeptics.

88. Maleuvre, *Museum Memories*, 58.

89. Arendt, *The Human Condition*, 147.

90. See Carrier, "Art History."

91. Schama, *Citizens*, 400, 402, 403.

92. Johnson, *Jacques-Louis David*, 1.

93. When I presented this claim on a College Art Association panel, Robert Storr said that he was interested in museum skepticism. But he did not explain how this concern affected his practice as a curator.

94. Nietzsche, *On the Genealogy of Morals*, 20. Where he speaks of "moral values," I substitute the words "aesthetic values."

Chapter 4: Picturing Museum Skepticism

1. Pomian, *Collectors and Curiosities*, 36–37.

2. Getty, *The Joys of Collecting*, 13.

3. Freedberg, *The Power of Images*, 201.

4. Danto, *Analytic Philosophy of Action*, ix.

5. Where Danto writes "arm," I put "hand."

6. See M. Lavin, *Piero della Francesca's Baptism of Christ*, and Langmuir, *The National Gallery Companion Guide*, 80–81.

7. See Amery, *The National Gallery Sainsburg Wing*.

8. See Danto, *Mark Tansey*, and Gaskell, *The Thyssen Bornemisza Collection*, 11. One of our artist's models is Hans Memling's *Panorama of the Passion* (Gallery Sabauda, Turin). It shows the events of the passion in one large elaborate pictorial space. See McFarlane, *Hans Memling*, and Andrews, *Story and Space in Renaissance Art*.

9. See Brilli, *Sansepolcro*.

10. Berenson, *The Italian Painters of the Renaissance*, 135.

11. Belting, "The New Role of Narrative," 153.

12. Reiss, *From Margin to Center*, 14. Reiss notes that although many installation artists originally were hostile to museums, soon their art was in these institutions.

13. I invented this example, but after publishing this analysis (Carrier, "Art Museums, Old Paintings and Our Knowledge of the Past") I discovered that

Samuel Morse's *The Gallery of the Louvre* (1832–33) has something of the same effect. Horrified at the modern French paintings in the Salon Carré—he particularly disliked Géricault's *Raft of the Medusa*—Morse created "an imaginary display. . . . [He] had to reduce the size of the works copied." Working within a well established tradition, the imaginary painting of a gallery, he created "an image of bourgeois education. . . . He replaced the elitist trappings that had marked every traditional variety of gallery picture with an image of discipline, ideation and effort" (Staiti, *Samuel F. B. Morse*, 190, 193). Staiti goes on to offer a suggestive analysis of the political implications of this picture.

14. Sickman, introduction to *Chinese Calligraphy and Painting in the Collection of John M. Crawford, Jr.*, 27.

15. The Master of the London Piero's Travels is influenced by the cataloguing system of the Getty Research Institute, which groups some books—catalogues raisonnés, histories of collections, and the various indexes of painting published by the Getty—in a special section, the Provenance Index. Just as people may be categorized as homebodies or adventurers, so pictures can be described according to their careers. Some paintings have always been famous. Others, famous once, lose their reputation. And some works of art, after disappearing from sight, have seen their reputations revived. Because the history of collecting normally is only a specialist concern among art historians, information about the location of paintings has not been gathered systematically. Almost every well-known artist has a catalogue raisonné, for an artist's oeuvre is a familiar unit of art historical discourse. But to find how works of art were displayed, you need to search, for art historians do not usually keep systematic records showing how paintings were displayed. Knowing the history of display of a painting permits you to know how its significance has changed over time.

16. Goehr, *The Imaginary Museum of Musical Works*, 173, notes that the modern concept of the musical work of art was created at the same time as the museum devoted to visual works of art.

17. Danto, *Connections to the World*, 6–8. Experimental psychology has identified various indiscernibles. (1) The Muller-Lyer illusion (Gregory, *Eye and Brain*, 138–39): two lines, one with outgoing, the other with ingoing arrows at both ends. The lines are the same length, but the one with the outgoing heads appears longer. (2) The Ponzo illusion: two horizontal lines the same length, enclosed by converging verticals. The upper horizontal line looks longer. Lines that appear of different lengths are observed to be identical when the initially misleading visual context is changed. The appearance of the lines being of different lengths contradicts what we know: that they are of the same length. (3) The Purkinje effect (Luckiesh, *Visual Illusions*, 140): "A blue and a red flower, which appear of the same brightness before sunset will begin to appear unequal in this respect as twilight deepens. The red will become darker more rapidly than the blue." Two

things that appear identical (in one respect) are then observed to differ. (4) The Ames rooms (Ittelson, *The Ames Demonstrations in Perception*, 40): two rooms, viewed with monocular vision from a proper viewpoint, "appear to be rectangular and identical. . . . Both rooms present to the retina the same pattern that would be produced by a normal rectangular room." But these especially constructed rooms have distorted walls. The first has oblique floor and ceiling and a real wall; the second, sloping walls between small floor and large ceiling. We see these oddly shaped rooms as normal rectangular rooms because, in the absence of strong contrary evidence, we believe that they are like the familiar rectangular rooms we already know.

18. What may give support to this confused way of thinking is a misleading formulation of Danto's argument. Instead of starting with two distinct things, and explaining how they are different, someone might rather imagine that one thing had two very different origins. See Carrier, "Indiscernibles and the Essence of Art."

19. Danto, *Analytic Philosophy of Action*, 28.

20. Ibid., 29.

21. Fisher, *Making and Effacing Art*, 3.

22. The best-known account, Wiggins, *Sameness and Substance*, has only brief remarks about art.

23. Gadamer, *The Relevance of the Beautiful*, 19. In his sympathetic summary, David Couzens Hoy speaks of how Gadamer's position "can be called *contextualism*, for according to it, the interpretation is dependent upon, or 'relative to,' the circumstances in which it occurs. . . . Since no context is absolute, different lines of interpretation are possible. But this is not radical relativism, since not all contexts are equally appropriate or justifiable" (*The Critical Circle*, 69).

24. Holly, *Panofsky and the Foundations of Art History*, 53.

25. Gadamer, *Philosophical Hermeneutics*, 101–2.

26. *Truth and Method*, 133. Gadamer is mistaken, however, to claim: "The reconstruction of the original circumstances, like all restoration, is a pointless undertaking in view of the historicity of our being. What is reconstructed, a life brought back from the lost past, is not the original. . . . Even the painting taken from the museum and replaced in the church, or the building restored to its original condition are not what they once were—they become simply tourist attractions." Art historians can often reconstruct these original circumstances.

27. Gadamer, *Truth and Method*, 265, 267. In a shrewd commentary on this issue, Baxandall, *Patterns of Intention*, opens with the example of the Forth Bridge near Edinburgh. When looking at such a collaborative creation, what is meant, he asks, by the creator's intention?

28. Wiggins, *Sameness and Substance*, 126.

29. In *Other Criteria*, 318, 320, Leo Steinberg argues that such contemporary

experience better equips us to understand art of the past; more recent commentators tend to suggest that it is not so much a matter of seeing that art as it really was made as projecting our new interpretation upon it. See Carrier, "Panofsky, Leo Steinberg, David Carrier."

30. Wind, *Art and Anarchy*, 76.

31. Goethe, *Italian Journey*, 343.

32. Mead, "The Ebb and Flow of Mana Maori," 24.

33. Bush, *The Chinese Literati on Painting*, 146.

34. See Soucek, "Nizami on Painters and Painting," 12–13.

35. Schapiro, *Romanesque Art*, 23.

36. Barolsky, *Michelangelo's Nose*, 33.

37. Quoted in M. Miller, *The Art of Mesoamerica*, 202.

38. Nicholson with Keber, *Art of Aztec Mexico*, 40.

39. Duncan, *Civilizing Rituals*, 1–2.

40. Ibid., 12.

41. See Donoghue, *Walter Pater*, 28.

42. See Carrier, "On the Possibility of Aesthetic Atheism."

43. Duncan, *Civilizing Rituals*, 13.

44. This argument is developed in Wollheim, *Art and Its Objects*.

45. Abt, "Museum, I, 7," 360.

Chapter 5: Art Museum Narratives

1. Haskell, *Rediscoveries in Art*, 8–13.

2. Barolsky, *Giotto's Father and the Family of Vasari's* Lives, 20.

3. Zoffany made this picture in the Uffizi, "improving" that collection "to make the selection of pictures gayer and livelier" (Millar, *Zoffany and His Tribuna*, 22).

4. See Fong, *Beyond Representation*, 165, and Carrier, *Sean Scully*, 118–19.

5. Foucault, *The Order of Things*, xv.

6. Lee, *Past, Present, East and West*, 62.

7. Wollheim, *On Art and the Mind*, 111.

8. Gombrich, *Art and Illusion*, 34.

9. Lorenzetti, *Venice and Its Lagoon*, 597, 593.

10. Varnedoe, panel discussion, 51.

11. Bal, *Looking In*, 187.

12. Greenberg used this phrase in conversation with me.

13. Bal, *Looking In*, 161.

14. Serota, *Experience or Interpretation*, 55.

15. Danto, *Narration and Knowledge*, 143, 351.

16. Here I extend Carrier, *Writing about Visual Art*, Chapter 4.

17. T. J. Clark, *Farewell to an Idea*, 15.

18. Fried, *Art and Objecthood*, 229.

19. Gombrich, *Art and Illusion*, 388.

20. Chantelou, *Diary of the Cavaliere Bernini's Visit to France*, 79.

21. See Carrier, *Poussin's Paintings*, 197n24.

22. Fisher, *Making and Effacing Art*, 9. Stephen Jay Gould makes a similar point about natural history museums: "Most museum halls are rectangles with a preferred linear flow of visitors in one direction along the major axis. All the exhibitions on the history of life that I have ever seen in any museum, anywhere in the world . . . use the bias of progress as a central principle for arranging organisms" (*Dinosaur in a Haystack*, 251).

23. Carrier, *Artwriting*, 35. I then gave too much importance to Greenberg and too little to Alfred H. Barr.

24. Krauss, "Postmodernism's Museum without Walls," 43.

25. Gaskell, *Vermeer's Wager*, 86.

26. See Findlen, *Possessing Nature*.

27. See Rosenberg and Dupuy, *Dominique-Vivant Denon*.

28. Hegel, *Aesthetics*, 2:870.

29. Jackson, *The Museum*, 21.

30. See Carrier, "Remembering the Past."

31. The original source for this discussion deserves mention, for it helps explain my reasoning. Frances Yates discussed the origin and development of the memory theater, and Gombrich linked her account to the museum (see Gombrich, *Ideals and Idols*, 204). At a banquet the poet Simonides, who recited a poem in honor of the host, was called out. During his absence, the roof fell in, killing all of the guests. Because Simonides remembered where the guests were sitting, he is able to identify the bodies. "This experience suggested to the poet the principles of the art of memory of which he is said to have been the inventor" (Yates, *The Art of Memory*, 2). The poet remembers by associating things with places in some large building. Yates's tracing out of the long uses of this memory theater suggests that there might be some relationship between that institution and the art museum. So far as I know, no concrete connection has been established. Perhaps none exists, for by the time that historically organized art museums were established, the memory theater had lost its once prominent place in the intellectual culture and became merely a conjuring device discussed in self-help books for people who wanted to improve their memory. But there is an important conceptual relationship between these memory techniques and the complex narrative orderings provided by our art museums.

32. Errington, *The Death of Authentic Primitive Art*, 22.

33. Hitchcock, *The Sheldon Memorial Art Gallery*, n.p.

34. Haskell, "Museums and Their Enemies," 21.

35. One exception to this generalization is Hahnloser-Ingold, "Collecting Matisses of the 1920s in the 1920s."

36. Staniszewski, *The Power of Display*, xxi.

37. But see Waterfield, *Palaces of Art*.

38. O'Doherty, *Inside the White Cube*, 24.

39. Beyer, "Between Academic and Exhibition Practice," 29.

40. K. Lynch, *The Image of the City*, 54.

41. Douglas, *Natural Symbols*, 11.

42. See Amery, *The National Gallery Sainsbury Wing*.

43. Steinberg, "Observations in the Cerasi Chapel."

44. Wittkower, *Art and Architecture in Italy*, 66.

45. Ibid., 201, 202.

46. "On the surface, it appears that visitors do not spend much time looking at works of art. But visitors experience museums much more holistically than the data indicate" (Schloder, Williams, De Bevec, and Mann, *The Visitor's Voice*, 76).

47. Schapiro, "Matisse and Impressionism," 289.

48. I owe this example to Wright, *Identity Trouble*, 162.

49. See Carrier, "Picasso/Matisse."

50. See Bucci and Torriti, *Il palazzo ducale di urbino*, and Macadam, *Blue Guide*, 381–83.

51. Belting, *The Invisible Masterpiece*, 52, 53. Chapter 2 is devoted to this Raphael.

52. See Carrier, *Principles of Art History Writing*, 240–41.

53. Freud, *Standard Edition*, 7:96.

54. See von Holst, *Creators, Collectors, and Connoisseurs*, 127.

55. Schnapper, "From Politics to Collecting," 120.

56. T. J. Clark, *The Painting of Modern Life*, 267–68.

57. The Getty Research Institute groups some books—catalogues raisonnés, histories of collections, and the various indexes of painting published by the Getty—in a special section, the Provenance Index. See Fredericksen, *Corpus of Paintings* and *The Index of Paintings*.

58. Mina Gregori, Caravaggio's *Amor Vincit Omnia*, 277.

59. See Carrier, "The Transfiguration of the Commonplace."

60. Nehamas, "The Art of Being Unselfish," 63. José López-Rey merely reports: "I have been unable to identify conclusively the room on whose ceiling the painting was placed; it might have been a bedchamber" (*Velázquez*, 452).

61. See Miranda Carter, *Anthony Blunt*, 499.

62. See Karmel, "Pollock at Work."

63. Greenberg, *Art and Culture*, 218.

64. On the history of hangings, see Waterfield, *Palaces of Art*.

65. Husserl, *Cartesian Meditations*, 60.

66. Merleau-Ponty, *The Primacy of Perception*, 15–16.

67. The concept of horizons, developed in phenomenology, can be formulated within the framework of Arthur Danto's analytic philosophy.

68. Haskell, *Rediscoveries in Art*, 84.

69. Wollheim, *On Art and the Mind*, 111.

70. Finn, How to Visit a Museum, 23.

Chapter 6: Isabella Stewart Gardner's Museum

1. Tribby, "Body/Building," 158.

2. See de Grazia, Quilligan, and Stallybrass, introduction to *Subject and Object in Renaissance Culture*. Classicists have explored "the importance of the art collection in the creation of an image of the collector" (Vasaly, *Representations*, 109n35).

3. Muensterberger, *Collecting*, 255. American collectors were motivated, it has been claimed, by the desire to imitate the Medici, banker-collectors (Einreinhofer, *The American Art Museum*, 1).

4. Getty, *The Joys of Collecting*, 7.

5. See Carrier, "Mrs. Isabella Stewart Gardner's Titian"; and Barkan, *The Gods Made Flesh*, 7–45.

6. Goldfarb, *Isabella Stewart Gardner Museum*.

7. Hadley, *The Letters of Bernard Berenson and Isabella Stewart Gardner*, 55–56. The Museum of Fine Arts, Boston, considered purchasing this painting, but ultimately thought it too much of a risk; see Morris Carter, *Isabella Stewart Gardner and Fenway Court*, 158.

8. Ovid, *The Metamorphoses of Ovid*, 73.

9. See Mather, *Venetian Painters*.

10. Nash, *Veiled Images*, 60.

11. Hendy, *European and American Paintings*, 371.

12. Panofsky, *Problems in Titian*, 166.

13. Hills, *Venetian Colour*, 224.

14. "Visitor Guide" and "An Eye for Art," n.p.

15. In *Diana Discovered by Actaeon*, the hunter Actaeon's inadvertent sighting of the nude Diana causes his death. She turns him into a stag, and so his dogs tear him to death. And in *Perseus and Andromeda* the nude Andromeda watches as Perseus fights the monster that would kill her.

16. L. Adams, *Art and Psychoanalysis*, 233–54.

17. Vasari, *The Lives of the Painters, Sculptors and Architects*, 4:208.

18. Freedberg, *Painting in Italy*, 348, 505n7.

19. See J. Brown, *Kings and Connoisseurs*. Velázquez's painting, also about metamorphosis, tells another story from Ovid. Arachne imprudently boasted that she was superior to Pallas in weaving. Pallas challenged her, and after victory turned Arachne into a spider. *The Fable of Arachne* shows Pallas in disguise, Athena, and in the background is the portion of Arachne's tapestry showing the rape of Europa. Copied (with minor changes) from Titian's painting, it "is homage to Titian, public acknowledgment of an inspiration which is especially evident in many of the latest pictures. . . . Velázquez has made a rare, if not unique, use of Titian's favourite colour, the pure ultramarine; and it is contrasted, as Titian loved to contrast it, with rose and gold" (Hendy, *Spanish Painting*, 23–24). Wanting to outdo Titian, Velázquez shows the spinning wheel, presenting an illusion of movement not found in the earlier master's art. See Bedaux, "Velázquez's Fable of Arachne."

20. Pater, *The Renaissance*, 24, 34, 50, 109.

21. See Steegmuller, *The Two Lives of James Jackson Jarves*.

22. James, *The American Scene*, 252.

23. Pater, *The Renaissance*, 128. In *Giorgione*, Jaynie Anderson discusses his iconography.

24. Pater, *The Renaissance*, 129, 134.

25. Ibid.

26. Ibid., 139. Berenson shared this view, observing that an artist's "civic status can be of interest only in the measure that it throws light on his artistic personality" (Berenson, *Homeless Paintings of the Renaissance*, 103).

27. Ibid., 222.

28. Charles Eliot Norton, father of American art history and Berenson's teacher, called *The Renaissance* a book "only fit to be read only in the bathroom" (Kantor, "The Beginnings of Art History at Harvard" 161). On collecting of Italian art in America before Berenson, see Steegmuller, "An Approach to James Jackson Jarves." In *William and Henry Walters, the Reticent Collectors*, William Johnston gives an account of another pioneering American collector, who employed Berenson.

29. Mallock, *The New Republic*, 27–28.

30. Pater, *Marius the Epicurean*, 270. See also Carrier, "Baudelaire, Pater and the Origins of Modernism."

31. Berenson, *One Year's Reading for Fun (1942)*; Pater, *Marius the Epicurean*, 105.

32. Pater, *Marius the Epicurean*, 115.

33. Levey, *The Case of Walter Pater*, 186.

34. See Schapiro, "Mr. Berenson's Values," and Court, "The Matter of Pater's 'Influence.'"

35. Pater, *The Renaissance*, 179.

36. Berenson, *The Italian Painters of the Renaissance*, 63. See also Berenson, *Venetian Painting in America*, and Verstegen, "Bernard Berenson and the Science of Anti-Modernism."

37. Berenson, *The Italian Painters of the Renaissance*, 137, 134. Compare the recent account in Baxandall, *Words for Pictures*, chapter 7.

38. Hadley, *The Letters of Bernard Berenson and Isabella Stewart Gardner*, 61.

39. Berenson, *Sketch for a Self-Portrait*, 20, 150.

40. Ibid.

41. Ibid., 18.

42. Berenson, *The Italian Painters of the Renaissance*, 152.

43. Berenson, *Sketch for a Self-Portrait*, 60.

44. Samuels, *Bernard Berenson*, 3.

45. Wollheim, *Painting as an Art*, 89. See also Gibson-Wood, *Studies in the Theory of Connoisseurship from Vasari to Morelli*; Jaynie Anderson, "Connoisseurship in Risorgimento Italy"; and D. Brown, "Giovanni Morelli and Bernard Berenson."

46. Pope-Hennessy, "Berenson's Certificate," 19.

47. Marx, *Capital*, 186.

48. Her father's possessions included a slave worth $50, and she married a wealthy man (Tharp, *Mrs. Jack*, 5).

49. Gardner's husband once spent $46,000 on jewels for her—more costly than all but her most expensive artworks (ibid., 111).

50. Their relationship is discussed in Strouse, *Morgan*.

51. Samuels, *Bernard Berenson*, 74.

52. Ibid., 442.

53. Berenson, *Sketch for a Self-Portrait*, 47.

54. Schapiro, "Mr. Berenson's Values," 211.

55. Schapiro, *Modern Art*, 218.

56. In a drawing from the 1940s, "Mr. Berenson and the Collector," Schapiro shows Berenson and the collector with the caption: " 'But are you sure that's by Masaccio? Sure of it? Why I know more about Masaccio's work than Masaccio did' " (Schapiro and Easterman, *Meyer Schapiro*, 172).

57. Gaskell, "Magnanimity and Paranoia in the Big Bad Art World," 19.

58. Schapiro, "Mr. Berenson's Values," 212, 215, 224.

59. In 1931, Berenson said that to live in Florence was to live in exile from Paris, where it would have been possible to study the art of the nineteenth century (Morra, *Conversations with Berenson*, 94).

60. Schapiro, "The Last Aesthete," 616.

61. Paraphrase of Schapiro, "The Last Aesthete," 615.

62. Schapiro, "Mr. Berenson's Values," 225n5.

63. When Yehudi Menuhin's father became an American citizen, he changed

the name Mnuchin, hard for Americans to pronounce, to Menuhin—and Menuhin was always proud of his Jewishness (Burton, *Yehudi Menuhin*, 13–14). See also Soussloff, "Introducing Jewish Identity to Art History," 10–11.

64. Pope-Hennessy, "Berenson," 274.

65. Freedberg, "Berenson, Connoisseurship, and the History of Art," 7, 9, 16, 10, 12, 13. See also Carrier, "In Praise of Connoisseurship."

66. Freedberg, "Berenson, Connoisseurship, and the History of Art," 16.

67. Ibid., 8. See also Barolsky, "Obituary."

68. This analysis extends Carrier, "Walter Pater's 'Winckelmann' " and *"Artforum*, Andy Warhol and the Art of Living."

69. See Weaver, *A Legacy of Excellence*.

70. Samuels, *Bernard Berenson*, 137.

71. Berenson, *Lorenzo Lotto*, 252.

72. His letters to Clotilde Marghieri reveal his most sympathetic side. "I truly want to enrich you with all you can take from me and my universe and assimilate. . . . This means that I want you most preciously to preserve every atom, every nuance of your own individuality but developed to the utmost, and then only to contribute all that you have to the ideal society of kindred souls which for accidental but happy reasons centers about me" (Biocca, *A Matter of Passion*, 20).

73. Berenson, *The Study and Criticism of Italian Art*, 120.

74. Sally Yard quoted in McShine, *The Museum as Muse*, 138. Other collectors of her generation did say more. Louisine W. Havemeyer, whose impressionist paintings form the core of the Metropolitan's collection, described her close relationship with Mary Cassatt, her talks with Degas, and her intense fascination with Courbet, Manet, and Degas. See Havemeyer, *Sixteen to Sixty*.

75. Tharp, *Mrs. Jack*, 338n2.

76. Shand-Tucci, *The Art of Scandal*, 222.

77. Nehamas, *The Art of Living*, 4–5.

78. Coles, "The Art Museum and the Pressures of Society," 188.

79. My account is influenced by Wollheim, *On Art and the Mind*, chapter 3, and Freud, "Creative Writers and Day-Dreaming."

80. Behrman, *Duveen*, 62.

81. Ross, "Session I: Panel Discussion," 138.

82. Quoted in McClellan, "A Brief History of the Art Museum Public," 27.

83. Clark, *Moments of Vision*, 110.

84. Higonnet, "Museum Sight," 135.

85. See Brese-Bautier and Morvan, *Palais du Louvre*, 22, 73, 38.

86. See Malgouyres, *Le Musée Napoléon*.

87. Von Holst, *Creators, Collectors, and Connoisseurs*, 159. Quotation from Alsop, *The Rare Art Traditions*, 475.

88. Bazin, *The Museum Age*, 95.

Chapter 7: Ernest Fenollosa's History of Asian Art

1. African art is in one gallery near to the contemporary art, and the art of the Americas, which includes pre-Columbian art and Native American art, is displayed on a lower floor. But these are relatively minor parts of the collection.

2. Lee, *A History of Far Eastern Art*, 7. Lee "knew Japanese art particularly well, a product in large part of his work . . . as a member of the Occupation authority in Japan . . . He kept his hand in teaching, tried with occasional success to find time to write, and advised collectors" (Cohen, *East Asian Art and American Culture*, 174). A summary of Lee's view of Chinese art appears in his introduction to *China, 5000 Years*. His work was controversial—in "Sinology or Art History," John Pope argues that only trained sinologists can understand Chinese art.

3. Said, *Orientalism*, 42.

4. Cahill, *The Compelling Image*, 3.

5. The standard biography is Chisolm, *Fenollosa*. See also Mary Fenollosa, preface to *Epochs of Chinese and Japanese Art*. A portrait of Fenollosa's Japan appears in La Farge, *An Artist's Letters from Japan*.

6. See Ienaga, *Japanese Art*, 90.

7. Chisolm, *Fenollosa*, 64.

8. The first Japanese artist to become well known in the West was Hokusai, who influenced the postimpressionists. Fenollosa thought him minor. See Fenollosa, *Review of the Chapter on Painting in Gonse's "L'art Japonais."*

9. See Lawton and Merrill, *Freer*, chapter 5.

10. Fenollosa, *Epochs of Chinese and Japanese Art*, 1:97.

11. Ibid., 1:99.

12. Berenson, preface to *The Bernard Berenson Collection of Oriental Art at Villa i Tatti*. Art museums did not develop in Asia, Malraux argues, because "for an Asiatic . . . artistic contemplation and the picture gallery are incompatible" (*The Voices of Silence*, 14).

13. Addison, *The Boston Museum of Fine Arts*, 334. Jan Fontein's introduction to *Museum of Fine Arts Boston* gives a history of Asian art collecting in Boston. See also Tomita, *A History of the Asiatic Department*, which offers a critical evaluation of Fenollosa's writings.

14. Cohen, *East Asian Art and American Culture*, 42.

15. March, *China and Japan in Our Museums*, 4.

16. Pound, introduction, to *The Classic Noh Theatre of Japan*, 3. See also Fenollosa, *The Chinese Written Character as a Medium for Poetry* and in Davie, *Articulate Energy*, chapter 4.

17. Kenner, *The Pound Era*, 239.

18. Fenellosa, *Epochs of Chinese and Japanese Art*, 1:xxiv.

19. Roberts, *The Pelican History of the World*.

20. See Elkins, *Stories of Art*.

21. Here I borrow from and take issue with Abu-Lughod, *Before European Hegemony*.

22. Braudel, *Civilization and Capitalism*, 386–87.

23. See Levenson, *Circa 1492*.

24. Chisolm, *Fenollosa*, 50.

25. A cross-cultural comparison is developed by Fong, "Why Chinese Painting Is History."

26. The story is told in Jardine and Brotton, *Global Interests*.

27. See Rosenberg and Dupuy, *Dominique-Vivant Denon*, 428–29.

28. Brooks, *Fenollosa and His Circle*, 25.

29. Danto, *Mysticism and Morality*, xix.

30. Arnheim, *Art and Visual Perception*, 418–20.

31. When I questioned this ahistorical analysis, which treats the picture as an exercise in gestalt psychology, Arnheim replied that even viewers who had no knowledge of Catholic doctrines would understand this picture. See Carrier, "On the Possibility of Aesthetic Atheism," "A Response to Rudolf Arnheim's 'To the Rescue of Art,'" and "Rudolf Arnheim as Art Historian."

32. Fry, "The Significance of Chinese Art," 1.

33. Fry, *Last Lectures*, 79.

34. Coomaraswamy, *Introduction to Indian Art*, v.

35. I speak here of "our culture," but my argument is not Eurocentric. A Chinese or Indian could, in a symmetrical way, imagine being a European. What is "exotic" or "alien" depends on where you are coming from.

36. See Ettinghausen, "The Early History, Use and Iconography of the Prayer Rug."

37. See "Report of the Director" and Carrier, "Seeing Cultural Conflicts."

38. African art might be treated as an influence on early-twentieth-century European modernism, and Islamic carpets and calligraphy might be hung alongside European paintings in which they are depicted or used decoratively. (On the depiction of Islamic art in European paintings, see Mills, "The Coming of the Carpet to the West.") And pre-Columbian art could be linked to modernist fascination with 'primitivism.' For example, Dore Ashton speaks of abstract art before Columbus: "The discovery of pre-Columbian art, or abstract art, is the simple effect of man's insatiable curiosity and his longing for fresh experiences" (*Abstract Art before Columbus*, 30).

39. See Clunas, "Souvenirs of Beijing."

40. Fairbank, *China*, 325, 75. See also Crowley, "The Historiography of Modern China."

41. Cahill, *Treasures of Asia*, 5, 6.

42. Sullivan, *The Birth of Landscape Painting in China*, 104. Wang Wei said: "When speaking of painting, what we ultimately are looking for is nothing but the (expressive) power contained in it . . . based on the shapes is an indwelling spiritual force (or sou, *ling*); what activates that force is the mind (or heart, *hsin*). If the mind ceases, that spiritual force is gone because what it relies on (to become visible) is not activated." And Hsieh Hoh argued, "The representation of natural objects requires likeness of the shapes, but the shapes must all have structure [bone] and life [spirit]. Structure, vitality [spirit] and shapes originate in the directing idea and are expressed by the brush-work. Therefore, those who are skilled in painting are also good in calligraphy." Quoted in Lehr, *The Great Painters of China*, 23. It seems hard to apply such observations to European painting. The same problem arises when Chang Yen-yüan claims, "the representation of things necessarily consists of formal resemblance, but formal resemblance must be completed with structural force [*ku-ch'i*]. Structural force and formal resemblance both derive from the artist's conception and depend on the use of the brush" (quoted in Sirén, *The Chinese on the Art of Painting*, 22).

43. Nelson, "*I-p'in* in Later Painting Criticism," 415.

44. Chinese writers claim that "the character *hua* [to paint] is [derived from] the raised paths between fields, it depicts the boundary lines around paddyfields" (Sirén, *Chinese Painting*, 2, 1).

45. Lee, *Chinese Landscape Painting*, 3.

46. Danto, *Mysticism and Morality*, xiii.

47. Gernet, *Daily Life in China on the Eve of the Mongol Invasion*, 197, 199.

48. Ibid.

49. Clunas, *Art in China*, 130. "The Europeans. . . . know how to represent light and shade, distance and proximity. . . . They paint palaces and rooms on walls, imitating reality so closely that you imagine you are confronted by a true palace and are about to enter it. . . . They admired the skill shown in his paintings, but thought them nothing but skilled craftsmanship. Our painting does not seek a formal resemblance. . . . The Europeans . . . strive by painstaking labour to obtain a formal resemblance" (Beurdeley and Beurdeley, *Giuseppe Castiglione*, 147).

50. His account has been much criticized; see Carrier, "Gombrich on Art Historical Explanations."

51. Gombrich, *The Story of Art*, 153. Gombrich is often criticized for being Eurocentric, but his book *The Sense of Order* is mostly devoted to non-European art; see Carrier, "The Big Picture." Because he never went to China, Gombrich hesitated to describe its art in detail.

52. Compare a Giotto with Chao Meng-Fu, *Autumn Colors on the Ch'iao and Hua Mountains* (1295); contrast a Piero della Francesca with Tai Chin's early fifteenth century *Fishermen on the River*; set a Raphael against Shen Cho's (1427–

1509) *Walking with Staff*; juxtapose to a Poussin the 1670 Wang Shih-min *Landscape in Manner of Chao Meng-fu*; and relate a Watteau to the Hua Yen *An Autumn Scene* (1729). These Chinese examples are from Cahill, *Treasures of Asia*. A sequence of comparisons of Chinese paintings with European modernist works is presented in Duthuit, *Chinese Mysticism and Modern Painting*.

53. The most forceful challenge to this generalization appears in Joseph Alsop's book on collecting: "Representation was not only a goal of art in China; it was also a goal toward which Chinese painters worked closer and closer, until they had reached the uttermost limits permitted by the calligraphic means the painters always used—whereupon other goals replaced representation." Referring to Gombrich's account of progress in the Renaissance, he argues that "Chinese art displays precisely the phases that are to be expected in a 'problem-solving' art tradition" (Alsop, *The Rare Art Traditions*, 234, 237). In his review, Gombrich reports Alsop's claims without accepting or denying them—"We shall have to await the verdict of experts" (Woodfield, *Reflections on the History of Art*, 171).

54. My view is that "the history of painting is different in China than in the West because the medium is different. European paintings are windows on the wall through which we look into an illusionistic space; Chinese paintings, scrolls which establish an essentially different relationship to the spectator" (Carrier, "Meditations on a Scroll"). See also Rowley, *Principles of Chinese Painting*, 24, and Sullivan, *The Meeting of Eastern and Western Art*.

55. Gombrich, *Norm and Form*, 4, 10.

56. Clunas, *Pictures and Visuality in Early Modern China*, 13. See also Jardine and Brotton, *Global Interests*.

57. Gombrich, *Reflections on the History of Art*, 175.

58. Kuhn, *The Structure of Scientific Revolutions*, 161.

59. Gombrich, "The Logic of Vanity Fair," 941–42.

60. Bush, *The Chinese Literati*, 23.

61. Cahill, *The Compelling Image*, 96.

62. Sullivan, *The Arts of China*, 156.

63. Gombrich argues that *Constantine's Dream* (1460s) shows that Piero della Francesca "had mastered the art of perspective completely, and the way in which he shows the figure of the angel in foreshortening is so bold as to be almost confusing.... But to these geometrical devices ... he has added a new one of equal importance: the treatment of light" (*The Story of Art*, 260). He sets this discovery in a larger historical narrative, a story of progress in illusionism: "Medieval artists had taken hardly any notice of light.... Masaccio had ... been a pioneer in this regard ... but no one had seen the immense new possibilities of this means as clearly as Piero." Compare Yang Xin's account of Shen Zhou's art from 1467, about the same date: "*Lofty Mount Lu* follows the manner of Want Meng

in both composition and brushwork. . . . Shen Zhu had never been there. The hanging scroll represents an attempt to describe the strong character and virtues of his teacher by depicting the height and grandeur of the mountain. He cleverly places the figure admiring the scenery at the very bottom of the picture, bringing it into relief against the rocky cliffs and the blank space that represents water." There is no suggestion that Shen Zhu similarly extends Chinese tradition (Yang Xin, "The Ming Dynasty," 217).

64. In the late tenth century, a modern historian explains, "Kuo Hsi has brought to perfection the technique of atmospheric perspective. . . . [He] did much to introduce the new more intimate mode that was to dominate landscape painting during the following two centuries. He maintained that the value of landscape painting lay in its capacity to make the viewer feel as if he were really in the place depicted" (Cahill, *Treasures of Asia*, 37, 38, 35). And Wang Wei (699–759), identified as the first painter to introduce "wrinkles" into landscapes, was imitated by his successors. "He changed the manner of painting," Osvald Sirén writes (*Chinese Painting*, 1:129).

65. Contrasting the Western concern with realism with Asian ideals, Wen Fong says that "pictorial representation for the Chinese . . . attempts to create neither realism nor ideal form alone. . . . the Chinese painter has sought to capture, through calligraphic brushwork, the spirit beyond physical likeness" (*Beyond Representation*, 4–5).

66. Quoted by Cao Yiqiang in his unpublished essay "Some Features of the History of Art History in China." I thank him for making it available to me.

67. See Hudson, *Europe and China*; Rowley, *Principles of Chinese Painting*; Sullivan, *The Birth of Landscape Painting in China*; Needham, *The Grand Titration*; Sickman and Soper, *The Art and Architecture of China*; Spence, *The Memory Palace of Matteo Ricci*.

68. Fong, *Beyond Representation*, 3–4.

69. On Hegel's influence in America, see Nute, *Frank Lloyd Wright and Japan*, 73–74.

70. See, for example, W. Harris, *Hegel's First Principle*.

71. On the role of Hegel in Harvard education, see Scheyer, *The Circle of Henry Adams*, 40–45.

72. Pinkard, *Hegel's Phenomenology*, 230.

73. Hegel, *The Phenomenology of Mind*, 707.

74. Hegel, *Aesthetics*, 1:74, 2:1095.

75. Bungay, *Beauty and Truth*, 124.

76. Pinkard, *Hegel's Phenomenology*, 339.

77. Hegel, *Aesthetics*, 1:74 and 2:799.

78. Hegel, *Philosophy of History*, 163.

79. Pinkard, "Constitutionalism, Politics and the Common Life," 169.

80. Podro, *The Critical Historians of Art*, 17.

81. Marxists adopted Hegel's expressionist doctrine. Giotto, a Marxist historian writes, "really was the master of a simple, sober, straightforward middle-class art, the classical quality of which sprang from the ordering and synthesizing of experience, from the rationalization and simplification of reality, not from an idealism abstracted from reality. . . . Giotto's art is austere and objective, like the character of those who commissioned his works, men who wished to be prosperous and to exercise authority but who attached not too much importance to outward show and lavish expenditure" (Hauser, *The Social History of Art*, 26–27). Giotto expresses the class interests of his patrons.

82. Fenollosa, *Epochs of Chinese and Japanese Art*, 1:xiv. In fact he includes in volume 2 a lengthy transcription of a Chinese treatise on painting (ibid., 2:12–19).

83. Ibid., 1:xxx.

84. Ibid., 1:xviii.

85. Ibid., 1:169.

86. Ibid., 2:5.

87. Ibid., 1:29.

88. Ibid., 2:52.

89. Ibid., 1:4.

90. But his book sometimes appears in modern bibliographies; see, for example, Paine and Soper, *The Art and Architecture of Japan*.

91. *Epochs of Chinese and Japanese Art*, 1:133.

92. Ibid., 2:31.

93. Ibid., 2:77.

94. Ibid., 2:82.

95. Ibid., 2:4, 49.

96. Ibid., 2:6.

97. Hung, *The Double Screen*, 20, 24.

98. This attempt to understand what is exotic with reference to the familiar is anticipated by familiar contrasts between Italian and Dutch art. "To a remarkable extent the study of art and its history has been determined by the art of Italy and its study" (Alpers, *The Art of Describing*, xix).

99. Clunas, *Pictures and Visuality in Early Modern China*, 15.

100. Claiborne and Lee, *The Chinese Cookbook*, xvii.

101. Sahni, *Classic Indian Cooking*, xi.

102. Hegel, *Aesthetics*, 2:519.

103. Ibid., 2:805.

104. Fenollosa, *Epochs of Chinese and Japanese Art*, 1:37.

105. H. White, *Metahistory*, 94.

106. Fenollosa, *Epochs of Chinese and Japanese Art*, 1:51.

107. Ibid., 1:150.

108. Because academic art history has lost sight of these Hegelian themes, recent historians of art have mostly not taken up this concern.

109. Some American museums, the Metropolitan, for example, hang their Chinese art in chronological order. But others such as the Cleveland Museum of Art do not.

110. Gombrich, *The Story of Art*, chapter 7, 143.

111. See Masheck, "Dow's 'Way' to Modernity for Everybody."

112. Danto, *Connections to the World*, 14.

113. Danto, *Philosophizing Art*, 166.

114. Danto, *Mysticism and Morality*, xvi–xvii.

115. Lee, *A History of Far Eastern Art*, 412.

116. Lee, *Past, Present, East and West*, 105–6.

117. Fenollosa, *Epochs of Chinese and Japanese Art*, 191–92.

118. Chisolm, *Fenollosa*, 127.

119. Fenollosa, *Epochs of Chinese and Japanese Art*, 189.

120. Benjamin Rowland offers suggestive pairings in *Art in East and West*.

121. Clunas, *Art in China*, 9.

122. See Quine, *Word and Object*, chapter 2.

123. Cahill, "Approaches to Chinese Painting," 5.

Chapter 8: Albert Barnes's Foundation

1. Foucault, *Language, Counter-Memory, Practice*, 92.

2. Fried, *Manet's Modernism*, 85.

3. B. Russell, *Logic and Knowledge*, 41. For commentary, see Pears, *Bertrand Russell and the British Tradition in Philosophy*, chapter 6.

4. See Carrier, "The Bohen Series on Critical Discourse," 58.

5. Flam, *Matisse on Art*, 73.

6. Elderfield, *The Drawings of Henri Matisse*, 55.

7. On Matisse's uses of tradition, see Wright, *Identity Trouble*.

8. Greenberg, *Art and Culture*, 218.

9. Greenberg, *The Collected Essays and Criticism*, 20.

10. Barr, *Cubism and Abstract Art*, 11.

11. Barr, *What Is Modern Painting*, 21.

12. Kantor, *Alfred H. Barr, Jr.*

13. He wrote in collaboration with Violette de Mazia, but since it is impossible to identify her independent role and Barnes was her employer, I will speak of Barnes's books.

14. Thomas Munro writes, "his taste is attracted chiefly by what is conven-

tional, weak and sentimental" ("The Aesthetics of Bernhard Berenson," 53). From our present perspective, Barnes's analysis (and his taste) seems similar to Fry's. Buermeyer speaks of "how grave are the consequences of error in fundamental aesthetic and psychological principles" ("The Aesthetics of Roger Fry," 287).

15. Cabanne, *The Great Collectors*, 173.

16. Barnes, "Negro Art and America."

17. See C. Clark, "African Art."

18. See V. Clark, *International Encounters*.

19. Russell, *Matisse*, 61. Russell, who titles this chapter "Dr. Barnes: Patron or Pest?" writes in support of the family, using the Pierre Matisse Archives.

20. Dewey and Barnes, *Art and Education*, vi.

21. Barnes, *Primitive Negro Sculpture*, 8. According to Barnes, Africans are closer to nature than white Americans. But he also generously proposes that whites should acknowledge the artistic gifts of blacks.

22. Dewey, "Dedication Address," 5.

23. Guillaume and Munro, *Primitive Negro Sculpture*, 32.

24. Fry, *Last Lectures*, 76.

25. Kermode, *Romantic Image*, 107.

26. Barnes and de Mazia, *The Art of Renoir*, 6.

27. Mullen, *An Approach to Art*, 16. Mullen was an early participant in Barnes's educational program; see Greenfeld, *The Devil and Dr. Barnes*, 56.

28. Barr, "Plastic Values," 948.

29. Barr complains about Barnes's championing of Soutine, which was one of the great triumphs of the collector's taste.

30. Ibid.

31. Greenberg, *The Collected Essays and Criticism*, 86.

32. The old master paintings in his collection are not of the same quality as his modernist masterpieces.

33. Flam, *Matisse on Art*, 41–42.

34. Calasso, *The Marriage of Cadmus and Harmony*, 117.

35. Matisse felt so close to the old masters that he copied Veronese's *The Rape of Europe* in 1928 and in 1935 and 1938 did studies after Antonio del Pollaiuolo. See Schneider, *Henri Matisse*.

36. The fullest account is Flam, *Matisse: The Dance*. See also Flam, *Great French Paintings from the Barnes Foundation*, 274–91.

37. Barnes and de Mazia, *The French Primitives and Their Forms*, 7.

38. J. White, *Art and Architecture in Italy*, 50.

39. Reiss, *From Margin to Center*, 14. As Reiss notes, although many installation artists were hostile to museums, soon enough their art was incorporated into these institutions.

40. Barnes, *The Art in Painting*, 115.

41. Shaw, "Profiles," 34.

42. Barnes, *Ancient Chinese and Modern European Paintings*, n.p.

43. Barnes and de Mazia, *The Art of Henri Matisse*, 1.

44. Nochlin, *The Body in Pieces*, 23–24.

45. O'Neill, *Barnett Newman*, 81.

46. Belting, *The End of the History of Art?*, 39. Gilbert Cantor claims that "prior to publication of *The Art of Painting* analysis of paintings in terms of the plastic means was virtually unheard of" (*The Barnes Foundation*, 67). That is wrong—Roger Fry and Heinrich Wölfflin devoted earlier books to exactly that concern.

47. Craven, *Modern Art*, 175, 176.

48. Barnes and de Mazia, *The Art of Henri Matisse*, 210–11.

49. Steinberg (*Other Criteria*, 65) links Barnes with Greenberg.

50. Dewey, *Art as Experience*, viii.

51. Barnes, *The Art in Painting*, v.

52. Barnes, "Method in Aesthetics," 89.

53. Rorty, *Consequences of Pragmatism*, 76. See also Jackson, *John Dewey and the Lessons of Art*.

54. Dewey, *Art as Experience*, 235.

55. In "The Art Museum as an Agency of Culture," Albert Levi examines the relationship of Barnes and Dewey. He thinks it paradoxical that Dewey could both attack museums and dedicate his book on aesthetics to Barnes. But Barnes's foundation was just the sort of museum that Dewey's aesthetic demanded.

56. Rockefeller, *John Dewey*, 345.

57. Ryan, *John Dewey and the High Tide of American Liberalism*, 207.

58. Ibid., 253, 383n16.

59. Dewey, *Art as Experience*, 3.

60. Ibid., 6.

61. Ryan, *John Dewey and the High Tide of American Liberalism*, 254.

62. Dewey, *Art as Experience*, 8.

63. Jensen, *Is Art Good for Us?*, 178. Jensen links this way of thinking with Barnes's collection (193n38).

64. Dewey, *Art as Experience*, 11.

65. My discussion draws on Spurling, *The Unknown Matisse*.

66. Schneider, *Matisse*, 241.

67. Shaw, "Profiles," 32.

68. See Flam, *Matisse: The Man and His Art*, chapter 5.

69. Flam, *Great French Paintings from the Barnes Foundation*; Russell, *The World of Matisse*, 144.

70. Flam, *Matisse on Art*, 49.

71. See Neff, "Matisse and Decoration," and Kean, *French Painters, Russian*, chapter 7.

72. This hanging has now been recreated in part in the Museum of Modern Art, New York; see Carrier, "New Museum of Modern Art."

73. See Carrier, *High Art*, 144.

74. Nabokov, *Pale Fire*, 244. To discover this, follow the index, which leads from "Crown Jewels" to "Hiding Place" to "Potaynik, taynik" to the definition of *taynik*: "Russian, secret place; see Crown Jewels." For full analysis, see Carrier, "Pale Fire Solved."

75. He also follows Baudelaire, whose poem provided the title for his earlier utopian painting, *Luxe, calme et volupté*: "My child, my sister, just imagine the happiness of voyaging there to spend our lives together, to love to our hearts' content, to love and die in the land which is the image of yourself." "The Invitation to the Voyage" tells of a world, certainly far from ours, where "everything . . . is order and beauty, luxury, calm, voluptuousness" (Baudelaire, *The Poems in Verse*, 125).

76. Dewey, *Art as Experience*, 276–77.

77. Barnes and de Mazia, *The Art of Henri Matisse*, 369, 370, 372.

78. Diego Rivera's ill-fated commission for Rockefeller Center was but one attempt to create a new public art. The most famous French muralist of the previous generation was Pierre-Cécile Puvis de Chavannes. After the Barnes project was completed, Matisse gave his impression of Chavannes. "My aim has been to translate paint into architecture, to make of the fresco the equivalent of stone or cement. This, I think, is not often done any more. The mural painter today makes pictures, not murals. . . . [Chavannes] approaches it, yes, but does not arrive perfectly in that sense. The walls of the Pantheon, for example, are of stone. Puvis's paintings are too soft in feeling to make the equivalent of that medium" (Flam, *Matisse on Art*, 109–10). The problem, he added two decades later when working on the Vence chapel, is that "a work of art is never made in advance, contrary to the ideas of Puvis de Chavannes, who claimed that one could never visualize the picture one wanted to paint too completely before starting. There is no separation between the thought and the creative act. They are completely one and the same" (*Matisse on Art*, 211).

Puvis de Chavannes presents the past using in-focus linear images within deep illusionistic spaces. He sought to link his art to tradition by making images of antiquity, as if showing subjects from the past would suffice to maintain his relationship with the old master muralists (see Petrie, *Puvis de Chavannes*, and also the visual evidence assembled in Boucher, *Catalogue des dessins et peintures de Puvis de Chavannes*). For him the past remains distant — hence the anemic quality of Chavannes's murals. Matisse, a deeper visual thinker, recognized the impos-

sibility of representing the past in that literal manner. He realized that only by painting in an entirely modern manner was it possible to reconnect.

79. A recent commentator writes: "If the *Merion Dance Mural* falls a bit short of our highest expectations — as it apparently did for Barnes — this is in part because the figures are not quite integrated with the wall" (Flam, *Matisse: The Dance*, 71). I think this judgment optimistic.

80. Flam, *Matisse: The Dance*, 63.

81. Barnes and de Mazia, *The Art of Henri Matisse*, 21. Barr, in describing the installation of the Barnes murals, also mentions Giotto: "Both Matisse and Dr. Barnes were pleased. But Matisse was also exhausted by the long strain. When he returned to Europe he went to Abano Bagni near Venice to take the cure. While there he once again visited the Giottos at Padua" (*Matisse*, 220). The first sentence is wrong: neither Matisse nor Barnes was pleased. But the connection to Giotto, alluded to so casually as if Matisse's choice of what to see merely depended upon his choice of spa, is important.

82. Barnes and de Mazia, *The Art of Henri Matisse*, 210–11.

83. Flam, *Matisse: The Dance*, 60.

84. Quoted in Russell, *Matisse*, 76.

85. O'Brian, *Ruthless Hedonism*, 76.

86. The problems of responding fairly to Barnes appear even in the recent account of the posthumous lawsuits surrounding his estate (Anderson, *Art Held Hostage*, 46, 55). Noting that Barnes was killed in 1951 in a traffic accident, it cites rumors that he was going to "Sunday afternoon trysts with [Violette] de Mazia," his collaborator.

87. Like the *Shchukin Triptych*, the *Merion Dance Mural* had to be reworked because Matisse initially made a disastrous miscalculation. These grand commissions disoriented him.

88. Matisse, Couturier, and Rayssiguier, *La chapelle de Vence*, 81.

89. See Carrier, *Rosalind Krauss and American Philosophical Art Criticism*.

90. The Indian collector and philanthropist O. P. Jain has rediscovered this Barnesian idea in the Museum of Everyday Art, part of the Sanskriti Pratishthan foundation, New Delhi; see Jain, *Everyday Art of India*.

Chapter 9: The J. Paul Getty Museum

1. Baudelaire, *The Painter of Modern Life*, 1. See Carrier, *High Art*, chapter 3.

2. Baudelaire, *The Painter of Modern Life*, 3.

3. Danto, *After the End of Art*, 77. See also Carrier, *Writing About Visual Art*.

4. Danto, *Embodied Meanings*, 322.

5. Hegel, *The Phenomenology of Mind*, 151.

6. Danto, *After the End of Art*, 166. A paragraph from Carrier, *Rosalind Krauss and American Philosophical Art Criticism*, 44–47, is incorporated here.

7. Ibid.

8. Holly, *Past Looking*, 31.

9. Derrida, *Writing and Difference*, 278.

10. I here discuss three artists Danto has championed.

11. See Carrier, "Robert Mangold."

12. The research institution has a large collection of photography, and in its gallery, as in the space devoted to temporary exhibitions in the museum, contemporary art is shown.

13. The museum did also purchase a large group of medieval illuminated manuscripts.

14. Walsh and Gribbon, *The J. Paul Getty Museum*, 272. See also Feldstein, *The Economics of Art Museums*, 23–29.

15. Al-Rasheed, *A History of Saudi Arabia*, 91.

16. Getty, *The Joys of Collecting*, 11.

17. On his business career, see Petzinger, *Oil and Honor*.

18. Laclotte, "A History of the Louvre Collection," 12.

19. The only comparable American institution is Louis Kahn's Kimbell Museum in Fort Worth. Judged purely as architecture, it is superior to Meier's buildings. But the ultimate success of the Getty does not depend merely on its architectural virtues.

20. See Brawne, *The Getty Center*; Williams, Huxtable, Rountree, and Meier, *Making Architecture*; and Williams, Lacy, Rountree, and Meier, *The Getty Center*.

21. Williams, Lacy, Rountree, and Meier, *The Getty Center*, 33.

22. Meier, "Building for the Future," 4.

23. Getty, *How to Be Rich*, 222. In *As I See It*, he writes: "I had no carefully prepared plan—I just took it a day at a time, buying what pleased me—what gratified my own tastes and esthetic senses. I never thought that I would one day end up with a collection so extensive that I would have to build a large public museum to house it" (267). The original Getty Museum was a copy of a Roman villa. In 1953 he purchased the *Lansdowne Kerakles*, a Roman copy of a Greek original. See Walsh and Gribbon, *The J. Paul Getty Museum*, 23, 31.

24. Muschamp, review of Getty.

25. Steve Rountree, director of operations and planning for the J. Paul Getty Trust has explained (in an e-mail to me) how the Getty came to be built on this land. "Around 1982–83 we began to search for a site. We engaged a professional firm, SRA out of Palo Alto, to assist. We wanted at least 25 acres, Los Angeles central locale (i.e. not outlying suburbs), good public access and some special qualities about the place, not defined (i.e. 'we'll know it when we see it'). After some work the prime targets were: Ambassador Hotel site on Wilshire Blvd. (not

far from LACMA); Playa Vista near the Marina and LAX; and a UCLA-owned parcel (called Lot 32) at the corner of Veteran and Wilshire. There were not and are not too many privately owned 25 acre parcels in the city that are attractive as public venues.

"One evening one of our trustees, Rocco Siciliano, was waiting for his car outside a hotel where Reagan had been giving a speech. Rocco left early, upset by a Reagan comment. Waiting beside him was Tom Jones, a wealthy industrialist. They got to talking and the conversation led to the Getty's property search and Jones's desire to sell a 67-acre parcel alongside the 405 freeway near Sunset. The rest is history. We bought that parcel from Jones. Later acquired another adjoining lot from the UC and then later still bought a 650 acre property that lies north and west of the Getty Center.

"The reasons for the purchase were clear from the first moment. It was a magical site with stunning vistas and, it seemed, great potential as a magnet for attracting people. It would attract and inspire a great architect. It was located right at the point of intersection between the Valley and the Basin and within a short hop from the Central City and South Bay. All freeways led to the site; indeed the main California state artery cuts right over our entrance. So, that's why we bought it." See also Muchnic's review of the Getty.

26. John Walsh quoted in Klawans, "Site and Vision," 23.

27. Frampton and Rykwert, *Richard Meier*, 22.

28. As in a Roman villa, the water for the garden descends from a long trough in the plaza above. See the account of the garden of Villa Lante, Bagnaia, in Hunt, *Garden and Grove*, 53. Water flows down into Robert Irwin's strikingly artificial garden. At the very top of the garden, you lose the view. The bottom of the garden is compressed, like a gigantic spring. You are held within the public space, prevented from crossing to the access road just beyond the top. With its unnatural juxtaposition of plants that normally wouldn't grow together, the metal trees covered with flowers, and the Cor-Ten steel borders, an oddly Richard Serra-esque touch, the garden stands to a traditional garden much as Meier's building stands to a traditional museum.

29. The museum is like Meier's houses, isolated enough to be photographed showing no neighbors; and shown almost unpopulated, with no evidence of ordinary domestic life.

30. Williams, introduction to *Making Architecture*, 9.

31. This role of the Getty is signaled by one painting in the museum, Phillips Knoinck's *Panoramic Landscape* (1665). It shows such a view on a mountain showing the flat landscape running to the horizon. The artist could have had no such vantage point in Holland—he imagined how to show this scene. Catalogue description by Fredericksen, *Masterpieces of the J. Paul Getty Museum*, 69.

32. This point I owe to Marcia Reed of the Getty Research Institute.

33. Meier quoted in Frampton and Rykwert, *Richard Meier*, 351. How odd that he calls the cityscape of Los Angeles—traffic, houses, and vegetation requiring intensive watering—"nature."

34. Farrow, "The Art of Abstraction," 93.

35. Repton, *The Art of Landscape Gardening*, 55.

36. Kant, *The Critique of Judgement*, 187. My discussion borrows from Forge, "Art/Nature."

37. Pope-Hennessy, *Learning to Look*, 246.

38. Baudelaire, *The Painter of Modern Life*, 11.

39. Debord, *Society of the Spectacle*, 1.

40. Ibid., 29. On Debord, see Carrier, "Wish You Were Here."

41. Meier, quoted in Williams, Huxtable, Rountree, and Meier, *Making Architecture*, 9.

42. Stokes, *The Quattro Cento*, 102, 255.

43. Pernia and Adams, *Federicoda Montefeltro and Sigismondo Malatesta*, 79.

44. Pearson, *Painfully Rich*, 217.

45. The authorized biography is Muchnis, *Odd Man In*.

46. Stein, *Masterpieces of the J. Paul Getty Museum*, 120.

47. West, *Miss Lonelyhearts and The Day of the Locust*, 184.

48. Quoted in Pichois, *Baudelaire*, 320.

49. Baudelaire, *The Complete Verse*, 343.

50. I have learned from Klein, *The History of Forgetting*; Rieff, *Los Angeles*; and Kaplan, *LA Lost and Found*.

51. M. Davis, *City of Quartz*, 21.

52. My account is based upon the two loose-leaf volumes of published media coverage of the opening assembled by the Getty Trust.

53. The failure of Dave Hickey to rise to the occasion is revealing: "Rather than taking credit for its very real generosity as a purveyor of exquisite pleasure and spectacle to the public, the Getty seems dedicated to reconstituting itself as an icon of bluestocking political correctness. . . . The atmosphere of high-dollar conceptual Protestantism is so pervasive that even the rough, split travertine that faces the buildings reads less as an expressive gesture than as a puritanical echo of travertine's ability to take a surface" (Hickey, "Ready for Art," 93, 90). An art critic who in the parking garage is "thinking earthquake all the way" and comes onto the plaza expecting "to see Aztec warriors engaged in ritual sacrifice" hardly seems in the right mood to look with an open eye.

54. Onians, "'I Wonder . . . ,'" 30. See also Kaufmann, *The Mastery of Nature*, Ch. 7.

55. Grabar, *The Alhambra*, 113–14.

56. Getty Scholars, like the art in the museum, are on display—open to scrutiny by colleagues and security cameras, with their weekly seminars recorded on tape.

57. Onians, *Classical Art and the Cultures of Greece and Rome*, 218.

58. Bergmann, "The Art of Ancient Spectacle," 23.

59. Williams, "Interview."

60. Donald Preziosi has argued that "the culture of spectacle and display comprising museology and museography [have] become indispensable to the Europeanization of the world" ("The Art of Art History," 513).

Chapter 10: The End of the Modern Public Art Museum

1. See Carrier, "The Aesthete in Pittsburgh."

2. Stokes, *The Critical Writings of Adrian Stokes*, 2:88.

3. I appeal to the authority of Hills, *Venetian Colour.*

4. Lefebvre, *The Production of Space*, 73.

5. H. White, *Metahistory*, 92.

6. I owe this idea to Banham, *Los Angeles.*

7. On Cleveland, see Turner and Leddy, *Object Lessons*; on Pittsburgh, see V. Clark, *International Encounters.* A useful history of Cleveland appears in a novel by Mark Winegardner, *Crooked River Burning.* See also Porter, *Cleveland*; and Miller and Wheeler, *Cleveland.*

8. See Toker, *Pittsburgh.*

9. See Mellon with Baskett, *Reflections in a Silver Spoon.* Joseph Wall explains: "Frick's only interest outside his business and his family was . . . the collection of great art. . . . What responsive chord of appreciation was struck in this business ascetic's soul by the rich, sensuous canvases of Titian, Tintoretto and Velázquez is difficult to say, for Frick . . . always kept his feelings and most of his thoughts to himself" (*Andrew Carnegie*, 716).

10. See my statement for the Associated Artists of Pittsburgh, published as Carrier, "New York Art, Pittsburgh Art, Art." And see Carrier, "Accessibility."

11. See Carrier, "The Warhol Museum."

12. See Carrier, "Pittsburgh: 1985 Carnegie International," "Carnegie International" (1992), "Carnegie International" (1996), and "1999 Carnegie International."

13. See M. Lynch, "The Growth of Cleveland as a Cultural Center," 200–201.

14. See Witchey with Vacha, *Fine Arts in Cleveland.*

15. Glueck, "The Ivory Tower," 80. Only one, the son of a Cleveland rabbi, was a "minority-group member." (She does not treat women as a minority.) For a list of trustees from 1913 to 1991, see Turner and Leddy, *Object Lessons*, 202–3.

16. Quoted in M. Lynch, "The Growth of Cleveland as a Cultural Center," 212.

17. Miggins, "A City of 'Uplifting Influences,'" 161–62.

18. Quoted in Abt, *A Museum on the Verge*, 123. There is no comparable independent history of the Cleveland Museum.

19. Ibid., 126.

20. Lee, *The Role of the College Art Museum*, 12, 17.

21. Lee, "The Idea of an Art Museum," 59.

22. Saisselin, preface to *Past, Present, East and West*, 11–12.

23. Lee, "Convocation Address on the Occasion of the Dedication of the Snite Museum of Art," n.p. Or as Arthur Danto puts it: "Temples have always been emblems of power, but in a way disguised by the spirituality of their practices and their claims. As long as the museums were represented as temples to truth-through-beauty, the realities of power were invisible" (*After the End of Art*, 182).

24. Lee, *Art against Things*, 14. This remark is unfair to capitalism, which has been the source (since Giotto) of almost all the best Western art.

25. Karl Marx quoted in Lang and Williams, *Marxism and Art*, 38.

26. Hauser, *The Philosophy of Art History*, 7.

27. Ovid, *The Metamorphoses of Ovid*, 111.

28. Jameson, *The Political Unconscious*, 9. He goes on to discuss the problems inherent in this way of thinking.

29. Saisselin, *Taste in Eighteenth-Century France*, 133.

30. The quoted phrase I owe to Glueck, "The Ivory Tower versus the Discotheque," 85.

31. On his career, see Rieser, "Thomas Munro's Position in American Aesthetics."

32. Munro, *The Arts and Their Interrelations*, 49.

33. Ibid., 107.

34. Munro, *Toward Science in Aesthetics*, 325.

35. Munro, *The Arts and Their Interrelations*, 213.

36. Munro, *Oriental Aesthetics*, 134.

37. Munro, *Evolution in the Arts*, xvii.

38. Ibid., 8.

39. Ibid., 249.

40. Ibid., 421, 436.

41. Ibid., 272.

42. Munro and Grimes, *Educational Work at the Cleveland Museum of Art*, 19.

43. Munro, *Evolution in the Arts*, 440.

44. Lee, *Past, Present, East and West*, 66.

45. Quoted in Glueck, "The Ivory Tower versus the Discotheque," 81.

46. Munro and Grimes, *Educational Work at the Cleveland Museum of Art*, 7, 8.

47. Ibid., 19. This claim is implausible.

48. Clark, *Image of the People*, 161.

49. See Carrier, "In Praise of Connoisseurship." I owe the idea that connoisseurship could be popularized to Steinberg, *Other Criteria*, 312–13.

50. Munro, *Toward Science in Aesthetics*, vii. In *Aesthetic Form*, Munro argues that the status of aesthetics today is like that of biology in the early eighteenth century. The standard account of the development of the modern concept of art is Kristeller, "The Modern System of the Arts."

51. Guillaume and Munro, *Primitive Negro Sculpture*, 33.

52. Ibid., 53–54.

53. A recent publication acknowledges Munro's importance while allowing that his ways of thinking are no longer entirely acceptable; see Schloder, Williams, DeBevec, and Mann, *The Visitor's Voice*.

54. E. Munro, *Memoir of a Modernist's Daughter*, 122. See also Wittke, *The First Fifty Years*, chapter 6.

55. On his career, see Munro, *The Future of Aesthetics*, and Goehr, "The Institutionalization of a Discipline." Munro, she notes, founded neither the organization nor the journal, but he "takes credit . . . for giving formal organization and constitutional security to the ASA and for making the *Journal* the 'official organ' of the society."

56. Stokrocki, "Interviews with Students," 299.

57. E. Munro, *Memoir of a Modernist's Daughter*, 164.

58. Ibid., 110.

59. Ibid., 27. On neo-Darwinism and the Holocaust, see Dwork and van Pelt, *Holocaust*, 260–61.

60. See E. Munro, *Originals*.

61. Smith, "Contemporary Aesthetic Education," 2:94.

62. On this distinction, see Geuss, *Public Goods*.

63. Gibbons and Zuppan, *Interpretations*, jacket copy.

64. Hauser, *The Philosophy of Art History*, 21.

65. Eagleton, *The Ideology of the Aesthetic*, 3.

66. Taylor, *Hegel*, 470, 471, 472.

67. Hegel, *Aesthetics*, 2:719.

68. Haskell, *History and Its Images*, 298.

69. J. Brown, *Kings and Connoisseurs*, 244. Danto has identified "two educational models" associated with art museums: "The art-appreciation model, and the cultural insight model. In the latter the art is a means to knowledge of a culture; in the former art is an object of knowledge in its own right. It is knowledge of art as art, and this often means arriving at an understanding of works through noting their formal features" (*The Abuse of Beauty*, 105).

70. Gribbons and Zujppan, *Interpretations*, n.p.

71. Haskell's *History and Its Images* shows how shaky are attempts to read cultural history from works of visual art.

72. Glueck, "The Ivory Tower versus the Discotheque," 80.

73. Lee, "The Art Museum in Today's Society," 2–3.

74. Hoving, *Making the Mummies Dance*, 133.

75. Ibid., 195.

76. Lee, "Works of Art, Ideas of Art, and Museums of Art," 188.

77. The damaged statue has been reinstalled near the original front entrance of the museum.

78. Lee quoted in Turner and Leddy, *Object Lessons*, 182.

79. A similar error occurs in his history of Asian art when he describes imperialism as organized by "adventurers who represented only an unfortunate aspect of the Western world" (Lee, *A History of Far Eastern Art*, 18). On the contrary, what has defined the West is its mercantile expansion.

80. The Getty Research Institute archive contains a book-length interview with Lee that I have read, but which I do not have permission to quote.

81. Goodman, foreword to *Past, Present, East and West*, 17.

82. Lee quoted in Turner and Leddy, *Object Lessons*, 176.

83. Huxtable, "The Clash of Symbols," 21; D. Davis, *The Museum Transformed*, 59.

84. Weil, "Five Meditations."

85. Althusser, *For Marx*, 11–12.

86. N. Harris, *Cultural Excursions*, 81.

87. Rawls, *A Theory of Justice*, 61. In his later *Political Liberalism*, Rawls stressed the connection of his theory with bourgeois democratic society.

88. As if intending to illustrate the worst fears of 1960s leftists, museums have happily displayed art that critiques and deconstructs that institution. See Putnam, *Art and Artifact*.

89. Fairbank, *China*, 21.

90. See Elderfield, *Pleasuring Painting*.

91. Here I extend the argument of Carrier, *Poussin's Paintings*, 35–41.

92. Right now, at least fifty new museums or large additions to existing museums are under construction; see Trulove, *Designing the New Museum*, 13.

93. Desai, *Marx's Revenge*, 304.

94. Lukács, *History and Class Consciousness*, 17.

95. Pinkard, *Hegel's Phenomenology*, 221. For a forceful skeptical account of Hegel's claim, see Pippin, *Modernism as a Philosophical Problem*.

96. Danto's art criticism very frequently tackles political issues; he is not apolitical.

97. Danto laid out early on his *philosophical* objection to Marxism. "Cartesians see us as external to a world we seek to know, and Skepticism then insists that

the gap between the world and us is cognitively insuperable. Marxists see us as one with the world, and so the problem of Skepticism cannot then arise" (*Analytic Philosophy of Action*, 2). He holds that we are both external to and within the world. But of course this abstract argument does not determine Danto's politics.

98. Carrier, *High Art*, 154–61, attempts to explain that transition.

99. Hughes, *Tales From Ovid*, x.

100. Kojève, *Introduction to the Reading of Hegel*, 159.

101. Fukuyama, *The Great Disruption*, 11.

102. Ibid., 320.

103. Debord, *The Society of the Spectacle*, 116.

104. Danto, *The Philosophical Disenfranchisement of Art*, 112.

105. Schiller, *On the Aesthetic Education of Man in a Series of Letters*, 107.

106. Wilkinson and Willoughby, introduction to *On the Aesthetic Education of Man*, xiv.

107. Lukács, *History and Class Consciousness*, 139.

108. Greenwood, *Museums and Art Galleries*, 11.

109. Quoted in Peniston, *The New Museum*, 51.

110. Haskell, "Museums and Their Enemies," 22.

111. Spalding, *The Poetic Museum*, 167.

112. Quoted in Feldstein, *The Economics of Art Museums*, 21.

113. Gombrich, *Ideals and Idols*, 190.

114. Ovid, The Metamorphoses of Ovid, 357.

Conclusion: What the Public Art Museum Might Become

1. Crow, *Painters and Public Life in Eighteenth-Century Paris*, 228.

2. Ibid., 236.

3. Ibid., 15. In "Marx to Sharks," Crow extends his concerns to the contemporary art world, though not the museum.

4. Crow, *Painters and Public Life in Eighteenth-Century Paris*, 101.

5. Crow's argument is discussed in Carrier, "The Political Art of Jacques-Louis David."

6. Habermas, *The Structural Transformation of the Public Sphere*, 40, 29, provides an invaluable perspective on the birth of the public art museum. For my present purposes, what is most problematic in Habermas's account is his essentially critical perspective on "mass culture [which] has earned its rather dubious name precisely by increased sales by adapting to the need for relaxation and entertainment . . . rather than through the guidance of an enlarged public toward the appreciation of a culture undamaged in its substance" (165). "The world of mass media," he adds, "is a public sphere in appearance only" (171). He makes a

distinction between the result of a vote and what I am calling public opinion; at present, he argues, " 'the' public opinion is indeed a fiction" (244). In my opinion, this analysis gives too little credit to the autonomous judgments possible within present bourgeois culture. See also Sennett, *The Fall of Public Man*, for discussion of "the history of the words 'public' and 'private' " (16).

7. Rawls, *Political Liberalism*, 15.

8. This ideal is presented in Hegel. According to Desai, "He viewed the events of the French Revolution and subsequent developments as a challenge to rethink how—to simplify—the old moral community could be restored in social intercourse" (*Marx's Revenge*, 329). At present, it may seem a nostalgic ideal. On museums and community, see Cuno, *Whose Muse*.

9. Crow, *Painters and Public Life in Eighteenth-Century Paris*, 2.

10. Quoted in J. White, *Art and Architecture in Italy*, 303.

11. Lee, *Past, Present, East and West*, 37.

12. Summers, *The Judgment of Sense*, 126.

13. Elias, *The Court Society*, 48.

14. Carlo Denina quoted in Villatri, *The Revolt of Naples*, 176–77.

15. Crow, *Painters and Public Life in Eighteenth-Century Paris*, 2.

16. Ibid., 3.

17. Ibid.

18. Crow, *Modern Art in the Common Culture*, 3.

19. On sports and intellectuals, see Nochlin, "Museums and Radicals," 36; and Carrier, *Writing about Visual Art*, chapter 5.

20. Diderot, *Diderot on Art*, x.

21. Crow, *Painters and Public Life in Eighteenth-Century Paris*, 1.

22. Quoted in Guralnick, *Last Train to Memphis*, 108.

23. Brightman, *Sweet Chaos*, 219.

24. Quoted in Sandford, *Springsteen*, 348.

25. Carroll, *A Philosophy of Mass Art*, 13.

26. Dawson, foreword to *Reading the Funnies*, xi. On the academic literature discussing mass art, see Carrier, *The Aesthetics of Comics* (2000), chapter 7.

27. Nehamas, *Virtues of Authenticity*, 290.

28. This account draws upon Danto, preface to *Analytical Philosophy of Knowledge*.

29. Danto, *Analytical Philosophy of Knowledge*, xi.

30. Rorty, *Philosophy and the Mirror of Nature*, 376.

31. McClellan, "A Brief History of the Art Museum Public," 34.

32. Robert Pincus-Witten gave me this idea.

33. In thus speaking of them as a group, I blur distinctions between their concerns. After working out this general argument, I was the *Art Bulletin* reader for a submission titled "Impossible Distance: Past and Present in the Study of

Dürer and Grünewald." This author, whose name is not known to me, deals interestingly with this issue.

34. Wölfflin, *Principles of Art History*, vii.

35. Holly and Moxey, *Visual Culture*, xvii. The phrase "semiotic approach," referring to theorizing developed at length by Bal and Bryson, usefully identifies their shared concerns.

36. See Holly, *Past Looking* and Moxey, *The Practice of Persuasion*.

37. Bal, *Quoting Caravaggio*, 12.

38. See Bal and Bryson, "Semiotics and Art History." Their highly controversial analysis has inspired a strong response; see Crow, *Modern Art in the Common Culture*: "This is a fair definition of what postmodernism has come to mean in academic life. But as a blueprint for the emancipation of art history, it contains a large and unexamined paradox: it accepts without question the view that art is to be defined by its essentially visual nature" (213).

39. Schapiro, *Worldview in Painting*, 184. Erwin Panofsky and Rudolf Arnheim wrote about film with more sympathy.

40. Kant, *On History*, 4.

41. Baxandall, *Patterns of Intention*, 137.

42. Vidal, *Watteau's Painted Conversations*, 109, 132, 196. See also McClellan, "Watteau's Dealer."

43. Hume, *Dialogues Concerning Natural Religion*, 3–4.

44. See Arnold, *Art Criticism as Narrative*, 82. His interest in dialogue is discussed in Furbank, *Diderot*. As in the dialogue of *Rameau's Nephew*, Diderot permits himself to play several roles without feeling the need to pin down his position. When in his *Phenomenology of Mind* Hegel discusses that book, he stabilizes the dialogue, identifying Rameau's Nephew as the victor and so turning this record of conversation into a moment in his philosophical monologue. *Rameau's Nephew* advocates perspectivism, keeping the options open; *Phenomenology of Mind* seeks to tell *the* story of culture's development.

45. Diderot, *Selected Writings on Art and Literature*, 107.

46. My account has been influenced by Manguel, *A History of Reading*.

47. The exception that proves the rule is Ernst Gombrich's Romanes Lecture for 1973 delivered in the Sheldonian Theatre, Oxford: "We art historians are used to talking in blacked-out interiors to display our slides, but while denying me this facility the Vice-Chancellor might have quoted the famous inscription over the door of Wren's masterpiece. . . . If you need an example, just look around you" (*Ideals and Idols*, 131–66).

48. Longhi, "Dialogo fra il Caravaggio e il Tiepolo." In *Louvre Dialogues*, Pierre Schneider asks: "Has the art of our time, which rejects all its predecessors, broken forever with the past. . . . I hoped that the confrontation between living artists and the art of the past could provide at least the beginnings of an

answer to questions such as these" (v). Schneider accompanies such artists as Joan Miró, Marc Chagall, and Barnett Newman into the museum, seeking to answer his question by examining their responses to old art. More recently, Michael Kimmelmann has interviewed American artists in New York museums.

49. See Bourdieu, *Distinction*.

50. Tomalin, *Samuel Pepys*, xxx.

51. On rapid change, see Eriksen, *Tyranny of the Moment*. I have learned from Beck, *The Tyranny of the Detail*.

52. Gladwell, *The Tipping Point*, 12.

53. Gleick, *Faster*, 250.

54. Peniston, *The New Museum*, 128.

55. Carrier, *Writing about Visual Art*, 105.

56. Barolsky, *Michelangelo and the Finger of God*, xvi.

57. Barolsky, "A Very Brief History of Art from Narcissus to Picasso," 258.

Bibliography

Abrams, M. H. *Natural Supernaturalism: Tradition and Revolution in Romantic Literature*. New York: W. W. Norton, 1971.

Abt, Jeffrey. "Museum, I, 7: Modern Reassessments of Function." *The Dictionary of Art*, ed. Jane Turner. London: Macmillan, 1996.

———. *A Museum on the Verge: A Socioeconomic History of the Detroit Institute of Arts, 1882–2000*. Detroit: Wayne State University Press, 2001.

Abu-Lughod, Janet. *Before European Hegemony: The World System, A.D. 1250–1350*. New York: Oxford University Press, 1989.

Acton, Harold. *Memoirs of an Aesthete*. London: Methuen, 1948.

Adams, Laurie Schneider. *Art and Psychoanalysis*. New York: Harper Collins, 1993.

Adams, Robert. *The Lost Museum: Glimpses of Vanished Originals*. New York: Viking, 1980.

Addison, Julie de Wolf. *The Boston Museum of Fine Arts*. Boston: L. C. Page, 1910.

Adorno, Theodor. *Prisms*, trans. Samuel and Shierry Weber. Cambridge: MIT Press, 1967.

Allen, Christopher. "Ovid and Art." *The Cambridge Companion to Ovid*, ed. Philip Hardie. Cambridge: Cambridge University Press, 2002.

Alpers, Svetlana. *The Art of Describing: Dutch Art in the Seventeenth Century*. Chicago: University of Chicago Press, 1983.

Al-Rasheed, Madawi. *A History of Saudi Arabia*. Cambridge: Cambridge University Press, 2002.

Alsop, Joseph. *The Rare Art Traditions: The History of Art Collecting and Its Linked Phenomena*. New York: Harper and Row, 1982.

Althusser, Louis. *For Marx*, trans. Ben Brewster. New York: Vintage, 1970.

Amery, Colin. *The National Gallery Sainsburg Wing: A Celebration of Art and Architecture*. London: National Gallery of Art, 1991.

Anderson, Jaynie. "Connoisseurship in Risorgimento Italy." *Collecting, Connoisseurship and the Art Market in Risorgimento Italy*. Venice: Istituto Veneto di Scienze, Lettere ed Arti, 1999.

———. *Giorgione: The Painter of "Poetic Brevity."* Paris: Flammarion, 1997.

Anderson, John. *Art Held Hostage: The Battle over the Barnes Collection*. New York: W. W. Norton, 2003.

Andrews, Lee. *Story and Space in Renaissance Art: The Rebirth of Continuous Narrative*. Cambridge: Cambridge University Press, 1995.

Arata, Stephen. "Object Lessons: Reading the Museum in *The Golden Bowl*." *Famous Last Words: Changes in Gender and Narrative Closure*, ed. Alison Booth. Charlottesville: University Press of Virginia, 1993.

Arendt, Hannah. *The Human Condition: A Study of the Central Dilemmas Facing Modern Man*. Garden City, N.Y.: Random House, 1959.

Arnheim, Rudolf. *Art and Visual Perception: A Psychology of the Creative Eye*. Berkeley: University of California Press, 1969.

Arnold, Julie Wegner. *Art Criticism as Narrative: Diderot's Salon de 1767*. New York: Peter Lang, 1995.

Ashton, Dore. *Abstract Art before Columbus*. New York: André Emmerich, 1957.

Avineri, Shlomo. *Hegel's Theory of the Modern State*. Cambridge: Cambridge University Press, 1972.

Baedeker, Karl. *Paris and Environs*. Leipzig, 1881.

Bal, Mieke. *Double Exposures: The Subject of Cultural Analysis*. New York: Routledge, 1996.

———. *Looking In: The Art of Viewing*. Amsterdam: G&B Arts, 2001.

———. *Quoting Caravaggio: Contemporary Art, Preposterous History*. Chicago: University of Chicago Press, 1999.

Bal, Mieke, and Norman Bryson. "Semiotics and Art History." *Art Bulletin* 72, no. 2 (1991): 174–208.

Ballard, J. G. *The Crystal World*. London: Triad/Panther, 1978.

Balsinger, Barbara. *The "Kunst-und Wunderkammern": A Catalogue Raisonné of Collecting in Germany, France and England, 1565–1750*. PhD diss., University of Pittsburgh, 1970.

Banham, Reyner. *Los Angeles: The Architecture of Four Ecologies*. Harmondsworth: Pelican, 1973.

Bann, Stephen. "Art History and Museums." *The Subjects of Art History: Historical Objects in Contemporary Perspectives*, ed. Mark A. Cheetham, Michael Ann Holly, and Keith Moxey. Cambridge: Cambridge University Press, 1998.

———. "Meaning/Interpretation." *Critical Terms for Art History*, 2d edn, ed. Robert S. Nelson and Richard Shiff. Chicago: University of Chicago Press, 2003.

———. *Romanticism and the Rise of History*. New York: Twayne, 1995.

———. *Under the Sign: John Bargrave as Collector, Traveler, and Witness*. Ann Arbor: University of Michigan Press, 1994.

Barkan, Leonard. *The Gods Made Flesh: Metamorphosis and the Pursuit of Paganism*. New Haven: Yale University Press, 1986.

———. *Unearthing the Past: Archaeology and Aesthetics in the Making of Renaissance Culture*. New Haven: Yale University Press, 1999.

Barnes, Albert. *Ancient Chinese and Modern European Paintings*. New York: Bigou Gallery, 1943.

———. *The Art in Painting*. Merion, Pa.: Barnes Foundation, 1931.

———. "Method in Aesthetics." *The Philosopher of the Common Man: Essays in Honor of John Dewey to Celebrate His Eightieth Birthday*. New York: Greenwood, 1968.

———. "Negro Art and America." *Survey Graphic*, Harlem Number, March 1925.

———. *Primitive Negro Sculpture and Its Influence on Modern Civilization*. Merion, Pa.: Barnes Foundation.

Barnes, Albert, and Violette de Mazia. *The Art of Henri Matisse*. Merion, Pa.: Barnes Foundation, 1931.

———. *The Art of Renoir*. New York: Minton, Bzalch, 1935.

———. *The French Primitives and Their Forms: From Their Origin to the End of the Fifteenth Century*. Merion, Pa: Barnes Foundation, 1931.

Barr, Alfred. *Cubism and Abstract Art*. New York: Museum of Modern Art, 1936.

———. *Matisse: His Art and His Public*. New York: Museum of Modern Art, 1951.

———. "Plastic Values." *Saturday Review of Literature*, July 24, 1926, 948.

———. *What Is Modern Painting?* New York: Museum of Modern Art, 1946.

Barolsky, Paul. *Giotto's Father and the Family of Vasari's Lives*. University Park: Pennsylvania State University Press, 1992.

———. *Michelangelo and the Finger of God*. Athens: Georgia Museum of Art, 2003.

———. *Michelangelo's Nose: A Myth and Its Maker*. University Park: Pennsylvania State University Press, 1990.

———. "Obituary: Sydney J. Freedberg and the Literature of Art." *Renaissance Studies* 11 (1997): 475–78.

———. "A Very Brief History of Art from Narcissus to Picasso." *Classical Journal* 90, no. 3 (1995): 253–55.

———. *Why Mona Lisa Smiles and Other Tales by Vasari*. University Park: Pennsylvania State University Press, 1991.

Batkin, "Conceptualizing the History of the Contemporary Museum: On Foucault and Benjamin." *Philosophical Topics* 25, no. 1 (spring 1997): 1–10.

Baudelaire, Charles. *The Complete Verse*, trans. Francis Scarfe. London: Anvil, 1986.

———. *Intimate Journals*, trans. Christopher Isherwood. San Francisco: City Lights, 1983.

———. *Oeuvres complètes*, ed. Claude Pichois. Paris: Gallimard, 1975.

———. *The Painter of Modern Life and Other Essays*, trans. Jonathan Mayne. London: Phaidon, 1964.

———. *The Poems in Verse*, trans. F. Scarfe. London: Anvil, 1989.

Baxandall, Michael. *Patterns of Intention: On the Historical Explanation of Pictures*. New Haven: Yale University Press, 1985.

————. *Words for Pictures: Seven Papers on Renaissance Art and Criticism*. New Haven: Yale University Press, 2003.

Bazin, Germain. *The Museum Age*, trans. Jane van Nuix Cahill. New York: Universe, 1967.

Beck, James. *The Tyranny of the Detail: Contemporary Art in an Urban Setting*. New York: Willis, Locker and Owens, 1992.

Beck, James, with Michael Daley. *Art Restoration: The Culture, the Business and the Scandal*. New York: W. W. Norton, 1994.

Bedaux, Jan Baptist. "Velázquez's Fable of Arachne (*Las Hilarderos*): A Continuing Story." *Simiolus* 21 (1992): 296–305.

Belting, Hans. *The End of the History of Art?*, trans. Christopher S. Wood. Chicago: University of Chicago Press, 1987.

————. *The Invisible Masterpiece*, trans. Helen Atkins. Chicago: University of Chicago Press, 2001.

————. "The New Role of Narrative in Public Painting of the Trecento: Historia and Allegory." *Studies in the History of Art: Pictorial Narrative in Antiquity and the Middle Ages*, ed. Herbert L. Kessler and Marianna Shreve Simpson. Washington: National Gallery of Art, 1985.

Benjamin, Walter. *The Arcades Project*, trans. Howard Eiland and Kenin McLaughlin. Cambridge: Belknap, 1999.

————. "The Work of Art in the Age of Mechanical Reproduction." *Illuminations*, trans. Harry Zohn. New York: Harcourt, Brace and World, 1968.

Berenson, Bernard. *The Italian Painters of the Renaissance*. London: Fontana, 1966.

————. *Homeless Paintings of the Renaissance*, ed. Hanna Kiel. London: Thames and Hudson, 1969.

————. *Lorenzo Lotto. An Essay in Constructive Art Criticism*. London: George Bell, 1905.

————. *One Year's Reading for Fun (1942)*. New York: Alfred A. Knopf, 1960.

————. *Sketch for a Self-Portrait*. New York: Pantheon, 1949.

————. *The Study and Criticism of Italian Art*, 2d ser. London: George Bell, 1910.

————. *Venetian Painting in America: The Fifteenth Century*. New York: Frederic Fairchild Sherman, 1916.

————. Preface to *The Bernard Berenson Collection of Oriental Art at Villa i Tatti*, by Laurance P. Roberts. New York: Hudson Hills, 1991.

Bergmann, Bettina. "The Art of Ancient Spectacle." *The Art of Ancient Spectacle*, ed. Bettina Bergmann and Christine Kondoleon. London: Yale University Press, 1999.

Bertelli, Sergio. *The King's Body: Sacred Rituals of Power in Medieval and Early Modern Europe*, trans. R. Burr Litchfield. University Park: Pennsylvania State University Press, 2001.

Beurdeley, Cécile, and Michel Beurdeley. *Giuseppe Castiglione: A Jesuit Painter at*

the Court of the Chinese Emperors, trans. Michael Bullock. Rutland: Charles E. Tuttle, 1971.

Beurdeley, Michel. *The Chinese Collector through the Centuries: From the Han to the 20th Century*. Rutland: Charles E. Tuttle.

Beyer, Andreas. "Between Academic and Exhibition Practice: The Case of Renaissance Studies." *The Two Art Histories: The Museum and the University*, ed. Charles W. Haxthausen. Williamstown, Mass.: Sterling and Francine Clark Art Institute, 2002.

Biocca, Dario, ed. *A Matter of Passion: Letters of Bernard Berenson and Clotilde Marghieri*. Berkeley: University of California Press, 1989.

Bjurström, Per. "Physiocratic Ideals and National Galleries." *The Genesis of the Art Museum in the Eighteenth Century*, ed. Per Bjurström. Stockholm: National Museum, 1992.

Blanchot, Maurice. *Friendship*, trans. Elizabth Rottenberg. Stanford: Stanford University Press, 1997.

Blunt, Anthony. "Poussin Studies VI: Poussin's Decoration of the Long Gallery in the Louvre." *Burlington Magazine*, no. 93 (1951): 369–74.

Boon, James. "Why Museums Make Me Sad." *Exhibiting Cultures: The Poetics and Politics of Museum Display*, ed. Ivan Karp and Steven D. Lavine. Washington: Smithsonian Institution Press, 1991.

Borges, Jorge Luis. *Collected Fictions*, trans. Andrew Hurley. New York: Viking, 1998.

Borsook, Eve. *The Mural Painters of Tuscany: From Cimabue to Andrea del Sarto*. Oxford: Clarendon, 1980.

Boucher, Marie-Christien. *Catalogue des dessins et peintures de Puvis de Chavannes*. Paris: Musée du petit palais, 1979.

Bourdieu, Pierre. *Distinction: A Social Critique of the Judgement of Taste*, trans. Richard Nice. Cambridge: Harvard University Press, 1984.

Bourdieu, Pierre, and Alain Darbel with Dominique Schnapper. *The Love of Art: European Art Museums and Their Public*, trans. Caroline Beattie and Nick Merriman. Stanford: Stanford University Press, 1990.

Boyle, Nicholas. *Goethe: The Poet and the Age*, vol. 2, *Revolution and Renunciation (1790–1803)*. Oxford: Clarendon, 2000.

Behrman, S. N. *Duveen*. New York: Little Bookroom, 2002.

Braudel, Fernand. *Civilization and Capitalism: Fifteenth to Eighteenth Century*, vol. 3, *The Perspective of the World*, trans. Siân Reynolds. New York: Harper and Row, 1982.

Brawne, Michael. *The Getty Center: Richard Meier and Partners*. London: Phaidon, 1998.

Bredekamp, Horst. *The Lure of Antiquity and the Cult of the Machine: The Kunst-*

kammer and the Evolution of Nature, Art and Technology, trans. Allison Brown. Princeton: Markus Wiener, 1995.

Brese-Bautier, Geneviève, and Frédric Morvan. *Palais du Louvre: Architecture et décor: Guide du visiteur*. Paris: Réunion des Musées Nationaux, 1998.

Brightman, Carol. *Sweet Chaos: The Grateful Dead's American Adventure*. New York: Pocket Books, 1998.

Brilli, Attilio. *Sansepolcro: La città di Piero della Francesca*. Milan: Electra, 1997.

Brooks, Van Wyck. *Fenollosa and His Circle with Other Essays in Biography*. New York: E. P. Dutton, 1962.

Brown, David Alan. "Giovanni Morelli and Bernard Berenson." *Giovanni Morelli e la culture dei conoscitori*, ed. Giocomo Agosti, Maria Elisabetta Manca, and Matteo Panzeri. Bergamo: Pierluigi Lubrina, 1993.

Brown, Jonathan. *Kings and Connoisseurs: Collecting Art in Seventeenth-Century Europe*. New Haven: Yale University Press, 1995.

Bynum, Caroline Walker. *Metamorphosis and Identity*. New York: Zone, 2001.

Bucci, Mario, and Piero Torriti. *Il palazzo ducale di urbino*. Florence: Sansoni, 1969.

Buck, Elizabeth Gray. "Museum Authority and Performance: The Musée Gustave Moreau." *Exceptional Spaces: Essays in Performance and History*, ed. Della Pollock. Chapel Hill: University of North Carolina Press, 1998.

Buermeyer, Laurence. "The Aesthetics of Roger Fry." *Art and Education*, by John Dewey and Albert C. Barnes. Merion, Pa.: Barnes Foundation, 1929.

Bungay, Stephen. *Beauty and Truth: A Study of Hegel's Aesthetics*. Oxford: Oxford University Press, 1984.

Burton, Humphrey. *Yehudi Menuhin: A Life*. Boston: Northeastern University Press, 2000.

Bush, Susan. *The Chinese Literati on Painting*. Cambridge: Harvard University Press, 1971.

Butor, Michel. *Histoire Extraordinaire: Essay on a Dream of Baudelaire's*, trans. Richard Howard. London: Jonathan Cape, 1969.

Cabanne, Pierre. *The Great Collectors*. New York: Farrar, Straus, 1963.

Cahill, James. "Approaches to Chinese Painting." *Three Thousand Years of Chinese Painting*, ed. Yang Xin et al. New Haven: Yale University Press, 1997.

———. *The Compelling Image: Nature and Style in Seventeenth-Century Chinese Painting*. Cambridge: Harvard University Press, 1982.

———. *Treasures of Asia: Chinese Painting*. Cleveland: Skira and World, 1960.

Calasso, Roberto. *The Marriage of Cadmus and Harmony*, trans. Tim Parks. New York: Vintage, 1994.

Cantor, Gilbert. *The Barnes Foundation: Reality vs. Myth*. Philadelphia: Chilton, 1963.

Carrier, David. "Accessibility: A Realistic Dream: Helping the Public Discover

the International." *Pittsburgh Tribune-Herald*, Special Supplement: Carnegie International, November 6, 1999.

———. "The Aesthete in Pittsburgh: Public Sculpture in an Ordinary American City." *Leonardo* 36, no. 1 (2003): 35–39.

———. *The Aesthete in the City: The Philosophy and Practice of American Abstract Painting in the 1980s*. University Park: Pennsylvania State University Press, 1994.

———. *The Aesthetics of Comics*. University Park: Pennsylvania State University Press, 2000.

———. "*Artforum*, Andy Warhol and the Art of Living: What Art Educators Can Learn from the Recent History of American Art Writing." *Journal of Aesthetic Education* 39, 1 (spring 2005): 1–12.

———. "Art History." *Contemporary Critical Terms in Art History*, ed. Robert Nelson and Richard Shiff. Chicago: University of Chicago Press, 1996.

———. "Art Museums, Old Paintings and Our Knowledge of the Past." *History and Theory* 40 (2001): 170–89.

———. *Artwriting*. Amherst: University of Massachusetts Press, 1987.

———. "Baudelaire, Pater and the Origins of Modernism." *Comparative Criticism: An Annual Journal*, ed. E. S. Shuffen, 109–21. Cambridge: Cambridge University Press, 1995.

———. "The Big Picture: David Carrier Talks with Sir Ernst Gombrich." *Artforum*, February 1996, 66–69, 106, 109.

———. "The Bohen Series on Critical Discourse: John Elderfield, Chief Curator-at-Large, the Museum of Modern Art." *Bomb*, spring 1996.

———. "Carnegie International." *Arts*, February 1992, 69.

———. "Carnegie International." *Artforum*, January 1996, 88–89.

———. "Gombrich on Art Historical Explanations." *Leonardo* 16, no. 2 (1983): 91–96.

———. *High Art: Charles Baudelaire and the Origins of Modernism*. University Park: Pennsylvania State University Press, 1996.

———. "Indiscernibles and the Essence of Art: The Hegelian Turn in Arthur Danto's Aesthetic Theory." Forthcoming in the Library of Living Philosophers volume devoted to Danto.

———. "In Praise of Connoisseurship." *Journal of Aesthetics and Art Criticism* 61, no. 2 (2003): 159–69.

———. "Meditations on a Scroll, or the Roots of Chinese Artistic Form." *Word and Image* 18, no. 1 (2002): 45–52.

———. "MoMA Renovation." *ArtUS* 7 (March–April 2005): 42–43.

———. "Mrs. Isabella Stewart Gardner's Titian." *Source* 20, no. 2 (2001): 20–24.

———. "New York Art, Pittsburgh Art, Art." *Journal of Aesthetic Education* 37, no. 3 (2003): 97–104.

———. "1999 Carnegie International: Carnegie Museum of Art, Pittsburgh." *Burlington Magazine*, February 2000, 128–29.

———. "On the Possibility of Aesthetic Atheism." *Leonardo* 18, no. 1 (1985): 35–39.

———. "*Pale Fire* Solved." *Acting and Reflecting*, ed. Wilfrid Sieg. Dordrecht: Reidel, 1990.

———. "Panofsky, Leo Steinberg, David Carrier: The Problem of Objectivity in Art History." *Journal of Aesthetics and Art Criticism* 47, no. 4 (1989): 333–47.

———. "Picasso/Matisse: Fort Worth." *Modern Painters*, summer 1999, 92–93.

———. "Pittsburgh: 1985 Carnegie International." *Burlington Magazine*, January 1986, 63.

———. "The Political Art of Jacques-Louis David and His Modern Day American Successors." *Art History* 26, no. 5 (2003): 730–51.

———. *Poussin's Paintings: A Study in Art-Historical Methodology*. University Park: Pennsylvania State University Press, 1993.

———. *Principles of Art History Writing*. University Park: Pennsylvania State University Press, 1991.

———. "Remembering the Past: Art Museums as Memory Theaters." *Journal of Aesthetics and Art Criticism* 61, no. 1 (winter 2003): 61–65.

———. "A Response to Rudolf Arnheim's 'To the Rescue of Art,'" *Leonardo* 19, no. 3 (1986): 251–54.

———. "Restoration as Interpretation: A Philosopher's Viewpoint." *Altered States: Conservation, Analysis, and the Interpretation of Works of Art*, 19–27. Mount Holyoke: Mount Holyoke College Art Museum, 1994.

———. "Robert Mangold, Gray Window Wall (1964)." *Burlington Magazine*, December 1996, 826–28.

———. *Rosalind Krauss and American Philosophical Art Criticism: From Formalism to beyond Postmodernism*. Westport: Greenwood/Praeger, 2002.

———. "Rudolf Arnheim as Art Historian." *Rudolf Arnheim: Revealing Vision*, ed. K. Kleinman and L. Van Duzer. Ann Arbor: University of Michigan Press, 1997.

———. *Sean Scully*. London: Thames and Hudson, 2004.

———. "Seeing Cultural Conflicts." *ArtUS* 4 (2004): 12–13.

———. "Three Kinds of Imagination." *Journal of Philosophy*, 70, no. 22 (1973), 819–31.

———. "The Transfiguration of the Commonplace: Caravaggio and His Interpreters." *Word and Image* 3, no. 1 (1987): 41–73.

———. "Walter Pater's 'Winckelmann,'" *Journal of Aesthetic Education* 25, no. 1 (2001): 99–109.

———. "The Warhol Museum, Pittsburgh." *Burlington Magazine*, August 1994, 578.

———. "Why Were There No Public Art Museums in Renaissance Italy?," *Source* 22, no. 1 (2002): 44–50.

———. *Wish You Were Here: Artistic Adventures in Reality*. Cleveland: Cleveland Institute of Art, 2003.

———. *Writing about Visual Art*. New York: Allworth, 2003.

Carroll, Noël. *A Philosophy of Mass Art*. Oxford: Clarendon, 1998.

Carter, Miranda. *Anthony Blunt: His Lives*. New York: Farrar, Straus and Giroux, 2001.

Carter, Morris. *Isabella Stewart Gardner and Fenway Court*. London: William Heinemann, 1926.

Chambers, Ross. *The Writing of Melancholy: Modes of Opposition in Early French Modernism*, trans. Mary Seidman Trouille. Chicago: University of Chicago Press, 1993.

Chantelou, Paul Fréart de. *Diary of the Cavaliere Bernini's Visit to France*, trans. Margery Corbett. Princeton: Princeton University Press, 1985.

Chatelain, Jean. *Dominique Vivant Denon et le Louvre de Napoléon*. Paris: Librairie Académique Perris, 1973.

Chatwin, Bruce. *Utz*. London: Jonathan Cape, 1983.

Chisolm, Lawrence. *Fenollosa: The Far East and American Culture*. New Haven: Yale University Press, 1963.

Claiborne, Craig, and Virginia Lee. *The Chinese Cookbook*. New York: Barnes and Noble, 1972.

Clark, Christa. "African Art: The Barnes Foundation." *African Arts* 30, no. 1 (1997): 77–78.

Clark, Kenneth. *Leonardo da Vinci: An Account of His Development as an Artist*. Rev. edn. Harmondsworth: Penguin, 1959.

———. *Moments of Vision*. New York: Viking, 1976.

Clark, T. J. *The Absolute Bourgeois: Artists and Politics in France, 1848–1851*. London: Thames and Hudson, 1973.

———. *Farewell to an Idea: Episodes from a History of Modernism*. New Haven: Yale University Press, 1999.

———. *Image of the People: Gustave Courbet and the 1848 Revolution*. London: Thames and Hudson, 1973.

———. *The Painting of Modern Life: Paris in the Art of Manet and His Followers*. New York: Alfred A. Knopf, 1985.

Clark, Vicky. *International Encounters: The Carnegie International and Contemporary Art, 1896–1996*. Pittsburgh: Carnegie Museum, 1996.

Clunas, Craig. *Art in China*. Oxford: Oxford University Press, 1997.

———. *Pictures and Visuality in Early Modern China*. Princeton: Princeton University Press, 1997.

———. "Souvenirs of Beijing: Authority and Subjectivity in Art Historical Mem-

ory." *Picturing Power in the People's Republic of China: Posters of the Cultural Revolution*, ed. Harriet Evand and Stephanie Donald. Lanham, Md.: Rowman and Littlefield: 1998.

Cohen, Warren. *East Asian Art and American Culture: A Study in International Relations*. New York: Columbia University Press, 1992.

Coles, Robert. "The Art Museum and the Pressures of Society." *On Understanding Art Museums*, ed. Sherman Lee. Englewood Cliffs, N.J.: Prentice-Hall, 1975.

Coomaraswamy, Ananda. *Introduction to Indian Art*. Madras: Theosophical Publishing, 1923.

Court, Franklin. "The Matter of Pater's 'Influence' on Bernard Berenson: Setting the Record Straight." *English Literature in Transition* 26, no. 1 (1983): 16–22.

Crane, Susan. *Collecting and Historical Consciousness in Early-Nineteenth-Century Germany*. Ithaca: Cornell University Press, 2000.

Craven, Thomas. *Modern Art: The Men, the Movements, the Meaning*. New York: Simon and Schuster, 1934.

Crimp, Douglas. *On the Museum's Ruins*. Cambridge: MIT Press, 1993.

Crow, Thomas. "Marx to Sharks: Thomas Crow on the Art-Historical '80s." *Artforum*, April 2003, 45–52.

———. *Modern Art in the Common Culture*. New Haven: Yale University Press, 1996.

———. *Painters and Public Life in Eighteenth-Century Paris*. New Haven: Yale University Press, 1985.

Crowley, Pamela Kyle. "The Historiography of Modern China." *Companion to Historiography*, ed. Michael Bentley. London: Routledge, 1997.

Cuno, James, ed. *Whose Muse: Art Museums and the Public Trust*. Princeton: Princeton University Press, 2004.

Daltrop, Georg. "Museum Pio-Clementino." *The Vatican Collections: The Papacy and Art*. New York: Metropolitan Museum of Art, 1982.

Dana, John Cotton. *The New Museum: Selected Writings*. Ed. William A. Peniston. Newark, N.J.: Newark Museum Association, 1999.

Danto, Arthur. *The Abuse of Beauty: Aesthetics and the Concept of Art*. Chicago: Open Court, 2003.

———. *After the End of Art: Contemporary Art and the Pale of History*. Princeton: Princeton University Press, 1997.

———. *Analytic Philosophy of Action*. Cambridge: Cambridge University Press, 1973.

———. *Analytic Philosophy of History*. Cambridge: Cambridge University Press, 1968.

———. *Analytical Philosophy of Knowledge*. Cambridge: Cambridge University Press, 1968.

———. *Beyond the Brillo Box: The Visual Arts in Post-Historical Perspective*. New York: Farrar, Straus and Giroux, 1992.

———. *Connections to the World. The Basic Concepts of Philosophy*. Berkeley: University of California Press, 1997.

———. *Embodied Meanings: Critical Essays and Aesthetic Meditations*. New York: Farrar, Straus and Giroux, 1994.

———. Foreword, *The Author, Art, and the Market: Rereading the History of Aesthetics*, by Martha Woodmansee. New York: Columbia University Press, 1994.

———. "Looking at the Future Looking at the Present as Past." *Mortality Immortality? The Legacy of Twentieth-Century Art*, ed. Miguel Angel Corzo. Los Angeles, 1999.

———. *The Madonna of the Future: Essays in a Pluralistic Art World*. New York: Farrar, Straus and Giroux, 2000.

———. *Mark Tansey: Visions and Revisions*. New York: Harry N. Abrams, 1992.

———. *Mysticism and Morality: Oriental Thought and Moral Philosophy*. New York: Columbia University Press, 1987.

———. *Narration and Knowledge*. New York: Columbia University Press, 1985.

———. *The Philosophical Disenfranchisement of Art*. New York: Columbia University Press, 1986.

———. *Philosophizing Art: Selected Essays*. Berkeley: University of California Press, 1999.

———. *The Transfiguration of the Commonplace*. Cambridge: Harvard University Press, 1981.

Daston, Lorraine, and Katherine Park. *Wonders and the Order of Nature, 1150–1750*. New York: Zone, 1998.

Dawson, Fielding. Foreword, *Reading the Funnies: Essays on Comic Strips*, by Donald Phelps. Seattle: Fantagraphics, 2001.

Desai, Megnad. *Marx's Revenge: The Resurgence of Capitalism and the Death of Statist Socialism*. London: Verso, 2002.

Davie, Donald. *Articulate Energy: An Inquiry into the Syntax of English Poetry*. London: Routledge and Kegan Paul, 1955.

Davis, Douglas. *The Museum Transformed: Design and Culture in the Post-Pompidou Age*. New York: Abbeville, 1990.

Davis, Mike. *City of Quartz*. London: Verso, 1990.

de Grazia, Margreta, Maureen Quilligan, and Peter Stallybrass. Introduction, *Subject and Object in Renaissance Culture*. Cambridge: Cambridge University Press, 1996.

de Quincy, Quatremère. *Lettres à Miranda sur le déplacement des monuments de l'art de l'Italie*, ed. Edouard Pommier. Paris: Macula, n.d.

Debord, Guy. *Society of the Spectacle*, trans. Donald Nicholson-Smith. New York: Zone, 1995.

Denon, Dominique Vivant. *Pages d'un journal de voyage en Italie (1788)*, ed. Elena Del Panta. Paris: Gallimard, 1998.

Denon, Dominique Vivant, and Abdel Rahman el-Gaharti. *Sur l'expédition de Bonaparte en Égypte*, ed. Mahmoud Hussein. Paris: Actes Sud, 1998.

Derrida, Jacques. *Writing and Difference*, trans. Alan Bass. Chicago: University of Chicago Press, 1978.

Descartes, René. *Philosophical Writings*, ed. and trans. Elizabeth Anscombe and Peter Thomas Geach. Indianapolis: Bobbs-Merrill, 1970.

Dewey, John. *Art as Experience*. New York: Capricorn, 1958.

———. "Dedication Address." *Journal of the Barnes Foundation* 1, no. 2 (1925).

———. *Impressions of Society: Russia and the Revolutionary World: Mexico, China, Turkey*. New York: New Republic, 1929.

Dewey, John, and Albert Barnes. *Art and Education*. Merion, Pa.: Barnes Foundation, 1929.

Diderot, Denis. *Selected Writings on Art and Literature*, trans. Geoffrey Gremner. London: Penguin, 1994.

———. *Diderot on Art*, vol. 2, *The Salon of 1767*, trans. John Goodman. New Haven: Yale University Press, 1995.

DiMaggio, Paul. *The Economics of Art Museums*, ed. Martin Feldstein. Chicago: University of Chicago Press, 1991.

Donoghue, Denis. *Walter Pater: Lover of Strange Souls*. New York: Alfred A. Knopf, 1995.

Douglas, Mary. *Natural Symbols: Explorations in Cosmology*. New York: Pantheon, 1970.

Dummett, Michael. "The Dewey Lectures 2002: Truth of the Past." *Journal of Philosophy* 100, no. 1 (2003).

Duncan, Carol. *The Aesthetics of Power: Essays in Critical Art History*. Cambridge: Cambridge University Press, 1993.

———. *Civilizing Rituals: Inside Public Art Museums*. London: Routledge, 1995.

Duthuit, Georges. *Chinese Mysticism and Modern Painting*. Paris: Chroniques du Jour, 1936.

Dwork, Debórah, and Robert Jan van Pelt. *Holocaust: A History*. New York: W. W. Norton, 2002.

Eagleton, Terry. *The Ideology of the Aesthetic*. Oxford: Basil Blackwell, 1990.

Edel, Leon. *Henry James: The Master, 1901–1916*. Philadelphia: J. B. Lippincott, 1972.

Einreinhofer, Nancy. *The American Art Museum: Elitism and Democracy*. London: Leicester University Press, 1997.

Elderfield, John. *The Drawings of Henri Matisse*. New York: Museum of Modern Art, 1984.

————. *Pleasuring Painting: Matisse's Feminine Representations*. London: Thames and Hudson, 1995.

Elias, Norbert. *The Court Society*, trans. Edmund Jephcott. New York: Pantheon, 1983.

Elkins, James. *Stories of Art*. New York: Routledge, 2002.

Engels, Friedrich. "Why There Is No Large Socialist Party in America." *Basic Writings on Politics and Philosophy*, by Karl Marx and Friedrich Engels, ed. Lewis S. Feuer. Garden City, N.Y.: Anchor, 1959.

Eriksen, Thoms Hylland. *Tyranny of the Moment: Fast and Slow Time in the Information Age*. London: Pluto, 2001.

Errington, Shelley. *The Death of Authentic Primitive Art and Other Tales of Progress*. Berkeley: University of California Press, 1998.

Ettinghausen, Richard. "The Early History, Use and Iconography of the Prayer Rug." *Prayer Rugs*. Washington: Textile Museum, 1974.

Fairbank, John King. *China: A New History*. Cambridge: Harvard University Press, 1991.

Farington, Joseph. *The Diary of Joseph Farington*, ed. Kenneth Garlick and Angus Macintyre. New Haven: Yale University Press, 1978–79.

Farrow, Clare. "The Art of Abstraction. Interview with Richard Meier." *Richard Meier, Frank Stella: Architecture and Art*. Aichi Prefectural Museum of Art, 1996.

Feldherr, Andrew. "Metamorphosis in the *Metamorphoses*." *The Cambridge Companion to Ovid*, ed. Philip Hardie. Cambridge: Cambridge University Press, 2002.

Feldstein, Martin, ed. *The Economics of Art Museums*. Chicago: University of Chicago Press, 1991.

Fenollosa, Ernest. *Catalogue: Museum of Fine Arts. Department of Japanese Art. No. 1. Hokusai, and His School*. Boston: Museum of Fine Arts, 1893.

————. *The Chinese Written Character as a Medium for Poetry*. Foreword and notes by Ezra Pound. New York: Arrow Editions, 1936.

————. *Review of the Chapter on Painting in Gonse's "L'art Japonais."* Boston: James R. Osgood, 1885.

————. *Epochs of Chinese and Japanese Art: An Outline History of East Asiatic Design*. New York: Frederick A. Stokes and William Heinemann, 1912.

Fenollosa, Mary. Preface, *Epochs of Chinese and Japanese Art: An Outline History of East Asiatic Design*, by Ernest Fenollosa. New York: Frederick A. Stokes and William Heinemann, 1912.

Filipczak, Zirka Zaremba. *Picturing Art in Antwerp, 1550–1700*. Princeton: Princeton University Press, 1987.

Findlen, Paula. *Possessing Nature: Museums, Collecting, and Scientific Culture in Early Modern Italy*. Berkeley: University of California Press, 1994.

Finn, David. *How to Visit a Museum*. New York: Harry N. Abrams, 1985.

Fisher, Philip. *Making and Effacing Art: Modern American Art in a Culture of Museums*. New York: Oxford University Press, 1991.

———. *Wonder, the Rainbow, and the Aesthetics of Rare Experiences*. Cambridge: Harvard University Press, 1998.

Flam, Jack. *Great French Paintings from the Barnes Foundation: Impressionist, Postimpressionist, and Early Modern*. New York: Alfred A. Knopf with Lincoln University Press, 1993.

———. *Matisse: The Dance*. Washington: National Gallery of Art, 1993.

———. *Matisse: The Man and His Art, 1869–1918*. Ithaca: Cornell University Press, 1986.

———, ed. *Matisse on Art*. New York: Dutton, 1978.

Fong, Wen. *Beyond Representation: Chinese Painting and Calligraphy Eighth–Fourteenth Century*. New York: Metropolitan Museum of Art, 1992.

———. "Why Chinese Painting Is History." *Art Bulletin* 85, no. 2 (June 2003): 258–80.

Fontein, Jan. Introduction, *Museum of Fine Arts Boston*, 11–15. New York: Newsweek, 1969.

Forge, Andrew. "Art/Nature." *Philosophy and the Arts*. London: Royal Institute of Philosophy, 1973.

Foster, Hal. "Mnémonique des musées, amnésie des archives." *L'avenir des musées*, ed. Jean Galard, 359–69. Paris: Réunion des Musées Nationaux, 2000.

Foucault, Michel. *Language, Counter-Memory, Practice: Selected Essays and Interviews*, ed. Donald F. Bouchard, trans. Bouchard and Sherry Simon. Ithaca: Cornell University Press, 1977.

———. *The Order of Things: An Archaeology of the Human Sciences*. New York: Vintage, 1970.

Frampton, Kenneth, and Joseph Rykwert. *Richard Meier, Architect*. New York: Rizzoli, 1999.

Freedberg, David. *The Power of Images: Studies in the History and Theory of Response*. Chicago: University of Chicago Press, 1989.

Freud, Sigmund. "Creative Writers and Day-Dreaming." *The Standard Edition of the Complete Psychological Works of Sigmund Freud* 9:141–53.

———. *The Standard Edition of the Complete Psychological Works of Sigmund Freud*, trans. James Strachey with Anna Freud, Alix Strachey, and Alan Tyson. London: Hogarth, 1953.

Fried, Michael. *Art and Objecthood: Essays and Reviews*. Chicago: University of Chicago Press, 1998.

———. *Manet's Modernism; or, The Face of Painting in the 1860s*. Chicago: University of Chicago Press, 1996.

Fredericksen, Burton. *Masterpieces of the J. Paul Getty Museum: Paintings*. Los Angeles: J. Paul Getty Trust, 1997.

Fredericksen, Burton, assisted by Julia I. Armstrong and Doris A. Mendenhall. *The Index of Paintings Sold in the British Isles during the Nineteenth Century.* Santa Barbara: ABC-CLIO, 1988–.

Fredericksen, Burton, with archival contributions by Ruud Priem, assisted by Julia I. Armstrong. *Corpus of Paintings Sold in the Netherlands during the Nineteenth Century.* Los Angeles: J. Paul Getty Information Institute, 1998–.

Freedberg, Sydney. "Berenson, Connoisseurship, and the History of Art." *New Criterion* 7 (1989): 7–13.

———. *Painting in Italy, 1500–1600*. Harmondsworth: Penguin, 1971.

Fry, Roger. *Last Lectures*. Boston: Beacon, 1962.

———. "The Significance of Chinese Art." *Chinese Art: An Introductory Handbook*. London: Batsford, 1935.

Fukuyama, Francis. *The Great Disruption: Human Nature and the Reconstitution of Social Order*. New York: Free Press, 1999.

Furbank, P. N. *Diderot: A Critical Biography*. New York: Alfred A. Knopf, 1991.

Gadamer, Hans-Georg. *Philosophical Hermeneutics*, trans. David E. Linge. Berkeley: University of California Press, 1976.

———. *The Relevance of the Beautiful and Other Essays*, trans. Nicholas Walker. Cambridge: Cambridge University Press, 1986.

———. *Truth and Method*, trans. Garrett Barden and John Cumming. New York: Continuum, 1975.

Galard, Jean, and Anne-Laure Charrier. *Visiteurs du Louvre*. Paris: Réunion des Musées Nationaux, 1993.

Gasarian, Gérard. " 'Le Cygne' of Baudelaire." *Understanding Les Fleurs du Mal: Critical Readings*, ed. William J. Thompson. Nashville: Vanderbilt University Press, 1997.

Gaskell, Ivan. "Magnanimity and Paranoia in the Big Bad Art World." *The Two Art Histories: The Museum and the University*, ed. Charles W. Haxthausen. Williamstown, Mass.: Sterling and Francine Clark Art Institute, 2002.

———. *The Thyssen Bornemisza Collection: Seventeenth-Century Dutch and Flemish Painting*. London: Sotheby's, 1990.

———. *Vermeer's Wager: Speculations on Art History, Theory and Art Museums*. London: Reaktion, 2000.

Gautier, Théophile. *The Travels of Théophile Gautier*, vol. 7, trans. F. C. de Sumichrast. Boston: Little, Brown, 1912.

Gernet, Jacques. *Daily Life in China on the Eve of the Mongol Invasion, 1250–1276*, trans. H. M. Wright. New York: Macmillan, 1962.

Getty, J. Paul. *As I See It*. Englewood Cliffs, N.J.: Prentice-Hall, 1976.

———. *How to Be Rich*. Chicago, 1965.

———. *The Joys of Collecting*. London: W. H. Allen, 1966.

Geuss, Raymond. *Public Goods, Private Goods*. Princeton: Princeton University Press, 2003.

Giacometti, Alberto. *Écrits*, ed. Michel Leiris and Jacques Dupin. Paris: Hermann, 1990.

Gibbons, Martha, and Jo Zuppan, eds. *Interpretations: Sixty-five Works from the Cleveland Museum of Art*. Cleveland: Cleveland Museum of Art, 1991.

Gibson-Wood, Carol. *Studies in the Theory of Connoisseurship from Vasari to Morelli*. New York: Garland, 1988.

Gladwell, Malcolm. *The Tipping Point: How Little Things Can Make a Big Difference*. Boston: Little, Brown, 2000.

Gleick, James. *Faster: The Acceleration of Just About Everything*. New York: Vintage, 2000.

Glover, Jonathan. *The Philosophy and Psychology of Personal Identity*. London: Allen Lane, 1988.

Glueck, Grace. "The Ivory Tower versus the Discotheque." *Art in America*, July–August 1971, 80–85.

Goehr, Lydia. *The Imaginary Museum of Musical Works: An Essay in the Philosophy of Music*. Oxford: Oxford University Press, 1992.

———. "The Institutionalization of a Discipline: A Retrospective of the *Journal of Aesthetics and Art Criticism* and the American Society for Aesthetics, 1939–1992." *Journal of Aesthetics and Art Criticism* 51 (1993): 99–121.

Goethe, Johann Wolfgang von. *The Autobiography of Johann Wolfgang von Goethe*, trans. John Oxenford. New York: Horizon, 1969.

———. *Italian Journey (1786–1788)*, trans. W. H. Auden and Elizabeth Mayer. New York: Schocken, 1968.

Goldfarb, Hilliard. *Isabella Stewart Gardner Museum: A Companion Guide and History*. New Haven: Yale University Press, 1995.

Gombrich, E. H. *Art and Illusion: A Study in the Psychology of Pictorial Representation*. Princeton: Princeton University Press, 1961.

———. *Ideals and Idols: Essays on Values in History and in Art*. Oxford: Phaidon, 1979.

———. "The Logic of Vanity Fair." *The Philosophy of Karl Popper*, ed. Paul Arthur Schilpp. La Salle, Ill.: Open Court, 1974.

———. *Norm and Form: Studies in the Art of the Renaissance*. London: Phaidon, 1966.

———. *The Sense of Order: A Study in the Psychology of Decorative Art*. Ithaca: Cornell University Press, 1979.

———. *The Story of Art*. London: Phaidon, 1995.

Goodman, Nelson. Foreword, *Past, Present, East and West*, by Sherman Lee. New York: George Braziller, 1983.

Gould, Cecil. *Trophy of Conquest: The Musée Napoléon and the Creation of the Louvre*. London: Faber and Faber, 1968.

Gould, Stephen Jay. *Dinosaur in a Haystack: Reflections in Natural History*. New York: Harmony, 1995.

Gowing, Lawrence. "A History of the Louvre's Collection." *Paintings in the Louvre*. New York: Stewart, Tabori and Chang, 1987.

Grabar, Oleg. *The Alhambra*. Cambridge: Harvard University Press, 1978.

Grasselli, Margaret Morgan, and Pierre Rosenberg. *Watteau, 1684–1721*. Washington: National Gallery of Art, 1984.

Greenberg, Clement. *Art and Culture: Critical Essays*. Boston: Beacon, 1961.

———. *The Collected Essays and Criticism*, vol. 4, *Modernism with a Vengeance, 1957–1969*. Chicago: University of Chicago Press, 1993.

Greenblatt, Stephen. *Learning to Curse: Essays in Early Modern Culture*. New York: Routledge, 1990.

———. *Marvelous Possessions: The Wonder of the New World*. Chicago: University of Chicago Press, 1991.

Greenfeld, Howard. *The Devil and Dr. Barnes: Portrait of an American Art Collector*. New York: Viking, 1987.

Greenwood, Thomas. *Museums and Art Galleries*. London: Routledge, 1996.

Gregori, Mina. "Caravaggio's *Amor Vincit Omnia*." *The Age of Caravaggio*. New York: Metropolitan Museum of Art, 1985.

Gregory, Richard, *Eye and Brain: The Psychology of Seeing*. New York: McGraw-Hill, 1978.

Guillaume, Paul, and Thomas Munro. *Primitive Negro Sculpture*. New York: Harcourt, Brace, 1926.

Guralnick, Peter. *Last Train to Memphis: The Rise of Elvis Presley*. Boston: Little, Brown, 1994.

Habermas, Jürgen. *The Structural Transformation of the Public Sphere: An Inquiry into a Category of Bourgeois Society*. Cambridge: MIT Press, 1989.

Hadley, Rollin, ed., *The Letters of Bernard Berenson and Isabella Stewart Gardner, 1887–1924*. Boston: Northeastern University Press, 1987.

Hahnloser-Ingold, Margrit. "Collecting Matisses of the 1920s in the 1920s." *Henri Matisse: The Early Years in Nice, 1916–1930*, ed. Jack Cowart and Dominique Fourcade. Washington: National Gallery of Art, 1986.

Hannoosh, Michel. *Painting and the Journal of Eugène Delacroix*. Princeton: Princeton University Press, 1995.

Harbison, Robert. *Eccentric Spaces*. New York: Alfred A. Knopf, 1977.

Hardimon, Michael. *Hegel's Social Philosophy: The Project of Reconciliation*. Cambridge: Cambridge University Press, 1994.

Harris, Neil. *Cultural Excursions: Marketing Appetites and Cultural Tastes in Modern America*. Chicago: University of Chicago, 1990.

Harris, William. *Hegel's First Principle: An Exposition of Comprehension and Idea.* St. Louis: George Knapp, 1868.

Haskell, Francis. "Benedict Nicolson (1914–1978)." *Past and Present in Art and Taste: Selected Essays.* New Haven: Yale University Press, 1987.

———. "The Dispersal and Conservation of Art-Historical Property." *History of Italian Art*, vol. 1, ed. Peter Burke, trans Ellen Bionchini and Claire Dorey. Oxford: Polity, 1994.

———. *The Ephemeral Museum: Old Master Paintings and the Rise of the Art Exhibition.* New Haven: Yale University Press, 2000.

———. *History and Its Images: Art and the Interpretation of the Past.* New Haven: Yale University Press, 1993.

———. "Museums and Their Enemies." *Journal of Aesthetic Education* 19, no. 2 (1985): 1–21.

———. *Rediscoveries in Art: Some Aspects of Taste, Fashion and Collecting in England and France.* Ithaca: Cornell University Press, 1976.

———. "Winckelmann et son influence sur les historiens." *Winckelmann: La naissance de l'histoire de l'art à l'épique des Lumières*, ed. Edouard Pommier. Paris: Documentation Française, 1991.

Haskell, Francis, and Nicholas Penny. *Taste and the Antique.* New Haven: Yale University Press, 1981.

Hauser, Arnold. *The Philosophy of Art History.* Cleveland: World, 1963.

———. *The Social History of Art*, vol. 2, *Renaissance, Mannerism, Baroque*, trans. A. Hauser and Stanley Godman. New York: Vintage, 1960.

Hautecoeur, Louis. *Histoire du Louvre: Le chateau, le palais, le musée.* Paris: L'illustration, 1928.

Havemeyer, Louisine. *Sixteen to Sixty: Memoirs of a Collector.* New York: Ursus, 1993.

Hegel, G. W. F. *Aesthetics: Lectures on Fine Art*, trans. T. M. Knox. Oxford: Clarendon, 1975.

———. *Hegel: The Letters*, trans. Clark Butler and Christiane Seilere, with commentary by Clark Butler. Bloomington: Indiana University Press, 1984.

———. *The Phenomenology of Mind*, trans. J. B. Baillie. New York: Harper Torchbooks, 1967.

———. *Philosophy of History*, trans. J. Sibree. New York: P. F. Collier and Son, 1902.

Hellekson, Karen. *The Alternate History: Refiguring Historical Time.* Kent, Ohio: Kent State University Press, 2001.

Hendy, Philip. *European and American Paintings in the Isabella Stewart Gardner Museum.* Boston: Isabella Stewart Gardner Museum, 1974.

———. *Spanish Painting.* London: Avalon Press and Collins, 1947.

Henrich, Dieter. *Judgment and the Moral Image of the World: Studies in Kant*. Stanford: Stanford University Press, 1992.

Hickey, Dave. *The Invisible Dragon: Four Essays on Beauty*. Los Angeles: Art Issues, 1993.

———. "Ready for Art." *Architecture*, December 1997.

Higonnet, Anne. "Museum Sight." *Art and Its Publics: Museum Studies at the Millennium*, ed. Andrew McClellan. Malden, Mass.: Blackwell, 2003.

Hills, Paul. *Venetian Colour: Marble, Mosaic, Painting and Glass, 1250–1550*. New Haven: Yale University Press, 1999.

Hitchcock, Henry Russell. *The Sheldon Memorial Art Gallery, University of Nebraska, Lincoln*. Lincoln: University of Nebraska, 1964.

Holland, Eugene. *Baudelaire and Schizoanalysis: The Sociopoetics of Modernism*. Cambridge: Cambridge University Press, 1993.

Hollier, *Against Architecture: The Writings of Georges Bataille*, trans. Betsy Wing. Cambridge: MIT Press, 1989.

Holly, Michael Ann. *Panofsky and the Foundations of Art History*. Ithaca: Cornell University Press, 1984.

———. *Past Looking: Historical Imagination and the Rhetoric of the Image*. Ithaca: Cornell University Press, 1996.

Holly, Michael Ann, and Keith Moxey, eds. *Visual Culture: Images and Interpretations*. Hanover, N.H.: Wesleyan University Press, 1994.

Holt, Elizabeth Gilmore, ed. *The Triumph of Art for the Public: The Emerging Role of Exhibitions and Critics*. Garden City, N.Y.: Anchor, 1979.

Honour, Hugh. *The Image of the Black in Western Art*, vol. 2, pt 2, *Black Models and White Myths*. Cambridge: Harvard University Press, 1989.

Hooper-Greenhill, Eilean. *Museums and the Shaping of Knowledge*. London: Routledge, 1992.

Houlgate, Stephen. "Hegel and the Art of Painting." *Hegel and Aesthetics*, ed. William Maker. Albany: State University of New York Press, 2000.

Hoving, Thomas. *Making the Mummies Dance: Inside the Metropolitan Museum of Art*. New York: Simon and Schuster, 1993.

Hoy, David. *The Critical Circle: Literature, History, and Philosophical Hermeneutics*. Berkeley: University of California, 1978.

Hudson, G. J. *Europe and China: A Survey of Their Relations from the Earliest Times to 1800*. Boston: Beacon, 1961.

Hughes, Ted. *Tales from Ovid*. New York: Farrar, Straus and Giroux, 1997.

Hume, David. *Dialogues Concerning Natural Religion*. Oxford: Oxford University Press, 1998.

Hunt, John Dixon. *Garden and Grove: The Italian Renaissance Garden in the English Imagination, 1600–1750*. Princeton: Princeton University Press, 1986.

Husserl, Edmund. *Cartesian Meditations: An Introduction to Phenomenology*, trans. Dorion Cairns. The Hague: Martinus Nikhoff, 1960.

Huxtable, Ada Louise. "The Clash of Symbols." *Making Architecture: The Getty Center*, by Harold M. Williams, Ada Louise Huxtable, Stephen D. Rountree, and Richard Meier. Los Angeles: J. Paul Getty Trust, 1997.

Ienaga, Saburo. *Japanese Art: A Cultural Appreciation*, trans. Richard L. Gage. New York: Watherhill, 1979.

Ittelson, William. *The Ames Demonstrations in Perception: A Guide to Their Construction and Use*. Princeton: Princeton University Press, 1952.

Jackson, Margaret Talbot. *The Museum: A Manual for the Housing and Care of Art Collections*. New York: Longmans, Green, 1917.

Jackson, Philip. *John Dewey and the Lessons of Art*. New Haven: Yale University Press, 1998.

Jain, Jyotindra. *Everyday Art of India*. New Delhi: Sanskriti Pratishthan, 2000.

James, Henry. *The American Scene*. Bloomington: Indiana University Press, 1968.

———. *Italian Hours*. New York: Grove, 1979.

———. *The Outcry*. New York: New York Review of Books, 2002.

———. *Selected Literary Criticism*, ed. Morris Shapira. New York: Horizon, 1964.

———. *A Small Boy and Others*. New York: Charles Scribner's Sons, 1913.

Jameson, Fredric. *The Political Unconscious: Narrative as a Socially Symbolic Act*. Ithaca: Cornell University Press, 1981.

Jardine, Lisa, and Jerry Brotton. *Global Interests: Renaissance Art between East and West*. Ithaca: Cornell University Press, 2000.

Jensen, Joli. *Is Art Good for Us? Beliefs about High Culture in American Life*. Lanham, Md.: Rowman and Littlefield, 2002.

Jobert, Barthélémy. *Delacroix*, trans. Terry Grabar and Alexandra Bonfante-Warren. Princeton: Princeton University Press, 1998.

Johns, Christopher. *Antonio Canova and the Politics of Patronage in Revolutionary and Napoleonic Europe*. Berkeley: University of California Press, 1998.

Johnson, Dorothy. *Jacques-Louis David: The Farewell of Telemachus and Eucharis*. Los Angeles: John Paul Getty Museum, 1997.

Johnston, William. *William and Henry Walters, the Reticent Collectors*. Baltimore: Johns Hopkins University Press, 1999.

Jullian, René. "Le thème des ruines dans la peinture de l'époque néo-classique en France." *Bulletin de la Société de l'histoire de l'art français*, 1976, 261–72.

Kant, Immanuel. *The Critique of Judgement*, trans. James Creed Meredith. Oxford: Clarendon, 1952.

———. *On History*, trans. Lewis White Beck. Indianapolis: Bobbs-Merrill, 1963.

Kantor, Sylbil Gordon. *Alfred H. Barr, Jr., and the Intellectual Origins of the Museum of Modern Art*. Cambridge: MIT Press, 2002.

———. "The Beginnings of Art History at Harvard and the 'Fogg Method.'"

The Early Years of Art History in the United States, ed. Craig Hugh Smyth and Peter M. Lukehart. Princeton: Princeton University Department of Art and Archaeology, 1993.

Kantorowicz, Ernest. The *King's Two Bodies: A Study in Medieval Political Theology*. Princeton: Princeton University Press, 1957.

Kaplan, Sam Hall. *LA Lost and Found: An Architectural History of Los Angeles*. New York: Crown, 1987.

Karmel, Pepe. "Pollock at Work: The Films and Photographs of Hans Namuth." *Jackson Pollock*. New York: Museum of Modern Art, 1998.

Kaufmann, Thomas DeCosta. *Court, Cloister, and City: The Art and Culture of Central Europe, 1450–1800*. Chicago: University of Chicago Press, 1995.

———. *The Mastery of Nature: Aspects of Art, Science, and Humanism in the Renaissance*. Princeton: Princeton University Press, 1993.

Kean, Beverly Whitney. *French Painters, Russian Collectors: The Merchant Patrons of Modern Art in Pre-Revolutionary Russia*. London: Hodder and Stoughton, 1983.

Kemal, Salim. *The Poetics of Alfarabi and Avicenna*. Leiden: E. J. Brill, 1991.

Kenner, Hugh. *The Pound Era*. Berkeley: University of California Press, 1971.

Kenseth, Joy. "A World of Wonders in One Closet Shut." *The Age of the Marvelous*, ed. Joy Kenseth. Hanover: Hood Museum of Art, Dartmouth College, 1991.

Kermode, Frank. *Romantic Image*. London: Fontana, 1971.

Klawans, Stuart. "Site and Vision." *Getty Bulletin* 6, no. 3 (1993): 5–7.

Klein, Norman. *The History of Forgetting: Los Angeles and the Erasure of Memory*. London: Routledge, 1997.

Kloss, William. *Samuel F. B. Morse*. New York: Harry N. Abrams, 1986.

Kojève, Alexandre. *Introduction to the Reading of Hegel*, ed. Raymond Queneau and Allan Bloom, trans. James H. Nichols. New York: Basic Books, 1969.

Krauss, Rosalind. "Postmodernism's Museum without Walls." *Thinking about Exhibitions*, ed. Resa Greenberg, Bruce W. Reguson, and Sandy Nairne. London: Routledge, 1996.

Krautheimer, Richard. *The Rome of Alexander XII, 1655–1667*. Princeton: Princeton University Press, 1985.

Kristeller, Paul. "The Modern System of the Arts: A Study in the History of Aesthetics." *Journal of the History of Ideas* 12 (1951): 496–527; 13 (1952): 17–46.

Kuhn, Thomas. *The Structure of Scientific Revolutions*. Chicago: University of Chicago Press, 1970.

Kuhns, Richard. *Decameron and the Philosophy of Storytelling*. New York: Columbia University Press, 2005.

———. "Reflections of the Metaphoric Power of Metamorphosis." Forthcoming.

———. *Tragedy: Contradiction and Repression*. Chicago: University of Chicago Press, 1991.

Laclotte, Michel. "A History of the Louvre's Collection." *Paintings in the Louvre*, by Lawrence Gowing. New York: Stewart, Tabori and Chang, 1987.

Ladurie, Emmanuel Le Roy, with Jean-François Fitou. *Saint-Simon and the Court of Louis XIV*, trans. Arthur Goldhammer. Chicago: University of Chicago Press, 2001.

La Farge, John. *An Artist's Letters from Japan*. New York: Century, 1897.

Lang, Berel, and Forrest Williams. *Marxism and Art: Writings in Aesthetics and Criticism*. New York: David McKay, 1972.

Langmuir, Erika. *The National Gallery Companion Guide*. London: National Gallery of Art, 1994.

Lavin, Marilyn Aronberg. *Piero della Francesca's Baptism of Christ*. New Haven: Yale University Press, 1981.

Lavin, Sylvia. *Quatremère de Quincy and the Invention of a Modern Language of Architecture*. Cambridge: MIT Press, 1992.

Lawton, Thomas and Linda Merrill. *Freer: A Legacy of Art*. Washington: Smithsonian Institution, 1993.

Leader, Darian. *Stealing the Mona Lisa: What Art Stops Us from Seeing*. London: Faber and Faber, 2002.

Lee, Sherman. *Art against Things*. Sydney: Art Association of Australia, 1976.

———. "The Art Museum in Today's Society." *Dayton Art Institute Bulletin*, March 19, 1973, 2–3.

———. *China, 5000 Years: Innovation and Transformation in the Arts*. New York: Guggenheim Museum, 1998.

———. *Chinese Landscape Painting*. Cleveland: Cleveland Museum, 1962.

———. "Convocation Address on the Occasion of the Dedication of the Snite Museum of Art." Address given at the University of Notre Dame, South Bend, Ind., 1971.

———. *A History of Far Eastern Art*. New York: Harry N. Abrams and Prentice Hall, 1994.

———. "The Idea of an Art Museum." *American Review*.

———. *Past, Present, East and West*. New York: George Braziller, 1983.

———. *The Role of the College Art Museum*. Poughkeepsie: Vassar College, 1993.

———. "Works of Art, Ideas of Art, and Museums of Art." *On Understanding Art Museums*, ed. Sherman Lee. Englewood Cliffs, N.J.: Prentice-Hall, 1975.

Lefebvre, Henri. *The Production of Space*, trans. Donald Nicholson-Smith. Oxford: Routledge, 1991.

Lehr, Max. *The Great Painters of China*. New York: Harper and Row, 1980.

Levenson, Jay. *Circa 1492: Art in the Age of Exploration*. Washington: National Gallery of Art, 1992.

Levey, Michael. *The Case of Walter Pater*. London: Thames and Hudson, 1978.

Levi, Albert William. "The Art Museum as an Agency of Culture." *Journal of Aesthetic Education* 19, no. 2 (1985): 23–40.

———. "Art Museums and Culture." *Readings in Discipline-Based Art Education: A Literature of Educational Reform*, ed. Ralph A. Smith. Reston, Va.: National Art Education Association, 2000.

Lichtheim, George. *Marxism: An Historical and Critical Study*. New York: Praeger, 1961.

———. *A Short History of Socialism*. New York: Praeger, 1970.

Longhi, Roberto. "Dialogo fra il Caravaggio e il Tiepolo." *Da Cimabue a Morandi*. Milan: Arnoldo Mondadori, 1973.

López-Rey, José. *Velázquez: The Artist as a Maker with a Catalogue Raisonné of his Extant Works*. Lausanne: Bibliothèque des Arts, 1979.

Lorenzetti, Giulio. *Venice and Its Lagoon*, trans. John Guthrie. Trieste: Lint, 1975.

Luchinat, Christina Acidini, ed. *Treasures of Florence: The Medici Collection, 1400–1700*, trans. Eve Leckey. Munich: Prestel, 1997.

Lugli, Adalgisa. "Inquiry as Collection: The Athanasius Kircher Museum in Rome." *RES* 12 (1986): 109–24.

Luckiesh, M. *Visual Illusions: Their Causes, Characteristics and Applications*. New York: Dover, 1965.

Lukács, Georg. *History and Class Consciousness: Studies in Marxist Dialectics*, trans. Rodney Livingstone. London: Merlin, 1968.

Lynch, Kevin. *The Image of the City*. Cambridge: Technology Press and Harvard University Press, 1960.

Lynch, Margaret. "The Growth of Cleveland as a Cultural Center." *The Birth of Modern Cleveland, 1865–1930*, ed. Thomas Campbell and Edward Miggins. Cleveland: Western Reserve Historical Society, 1988.

Macadam, Alta. *Blue Guide. Northern Italy: From the Alps to Rome*. London: A. and C. Black, 1984.

Maleuvre, Didier. *Museum Memories: History, Technology, Art*. Stanford: Stanford University Press, 1999.

Malgouyres, Philippe. *Le musée Napoléon*. Paris: Réunion des Musées Nationaux, 1999.

Mallock, W. H. *The New Republic: Culture, Faith and Philosophy in an English Country House*. Leicester: Leicester University Press, 1975.

Malraux, André. *The Voices of Silence*, trans. Stuart Gilbert. Garden City, N.Y.: Doubleday, 1953.

Manguel, Alberto. *A History of Reading*. New York: Penguin, 1996.

Manning, Susan. Introduction, *The Marble Faun*, by Nathaniel Hawthorne. Oxford: Oxford University Press, 2002.

March, Benjamin. *China and Japan in Our Museums*. New York: American Council Institute of Pacific Relations, 1929.

Marin, Louis. *Portrait of the King*, trans. Martha M. Houle. Minneapolis: University of Minnesota Press, 1988.

Marx, Karl. *Capital: A Critique of Political Economy*, trans. Samuel Moore and Edward Aveling. New York: International, 1967.

Masheck, Joseph. "Dow's 'Way' to Modernity for Everybody." *Composition: A Series of Exercises in Art Structure for the Use of Students and Teachers*, by Arthur Wesley Dow. Berkeley: University of California Press, 1997.

Mather, Frank Jewett. *Venetian Painters*. New York: Henry Holt, 1936.

Matisse, Henri, M.-A. Couturier, and L.-B. Rayssiguier. *La Chapelle de Vence: Journal d'une création*. Geneva: Skira and Menil Foundation, 1993.

Maynard, Patrick. *The Engine of Visualization: Thinking through Photography*. Ithaca: Cornell University Press, 1997.

McClellan, Andrew. "A Brief History of the Art Museum Public." *Art and Its Publics: Museum Studies at the Millennium*, ed. Andrew McClellan. Malden, Mass.: Blackwell, 2003.

———. *Inventing the Louvre: Art, Politics, and the Origins of the Modern Museum in Eighteenth-Century Paris*. Berkeley: University of California Press, 1994.

———. "Watteau's Dealer: Gersaint and the Marketing of Art in Eighteenth-Century Paris." *Art Bulletin* 78, no. 3 (September 1996): 439–53.

McFarlane, K. B. *Hans Memling*. Oxford: Oxford University Press, 1971.

McShine, Kynaston. *The Museum as Muse: Artists Reflect*. New York: Museum of Modern Art, 1999.

Mead, Sidney Moko. "The Ebb and Flow of Mana Maori and the Changing Context of Maori Art." *The Maori: Maori Art from New Zealand Collections*, ed. Sidney Moko Mead. New York: Harry N. Abrams, 1984.

Meier, Richard. "Building for the Future." *Getty Bulletin* 1, no. 1 (1986).

Mellon, Paul with John Baskett. *Reflections in a Silver Spoon*. New York: William Morrow, 1992.

Melville, Robert. *Erotic Art of the West*. London: Weidenfeld and Nicolson, 1973.

Merleau-Ponty, Maurice. *The Primacy of Perception*, trans. James M. Edie. Evanston: Northwestern University Press, 1964.

Miggins, Edward. "A City of 'Uplifting Influences.'" *The Birth of Modern Cleveland, 1865–1930*, ed. Thomas Campbell and Edward Miggins. Cleveland: Western Reserve Historical Society, 1988.

Millar, Oliver. *Zoffany and His Tribuna*. London: Paul Mellon Foundation for British Art, 1966.

Miller, Carol Poh, and Robert Wheeler. *Cleveland: A Concise History, 1796–1990*. Bloomington: Indiana University Press, 1990.

Miller, Mary Ellen. *The Art of Mesoamerica: From Olmec to Aztec*. New York: Thames and Hudson, 1996.

Mills, John. "The Coming of the Carpet to the West." *The Eastern Carpet in the*

Western World: From the Fifteenth to the Seventeenth Century. London: Hayward Gallery, 1983.

Moore, George Edward. "Certainty." *Descartes: A Collection of Critical Essays*, ed. Willis Doney. Garden City, N.Y.: Anchor, 1967.

———. *Principia Ethica*. Cambridge: Cambridge University Press, 1965.

Morra, Umberto. *Conversations with Berenson*, trans. Florence Hammond. Boston: Houghton Mifflin, 1965.

Morton, Brian. *Americans in Paris*. Ann Arbor: Olivia and Hill, 1984.

Moxey, Keith. *The Practice of Persuasion: Paradox and Power in Art History*. Ithaca: Cornell University Press, 2001.

Muchnic, Suzanne. *Odd Man In: Norton Simon and the Pursuit of Culture*. Berkeley: University of California Press, 1999.

———. Review of Getty. *Los Angeles Times*, Orange County Edition, November 30, 1997.

Muensterberger, Werner. *Collecting: An Unruly Passion. Psychological Perspectives*. Princeton: Princeton University Press, 1994.

Mullen, Mary. *An Approach to Art*. Merion, Pa.: Barnes Foundation, 1923.

Munro, Eleanor. *Memoir of a Modernist's Daughter*. New York: Viking, 1988.

———. *Originals: American Women Artists*. New York: Simon and Schuster, 1979.

Munro, Thomas. *Aesthetic Form: The Analysis of Form in the Arts*. Undated typescript, Case Western Reserve University library.

———. "The Aesthetics of Bernard Berenson." *Journal of the Barnes Foundation* 1, no. 2 (May 1925): 48–53.

———. *The Arts and Their Interrelations*. Cleveland: Western Reserve University, 1967.

———. *Evolution in the Arts and Other Theories of Culture History*. Cleveland: Cleveland Museum of Art, 1963.

———, ed. *The Future of Aesthetics: A Symposium on Possible Ways of Advancing Theoretical Studies of the Arts and Related Types of Experience*. Cleveland: Cleveland Museum of Art, 1942.

———. *Oriental Aesthetics*. Cleveland: Western Reserve University, 1965.

———. *Toward Science in Aesthetics: Selected Essays*. New York: Liberal Arts, 1956.

Munro, Thomas, and Jane Grimes. *Educational Work at the Cleveland Museum of Art*. Cleveland: Cleveland Museum of Art, 1952.

Muschamp, Herbert. Review of Getty. *New York Times*, December 2, 1997.

Nabokov, Vladimir. *Pale Fire*. New York: Vintage, 1989.

Nahin, Paul. *Time Machines: Time Travel in Physics, Metaphysics, and Science Fiction*. New York: Springer, 1999.

Nash, Jane. *Veiled Images: Titian's Mythological Paintings for Philip II*. Philadelphia: Art Alliance, 1985.

Needham, Joseph. *The Grand Titration: Science and Society in East and West.* London: George Allen and Unwin, 1969.

Neff, John. "Matisse and Decoration: The Shchukin Panels." *Art in America*, July–August 1975, 59–63.

Nehamas, Alexander. "The Art of Being Unselfish." *Daedalus* 131, no. 4 (fall 2002): 57–68.

———. *The Art of Living: Socratic Reflections from Plato to Foucault.* Berkeley: University of California Press, 1998.

———. *Nietzsche: Life as Literature.* Cambridge: Harvard University Press, 1985.

———. *Virtues of Authenticity: Essays on Plato and Socrates.* Princeton: Princeton University Press, 1999.

Nelson, Susan. "*I-p'in* in Later Painting Criticism." *Theories of the Arts in China*, ed. Susan Bush and Christian Murck. Princeton: Princeton University Press, 1983.

Newhouse, Victoria. *Towards a New Museum.* New York: Monacelli, 1998.

Nicholson, H. B., with Eloise Quinones Keber. *Art of Aztec Mexico: Treasures of Tenochtitlan.* Washington: National Gallery of Art, 1983.

Nietzsche, Friedrich. *On the Genealogy of Morals*, trans. Walter Kaufmann and R. J. Hollingdale. New York: Vintage, 1989.

Nochlin, Linda. *The Body in Pieces: The Fragment as a Metaphor of Modernity.* London: Thames and Hudson, 1994.

———. "Museums and Radicals: A History of Emergencies." *Art in America*, July–August 1971.

Nute, Kevin. *Frank Lloyd Wright and Japan: The Role of Traditional Japanese Art and Architecture in the Work of Frank Lloyd Wright.* New York: Van Nostrand Reinhold, 1993.

O'Brian, John. *Ruthless Hedonism: The American Reception of Matisse.* Chicago: University of Chicago Press, 1999.

O'Doherty, Brian. *Inside the White Cube: The Ideology of the Gallery Space.* Santa Monica: Lapis, 1986.

O'Neill, John, ed., *Barnett Newman. Selected Writings and Interviews.* Berkeley: University of California Press, 1990.

Onians, John. *Classical Art and the Cultures of Greece and Rome.* New Haven: Yale University Press, 1999.

———. " 'I Wonder . . .': A Short History of Amazement." *Sight and Insight: Essays on Art and Culture in Honor of E. H. Gombrich at 85*, ed. John Onians. London: Phaidon, 1994.

Ostrow, "The Cultural Politics of Preservation." *The Bird of Self-Knowledge: Folk Art and Current Artists' Positions*, ed. Peter Weiermair. Zurich: Stemmle, 1998.

Ovid. *The Metamorphoses of Ovid*, trans. Mary M. Innes. London: Penguin, 1965.

Pach, Walter. *The Art Museum in America.* New York: Pantheon, 1948.

Paine, Robert, and Alexander Soper. *The Art and Architecture of Japan*. Harmondsworth: Penguin, 1974.

Panofsky, Erwin. *Problems in Titian, Mostly Iconographic*. New York: New York University Press, 1969.

Parfit, Derek. *Reasons and Persons*. Oxford: Oxford University Press, 1984.

Pascal, Blaise. *Pensées and Other Writings*, trans. H. Levi. Oxford: Oxford University Press, 1995.

Pater, Walter. *The Renaissance: Studies in Art and Poetry*, ed. Donald L. Hill. Berkeley: University of California Press, 1980.

———. *Marius the Epicurean*. Harmondsworth: Penguin, 1985.

Pearce, Susan. *On Collecting: An Investigation into Collecting in the European Tradition*. London: Routledge, 1995.

Pearson, John. *Painfully Rich: J. Paul Getty and His Heirs*. London: Macmillan, 1995.

Peniston, William, ed. *The New Museum: Selected Writings by John Cotton Dana*. Newark, N.J.: The Newark Museum Association, 1999.

Pernia, Maria Grazia, and Laurie Schneider Adams. *Federicoda Montefeltro and Sigismondo Malatesta: The Eagle and the Elephant*. New York: Peter Lang, 1996.

Petrie, Brian. *Puvis de Chavannes*, ed. Simon Lee. Aldershot: Ashgate: 1997.

Perry, Marilyn. "The Renaissance Showplace of Art: The Palazzo Grimani at Santa Maria Formosa, Venice." *Apollo* 113 (April 1981): 215.

Pears, D. F. *Bertrand Russell and the British Tradition in Philosophy*. New York: Random House, 1967.

Petzinger, Thomas, Jr. *Oil and Honor: The Texaco-Pennzoil Wars*. New York: G. P. Putnam's Sons, 1987.

Pevsner, Nikolaus. *An Outline of European Architecture*. Harmondsworth: Penguin, 1972.

Pichois, Claude. *Baudelaire*, trans. Graham Robb. London: Hamish Hamilton, 1989.

Pietrangeli, Carlo. "The Vatican Museums." *The Vatican Collections: The Papacy and Art*. New York: Metropolitan Museum of Art, 1982.

Pinkard, Terry. "Constitutionalism, Politics and the Common Life." *Hegel Reconsidered: Beyond Metaphysics and the Authoritarian State*, ed. H. Tristram Engelhardt and Terry Pinkard. Dordrecht: Kluwer, 1994.

———. *Hegel's Phenomenology: The Sociality of Reason*. Cambridge: Cambridge University Press, 1994.

Pippin, Robert. *Modernism as a Philosophical Problem: On the Dissatisfactions of European High Culture*. Malden, Mass.: Blackwell, 1991.

Plant, Margaret. *Venice: Fragile City, 1797–1997*. New Haven: Yale University Press, 2002.

Pliny. *Letters and Panegyricus*, trans. Betty Radice. Cambridge: Belknap, 1972.

Podro, Michael. *The Critical Historians of Art.* New Haven: Yale University Press, 1982.

Pomian, Krzystof. *Collectors and Curiosities: Paris and Venice, 1500–1800,* trans. Elizabeth Wiles-Portier. Cambridge: Polity, 1990.

Pommier, Edouard Ed. *Les musées en Europe à la veille de l'ouverture du Louvre.* Paris: Musée du Louvre, 1995.

Pope, John. "Sinology or Art History: Notes on Method in the Study of Chinese Art." *Harvard Journal of Asiatic Studies* 10 (1947): 388–417.

Pope-Hennessy, John. "Berenson." *On Artists and Art Historians: Selected Book Reviews of John Pope-Hennessy,* ed. Walter Kaiser and Michael Mallon. Florence: Leo S. Olschki, 1993.

———. "Berenson's Certificate." *New York Review* 34, no. 4 (1987): 19.

———. *Learning to Look.* New York: Doubleday, 1991.

Porter, Philip. *Cleveland: Confused City on a Seesaw.* Columbus: Ohio State University Press, 1976.

Pound, Ezra, and Ernest Fenollosa. *The Classic Noh Theatre of Japan.* New York: New Directions, 1959.

Potts, A. "Political Attitudes and the Rise of Historicism in Art History." *Art History* 1, no. 2 (1978): 191–213.

Preziosi, Donald. "The Art of Art History." *The Art of Art History: A Critical Anthology.* Oxford: Oxford University Press, 1998.

———. *Brain of the Earth's Body: Art, Museums, and the Phantasms of Modernity.* Minneapolis: University of Minnesota Press, 2003.

———. "Collecting/Museums." *Contemporary Critical Terms in Art History,* ed. Robert Nelson and Richard Shiff. Chicago: University of Chicago Press, 1996.

Prior, Nick. *Museums and Modernity: Art Galleries and the Making of Modern Culture.* New York: Berg, 2002.

Putnam, James. *Art and Artifact: The Museum as Medium.* London: Thames and Hudson, 2001.

Quine, Willard Van Orman. *Word and Object.* Cambridge: MIT Press, 1960.

Radisich, Paula Rea. *Hubert Robert: Painted Spaces of the Enlightenment.* Cambridge: Cambridge University Press, 1998.

Ransmawy, Christoph. *The Last World: A Novel with an Ovidian Repertory,* trans. John E. Woods. New York: Grove Weidenfeld, 1990.

Rawls, John. *Political Liberalism.* New York: Columbia University Press, 1996.

———. *A Theory of Justice.* Cambridge: Harvard University Press, 1971.

Rockefeller, Steven. *John Dewey: Religious Faith and Democratic Humanism.* New York: Columbia University Press, 1991.

Reiss, Julie. *From Margin to Center: The Spaces of Installation Art.* Cambridge: MIT Press, 1999.

"Report of the Director." *Philadelphia Museum of Art: Annual Report 1994,* 11–12.

Repton, Humphrey. *The Art of Landscape Gardening*. Boston: Houghton Mifflin, 1907.

Rieff, David. *Los Angeles: Capital of the Third World*. New York: Simon and Schuster, 1991.

Rieser, Max. "Thomas Munro's Position in American Aesthetics." *Journal of Aesthetics and Art Criticism* 23, no. 1 (fall 1964): 13–20.

Roberts, J. M. *The Pelican History of the World*. Harmondsworth: Penguin 1980.

Rorty, Richard. *Consequences of Pragmatism: Essays, 1972–1980*. Minneapolis: University of Minnesota Press, 1982.

———. *Philosophy and the Mirror of Nature*. Princeton: Princeton University Press, 1979.

Rosenberg, Pierre. *Nicolas Poussin, 1594–1665*. Paris: Réunion des Musées Nationaux, 1994.

Rosenberg, Pierre and, Dupuy, Marie-Anne. *Dominique-Vivant Denon: L'oeil de Napoléon*. Paris: Réunion des Musées Nationaux, 1999.

Ross, David. "Session I: Panel Discussion: Is This an Age of Museums." *Salmagundi* 139–40 (summer–fall 2003).

Rossi, Filippo. *The Uffizi: Florence*. New York: Harry N. Abrams, 1957.

Rossiter, Stuart, ed. *The Blue Guides: England*. London: Ernest Benn, 1976.

Rowland, Benjamin. *Art in East and West: An Introduction through Comparisons*. Cambridge: Harvard University Press, 1965.

Rowland, Ingrid. *The Culture of the High Renaissance: Ancients and Moderns in Sixteenth-Century Italy*. Cambridge: Cambridge University Press, 1998.

Rowley, George. *Principles of Chinese Painting*. Princeton: Princeton University Press, 1947.

Ruskin, John. "A Museum or Picture Gallery: Its Functions and Its Formation." *The Works of John Ruskin*, vol. 34, ed. E. T. Cook and Alexander Wedderburn. London: George Allen, 1908.

Russell, Bertrand. *Logic and Knowledge: Essays, 1901–1950*. London: George Allen and Unwin, 1956.

Russell, John. *Matisse: Father and Son*. New York: Harry N. Abrams, 1999.

———. *The World of Matisse, 1869–1945* . New York: Time-Life, 1969.

Rubin, James. "Delacroix and Romanticism." *The Cambridge Companion to Delacroix*, ed. Beth S. Wright. Cambridge: Cambridge University Press, 2001.

Ryan, Alan. *John Dewey and the High Tide of American Liberalism*. New York: W. W. Norton, 1995.

Sahni, Julie. *Classic Indian Cooking*. New York: William Morrow, 1980.

Said, Edward. *Orientalism*. New York: Vintage, 1978.

Saisselin, Rémy. *The Enlightenment against the Baroque: Economics and Aesthetics in the Eighteenth Century*. Berkeley: University of California Press, 1992.

————. Preface, *Past, Present, East and West*, by Sherman Lee. New York: George Braziller, 1983.

————. *Taste in Eighteenth-Century France: Critical Reflections on the Origins of Aesthetics, or An Apology for Amateurs*. Syracuse: Syracuse University Press, 1965.

Samuels, Ernest, with Jayne Newcomer Samuels. *Bernard Berenson: The Making of a Legend*. Cambridge: Harvard University Press, 1987.

Sandford, Christopher. *Springsteen: Point Blank*. New York: Da Capo, 1999.

Sartre, Jean-Paul. *Nausea*, trans. Lloyd Alexander. New York: New Directions, 1969.

Sassoon, Donald. *Becoming Mona Lisa: The Making of a Global Icon*. New York: Harcourt, 2001.

Schama, Simon. *Citizens: A Chronicle of the French Revolution*. New York: Vintage, 1980.

Schapiro, Lillian Milgram, and Daniel Easterman, eds. *Meyer Schapiro: His Painting, Drawing, and Sculpture*. New York: Harry N. Abrams, 2000.

Schapiro, Meyer. "The Last Aesthete." *Commentary* 8, no. 6 (1949): 614–16.

————. "Matisse and Impressionism." *Matisse: A Retrospective*, ed. Jack Flam. New York: Beaux Arts, 1988.

————. *Modern Art: Nineteenth and Twentieth Centuries: Selected Papers*. New York: George Braziller, 1978.

————. "Mr. Berenson's Values." *Theory and Philosophy of Art. Style, Artist, and Society*. New York: George Braziller, 1994.

————. *Romanesque Art: Selected Papers*. New York: George Braziller, 1977.

————. *Worldview in Painting: Art and Society*. New York: George Braziller, 1999.

Scheyer, Ernst. *The Circle of Henry Adams: Art and Artists*. Detroit: Wayne State University Press, 1970.

Schiller, Friedrich. *On the Aesthetic Education of Man in a Series of Letters*, trans. Elizabeth M. Wilkinson and L. A. Willoughby. Oxford: Clarendon, 1967.

Schlegel, "Descriptions of Paintings from Paris and the Netherlands in the Years 1802 to 1804." *German Essays in Art History*, ed. Gert Schiff. New York: Continuum, 1988.

Schloder, John, Marjorie Williams, Diane DeBevec, and C. Griffith Mann. *The Visitor's Voice: Visitor Studies in the Renaissance-Baroque Galleries of the Cleveland Museum of Art, 1990–1993*. Cleveland: Cleveland Museum of Art, 1993.

Schnapper, Antoine. "From Politics to Collecting: Louis XIV and Painting." *The Sun King: Louis XIV and the New World*. New Orleans: Louisiana Museum Foundation, 1984.

————. "The King of France as Collector in the Seventeenth Century." *Journal of Interdisciplinary History* 12, no. 1 (1986): 199–200.

Schneider, Pierre. *Louvre Dialogues*, trans. Patricia Southgate. New York: Atheneum, 1971.

————, ed. *Henri Matisse: Matisse et l'Italie*. Milan: Arnoldo Mondadori, 1987.

————. *Matisse*, trans. Michael Taylor and Bridget Stevens Romer. New York: Rizzoli, 1984.

Schneider, Rogier. *Quatremère de Quincy et son intervention dans les arts*. Paris: Hachette, 1910.

Schubert, Karsten. *The Curator's Egg: The Evolution of the Museum Concept from the French Revolution to the Present Day*. London: One-Off, 2000.

Schulz, Eva. "Notes on the History of Collecting and of Museums." *Journal of the History of Collections* 2, no. 2 (1990): 205–18.

Schulze, Franz. *Philip Johnson: Life and Work*. New York: Alfred A. Knopf, 1994.

Schuster, J. Mark Davidson. "The Public Interest in the Art Museum's Public." *Art Museums and the Price of Success*, ed. Truus Gubbels and Annemoon van Hemel. Amsterdam: Boekman Foundation, 1993.

Scott, Katie. "Introduction: 'Pour la gloire des arts et l'honneur de France': Commemorating Poussin, 1784–1995." *Commemorating Poussin: Reception and Interpretation of the Artist*, ed. Scott and Genevieve Warwick. Cambridge: Cambridge University Press, 1999.

Sedlmayr, Hans. *Art in Crisis: The Lost Center*. London: Hollis and Carter, 1957.

Sennett, Richard. *The Fall of Public Man: On the Social Psychology of Capitalism*. New York: Vintage, 1978.

Serota, Nicholas. *Experience or Interpretation: The Dilemma of Museums of Modern Art*. London: Thames and Hudson, 1996.

Shand-Tucci, Douglass. *The Art of Scandal: The Life and Times of Isabella Stewart Gardner*. New York: Harper Collins, 1997.

Shapiro, Gary. *Archaeologies of Vision: Foucault and Nietzsche on Seeing and Saying*. Chicago: University of Chicago Press, 2003.

Shaw, A. H. "Profiles: De Medici in Merion." *New Yorker*, September 22, 1928.

Shearman, John. *Only Connect . . . : Art and the Spectator in the Italian Renaissance*. Washington: National Gallery of Art, 1992.

Sheehan, James. "From Princely Collections to Public Museums: Toward a History of the German Art Museum." *Rediscovering History: Culture, Politics, and the Psyche*, ed. Michael S. Roth. Stanford: Stanford University Press, 1994.

————. *Museums in the German Art World from the End of the Old Regime to the Rise of Modernism*. New York: Oxford University Press, 2000.

Shelton, *No Direction Home: The Life and Music of Bob Dylan*. New York: Beech Tree, 1986.

Sherman, Daniel. "Quatremère/Benjamin/Marx: Art Museums, Aura, and Commodity Fetishism." *Museum Culture: Histories, Discourses, Spectacles*, ed. Daniel J. Sherman and Iris Rogott. Minneapolis: University of Minnesota Press, 1994.

Shiner, Larry. *The Invention of Art: A Cultural History*. Chicago: University of Chicago Press, 2001.

Sickman, Laurence. Introduction, *Chinese Calligraphy and Painting in the Collection of John M. Crawford, Jr.* New York: Metropolitan Museum of Art, 1962.

Sickman, Laurence, and Alexander Soper. *The Art and Architecture of China*. Harmondsworth: Penguin, 1971.

Sirén, Osvald. *The Chinese on the Art of Painting*. New York: Schocken, 1963.

———. *Chinese Painting: Leading Masters and Principles*, pt 1, vol. 1. New York: Ronald, 1956.

Smith, Ralph. "Contemporary Aesthetic Education." *Encyclopedia of Aesthetics*, ed. Michael Kelly. New York: Oxford University Press, 1998.

Soucek, Priscilla. "Nizami on Painters and Paintings." *Islamic Art in the Metropolitan Museum of Art*, ed. Richard Ettinghausen. New York: Metropolitan Museum of Art, 1972.

Spalding, Julian. *The Poetic Museum: Reviving Historic Collections*. Munich: Prestel, 2002.

Spence, Jonathan. *The Memory Palace of Matteo Ricci*. New York: Viking, 1984.

Spitz, Ellen Handler. "Tattoos and Teddy Bears: Fetishism on Exhibit in Paris." *Studies in Gender and Sexuality* 1, no. 2 (2000): 218–20.

Soussloff, Catherine. "Introducing Jewish Identity to Art History." *Jewish Identity in Modern Art History*. Berkeley: University of California Press, 1999.

Springer, Carolyn. *The Marble Wilderness: Ruins and Representation in Italian Romanticism, 1775–1850*. Cambridge: Cambridge University Press, 1987.

Spurling, Hilary. *The Unknown Matisse: A Life of Henri Matisse: The Early Years, 1869–1908*. New York: Alfred A. Knopf, 1998.

Staiti, Paul. *Samuel F. B. Morse*. Cambridge: Cambridge University Press, 1985.

Staniszewski, Mary Anne. *The Power of Display: A History of Exhibition Installations at the Museum of Modern Art*. Cambridge: MIT Press, 1998.

Steegmuller, Francis. "An Approach to James Jackson Jarves." *Stories and True Stories*. Boston: Little, Brown, 1972.

———. *The Two Lives of James Jackson Jarves*. New Haven: Yale University Press, 1951.

Stein, Perrin. *Masterpieces of Journal Paul Getty Museum: Paintings*. Los Angeles: J. Paul Getty Trust, 1997.

Steinberg, Leo. *Leonardo's Incessant Last Supper*. Cambridge: MIT Press, 2001.

———. *Michelangelo's Last Paintings: The Conversion of St. Paul and the Crucifixion of St. Peter in the Cappella Paolina, Vatican Palace*. New York: Oxford University Press, 1975.

———. "Observations in the Cerasi Chapel." *Art Bulletin* 49 (1959): 183–90.

———. *Other Criteria: Confrontations with Twentieth-Century Art*. New York: Oxford University Press, 1972.

Stirling, James Hutchinson. *The Secret of Hegel: Being the Hegelian System in Origin, Principle, Form, and Matter*. London: Longman, Green, Roberts, 1865.

St. John, Bayle. *The Louvre, or Biography of a Museum*. London: Chapman and Hall, 1855.

Stokes, Adrian. *The Critical Writings of Adrian Stokes*. London: Thames and Hudson, 1978.

———. *The Quattro Cento and Stones of Rimini*. University Park: Pennsylvania State University Press, 2002.

Stokrocki, Mary. "Interviews with Students: Thomas Munro as a Teacher of Aesthetics and Art Criticism." *The History of Art Education: Proceedings from the Second Penn State Conference 1899*, ed. Patricia Amburgy, Donald Soucy, Mary Ann Stankiewicz, Brent Wilson, and Marjorie Wilson. Reston, Va.: National Art Education Association, 1992.

Strong, Roy. *Art and Power: Renaissance Festivals, 1450–1650*. Berkeley: University of California Press, 1984.

———. *Splendor at Court: Renaissance Spectacle and the Theater of Power*. Boston: Houghton Mifflin, 1973.

Strouse, Jean. *Morgan: American Financier*. New York: Random House, 1999.

Sullivan, Michael. *The Arts of China*. Berkeley: University of California, 1984.

———. *The Birth of Landscape Painting in China*. Berkeley: University of California, 1962.

———. *The Meeting of Eastern and Western Art*. Berkeley: University of California Press, 1997.

Summers, David. *The Judgment of Sense: Renaissance Naturalism and the Rise of Aesthetics*. Cambridge: Cambridge University Press, 1987.

Tafuri, Manfredo. *Venice and the Renaissance*, trans. Jessica Levine. Cambridge: MIT Press, 1989.

Taylor, Charles. *Hegel*. Cambridge: Cambridge University Press, 1975.

Tharp, Louise Hall. *Mrs. Jack: A Biography of Isabella Stewart Gardner*. Boston: Little, Brown, 1965.

Tintner, Aldeine. *The Museum World of Henry James*. Ann Arbor, Mich.: UMI Research Press, 1986.

Tocqueville, Alexis de. *The Old Régime and the French Revolution*, trans. Stuart Gilbert. New York: Doubleday, 1955.

Toker, Franklin. *Pittsburgh: An Urban Portrait*. University Park: Pennsylvania State University Press, 1986.

Tomalin, Claire. *Samuel Pepys: The Unequalled Self*. New York: Alfred A. Knopf, 2002.

Tomita, Kojiro. *A History of the Asiatic Department*. Boston: Museum of Fine Arts, 1990.

Treue, Wilhelm. *Art Plunder: The Fate of Works of Art in War and Unrest*. New York: John Day, 1961.

Tribby, Jay. "Body/Building: Living the Museum Life in Early Modern Europe." *Rhetorica* 10, no. 2 (1992).

Trodd, Colin. "Culture, Class, City: The National Gallery, London, and the Spaces of Education." *Art Apart: Art Institutions and Ideology across England and North America*. Manchester: Manchester University Press, 1994.

Trulove, James Grayson. *Designing the New Museum: Building a Destination*. Gloucester, Mass.: Rockport, 2000.

Turner, Evan, and Walter Leddy, eds. *Object Lessons: Cleveland Creates an Art Museum*. Cleveland: Cleveland Museum of Art, 1991.

Updike, John. *Museums and Women and Other Stories*. Greenwich, Conn.: Fawcett Crest, 1972.

Valéry, Paul. *Degas, Manet, Morisot*, trans. David Paul. Princeton: Princeton University Press, 1960.

Varnedoe, Kirk. Panel Discussion. *Imagining the Future of the Museum of Modern Art*, ed. John Elderfield. New York: Museum of Modern Art, 1998.

Vasaly, Ann. *Representations: Images of the World in Ciceronian Oratory*. Berkeley: University of California Press, 1993.

Vasari, Giorgio. *The Lives of the Painters, Sculptors and Architects*, trans. A. B. Hinds. London: Dent, 1963.

Verstegen, Ian. "Bernard Berenson and the Science of Anti-Modernism." *Art Criticism* 15, no. 2 (2001): 9–22.

Vidal, Mary. *Watteau's Painted Conversations: Art, Literature, and Talk in Seventeenth- and Eighteenth-Century France*. New Haven: Yale University Press, 1992.

"Visitor Guide" and "An Eye for Art." Handouts. Boston: Isabella Stewart Gardner Museum, 2003.

Villatri, Rosario. *The Revolt of Naples*, trans. James Newell and John A. Marino. Cambridge: Polity, 1993.

von Holst, Niels. *Creators, Collectors, and Connoisseurs*, trans. B. Battershaw. New York: G. P. Putnam, 1967.

von Schlosser, Julius. *Raccolte d'arte e di meraviglie del tardo Rinascimento*, trans. Paola Di Paola. Florence: Sansoni, 1974.

Wackernagel, Martin. *The World of the Florentine Renaissance Artists: Projects and Patrons, Workshop and Art Market*, trans. Alison Luchs. Princeton: Princeton University Press, 1981.

Wall, Joseph Frazier. *Andrew Carnegie*. New York: Oxford University Press, 1970.

Walsh, John, and Deborah Gribbon. *Journal Paul Getty Museum and Its Collections: A Museum for the New Century*. Los Angeles: J. Paul Getty Trust, 1997.

Warner, Marina. *Fantastic Metamorphoses, Other Worlds: Ways of Telling the Self*. Oxford: Oxford University Press, 2002.

Waterfield, Giles. *Palaces of Art: Art Galleries in Britain, 1790–1990*. London: Dulwich Picture Gallery, 1991.

Weaver, William. *A Legacy of Excellence: The Story of Villa i Tatti*. New York: Harry N. Abrams, 1997.

Weil, Stephen. "Five Meditations." *Museum News*, January–February 2003, 28.

West, Nathanael. *Miss Lonelyhearts and The Day of the Locust*. New York: New Directions, 1962.

Wheeler, Stephen M. *A Discourse of Wonders: Audience and Performance in Ovid's Metamorphoses*. Philadelphia: University of Pennsylvania Press, 1999.

White, Hayden. *Metahistory: The Historical Imagination in Nineteenth-Century Europe*. Baltimore: Johns Hopkins University Press, 1973.

White, John. *Art and Architecture in Italy, 1250 to 1400*. Harmondsworth: Penguin, 1987.

Wind, Edgar. *Art and Anarchy*. New York: Vintage, 1969.

Winegardner, Mark. *Crooked River Burning*. San Diego: Harcourt 2001.

Wiggins, David. *Sameness and Substance*. Oxford: Basil Blackwell, 1980.

Williams, Harold. Interview. *Getty Bulletin* 10, no. 2.

Williams, Harold, Bill Lacy, Stephen D. Rountree, and Richard Meier. *The Getty Center: Design Process*. Los Angeles: J. Paul Getty Trust, 1991.

Williams, Harold, Ada Louise Huxtable, Stephen D. Rountree, and Richard Meier. *Making Architecture: The Getty Center*. Los Angeles: J. Paul Getty Trust, 1997.

Witchey, Holly Rarick, with John Vacha. *Fine Arts in Cleveland: An Illustrated History*. Bloomington: Indiana University Press, 1994.

Wittke, Carl. *The First Fifty Years: The Cleveland Museum of Art, 1916–1966*. Cleveland: Cleveland Museum of Art, 1966.

Wittkower, Rudolf. *Art and Architecture in Italy, 1600 to 1750*. Harmondsworth: Penguin, 1973.

Wölfflin, Heinrich. *Principles of Art History: The Problem of the Development of Style in Later Art*, trans. M. D. Hottinger. London: G. Bell and Sons, 1932.

Wollheim, Richard. *Art and Its Objects: An Introduction to Aesthetics*. New York: Harper and Row, 1968.

———. *On Art and the Mind: Essays and Lectures*. London: Allen Lane, 1973.

———. *Painting as an Art*. Princeton: Princeton University Press, 1987.

———. *The Thread of Life*. Cambridge: Harvard University Press, 1984.

Wood, Christopher. *The Vienna School Reader: Politics and Art Historical Method in the 1930s*. New York: Zone, 2000.

Woodfield, Richard Ed. *Reflections on the History of Art: Views and Reviews*. Berkeley: University of California Press, 1987.

Woodmansee, Martha. *The Author, Art, and the Market: Rereading the History of Aesthetics*. New York: Columbia University Press, 1994.

Woolf, Virginia. *Orlando: A Biography*. London: Triad Gafton, 1977.

Wright, Alastair Ian. *Identity Trouble: The Deconstructive Drive in Henri Matisse's Painting, 1905–1914*. PhD diss., Columbia University, 1997.

Wright, Christopher. *Poussin Paintings: A Catalogue Raisonné*. London: Harlequin, 1985.

Wrigley, Richard. *The Origins of French Art Criticism: From the Ancien Régime to the Restoration*. Oxford: Clarendon, 1993.

Wu Hung. *The Double Screen: Medium and Representation in Chinese Painting*. Chicago: University of Chicago Press, 1996.

Wyss, Beat. *Hegel's Art History and the Critique of Modernity*, trans. Caroline Dobson Saltzwedel. Cambridge: Cambridge University Press, 1999.

Yang Xin, "The Ming Dynasty." *Three Thousand Years of Chinese Painting*, ed. Yang Xin et al. New Haven: Yale University Press, 1997.

Yanni, Carla. *Nature's Museums: Victorian Science and the Architecture of Display*. Baltimore: Johns Hopkins University Press, 1999.

Yates, Frances. *The Art of Memory*. Chicago: University of Chicago Press, 1966.

Zuidervaart, Lambert. *Adorno's Aesthetic Theory: The Redemption of Illusion*. Cambridge: MIT Press, 1991.

Index

Abt, Jeffrey, 88
Adams, Laurie, 113
Adorno, Theodor, 234n37; on museum skepticism, 59
African art, 247n38
Agostino di Duccio, 176–77
Alhambra, 179
Alsop, Joseph, 10; on collecting, 249n53
Alternative worlds, 208
Arata, Stephen, on museum skepticism, 66
Architecture, of museums: entrances, 35–37, 91, 99–100, 170; floor plans, 100–102, 109
Arena Chapel (Giotto), 76, 80, 163
Arendt, Hannah, on museum skepticism, 70
Arnheim, Rudolf, 247n31; on Piero della Francesca's *Resurrection*, 130
Artforum, 215
Art history: history of, 8; world, 128–29
Art museums: architecture of, 91, 99–102, 109; Asian collections and, 142; capitalism and, 15, 186; change and, 222–23; conversations in, 220–21; end of history of, 199; Enlightenment and, 210–11; expansion of, 15, 145, 200; fantasy play in, 27–29; forces of destruction and, 32; French Revolution and, 12, 15; future and, 205–6; identification and, 123–25; imperialism and, 67; interpreted, 6–7, 17, 19–21: locations of, 181; mass art and, 212–13; memory theater and, 240n31; narratives about, 91–109; narratives of Asian art, 141–42; narratives within, 100–102, 126–27, 240n22; Napoleon and, 13; Native American art and, 88; non-European art and, 127, 247n38; optimism about, 206; origin of, 9–10, 11–12, 226n33, 264–65n6; paternalism and, 204; power and, 37–39, 41, 49, 62, 67, 179; provincial, 199; public good and, 67; radical innovation and, 198; Renaissance and, 9, 10, 98; sexy pictures in, 34; time travel and, 39–50; as total works of art, 18; utopian visions and, 224; varieties of American, 182; violence and, 86–87; as Western phenomenon, 10, 15

Bal, Mieke, 19, 94, 218
Bann, Stephen, 21; on museum skepticism, 63–64
Barnes, Albert, 8, 41, 148–64, 180, 181, 256n86; aesthetic theory and, 152–53, 157; on African American art, 150–51; African American culture and, 149, 164; *The Art in Painting*, 149, 151, 156; art world and, 158; Barr and, 148, 163; on Chinese painting, 153; collecting style of, 149–50; Thomas Craven and, 155; Dewey and, 150, 156–57, 160–61; formalism of, 151, 167; *The French Primitives*, 149; Gardner and, 155, 164; on Giotto, 153; Greenberg and, 148, 151–52, 163–64; Matisse and, 149–50, 155, 159, 162–63; on modernism, 200; Munro and, 150; *Primitive Negro Sculpture*, 187, 253n21; progressive politics of, 150
Barnes Foundation, 146–64: as democratic public art museum, 206–7; Matisse's *The Joy of Life* in, 157–59, 161–62; old-fashioned installations in, 157, 180
Barolsky, Paul, ix, 35, 84–85, 223

DAVID CARRIER is the Champney Family Professor

of Art History at Case Western Reserve University and

the Cleveland Institute of Art.

Library of Congress Cataloging-in-Publication Data
Carrier, David.
Museum skepticism : a history of the display of art in public
galleries / David Carrier.
p. cm.
Includes bibliographical references and index.
ISBN 0-8223-3682-0 (cloth : alk. paper) —
ISBN 0-8223-3694-4 (pbk. : alk. paper)
1. Art museums—Social aspects. 2. Art museums—
Philosophy. 3. Art—Exhibition techniques. I. Title.
N430.C37 2006
708.009—dc22